T0237049

Mare Plasticum – The Plastic Sea

Marilena Streit-Bianchi • Margarita Cimadevila •
Wolfgang Trettnak

Editors .

Mare Plasticum – The Plastic Sea

Combatting Plastic Pollution Through Science and Art

Springer

Editors
Marilena Streit-Bianchi
ARSCIENCIA and CERN
Honorary Staff Member
Wien, Austria

Margarita Cimadevila
ARSCIENCIA
Sada, A Coruña, Spain

Wolfgang Trettnak
ARSCIENCIA
Werndorf, Steiermark, Austria

ISBN 978-3-030-38947-5 ISBN 978-3-030-38945-1 (eBook)
https://doi.org/10.1007/978-3-030-38945-1

This Springer imprint is published by the registered company Springer Nature Switzerland AG.
The registered company address is: Gewerbestrasse 11, 6330 Cham, Switzerland

Foreword

Plastic is a wonderful material that may save lives in medicine, adds safety to cars or protects food from being wasted. Plastic has revolutionized electronics we rely on every day.

At the same time, plastic is the most visible threat to our oceans. But there is more than meets the eye. Microplastics are frighteningly invisible. Yet they have permeated water sources across the planet from the rivers right down to the deepest depths of the oceans and in the Arctic sea ice. Recent studies show that microplastic is also found in drinking water and seafood.

The EU is committed to fight plastics in the ocean and has taken several initiatives. Prominent examples include the following:

- the European Strategy for Plastics in a Circular Economy, promoting new circular business models;
- the directive on single-use plastics, reducing the use of single-use plastic items, including fishing gear, that pollute Europe's beaches and seas;
- the new Directive on Port Reception Facilities, providing an incentive to bring ashore all waste from ships;
- and the Commission's proposal for a revised Fisheries control regulation, including obligations to report and recover lost fishing gear.

Through the European Maritime and Fisheries Fund we have financed efforts to reduce, quantify, remove and recycle marine litter. We support "fishing for litter" operations with some 30 million €, and 14 EU Member states have joined the effort so far. And the Mission for Healthy Oceans, under the European Research programme, will further bundle and intensify research and innovation efforts to address, among others, the ocean's plastics challenge.

Of course, marine litter is very much an international problem and we are working in the United Nations, at the G7 and G20 as well as in other international fora to work with our international partners to take decisive action on marine litter.

I believe in leading by example. That is why DG MARE organizes an annual beach clean-up campaign, together with the European External Action Service. In 2018, our global beach clean-up resulted in more than 70 combined cleaning and awareness-raising actions and mobilized 3,000 participants around the world.

The programme for the incoming European Commission will continue to give priority to fighting plastic in the oceans. As part of a European Green Deal, the Commission is to lead efforts towards plastic-free oceans, among others addressing the issue of microplastics. Together, we can act to tackle the plastic pollution in our seas and oceans.

I hope you find this book an inspiring read and that we can count on you at the next beach clean-up.

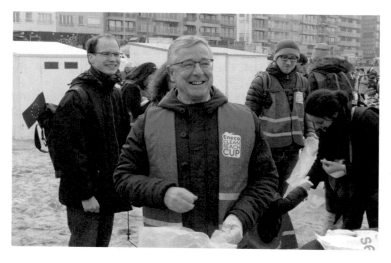

Directorate-General for Maritime Affairs João Aguiar Machado
and Fisheries (DG MARE),
European Commission, Brussels,
Belgium
September 2019

Preface

Plastic and plastic derivatives have become so abundantly used in our daily life that the issues linked to disposal, recycling and avoiding the pollution of our soils, rivers and oceans is of world-wide concern. The quantity of plastic debris in the form of mega-, macro-, micro- and nano-plastic as well as plastic particulates, better known as microbeads, has reached a level that is a threat to the waters of our rivers and oceans endangering marine wildlife, as the animals are mistaking this trash for food, and consequently human health. Several hundred marine species including marine mammals and sea birds have been found with plastic in their stomachs which affected them both in chemical and mechanical ways, killing them. Research and data collection have been undertaken since many decades with minor world-wide practical outcomes. It has been demonstrated that data collected from just the surface of seawater generally underestimate the total amount of plastic residual in ocean waters by an average factor of 2.5. As winds push the plastic more deeply, with strong winds the volume of plastic can be underestimated by a factor of 27 [1]. Furthermore, the tiny plastic pieces become good homes for bacteria and algae, creating a *"plastisphere"*, to which a chapter of the book is dedicated.

At the opening of the exhibition "Plastic fishes" in February 2015 at the *Oceanographic Museum* in Monaco Principality, being provocative I said: "Have we ever eaten plasticized fish?". We know today that this has become a reality.

Eighty per cent of the plastic at sea originates from inland, mostly rivers. This is why we thought it important to relate actual data collected in one of the most important rivers of Europe that flows through 10 countries: the Danube. An assessment of microplastic in 10 major European rivers, the Thames (England), the Elbe and Rhine (Germany), the Seine, Loire, Garonne and Rhone (France), the Tagus (Portugal), the Ebro (Spain) and the Tiber (Italy), will be made by the *Tara Ocean Foundation* and the *"Mission Microplastics 2019"* will have the *French*

National Centre for Scientific Research (CNRS) in charge of scientific coordination. An interdisciplinary team of about 40 scientists from marine biologists, to eco-toxicologists, oceanographers, mathematicians/modellers, chemists and physicists will identify the sources of pollution, the behaviour of microplastics dispersing in the ocean and their impact on marine life and food chain [2].

The Mediterranean Sea covers an area of 2,500,000 km^2, has an average depth of 1500 m and is especially fragile as it is almost completely enclosed by lands. This is why the creation and monitoring of protected areas like the Pelagos Sanctuary, a sea triangle of 87,500 km^2 in the Mediterranean, is of paramount importance.

The level of pollution is so high, as described by the contributions presented in this book, that it is not an exaggeration to define it as a major disaster. Plastic has become the most important anthropogenic litter of our Oceans reaching not only the Poles, a chapter of the book is dedicated to plastic and microplastic at 82°07′ North, but also the Mariana Trench, the deepest ocean trench [3].

The items produced and applications that are using plastic and plastic compounds are still growing in spite of the growing awareness of the induced pollution.

Since 2002 the *World Ocean Day* gets celebrated on the 8th of June. *"Clean Our Ocean"* was the theme of the *World Ocean Day 2018*, celebrated by UN in New York and elsewhere around the world [4], thus reminding people of the crisis humanity is facing if we do not take immediate and adequate measures.

Protection and sustainability are not void terms. The need is to understand and tackle in a circular way from producers to consumers, looking on large scale at the direct and indirect impact of biodegradable substitutes and new compounds on the environment, and evaluating the multiple economic costs and consequences. This will be of paramount importance, the establishment of a systemic approach with the involvement of all sectors concerned: researchers, economists, NGOs, companies, governmental bodies and legislators providing the necessary information and acting jointly to propose actions and find solutions. Simply assessing and analysing without a strategy for mandatory agreed world-wide actions is inadequate in view of the magnitude and extent of today's problem. Sustainability has multiple facets and demands the development of new materials, the establishment and enforcement of policies, plus a change in habits of the consumers. All this cannot be done quickly. It will require time and as is evident from the data presented, not much time is left. We cannot keep postponing the problem, we owe this to our descendants, and the time of action has come.

The changes required will affect many sectors along the production chain and the fear of disruption and of the huge cost associated with the replacement of plastic products might create opposition in spite of public awareness and of the creation of new more sound commercial opportunities.

The book presents art works made out of plastic debris found on the beaches of Galicia by the artists Margarita Cimadevila and Wolfgang Trettnak. The beauty of their art work should not make us forget the waste that man produces by his carelessness.

Art, museums, as well as teachers and media have an important role to play in raising in the general public the awareness of how urgent is the need for actions and behavioural changes and why it is important to fight plastic pollution. Exhibitions at national or school level as explained by the artists are also an important channel for dissemination of information and sharing the scientific knowledge.

Providing sound information and a global vision of the various issues, showing what is actually done, not only to assess but also to reduce the damage, or promoting road maps and changes, this is also a clear aim of this book.

The ban of the plastic bags, of cotton tips and plastic straws is just a start. The production and multiple uses of biodegradable materials are another, but surely among the various issues, for instance the concept of packaging has to be rethought. In spite of the commitment of many international companies towards sustainable packaging as reported in their web sites and the signature by many of them of the *New Plastics Economy Global Commitment* [5], we are still far from world-wide reusable plastic packaging and from having on the market new substitute materials. On the 12th of September 2019, *Nestlé* inaugurated in Lausanne the *Institute of Packaging Sciences*, first-of-its-kind in the food industry, as they say, with the aim of developing environmentally friendly packaging materials, reusable packaging solutions and thereafter the support of the development of local recycling infrastructures [6].

The need of monitoring the health of our oceans and rivers will not be terminated if we find ecologically sustainable solutions. We shall learn from the mistakes of the past and always consider the environmental impact, lifetime and disposal of the products put into commercial operations. Their amounts might become gigantic when becoming of world-wide daily use thus rapidly creating, if not taken into account at the start, unmanageable situations.

Wien, Austria Marilena Streit-Bianchi

References

1. Kukulka T, Proskurowski G, Morét-Ferguson S et al (2012) The effect of wind mixing on the vertical distribution of buoyant plastic debris. Geophys Res Lett 39:L07601. https://doi.org/10.1029/2012GL051116
2. Tara Ocean Foundation. https://oceans.taraexpeditions.org/en/m/science/news/press-2019-microplastics-mission/
3. Chiba S, Saito H, Fletcher R et al (2018) Human footprint in the abyss: 30 year records of deep-sea plastic debris. Marine Policy 96: 204–212
4. United Nations. https://www.un.org/sustainabledevelopment/blog/2018/06/world-oceans-day-2018-to-focus-on-cleaning-up-plastic-in-oceans/
5. The New Plastics Economy (2019) https://www.newplasticseconomy.org/
6. Nestlé (2019) https://www.nestle.com/media/pressreleases/allpressreleases/nestle-inaugurates-packaging-research-institute

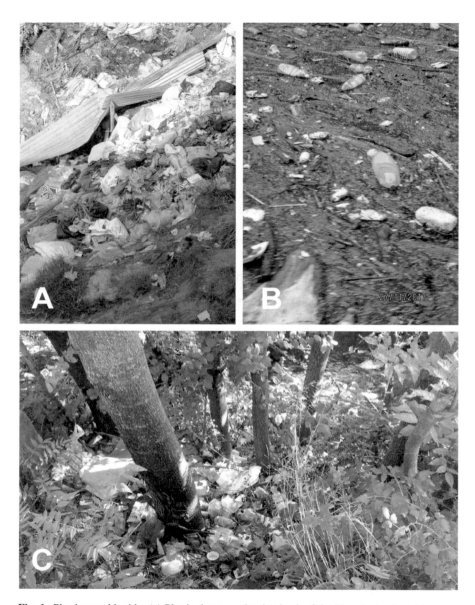

Fig. 1 Plastics world-wide: (**a**) Plastic dump on the riverbank of the Than Lwin river, Myanmar (Burma) 2017; (**b**) Plastics in the Grijalva river in the Sumidero Canyon National Park, Chiapas region, Mexico (2017); (**c**) Plastic dump next to the river Buna in Bosnia-Herzegovina (2019). Photos: Marilena Streit-Bianchi

Acknowledgements

The editors would like to thank all the authors who have made this book a reality with their good and enthusiastic participation and collaboration. The amount of research going on in plastic pollution issues at any level and the data available or forecasted, which are reported in their contributions, are impressive and well summarize today's situation and need of actions. We acknowledge the way they have been able to make clear and comprehensible overviews and to provide the beautiful even if sometimes terrifying illustrations. This makes this book interesting and attractive also to non-experts.

Connecting Science with Art we always have been convinced to be an effective way to raise and increase awareness and to back education on sustainable issues, and we warmly thank *Springer Nature* and in particular *Springer*'s Executive Editor Marina Forlizzi for having believed in and supported our project.

Contents

About the Editors

Marilena Streit-Bianchi was born in Rome (Italy). She received a doctorate in Biological Sciences from the University of Rome and joined CERN, the European Organization for Nuclear Research, in Geneva (Switzerland), in 1969. She has been a pioneer in the study of high-energy particles produced by accelerators for cancer treatment. She has held managerial positions in the area of safety training and technology transfer and is currently a senior honorary staff member at CERN, actively engaged in art and science as a book editor and curator of exhibitions in Europe and Mozambique.

Margarita Cimadevila The artist who was born in Sada (A Coruña, Spain), graduated in Chemistry. She then worked as a secondary school science teacher for the Government of Galicia for thirty years, nine of them as director. Her artistic work combines science and art on topics such as the particle physics at CERN, women in science, gender equality and eco art. She is president of the organization ARSCIENCIA and a member of AMIT (Spanish Association of Women Researchers and Technologists). Her work has been exhibited in Europe, America and China.

Wolfgang Trettnak was born in Graz (Austria) and received a PhD in Chemistry from the University of Graz. He undertook applied research on sensors and biosensors for several years and published a number of scientific articles. In 2002, he became a freelance artist, and his work, which comprises painting, object art, and installations, has been exhibited in Europe, America, and China. His work links science with art on subjects such as bionics, electronics, luminescence and environmental topics.

The Exhibition MARE PLASTICUM: Art and Science for the Environment

Margarita Cimadevila and Wolfgang Trettnak

Abstract Plastic on the beach: Where does it come from? What is it made of? Will it degrade? What impact does it have on marine organisms? These questions were the sources of inspiration for the eco-art exhibition MARE PLASTICUM, which deals with the pollution of the oceans by plastics, its consequences and other environmental problems: entanglement, ingestion, mortality of species, toxicity, overfishing and overexploitation of the oceans. This is the story of the making of this exhibition by the authors in Galicia, from the first visual impact of beach litter, its investigation and documentation, the collection of marine plastic debris on the beaches, to its conversion into works of art. The exhibition combines recycling, sustainability, environmental protection, science and art. Its aim is to show these problems in a creative and appealing manner, to provide information and to raise public awareness of these topics, especially among young people. The alarm is ringing: *It is time to act!*

Keywords Plastic pollution · Marine litter · Beach litter · Eco-art · Art and science

1 Introduction

The exhibition MARE PLASTICUM belongs to a new avant-garde type of art movement called ECO-ART, which is trying to use art as a means of alerting on environmental issues. It deals with the pollution of the oceans by plastics, its environmental consequences as well as problems of sustainability related with the overfishing and overexploitation of the oceans. Its aim is to show these problems, to

M. Cimadevila
ARSCIENCIA, Sada, A Coruña, Spain
e-mail: cimadevila@arsciencia.org

W. Trettnak (✉)
ARSCIENCIA, Werndorf, Austria
e-mail: wolfgang@trettnak.com

© Springer Nature Switzerland AG 2020
M. Streit-Bianchi et al. (eds.), *Mare Plasticum – The Plastic Sea*,
https://doi.org/10.1007/978-3-030-38945-1_1

provide information and to create sensibility for these topics in the public, especially among the young people. The alarm is ringing:

It is time to act!

In this chapter the authors, Margarita Cimadevila (Spain) and Wolfgang Trettnak (Austria), artists with scientific background, explain how they came across the plastic problem: starting from the first visual impacts of beach litter in winter on the beaches of Galicia (Spain), the investigation of the kind and the origin of plastic materials found, and ending up with the decision to collect and use the plastic rubbish from the beach in order to create works of art. It will also be shown to which extent science and art have been merged in the exhibition MARE PLASTICUM, and how its objectives of a multiple nature (artistic, environmental, scientific and educational) were developed, pursued and reached.

The aim of the various exhibitions held since 2013 is manifold:

- To show the beauty of marine life through art and how it is affected by plastic.
- To release the most recent information of scientific research about this unnatural connubium, as well as the resulting health and environmental implication it has.
- To bring experts, civil society, school teachers and students together.

In fact the amount of plastic that gets into our oceans is threatening marine life and consequently will affect human life. Raising public awareness about how this plastic gets there, and the damage it is doing to the creatures living in our seas and oceans, is an important civic duty. Education of children about what should be done to preserve marine environment from discarded plastic can also be done by taking them to an exhibition and, whenever possible, having a school trip to the sea side in order to grasp to what extent plastic is polluting our beaches.

2 Plastics on the Beach

Galicia, located in the north-west of Spain (Europe), is facing both the Atlantic Ocean and the Cantabrian Sea (Fig. 1). Its coast line, which extends over 1200 km, shows a remarkable variability and is characterized by 800 km of steep coast, a large number of firth-like inlets or estuaries called *rías* and about 300 km of beautiful beaches (Fondo documental del Instituto Nacional de Estadística, Annuario 1985).

The comparatively mild summer temperatures, the lovely landscape and clean sandy beaches are charming. So it might be of no surprise that its seaside is very attractive as a summer resort, especially for someone like Wolfgang Trettnak coming from a country like Austria in the centre of Europe, which does not have access to the sea.

In winter time, however, weather can change a lot, since the coast of Galicia is fully exposed to the Atlantic storms. In this period of the year, temperatures are low and the beaches are not used by people. But they may show many surprises for the visitor: sea shells, algae, wood, plenty of litter and very strange objects! For Trettnak, being a chemist and an artist, it was quite shocking to watch, for the first time, the large variety of plastics, metal cans, glass pieces, tyres and other materials washed ashore (Fig. 2).

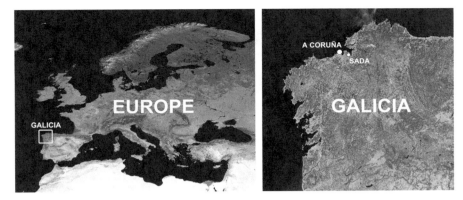

Fig. 1 Galicia (Spain) and its location within Europe. (Photos: *NASA* satellite images; public domain)

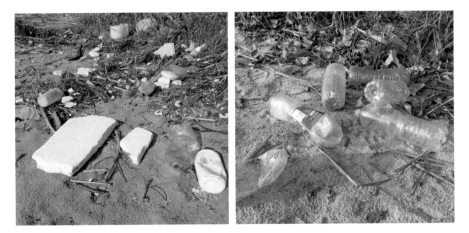

Fig. 2 Plastic litter on the beach. (Photos: © M. Cimadevila & W. Trettnak 2014. All rights reserved)

"What is it? Where does it come from?" he asked to the Galician artist Margarita Cimadevila. To give an answer to these questions about the plastics they found on the beaches was the origin of the exhibition MARE PLASTICUM (Fig. 3).

3 What Is It? Where Does It Come from?

In 2011, both artists started a joint investigation about the type of plastic materials, which they could find on the beaches of Galicia, with special emphasis on the *Golfo Ártabro* and its *rías* of A Coruña, Betanzos and Ares. Step by step the items were

Fig. 3 What is it? Where does it come from? The authors on the beach. (Photos: © M. Cimadevila & W. Trettnak 2018 and 2014.)

documented photographically and their potential sources and original purposes were identified. As a result, the principal sources of the plastic on the beaches were found to be:

- **Fishing and Aquaculture**

 Fishing and aquaculture play an important role in the economy and diet in Galicia. The ports of Vigo and A Coruña are two of the principle fishing ports for landing fresh fish in Spain (Puertos del Estado 2019) and the *rías* of Galicia allow the cultivation of mussels, oysters and other shell fish in large scale, being Galicia the main producer of mussels in Europe (The European Market for Mussels 2019).

 So it was not surprising to find plenty of items from these industries on the beach: fishing nets, trap boxes and their constituent parts, net bags, ropes, lines, floats, buoys, lures, buckets, boots, rubber gloves, brooms and even car tyres. In addition, aquaculture provides strange heaps, which seem to be stranded monsters from the abyss. In a closer investigation these heaps turned out to be agglomerations of special ropes spiked with plastic sticks, which are used in mussel cultivation, entangled with lines, fishing nets and other materials. Other strange objects were devices for collecting seeds of shell fish (Fig. 3).

- **Domestic and Urban Litter**

 Not surprisingly, a large part of the plastic debris found on the beach could easily be identified as products of daily life and as household goods. Practically any product, which is available in the supermarket, or, more accurately, its packaging material, could be encountered: bottles, bags, sheets, boxes, caps, tubes, cups, polystyrene foam. . .

 For some curious reason, a large number of shoes, shoe soles and heels, sandals, flip-flops, slippers, sneakers and boots were found. Children's toys,

cigarette lighters, eyeglasses, mobile phones, sport equipment and sanitary prod-
ucts (cotton buds, condoms and tampon applicators) complemented the vast offer.

 The major part of this urban litter is of land-based origin. It is transported to the
sea in part by the wind, rivers, sewerage systems and rain drains, or left behind or
lost by people on the beach.

The investigation of the beach litter was done by the authors on a qualitative basis
only. Very interestingly, a scientific analysis of the beach litter in three different
North Atlantic Galician beaches, carried out from 2001 to 2010, was published in
2014. Although a more sophisticated system for the classification of litter sources
was used, it confirmed some of the author's findings (Gago et al. 2014):

- The sectors of fishing and aquaculture were important contributors.
- Plastic was the main component.

A winter phenomenon? Plastics and other marine litter are found especially
during winter time on the beach. In this period of the year beach cleaning is not or
rarely performed and the storms agitate the sea and move the seabed. So the tides in
combination with the waves bring a lot of material ashore, which may come from the
sea floor or from distant sources.

A global problem Very soon the artists realized that marine plastic pollution was
not only a local problem but a worldwide dimension problem. The rubbish found
was not necessarily of local origin, since it might have travelled over large distances
and come from remote places. Ocean currents are responsible for distributing the
plastic all over the world, and thus it may even affect the most remote regions. The
famous *Great Pacific Garbage Patch* turned out to be only one of many accumula-
tions of marine debris in the oceans (Tekman et al. 2017; Leichter 2011; Chiba et al.
2018; Eriksen et al. 2016).

4 What Are the Problems Related with the Plastics?

The more important questions were: What are the problems related with these plastic
materials? Which effects are they having on the marine environment? In the year
2011 the authors started a search in literature and in the Internet in order to find
answers to these questions and to get more information on the potential risks and
impacts on the environment. They soon came across a number of alerting scientific
papers and reports, which confirmed that the negative visual impact of the plastic
beach litter was not the principal problem (Allsopp et al. 2006; Derraik 2002):

- **Durability**
 One of the most distinct properties of plastic is its durability and longevity. Many
 plastic materials do not decompose, especially under conditions such as the
 absence of light, low temperatures or lack of oxygen, which may be found on
 the seabed. Instead of degrading, the plastic material is fragmenting to smaller
 and smaller pieces resulting finally in so-called microplastics. This is favoured by

the action of the waves and the tides, especially on the beach. For example, plastic water bottles, which constitute a major part of the marine plastic debris, are typically made of polyester, which has got an estimated lifetime of hundreds of years. As a consequence, more and more plastic will be accumulating in the oceans unless the plastic input is stopped (Webb et al. 2013; Marnes et al. 2009).

- **Entanglement**
 It is quite obvious that marine animals could get entangled in fishing nets, trap boxes, ropes and lines. In fact, entanglement was reported for a large variety of organisms such as sea turtles, seabirds, marine mammals and fish. The lost, abandoned or discarded nets and pots may continue catching organisms for decades, a process, which has become known as "ghost fishing". Fishing nets are typically made of nylon, another material of high durability and resistance (Allsopp et al. 2006; Derraik 2002).

- **Plastic Ingestion**
 Among the species reported to have ingested plastic materials were sea turtles, sea birds, marine mammals and fish (Allsopp et al. 2006; Derraik 2002; Boerger et al. 2010). However, in the following years it became evident that almost all marine organisms may be affected by the ingestion of plastics and especially microplastics.

 In 2012, the authors were able to see in the Aquarium of O Grove (Pontevedra, Galicia) the skeleton of a Cuvier's beaked whale, which had been found dead on a beach in Galicia. In front of it, there was an impressive and huge amount of plastic sheets, which were found inside the whale, and which were, highly probably, the reason for its death (Fig. 4).

 A series of photographs taken on the Midway Islands, in the middle of the Pacific Ocean and far away from any civilization, showed intriguing photos of the carcasses of seabirds having large quantities of plastic materials inside, which had obviously been eaten by them (Jordan 2009).

- **Toxicity**
 Marine plastic debris may contain, accumulate or adsorb organic toxic substances, which may leach to the seawater or may be ingested together with the marine plastic. So-called persistent organic substances (POPs) have a large potential for acting as carcinogenic and mutagenic agents or as endocrine disrupters. It has also been reported that some chemicals used as plasticizers may even have influence on the sex of fish. The substances may directly affect the organism or may be bioaccumulated, thus also providing risks for human consumers of seafood (Ríos et al. 2010; Kang et al. 2007; Typer and Jobling 2008).

- **Invasive Species**
 It has been shown that marine organisms such as, for example, barnacles or molluscs may grow on plastic debris and then use the light-weight material as means of transport (Fig. 5). This allows them for travelling to new locations and eventually invading existing ecosystems (Allsopp et al. 2006; Derraik 2002).

All of these impacts were found to increase significantly the mortality of marine species and to be responsible for severe damages to their habitat. When the authors

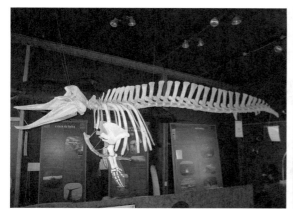

Fig. 4 Skeleton of a Cuvier's beaked whale and pile of plastic found inside the whale. (Aquarium of O Grove, Pontevedra, Galicia; photos: © M. Cimadevila & W. Trettnak 2012. All rights reserved)

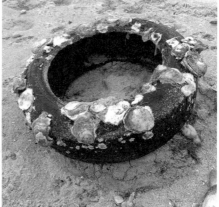

Fig. 5 Marine organisms growing on plastic materials: barnacles on seed collectors for aquaculture and oysters on a car tyre. (Photos: © M. Cimadevila & W. Trettnak 2014. All rights reserved)

started their investigations, there was limited scientific information available about these problems and the public had little knowledge about the problems related with the plastics. So their question was: How to make known these problems and the impact of plastic pollution to the audience in an attractive, creative, artistic and scientific way? Their answer was to create the exhibition MARE PLASTICUM.

5 MARE PLASTICUM

5.1 Beginnings

By 2011 the amount of plastic bags used in Spain was enormous, the bags were gratis and every visit to a shop or supermarket resulted in a large number of plastic bags back at home. Consequently, plenty of plastic bags could also be seen on the beach and in the sea.

At the same time, fish populations were reported to be declining, and the threat to have more plastic in the oceans than fish one day seemed to be quite real to the artists. This impression was also confirmed in 2016 by the *Ellen MacArthur Foundation* (Ellen MacArthur Foundation 2016): *"There are over 150 million tonnes of plastic waste in the ocean today. Without significant action, there will be more plastic than fish in the ocean, by weight, by 2050"*.

In addition, there seemed to be the problem that animals such as sea turtles and toothed whales ingest plastic bags with deleterious and even lethal consequences, since they might confuse them with food (Schuyler et al. 2012; Denuncio et al. 2011). "How was this possible?" the authors asked themselves.

Actually, these problems were the sources of inspiration to start experimenting and working with plastic materials, which finally resulted in whole series of art works:

- Initial experiments were done in order to convert plastic bags into fish, jellyfish or squid, which were fixed onto a canvas. And the idea worked, especially for jellyfish! The results were very convincing and now it seemed to be quite possible that a sea turtle would mistake a plastic bag for food and try to eat it (Fig. 6).
- Afterwards, plastic beverage bottles made of polyester were converted into fish by taking advantage of their thermoplasticity, which allowed to change their shape and size and for the creation of hanging mobiles based on "plastic fish" (Fig. 7).
- It was also found that the plastic used in hot glue guns was an excellent material to create artificial fish bones and skeletons on canvas, resembling ghost-like creatures, which might be left, when all real fish is gone. Some of these creatures were eating plastics; others were entangled in nets or just watching from below a great garbage patch, consisting of marine plastic litter (Figs. 8 and 9).
- Collecting marine plastic debris on the beaches of Galicia for integrating them in the art work also started by 2011 and culminated in a frenetic collecting activity by the authors in the following years (Fig. 10). Since the accumulated materials sometimes exceeded the place for storage, this led from time to time to serious discussions between the artists, although both of them kept collecting the beach litter. Whereas people were disconcerted when watching their activity at the beginning, later on they even helped to gather items.

Working in this way for 3 years in Galicia, the exhibition PLASTIC FISHES was created by Trettnak, with the sporadic support of Cimadevila. PLASTIC FISHES

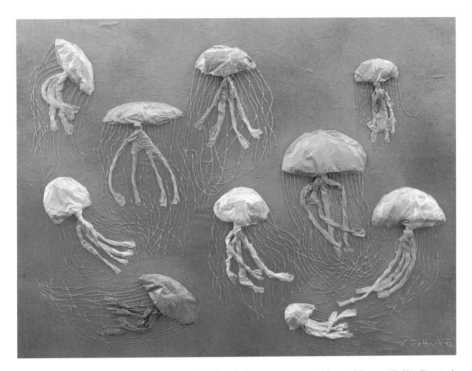

Fig. 6 *JELLYFISH*. Plastic bags and mixed technique on canvas; 80 × 100 cm. (© W. Trettnak 2012. All rights reserved)

was intended as a cry of alert and dedicated to the marine pollution by plastic debris, its effects on marine life, as well as the overfishing and overexploitation of the oceans (Worm et al. 2013; Atlantic Bluefin Tuna Status Review Team 2011; May 2009). It was the basis of MARE PLASTICUM, which started to emerge in 2014.

5.2 About the Exhibition and Its Art Works: Flourishing Creativity

The collaboration between Cimadevila and Trettnak initiated in the series PLASTIC FISHES and concretized in MARE PLASTICUM, which was done in full cooperation from conception, ideation, planning to execution, opening for them a new, exciting and fruitful artistic path. The extent was such that one of the artists told the other: "I don't really know where my work finishes and your work starts." and the answer was "Me too!" Both of them were working absolutely free, however trying to respect the contribution of each other, which sometimes was not an easy task.

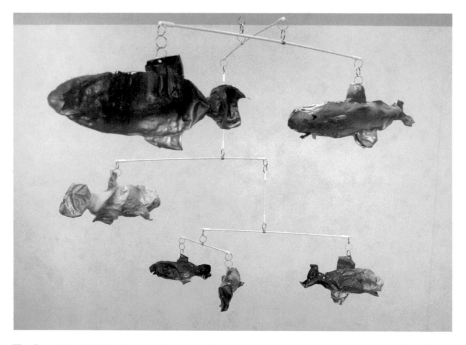

Fig. 7 *FISH MOBILE*. Plastic bottles, glass fibre rods, spray paint and other materials; 75 × 90 cm. (© M. Cimadevila & W. Trettnak 2016. All rights reserved)

Regarding the creative process, it was governed by an original and innovative character in the approach and execution and by a spirit of reusing the marine garbage and plastic to create innovative art works with fishing nets, trap boxes, floats, buoys, lures, ropes, lines, bags, bottles, shoes, toys and many other types of items.

The exhibition MARE PLASTICUM is mainly inspired by and dedicated to the problems related with marine plastic debris such as entanglement, ghost fishing, ingestion, toxicity, gyres of marine litter and microplastics. Recycling, sustainability, environmental protection, science and art are combined in the artistic works, which offer a poetic vision of the problems depicted that is both real and imaginary:

- Whole underwater worlds and submarine gardens evolved, with fantastic flowers, corals and algae, with the gardens being populated by fish and sea horses. The view of this underwater world by day and by night seems to be beautiful and attractive; however, the menace still remains there, since it completely consists of marine debris (Figs. 11 and 12).
- The large number of shoes, slippers, shoe soils and heels found on the beaches needed special attention. So in one work they were converted into slipper animalcules and dinoflagellates, and in another one a spider crab is selecting an appropriate shoe for camouflage from a large selection of footwear in the "marine shoe shop" (Fig. 13).

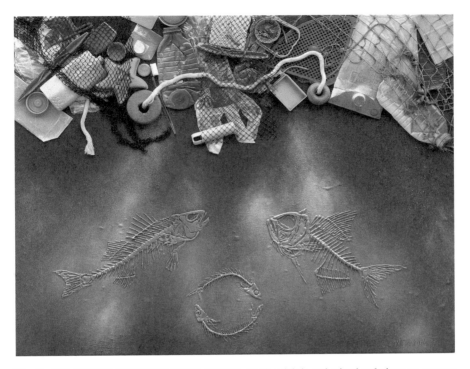

Fig. 8 *BELOW THE GREAT GARBAGE PATCH*. Marine debris and mixed technique on canvas; 80 × 100 cm. (© W. Trettnak 2012. All rights reserved)

- A dolphin seems to be entangled in a suspended fishing net, or is it just relaxing in it and playing? (Fig. 14)
- Octopuses are watching with astonishment and horror a badge, which indicates that it belonged to a trap box designed for catching octopus (Fig. 15).
- Turtles are playing with derelict fishing nets, or are they trying to eat them? (Fig. 16)
- Since plankton is very small and can be seen under the microscope only, it was enlarged to macroscopic scale on the canvases, where it is playing with pieces of supposed (micro-)plastics, which are already outnumbering the plankton (Moore et al. 2001).

As a highlight, in December 2017 the authors received a small box from the *Spanish Institute of Oceanography* in Vigo (Galicia) with a very special content: plastics from the stomachs of longnose lancetfish (*Alepisaurus ferox*), which were caught in the Atlantic Ocean! Apart of small fragments of plastic film and filament, it contained a large ribbon and the cartridge of a shotgun (Gago et al. 2020)! Although the material did not seem to be very spectacular, both artists were delighted and created a large work showing two voracious lancetfish just in the moment before ingesting these materials.

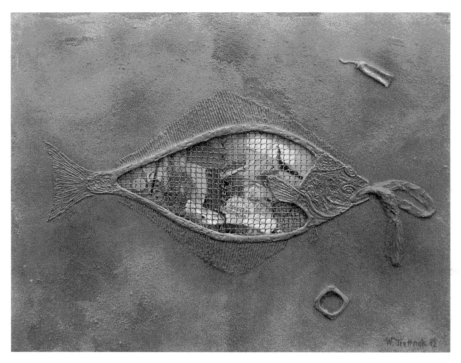

Fig. 9 *I'M STUFFED UP*. Marine debris and mixed technique on canvas; 80 × 100 cm. (© W. Trettnak 2012. All rights reserved)

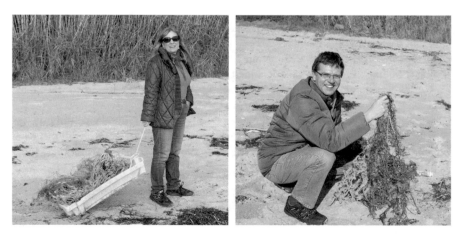

Fig. 10 Collecting materials on the beach. (Photos: © M. Cimadevila & W. Trettnak 2014 and 2015. All rights reserved)

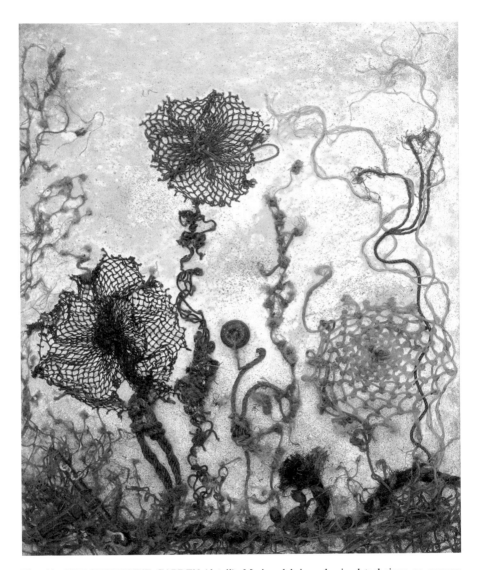

Fig. 11 *THE SUBMARINE GARDEN* (detail). Marine debris and mixed technique on canvas; 100 × 160 cm. (© M. Cimadevila & W. Trettnak 2014. All rights reserved)

The making of

What began as a small collaboration between artists became a big project, not only in its objectives but also in its dimensions. The first works were realized on small canvases of 30 × 40 cm, size that was increasing progressively, growing to 80 × 100 cm, and later multiplying in diptychs, triptychs and quadriptychs what forced the artists to extend their zones of work. In spite of this, the size of the works

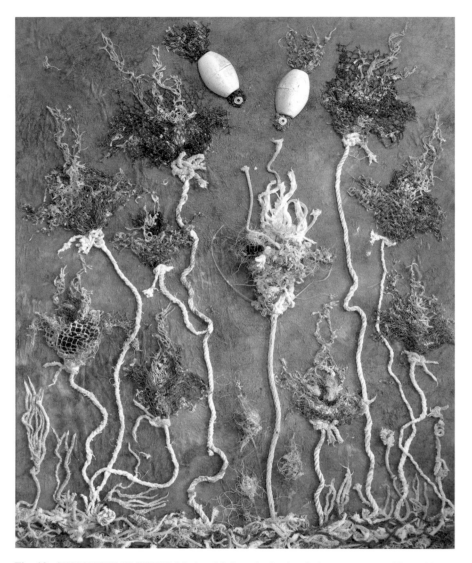

Fig. 12 *SUBMARINE FLOWERS*. Marine debris and mixed technique on canvas; 80 × 100 cm. (© M. Cimadevila & W. Trettnak 2016.)

was limited by the dimensions of the studios available and the manoeuvrability of the works in transport, the authors regretting having not being able to attack larger works in their "Atlantic studio" located in Sada (Galicia) (Fig. 17).

Recycling materials became a real obsession, thus creating new ways and forms of using plastics. A simple mooring line became a flagellum of a slipper animalcule, after going through a process of stretching and curling. The bait bags from the pots

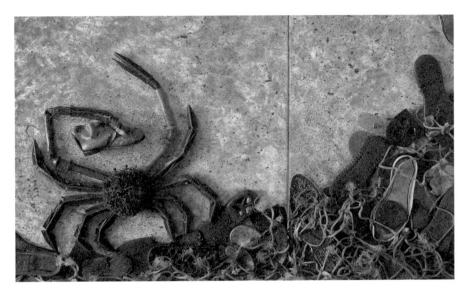

Fig. 13 *THE MARINE SHOE SHOP* (detail). Marine debris and mixed technique on canvas; 100 × 160 cm. (© M. Cimadevila & W. Trettnak 2016. All rights reserved)

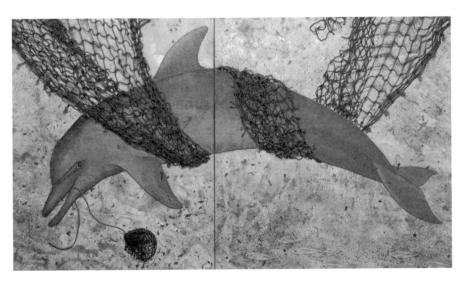

Fig. 14 *THE ENTANGLED DOLPHIN* (detail). Marine debris and mixed technique on canvas; 100 × 160 cm. (© M. Cimadevila & W. Trettnak 2015. All rights reserved)

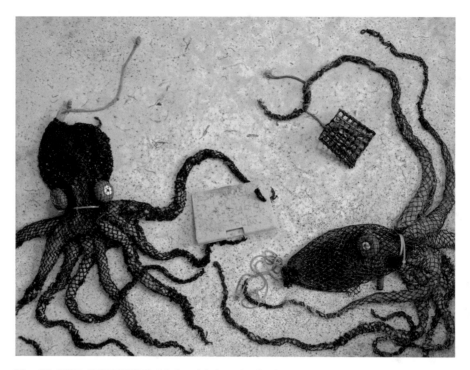

Fig. 15 *TWO OCTOPUSES*. Marine debris and mixed technique on canvas; 80 × 100 cm. (© M. Cimadevila & W. Trettnak 2016. All rights reserved)

became fruits of trees and submarine plants, net bags were transformed into jellyfish. The careful selection and appropriate combination of waste materials (sometimes already works of art on their own due to their fantastic appearance) created imaginary worlds populated by strange forms and on many occasions provided colour to the paintings without the need for additives.

As for the working technique, in the beginning painting was prevalent and the amount of plastics introduced was relatively small. However, the successive and incessant incorporation of all kinds of materials, which progressively increased in size and weight, made it necessary for the artists to use different techniques in order to incorporate the desired materials to their works, thus beginning to staple, sew, glue, hot-glue... The resulting art works could be considered as authentical assemblages or collages on canvas. They constitute the central part of the whole exhibition, which is completed by hanging mobiles, comics, posters, videos, flyers and lectures. The comics were prepared for the young audience in order to transport the information in a more visual and direct way (an example can be seen in chapter *"The Bottlenose Dolphin" (An Eco-comic)*!).

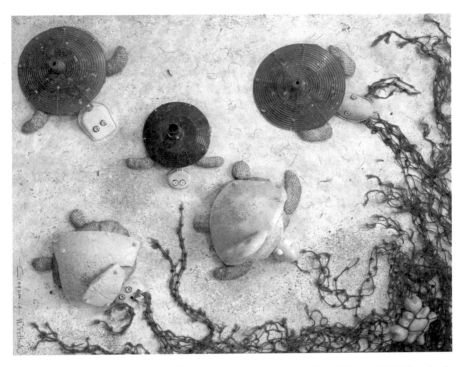

Fig. 16 *TURTLES* Marine debris and mixed technique on canvas; 80 × 100 cm. (© M. Cimadevila & W. Trettnak 2016. All rights reserved)

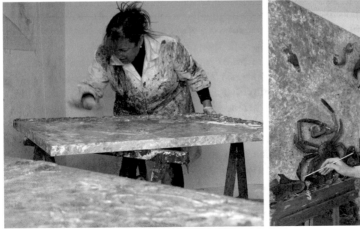
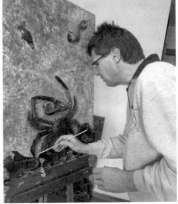

Fig. 17 The artists at work in their studio. (Photos: © M. Cimadevila & W. Trettnak 2014 and 2016. All rights reserved)

5.3 Art and Science

Science and Art established the contact between Cimadevila and Trettnak in 2006, when they participated in *"Dialogue between Science and Art"*, a *Comenius* course organized by the European Union in the Czech Republic, in which Trettnak acted as a teacher (Dialogue Science and Art 2019). The two artists have a scientific background and have been linking the worlds of science and art for a long time in their artistic work, although in a very different way:

- Cimadevila graduated in chemistry and worked as a science teacher in secondary schools. Her artistic work has a strong didactic aspect and is focusing on physics (especially particle physics), chemistry, women in science and gender equality.
- Trettnak, doctor of chemistry, worked in research on sensors and biosensors for many years and his artistic work, which is characterized by an investigative character, is focusing on bionics, electronics, luminescence and the environment.

Before starting their collaboration in MARE PLASTICUM, recycling of materials was already playing an important role in their individual work. Trettnak used to incorporate electronic circuit boards and pieces from computers in his artworks (Trettnak 2019) and Cimadevila enjoyed putting all kind of textiles, sheets and old clothes onto her canvases (Cimadevila 2009, 2019; López Díaz and Cimadevila 2013).

The two artists are convinced that art and science are very similar since both involve inspiration, creativity, investigation, meditation and experimentation. For them, the combination of art and science can lead to completely new results in both fields. It also makes possible to reach all kind of audiences in a way, which is very different than, e.g. in scientific conferences, because the impact is subtler, since beauty, poetry and creativity are mixing up with uncomfortable facts. So art may be considered a very good medium to send a message to the public, especially young people, and to attract attention to specific questions.

It was in *CERN, European Organization for Nuclear Research*, when Cimadevila participated in *High School Teachers at CERN 2003/2004* (http://hst-archive.web. cern.ch/hst/2003/work.htm; http://hst-archive.web.cern.ch/hst/2004/work.htm), where she started to paint about science. Since then Cimadevila organized and coordinated numerous activities mixing the worlds of science and art (*Comenius* courses, programmes with *CERN,* art workshops...), which in 2013 led to the creation of *ARSCIENCIA*, of which both artists are founding members and which is composed of a small and multidisciplinary team (ARSCIENCIA 2019). It is an international non-profit organization, whose principal aims are to promote activities about science and art and to show the relationship between them. All exhibitions and activities of MARE PLASTICUM have been organized through *ARSCIENCIA* and with the enthusiasm of the organizers rather than with the abundant means or generous support of sponsors or similar. Another curious but important fact common to both, science and art, is the frequent lack of financial resources to carry out the work.

Before starting each artistic work, Trettnak did an intense literature study on the topic to be addressed in the painting and documented it with scientific information. Besides the problems related to plastics as detailed before, these were, for example, the overfishing of the Atlantic cod or the decline of populations of bluefin tuna and sharks (Worm et al. 2013; Atlantic Bluefin Tuna Status Review Team 2011; May 2009). Upon finishing the art works, accompanying fact sheets were created, which contain condensed, short and clear scientific explanations on the problem depicted and which can be understood easily also by a non-academic audience.

The plastic debris found on the Galician beaches and the making of the exhibition has been documented photographically from 2014 on. On the basis of these photos, plastic materials were classified and analysed on a qualitative basis and posters very created, which are showing the large variety of plastic encountered and its potential origin. The photos also served for preparing videos and lectures on the collection of plastic debris by the authors, the kind of plastics encountered, the dangers related with them and their recycling and reusing by making works of art.

5.4 Objectives, Target Audience and Impact

The aim of MARE PLASTICUM is to fight against the marine plastic contamination, to show up the related problems and their environmental consequences, as well as problems of sustainability associated with the overfishing and overexploitation of the oceans. Its aim is to provide information and to generate sensibility and consciousness for these topics in the public. It tries to mobilize people, in particular citizens and young people in order to take actions against the threats to our environment. The objectives of the exhibition are of a multiple nature:

Artistic
- *Original:* showing problems in an attractive, creative and visual way.
- *Vanguardistic:* by being part of the new art movement called ECO-ART, which is using art as a means for alerting on environmental issues.
- *Innovative* in its conception and realization.

Environmental
- *Showing up* the relevant problems and their consequences.
- *Recycling*: changing plastic materials into art works and motivating their reuse.
- *Sustainability*: fighting for a responsible use of the oceans.

Scientific
- *Showing* the scientific background of the problems.
- *Spreading* the problems related to oceans and seas.

Educational
- *Creating consciousness* in the public and among young people.
- *Didactic:* creating useful materials for pupils and teachers.
- *Interdisciplinary:* showing the transversal nature of art and science and the relationship between.

As target audience of MARE PLASTICUM can be named students and teachers of primary, secondary and university level, scientists, politicians, decision-makers, journalists and the public in general. Its impact is immediate as it shows the problems in an attractive, visual, clear and simple way for all kind of people.

5.5 Spreading the Plastic Problem: Exhibitions, Educational Activities, Diffusion

In order to achieve the aforementioned objectives, the association *ARSCIENCIA*, the authors and the curator have organized and participated in a large number of activities and events such as exhibitions, high-level conferences, lectures, courses or workshops.

5.5.1 Exhibitions

The exhibition MARE PLASTICUM (initially also named PLASTIC FISHES or MARE PLASTICUM—PLASTIC FISHES) has been shown in different places and forums, among others and in chronological order:

- *Parque Eólico Experimental SOTAVENTO*, Momán, Xermade, Lugo, Spain; 2019
- *CEIDA—Centro de Extensión Universitaria e Divulgación Ambiental de Galicia* (Participation in *A mar asoballada*, with *RetoqueRetro* and *Mar de fábula*), Oleiros, A Coruña, Spain; 2019
- *World Wide Fund for Nature WWF—No Plastic in Nature*, *China Central Place*, Beijing, China; 2019
- *XVII Assembly of the Association of Women Researchers and Technologists, AMIT—The women and the sea*, *University of A Coruña*, A Coruña, Spain; 2018
- Exhibition hall *Capilla de San Roque*, Sada, A Coruña, Spain; 2018
- *Our Ocean, an ocean for life—4th high-level conference*, St. Julian's, Malta; 2017
- *EXPO 216* (Participation in *Ocean Plastics*), Wilmington, NC, USA; 2017
- *CONAMA 2016—13th National Congress on the Environment*, Madrid, Spain; 2016.
- *Silber Gallery*, Rome, Italy (Participation in *De Arte et Alimonio—Biennale di Arte Quantistica*); 2016
- *National Museum of China*, Beijing, China (Participation in *On Sharks & Humanity*); 2015

- *MUNCYT—National Museum of Science and Technology*, A Coruña, Spain; 2015
- *CERN—European Organization for Nuclear Research*, Geneva, Switzerland; 2015
- *Oceanographic Museum of Monaco*, Monaco; 2015
- *Visitor's Centre of the Atlantic Islands of Galicia National Park*, Vigo, Spain; 2014
- *XXVII Congress of ENCIGA—Association of the Galician Science Teachers*, Moaña, Pontevedra, Spain; 2014
- *Comenius-Grundtvig Course "Science & Art: So different, so similar!"*, Santiago de Compostela, Spain; 2013 and 2014

The exhibition has got a wide diffusion and reach, thanks to the international relevance and public affluence of the centres in which it has been exhibited, such as the *Oceanographic Museum of Monaco* (2015), the *CERN*, the *National Museum of China* in Beijing (where it participated in the global-art exhibition *On Sharks & Humanity* dedicated to the protection of sharks (Parkview Arts Action 2015)) or in the multifaceted long-term event *OCEAN PLASTICS* at *EXPO216* in Wilmington (2019). This allowed the exhibition to reach a very broad and diverse audience, from children to scientists.

Some of the shows took place in the frame of environmental national conferences, as *CONAMA 2016* (Fig. 18), or the world congress *Our Ocean 2017* to which it was invited by the *European Commission*, which organized the event. This provided the possibility to get in contact with scientists, politicians, policy- and decision-makers, journalists and people working in the field of environmental protection, who opened new ways of diffusion for the exhibition.

In order "to use art to protect the ocean", MARE PLASTICUM was invited by the *WWF China* to the launch of the *China No Plastic in Nature Action Network* (2019). The event took place in the context of the *World Environmental Day* and the *World Oceans Day* in Beijing in June 2019. In the same year the exhibition was also shown at *CEIDA*, which is the most important centre for environmental education in Galicia (2019).

The exhibition has been shown not only in important museums and large congresses, but also in modest museums and local meetings interested in the dissemination of the problems of marine plastic contamination. Whenever the authors were invited, they were ready to act and to spread their message.

5.5.2 Educational Activities

The exhibition tries to create sources of inspiration and materials for pupils and teachers, so it is not surprising that its first exhibitions were in the international *Comenius* course addressed to European teachers *"Science & Art: So different, so similar!"* (Miller 2014; OAPEE—Organismo Autónoma Programas Educativos

Fig. 18 Exhibition view at the environmental congress *CONAMA 2016* in Madrid. (Photo: © M. Cimadevila & W. Trettnak 2016. All rights reserved)

Europeos 2013), which were coordinated by Cimadevila, and in the congress of Galician science teachers "*XXVII Congreso de ENCIGA*" (2014).

It participated in the international competition aimed at students, teachers, researchers and disseminators of the scientific community, *CIENCIA EN ACCIÓN XVI—SCIENCE ON STAGE SPAIN 2015* and was awarded with the first prize in the category *Sustainability*: "*For its originality in showing an urgent problem in a creative manner, but without losing sight of scientific severity...*" (Ciencia en Acción 2015).

In order to educate pupils in environmental questions, actions have been proposed in which they have to collect beach litter, create art work with these materials, and identify their origin and dangers (Ciencia en Acción 2016). Didactic and interactive materials were created based on an innovative approach that seeks to unite science and art and that allows the students to access to both disciplines in an entertaining and enjoyable way (Espazo ABALAR 2016a, b). In addition, educational activities on the plastic pollution, such as guided tours, competitions or workshops, have been organized by the institutions showing the exhibition.

Throughout the years various activities have been carried out by *ARSCIENCIA* directly addressing the students, such as visits by the authors to the schools or the participation in the *European Maritime Day 2019* with a multimedia activity in collaboration with the *European Commission*, in which primary and secondary

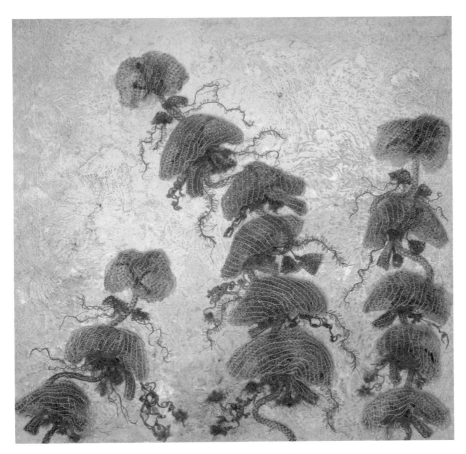

Fig. 19 *NECTOCARMEN ANTONIOI. ANGELES ALVARIÑO*. Plastic materials and mixed technique on canvas; 100 × 100 cm. *"Creativity and imagination are the basic ingredients for the scientist, as in the arts, because science is an art."* Ángeles Alvariño (2019). (© M. Cimadevila 2018. All rights reserved)

schools, universities and even a small nautical enterprise based on a sailing boat were involved (http://www.arsciencia.org/instituciones-participantes/; A-02 VELAS 2019). To give an idea of its dimension: in one of the schools there was "full participation" with 1000 pupils from 3 to 18 years old and their teachers being implicated. It was really nice to see that the older students explained the problems to the younger ones!

The theme for the *World Oceans Day 2019* was *Gender and the Ocean*. *ARSCIENCIA* participated with a media activity about the outstanding oceanographer Ángeles Alvariño through one work, which was dedicated to her and with the aim, apart of denouncing plastic pollution, to value the role of women in science and to fight for equality in science and in life (Fig. 19). It was shown for the first time in

the *XVII Assembly of the AMIT. The women and the sea*. One of the strengths of art is that it may address multiple issues at the same time!

5.5.3 Diffusion

The principal media of diffusion of MARE PLASTICUM have been the website of *ARSCIENCIA* (2019) and the social media and nets. Print material (flyers, poster and bookmarks) accompanying the exhibition or for educational purposes has been prepared in various languages: English, Spanish, French, German and Galician. Lectures not only provided information on the making of the exhibition, but also on its scientific background, and were directed to the public in general, teachers and even scientists.

In addition, the exhibition has found diffusion through features in various media such as television and radio (*RTVE Spain, RTVG Galicia, AzurTV France, MonacoInfo...*) in their programmes dedicated to art, science and environment (*Artesfera, Agrosfera, Efervesciencia, Zig-Zag...*), reports in websites (such as *Chinadialogue* (Hilton and Middlehurst 2017) or *Mujeres con ciencia* (Macho Stadler 2017)) and in science magazines (e.g. *CERN Bulletin* (Del Rosso 2015) or *QUO* (2017)).

A special mention should be made of the publication of this book at hand *MARE PLASTICUM—THE PLASTIC SEA—Combatting plastic pollution through science and art*, which was conceived in a fruitful encounter of the curator of the exhibition Marilena Streit-Bianchi with Marina Forlizzi, editor at Springer, at a congress of the *Italian Physical Society* in September 2018. This book has been enabled thanks to all the authors and co-authors, who willingly accepted to participate, and to their magnificent contributions. It will be another milestone in the diffusion of the problems related with plastic in the environment.

6 Conclusions and Outlook

Since the beginnings of the authors' investigations in 2011 a lot of things have changed. Although the amount of plastics in the oceans may have been increasing further, the knowledge about the problems related has increased substantially. The number of scientific publications on the plastic, its behaviour and its effects in the environment, has almost exploded. Plastics have been found in the most remote parts of the oceans and almost all species of living marine organisms have been reported to ingest plastics or microplastics.

However, apart from these threatening findings, there are many positive developments going on worldwide: from the reduction of plastic use in many countries, events to create consciousness, environmental conferences, to beach and even ocean cleaning actions. Newspapers are writing almost daily about the plastic problem, which seems to be *in vogue*. Now people know about the existence of the problem, even in a country like Austria, which is far-off from any ocean.

In Spain, for example, plastic bags are not available gratis anymore, beach cleaning actions are performed by various organizations, and there are projects to clean the basins of harbours and the sea floor and to employ drones in the monitoring of beach litter. Special projects are dedicated to establish good practices in the waste management in the fishing activities and fishermen are engaged to collect worn-out and discarded nets for recycling, e.g. to produce shoes or clothes. The level of consciousness has grown significantly in the population due to numerous events raising the awareness and the sensitization through the media. The word "microplastics" has even been elected word of the year in Spain 2018 (Fundéu BBVA 2018).

MARE PLASTICUM certainly has neither been the only nor the first exhibition based on the recycling of marine plastic litter. Currently, there are many artists working on the plastic contamination in all kind of fields. Besides art works based on photography and sculpture (Jordan 2009; Barker 2019; Washed ashore 2019; Skeleton Sea—Art from the Sea 2019; Mar de fábula 2019), painting, collage, installation, video, fashion design, performance and literature have been reported (EXPO216 2019). In addition, today producing art work or sculptures from marine litter has become a sort of fashion, which is practiced by many organizations and even school classes. This is a good example of how art can be used to fight against the "plastic invasion" and to protect the ocean and the environment.

MARE PLASTICUM is not a finished project, it can be considered as a work in progress, which will exist as long as plastics exist in the environment (Figs. 20 and 21). The authors like to think that they have contributed their grain of sand in the fight against marine plastic, and hopefully this book will add some more grains to new positive developments in near future. But we don't have to forget:

It is time to act!

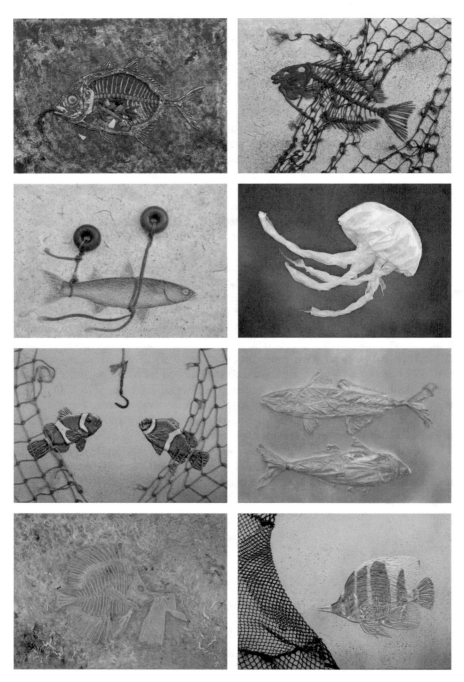

Fig. 20 From the series *PLASTIC SEA LIFE*. Marine debris and mixed technique on canvas; 30 × 40 cm; 2011–2015. (© M. Cimadevila & W. Trettnak 2019. All rights reserved)

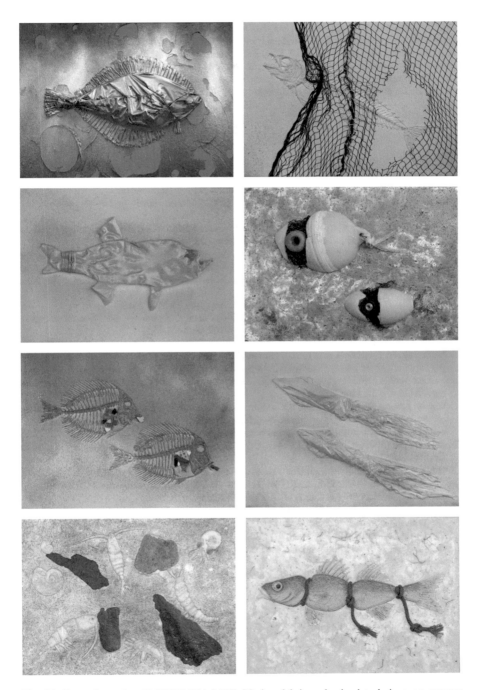

Fig. 21 From the series *PLASTIC SEA LIFE*. Marine debris and mixed technique on canvas; 30 × 40 cm; 2011–2015. (© M. Cimadevila & W. Trettnak 2019. All rights reserved)

Acknowledgments The authors would like to thank the members of *ARSCIENCIA* for their unconditional support, especially Marilena Streit-Bianchi, the enthusiastic and inexhaustible curator of the exhibition MARE PLASTICUM, and Amaia Alcalde Gimilio for her work of diffusion and communication. Furthermore they wish to thank Santiago Fernández Lorenzo for his indispensable computer support and all the people, entities, organizations and networks that have collaborated with the artists in one or the other way.

References

A-02 VELAS (2019). http://a-02velas.eu/. Accessed 26 July 2019

Allsopp M, Walters A, Santillo D, Johnston P (2006) Plastic debris in the World's oceans. Greenpeace, Amsterdam

Angeles Alvariño Biography (2019). https://www.notablebiographies.com/supp/Supplement-A-Bu-and-Obituaries/Alvari-o-Angeles.html. Accessed 23 May 2019

ARSCIENCIA (2019). http://www.arsciencia.org/. Accessed 19 May 2019

Atlantic Bluefin Tuna Status Review Team (2011) Status Review Report of Atlantic bluefin tuna (*Thunnus thynnus*). Report to National Marine Fisheries Service, Northeast Regional Office. March 22, 2011. p 104

Barker M (2019) Soup. https://mandy-barker.com/. Accessed 19 May 2019

Boerger CM, Lattin GL, Moore SL, Moore CJ (2010) Plastic ingestion by planktivorous fishes in the North Pacific central gyre. Mar Pollut Bull 60:2275–2278

CEIDA (2019). http://www.ceida.org/. Accessed 13 Sep 2019

Chiba S, Saiti H, Fletcher R et al (2018) Human footprint in the abyss: 30 year records of deep-sea plastic debris. Mar Policy 96:204–212. https://doi.org/10.1016/j.marpol.2018.03.022

Ciencia en Acción (2015) Acta de la Comisión de "Ciencia en Acción". p 8. https://cienciaenaccion.org/. Accessed 18 June 2019

Ciencia en Acción (2016) Experimentos > Arte & Ciencia: *MARE PLASTICUM*, plástico marino y medioambiente. http://anteriores.cienciaenaccion.org/2016/es/2016/experimento-411/arte-ciencia-mare-plasticum-plastico-marino-y-medioambi.html. Accessed 18 June 2019

Cimadevila M (2009) CIENCIA EX AEQUO. Concellería de Igualdade, Ayuntamiento de A Coruña, Galicia

Cimadevila (2019). http://www.cimadevila.tk/. Accessed 18 June 2019

Del Rosso A (2015) Plastic fish. CERN Bulletin 24–25. http://cds.cern.ch/journal/CERNBulletin/2015/24/News%20Articles/2020914. Accessed 19 May 2019

Denuncio P, Bastida R, Dassis M et al (2011) Plastic ingestion in Franciscana dolphins, Pontoporia blainvillei (Gervais and d'Orbigny, 1844), from Argentina. Mar Pollut Bull 62:1836–1184. https://doi.org/10.1016/j.marpolbul.2011.05.003

Derraik JGB (2002) The pollution of the marine environment by plastic debris: a review. Mar Pollut Bull 44:842–852

Dialogue Science & Art (2019). http://www.sciart-cz.eu. Accessed 18 June 2019

Ellen MacArthur Foundation (2016) The new plastics economy—rethinking the future of plastics p 29

Eriksen M, Thiel M, Lebreton L (2016) Nature of plastic marine pollution in the subtropical gyres. In: Takada H, Karapanagioti HK (eds) Hazardous chemicals associated with plastics in the marine environment. Springer International Publishing, Hdb Env Chem. https://doi.org/10.1007/698_2016_123

Espazo ABALAR (2016a) Ciencia y arte. https://www.edu.xunta.es/espazoAbalar/es/espazo/repositorio/cont/ciencia-y-arte?quicktabs_2=1. Accessed 18 June 2019

Espazo ABALAR (2016b) Ciencia y arte 2. https://www.edu.xunta.es/espazoAbalar/es/espazo/repositorio/cont/ciencia-y-arte-2?quicktabs_2=1. Accessed 18 June 2019

EXPO216 (2019). https://www.expo216.com/. Accessed 18 June 2019

Fondo documental del Instituto Nacional de Estadística, Annuario (1985) Longitud en kilómetros de la costa española, por provincias. http://www.ine.es/inebaseweb/pdfDispacher.do? td=38228. Accessed 18 June 2019

Fundéu BBVA (2018) Microplástico, palabra del año 2018 para la Fundéu BBVA. https://www.fundeu.es/recomendacion/microplastico-palabra-del-ano-2018/. Accessed 19 May 2019

Gago J, Lahuerta F, Antelo P (2014) Characteristics (abundance, type and origin) of beach litter on the Galician coast (NW Spain) from 2001 to 2010. Sci Mar 78(1):125–134. https://doi.org/10.3989/scimar.03883.31B

Gago J, Portela S, Filgueiras AV et al (2020) Ingestion of plastic debris (macro and micro) by longnose lancetfish (Alepisaurus ferox) in the North Atlantic Ocean. Reg Stud Mar Sci 33:100977. https://doi.org/10.1016/j.rsma.2019.100977. Accessed 2 April 2020

Hilton I, Middlehurst C (2017) Plastic fish—Science and art meet to tell a powerful story of how plastic pollution is harming the ocean. https://chinadialogueocean.net/703-plastic-fish/. Accessed 19 May 2019

http://hst-archive.web.cern.ch/hst/2003/work.htm. Accessed 8 Aug 2019

http://hst-archive.web.cern.ch/hst/2004/work.htm. Accessed 8 Aug 2019

http://www.arsciencia.org/instituciones-participantes/. Accessed 26 July 2019

Jordan C (2009) Midway: message from the gyre. http://www.chrisjordan.com. Accessed 17 May 2019

Kang J-H, Aasi D, Katayama Y (2007) Bisphenol a in the aquatic environment and its endocrine-disruptive effects on aquatic organisms. Crit Rev Toxicol 37:607–625. https://doi.org/10.1080/10408440701493103

Leichter JJ (2011) Investigating the accumulation of plastic Debris in the North Pacific Gyre. In: Omori K et al (eds) Interdisciplinary studies on environmental chemistry. Marine Environmental Modeling & Analysis, Terrapub, pp 251–259

López Díaz AJ, Cimadevila M (eds) (2013) Ciencia/Science Ex Aequo. Oficina para a Igualdade de Xénero, Universidade da Coruña

Macho Stadler M (2017) *MARE PLASTICUM.* https://mujeresconciencia.com/2018/11/02/mare-plasticum/. Accessed 19 May 2019

Mar de fábula (2019). http://www.mardefabula.org/. Accessed 13 Sep 2019

Marnes DKA, Galgani F, Thompson RC, Barlaz M (2009) Accumulation and fragmentation of plastic debris in global environments. Philos Trans R Soc B 364:1985–1998. https://doi.org/10.1098/rstb.2008.0205

May A (2009) The collapse of the northern cod. Newfoundland Quarterly 102(2):41–44

Miller AI (2014) Colliding worlds—how cutting-edge science is redefining contemporary art. W. W. Norton & Company, New York, p 346

Moore CJ, Moore SL, Leecaster MK, Weisberg SB (2001) A comparison of plastic and plankton in the North Pacific central gyre. Mar Pollut Bull 42(12):1297–1300

OAPEE—Organismo Autónomo Programas Educativos Europeos (2013) PAPeles europeos 5/6: pp 132–138

Oceanographic Museum of Monaco (2015) Exhibition "*PLASTIC FISHES*", Press release. https://www.oceano.mc/docs_site/1423751723.pdf. Accessed 19 June 2019

Parkview Arts Action (2015) On Sharks & Humanity—Artists' Action—Beijing. National Museum of China and Parkview Arts Action. http://www.parkviewartsaction.com/. Accessed 19 May 2019

Puertos del Estado (2019) Resumen general del tráfico portuario, p 10. http://www.puertos.es. Accessed 18 June 2019

Quo (2017) Arte hecho con basura de playas gallegas. Quo 265:28

Ríos LM, Jones PR, Moore C, Narayan UV (2010) Quantitation of persistent organic pollutants absorbed on plastic debris from the northern Pacific Gyre's "eastern garbage patch". J Environ Monit 12:2226–2236. https://doi.org/10.1039/c0em00239a

Schuyler Q, Hardesty BD, Wilcox C, Townsend K (2012) To eat or not to eat? Debris selectivity by marine turtles. PLoS One 7(7):e40884. https://doi.org/10.1371/journal.pone.0040884

Skeleton Sea—Art from the Sea (2019). http://www.skeletonsea.com/. Accessed 19 May 2019

Tekman MB, Krumpen T, Bergmann M (2017) Marine litter on deep Arctic seafloor continues to increase and spreads to the north at the HAUSGARTEN observatory. Deep-Sea Res I 120:88–99. https://doi.org/10.1016/j.dsr.2016.12.011

The European Market for Mussels (2019) GLOBEFISH—Information and Analysis on World Fish Trade, FAO Food and Agriculture Organization of the United Nations. http://www.fao.org. Accessed 18 June 2019

Trettnak W (2019). http://www.trettnak.com/. Accessed 18 June 2019

Typer CR, Jobling S (2008) Roach, sex, and gender-bending chemicals: the feminization of wild fish in English Rivers. Bioscience 58(11):1051–1059. https://doi.org/10.1641/B581108

Washed ashore (2019). http://washedashore.org/. Accessed 19 May 2019

Webb HK, Arnott J, Crawford RJ, Ivanova EO (2013) Plastic degradation and its environmental implications with special reference to poly (ethylene terephthalate). Polymers 5:1–18. https://doi.org/10.3390/polym5010001

Worm B, Davis B, Kettemer L et al (2013) Global catches, exploitation rates, and rebuilding options for sharks. Mar Policy 40:194–204. https://doi.org/10.1016/j.marpol.2012.12.034

WWF China (2019). http://wwfchina.org/pressdetail.php?id=1915. Accessed 18 June 2019

XXVII Congreso de ENCIGA (2014) MARE PLASTICUM. Boletín das Ciencias 79:25–26

A Brief History of Plastics

Roland Geyer

Abstract This book chapter provides a comprehensive account of global plastic production, use, and fate from 1950 to 2017 and thus covers all plastic humankind has ever made. It starts with a brief introduction of plastic's origin and nomenclature, followed by a detailed global material flow analysis of the 68 years of plastic mass production, use, and end-of-life management. The analysis includes all major polymer resins and fibers, as well as all additives, and discusses production by polymer, use by consuming sector, and end-of-life management by waste management type. The historical analysis is followed by a discussion of the current global state of plastic production, use, and end-of-life management. The chapter closes with trend projections from 2017 to 2050, which show that even if recycling and incineration rates were to increase at historical rates, this would not be enough to stem the tide of plastic waste. This suggests that changes and improvements in waste management strategies need to be supplemented with serious source reduction efforts in order to make our use of plastic more sustainable.

Keywords Plastic · Synthetic polymers · Material flow analysis · Plastic production · Plastic waste generation · Plastic waste management

1 Origins and Taxonomy

Polymers are not a human invention. The natural world is full of polymers. Examples are cellulose, silk, rubber, muscle fiber, horn, hair, and DNA. A polymer is a large molecule consisting of many equal or similar subunits bonded together. The word polymer is derived from the Greek words πολύς, which means "many," and μέρος, which means "part."

R. Geyer (✉)
Bren School of Environmental Science and Management, University of California, Santa Barbara, CA, USA
e-mail: rgeyer@ucsb.edu

© Springer Nature Switzerland AG 2020
M. Streit-Bianchi et al. (eds.), *Mare Plasticum – The Plastic Sea*,
https://doi.org/10.1007/978-3-030-38945-1_2

Plastics, on the other hand, are a human invention. Plastic is a summary term typically used for man-made, i.e. synthetic, polymers. The first man-made polymer was still not fully synthetic. In the 1850s, English metallurgist and inventor Alexander Parkes treated cellulose with nitric acid and thus created the thermoplastic nitrocellulose (Freinkel 2011). Thermoplastics are a family of plastics that melt when heated and harden when cooled. Parkes patented the material as *Parkesine* and presented it at the 1862 *Great International Exhibition* in London, where it won a bronze medal. However, *Parkesine* was not a commercial success. The American inventor John Wesley Hyatt experimented with *Parkesine* while researching ivory substitutes for billiard balls and found a viable way of producing solid, stable nitrocellulose, which he patented in the United States in 1869 as *Celluloid*. *Celluloid* thus became the first commercially successful man-made polymer (Freinkel 2011).

The first truly synthetic polymer was invented by Belgian-American chemist Leo Baekeland, who combined phenol and formaldehyde to form the first synthetic thermoset (American Chemical Society 1993). Thermosets are different from thermoplastics. They undergo a chemical change when heated by forming a three-dimensional network that is irreversible. Unlike thermoplastics, thermosets cannot be re-melted and reformed. Baekeland filed patents for the new material *Bakelite* in 1907 in the USA and many other countries. *Bakelite* and *Celluloid* can be considered the dawn of the plastic age, even though their production output was tiny compared to today's production volumes.

Today, *Celluloid* and *Bakelite* are mostly of historical interest and most items made from them are collectors' items. The first modern plastic was polyvinyl chloride (PVC), which was discovered accidentally by German chemist Eugen Baumann in 1872 and is still being produced and used in large quantities. Pure PVC is too rigid and brittle to be useful, though. In the 1920s, chemicals now known as plasticizers were added, which made the resulting material softer and more flexible than the pure polymer. Adding an additive to an otherwise unattractive pure polymer created the first modern plastic. The most widely used plasticizers for PVC are phthalates, or phthalate esters. Virtually all plastics contain significant amounts of chemical additives in order to modify and enhance their properties.

Today, plastics comprise a large and growing number of polymers and an equally large number of additives. As mentioned earlier, a fundamental distinction is whether the plastic melts when heated or not (PlasticsEurope 2018). The ones that do are called thermoplastics and contain the best-known and most widely used types of plastic, such as polyethylene (PE), polypropylene (PP), polyvinyl chloride (PVC), polyethylene terephthalate (PET), polystyrene (PS), and polyamide (PA). Being able to melt, harden, and re-melt thermoplastics makes them potentially recyclable.

The other group of plastics is called thermosets. This group of polymers forms an irreversible three-dimensional network instead of linear or branched chains. As a result, thermosets cannot be re-melted and reformed, which makes their recycling challenging. Widely used thermosets include polyurethanes (PUR), unsaturated polyester, silicone, and epoxy, melamine, phenolic, and acrylic resins.

Thermosets and thermoplastics can be combined with fibers to enhance their strength. The result is called a fiber-reinforced polymer or plastic (FRP). The most

popular fibers are made from glass or carbon. Currently, most FRPs use a thermoset. For example, glass-fiber-reinforced epoxy is common in boat hulls or wind turbine blades. Carbon-fiber-reinforced epoxy, on the other hand, is increasingly used in bicycle frames and vehicle parts. Fiber-reinforced thermosets are even more challenging to recycle than pure thermosets.

The vast majority of plastics are based on hydrocarbons, i.e. molecules predominantly made of hydrogen and carbon. An alternative plastic taxonomy is based on the source of the carbon in the polymer, which can either be fossil, i.e. from ancient biomass, or biogenic, i.e. from recently grown biomass (European Bioplastics 2016). Almost all of historic and current plastic production is fossil-based. Almost all fossil feedstock is petroleum or natural gas, but coal can also be used.

A minute amount of current plastic production does use bio-based feedstock, the most common of which are corn and sugarcane. Pertinent examples of bio-based polymers are *NatureWorks' Ingeo* and *Coca-Cola's PlantBottle*. *Ingeo* is made of polylactide (PLA) derived from corn. The *PlantBottle* material is PET that uses monoethylene glycol (MEG) made from ethanol derived from sugarcane (The Coca-Cola Company 2012). PET is 30% MEG and 70% purified terephthalic acid (PTA), which means that the current *PlantBottle* material is 30% bio-based and 70% fossil-based. In 2015, *Coca-Cola* announced that it found a way to also produce PTA from bio-based sources, which would result in a 100% bio-based *PlantBottle*. Apart from the carbon source, bio-based PET is chemically identical to fossil-based PET.

Yet another way to categorize plastics are their biodegradability. Biodegradation of hydrocarbon-based material is its complete breakdown by microbial activity into carbon dioxide, water, and other basic constituents. Whether the carbon in the plastic is bio-based or fossil-based is unrelated to its biodegradability. None of the most widely used fossil-based plastics are biodegradable on timescales that are meaningful for sustainable materials management. A considerable, and growing, fraction of bio-based plastic is also not biodegradable, such as the *PlantBottle* PET. Some bio-based plastics do biodegrade under specific conditions. The best-known ones are PLA and polyhydroxyalkanoates (PHAs). Biodegradation is a complex process that depends on many factors, such as temperature, moisture level, and the specific microbes required. The speed at which it occurs is called biodegradation rate and can vary from weeks to years to decades. Calling a particular plastic biodegradable without specifying the degradation conditions and the resulting degradation rate is thus not very meaningful.

2 The Ghost of Plastics Past

2.1 Production

There was, of course, plastic production prior to the Second World War, but the amount was insignificant from a historical perspective. During the Second World War, plastic production started to increase due to growing shortages of other

materials and plastic's ability to be used instead. After the end of the war, plastic producers started to look for new markets for their newly created production capacity. The unprecedented economic growth of the postwar decades, together with the emergence of the modern consumer society, has led to a rapid and sustained growth of global plastic production. Entire new product categories were invented, such as single-use packaging, which increasingly displaced more traditional reusable packaging.

Cumulative global production prior to 1950 was somewhere between 4 and 8 million metric tons (Mt) (Freinkel 2011). In 1950, annual global plastic production had reached 2 Mt. Mostly due to convenience and data availability, 1950 is frequently regarded as the beginning of plastic mass production. 1950 also happens to be the proposed beginning of the Anthropocene, the geological era in which humanity became the predominant force on the earth's climate, geology, and ecosystems. It was recently proposed to use plastic as a key geological indicator of the Anthropocene, since it is absent in sediment layers prior to 1950, but increasingly present thereafter (Zalasiewicz et al. 2016).

For the next two decades after 1950, the compound annual growth rate (CAGR) of global annual plastic production was around 15%. Plastic's CAGR has slowed down since the early 1970s, but was still 8.3% overall for the period from 1950 to 2017, more than two and a half times that of global gross domestic product (GDP) for the same time period (Geyer et al. 2015). The best fit for historical global annual plastic production is actually generated by polynomial rather than exponential trend lines. There were only 3 years in which global annual plastic production decreased relative to the previous year. The years are 1975, 1980, and 2008, and coincide with the two global Oil Crises and the Great Recession.

Figure 1 shows annual global primary plastics production in Mt from 1950 to 2017 by material type (Geyer et al. 2015; PlasticsEurope 2019). Primary plastic is plastic made from primary feedstock, i.e. natural gas and crude oil. LDPE, LLDPE, and HDPE denote low density, linear low density, and high density polyethylene, respectively. Together with PP, they make up 45% of global production. PS, PVC, PET, and PUR each contribute between 6 and 9% to global production. PP&A stands for polyester, polyamide, and acrylic, which are all used to make fiber. Synthetic fibers account for 14% of global plastic production (PCI Wood Mackenzie 2017; The Fiber Year 2017). Synthetic fiber production is dominated by polyester. In 1980, it already accounted for 50% of annual synthetic fiber production. In 2016, its share had grown to 83%.

All these numbers are for the pure polymer, without any additives. Additives add another 6%, meaning that, on global average, plastic consists of 94% pure polymer and 6% additives (Global Industry Analysis (GIA) 2008; Rajaram 2009). The actual additive content of plastic varies significantly by polymer and application. The most widely used additives are plasticizers, flame retardants, and fillers, which together make up 75% of global annual additive production. Other additive types are heat stabilizers, antioxidants, impact modifiers, colorants, and lubricants. Examples of polymers that fall into the "Other" category are acrylonitrile butadiene styrene (ABS), polycarbonate (PC), polymethyl methacrylate (PMMA), polyoxymethylene

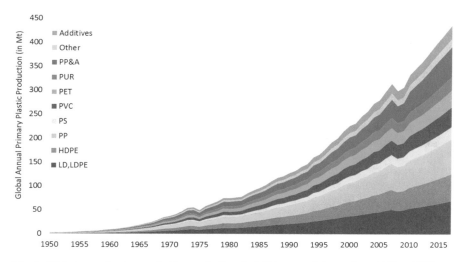

Fig. 1 Global annual primary plastics production (in Mt) by material type from 1950 to 2017

(POM), styrene-acrylonitrile copolymer (SAN), and polytetrafluoroethylene (PTFE), which is best known under the brand name *Teflon*.

2.2 Use

Plastics are used for virtually all types of products and owe their popularity to their low cost and technical versatility. Plastic dominates packaging, is used widely in construction, transportation, electrical and electronic equipment, agriculture, and also very common in furniture and other household items, leisure and sports goods, as well as medical supplies and equipment (PlasticsEurope 2018; American Chemistry Council (ACC) 2013).

Figure 2 shows annual global primary plastics production in Mt from 1950 to 2017 by consuming sector. Packaging is by far the largest consuming sector and uses 36% of global plastic production. If synthetic fibers are excluded, i.e. only polymer resins are counted, the share increases to 42%. Over 90% of packaging is made of PE, PP, or PET. Almost all of PET is used for packaging, while PE and PP are also popular in other applications.

Building and construction uses 16% of global plastic production and is thus the second largest consuming sector. A close third, with 14%, is the textile sector. Building and construction predominantly uses PVC. Almost all synthetic fiber output is consumed by the textile sector, which produces mostly apparel, but also many other products like carpet, upholstery, and household textiles (PCI Wood Mackenzie 2017).

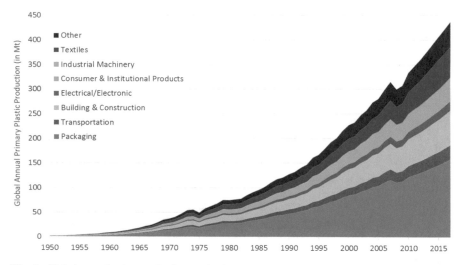

Fig. 2 Global annual primary plastics production (in Mt) by sector from 1950 to 2017

Due to their different technical properties, specific polymers are associated with particular product applications (PlasticsEurope 2018). Pipes, hoses, cable insulation, and window frames are typically made from PVC. HDPE is used for bottles containing milk, toiletries, detergent, and other cleaning products. LLDPE and LDPE are the go-to material for bags, food and other packaging, as well as plastic film. PET is mostly used for beverage bottles, but also for packaging clamshells containing produce and many other retail items. PUR is used to make foam products, like mattresses, pillows, and insulation. Due to its versatility, PP can be found in many different types of application. PS is frequently used to make foam, i.e. expanded polystyrene (EPS).

How long a product is in use depends on what type of product it is, but also on its design, durability, and the way it is used. It is thus common to represent the lifetime of products as a distribution around a typical or average value (Davis et al. 2007). Depending on the product type, typical lifetimes of plastic-containing products range from days to weeks to years to many decades (Geyer et al. 2015). Single-use packaging, for example, is used from the time the content is packaged to the time the packaging is opened, which can be as short as a few days or weeks. Apparel may be used for less than 1 year (sometimes called fast fashion), multiple years, or even decades in some instances (Drycleaning Institute of Australia 2012). Plastic items used in vehicle production are used as long as the vehicle, unless it is replaced sooner, such as a damaged bumper. Typical vehicle lifetimes range from 10 to 20 years. The longest lifetimes are experienced by products used in buildings and other construction, where they could be in use for many decades.

From a material flow perspective the use phase is like a reservoir of all products that are currently being used. The size of this reservoir, sometimes called in-use stock or stock in use, indicates the material intensity of households and can also be

used to estimate future amounts of waste generation (Davis et al. 2007). New products are continuously entering the use phase, while so-called end-of-life products are continuously leaving it. The lag between the times a specific product enters and leaves the use phase reservoir is its lifetime. As can be seen in Fig. 2, production and consumption of plastic has been increasing rather dramatically across all product categories. Combined with the fact that product lifetimes are changing relatively slowly, this means that the in-use stock of plastic contained in goods has also been growing steadily.

2.3 Waste Generation

Plastic waste is generated during production processes and after the plastic-containing products reach the end of their lives. Production of plastic-containing goods typically involves a whole series of processes, such as monomer production, polymerization, part forming, product assembly, and multiple transportation steps in between. Waste generated during any of these steps is called pre-consumer or production waste. Waste is also generated as soon as the consumer is done using the plastic-containing product. This waste is called post-consumer or end-of-life waste.

Pre-consumer waste is generally easier to recycle than post-consumer waste for a variety of reasons. First, it tends to be less contaminated and mixed up with other materials, which facilitates its reprocessing into valuable secondary material. Second, it is less dispersed than post-consumer waste, since there are fewer production locations than there are consumption points, e.g. households. This makes pre-consumer waste easier and cheaper to collect. All this reduces the cost and technical difficulty of collection and recycling and yields a higher-value secondary material. This does not mean that recycling of pre-consumer waste is always free of challenges, but it is frequently much easier than post-consumer recycling and often driven by economic incentives rather than environmental aspirations.

It is typically the case that more material ends up in the product rather than as production waste, which means that post-consumer waste outweighs pre-consumer waste. Data on waste generation in general is much harder to find than data on material production, which is routinely tracked by industry associations and governmental organizations (Hoornweg and Bhada-Tata 2012; D-Waste 2019). There are two fundamentally different ways to calculate plastic waste generation data. One is a "bottom-up" method, which uses solid waste generation data and combines it with waste composition data. Here is an example: Assuming that, on average, everyone of the roughly 7.5 billion people on the planet generates 1 kg of solid waste per day and that about 10% of this waste is plastic yields a global plastic waste generation of 274 Mt per year. Of course, solid waste generation and plastic fraction vary widely by nation and even region, which should be considered in such analyses (Jambeck et al. 2015; Lebreton and Andrady 2019).

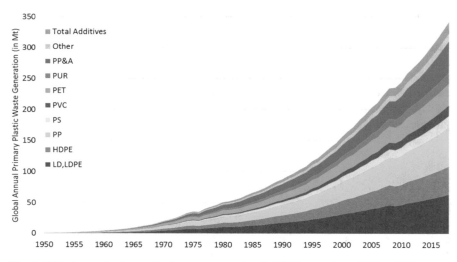

Fig. 3 Global annual primary plastic waste generation (in Mt) by type from 1950 to 2018

This bottom-up approach suffers from poor data availability and is also better suited for post-consumer than pre-consumer waste. An alternative is a "top-down" method which combines the plastic production data discussed in the production section with the product lifetime distribution data mentioned in the use section (Mutha et al. 2006; Kuczenski and Geyer 2010). In other words, the time plastic is in use is added to the year in which it was produced which results in an estimate of when it will become waste. Since product lifetimes vary dramatically between product types, this approach needs to be applied to each consuming sector shown in Fig. 2. The results are shown in Figs. 3 and 4. Both show global primary plastic waste generation estimates using the top-down method, the first by material type, the second by consuming sector. Primary plastic waste means that it is primary material that is becoming waste, not recycled material.

Comparing Figs. 1 and 3 and Figs. 2 and 4, it can be seen that plastic waste generation tracks plastic production, but with a time delay caused by the use phase. Every year the amount of plastic waste generated is lower than the amount of new plastic being produced and entering use. As a result, every year plastic is added to the stock in use.

It can also be seen that the composition of plastic waste is different than that of plastic production of the same year. The reason for that is the fact that different sectors/product types have different average lifetimes, which causes different time lags between plastic production and waste generation. The two most extreme cases are packaging and construction. Most of the packaging will become waste within a year, while most of the plastic in construction waste was produced decades earlier. This means that the share of packaging in plastic waste generation is even higher than its share in production, while the share of plastic construction waste is lower than construction's share in plastic production.

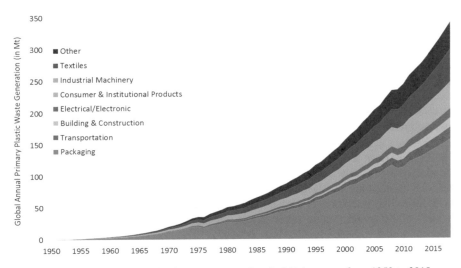

Fig. 4 Global annual primary plastics waste generation (in Mt) by sector from 1950 to 2018

2.4 Waste Management

Waste management can be grouped into a small set of options, which are reuse, recycling, thermal destruction, and disposal. Reusing the entire plastic-containing product or at least some of its components is environmentally desirable, but plagued by all kinds of challenges (Geyer and Jackson 2004). The environmental advantage is that not only the material but also value added is recovered. Some of the challenges are costly reverse logistics and labor-intensive reprocessing, and lack of consumer demand for second-hand, refurbished, or remanufactured products. Reuse appears to be on the decline in general. It is particularly uncommon for plastic-intensive products, and the reuse rate of plastic waste is therefore close to zero.

Recycling recovers only the material of the end-of-life product and reprocesses it into secondary, or recycled, material. Without regulation, recycling is driven entirely by its economics, which means that the cost of collection and reprocessing needs to be lower than the value of the resulting secondary material. Unfortunately, plastic recycling suffers from poor economics. Plastic waste is frequently highly contaminated with other materials and also needs to be separated by polymer type to be valuable. To make things worse, recycled plastic has to compete against low-cost primary plastic with superior technical specifications.

Plastic waste can be recycled mechanically or chemically. In mechanical recycling the plastic waste is shredded or ground up mechanically, cleaned and decontaminated, and re-compounded into granulate (Kuczenski and Geyer 2013). Chemical recycling means that the pre-treated plastic waste is depolymerized, i.e. separated into its monomers, which can then be re-polymerized into the original plastic. Chemical recycling is more expensive and has higher environmental impacts

than mechanical recycling, but generates higher-value recycled material. So far almost all recycling has been mechanical.

Reuse and recycling generate environmental benefits when the incurred impacts of collection and reprocessing are smaller than the avoided impacts of displaced primary production and avoided disposal (Geyer et al. 2016). Reuse and recycling avoid disposal only if they reduce primary production, otherwise disposal is only delayed (Zink and Geyer 2018). The environmental benefits of displaced primary plastic production are much higher than those of avoiding landfill of plastic waste.

Thermal destruction is the only way to remove plastic waste that does not biodegrade from the earth. Waste-to-fuel technologies, such as pyrolysis and gasification, are currently not cost-effective and thus not widespread. So far virtually all thermal destruction of plastic waste has been through incineration, either with or without energy recovery. The health and environmental impacts of incineration vary widely and depend, among other things, on incineration technology, temperature, operation, and emission control technology.

The last waste management option is disposal, either in managed landfills, unmanaged dumps, or the natural environment. Reuse or recycling do not avoid final disposal, since plastic cannot cycle indefinitely (Zink and Geyer 2018). Some uses of plastic are inherently dissipative, which means it cannot be collected after use and thus ends up in the environment. A pertinent example is microbeads in cosmetic products and toiletries. Another example is plastic film and sheet used in agriculture, gardening, or landscaping, where it starts to disintegrate during use and is therefore at least partially lost to the environment.

Figure 5 shows estimated global recycling, incineration, and discard rates for non-fiber plastic waste. The discard rate is calculated as one minus incineration and recycling rates and includes disposal in landfills, dumps, and the natural environment. The three disposal fates had to be aggregated due to poor data availability.

Formal plastic waste incineration and recycling started in the 1980s and has since been increasing slowly, but steadily. The estimated rates are subject to considerable

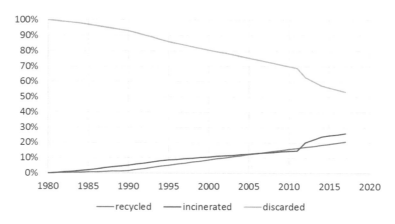

Fig. 5 Estimated global recycling, incineration, and discard rates for non-fiber plastic waste

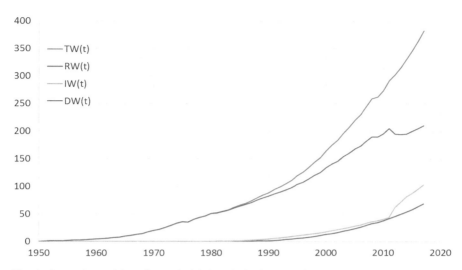

Fig. 6 Generation and fate of annual global total plastic waste, from 1950 to 2017, in Mt

uncertainty and based on publicly available information, some of which has been criticized as overly optimistic (Consultic 2015; U.S. Environmental Protection Agency (EPA) 2014, 2018; National Bureau of Statics of China 2017; Zhan-feng and Bing 2009; Linzner and Salhofer 2014; National Development and Reform Commission of China 2014; China Ministry of Commerce 2016). Figure 5 shows global averages. Incineration and recycling rates vary significantly by region. 2014 recycling rate estimates are 30% for Europe, 25% for China, and 9% for the USA, while 2014 incineration rate estimates are 39% for Europe, 30% for China, and 16% for the USA. While the European plastic recycling rate has experienced a steady increase, the US rate appears to have been stagnant since 2012. The recycling rates are for non-fiber plastic waste only. So far synthetic fiber waste has not experienced any significant recycling efforts.

Figure 6 combines the waste generation data from the previous section with the waste management rates shown in Fig. 5. TW, RW, IW, and DW stand for total, recycled, incinerated, and discarded plastic waste. Total plastic waste accounts for not only primary but also secondary plastic waste, which is recycled plastic leaving the use phase and becoming waste again.

3 The Ghost of Plastics Present

After 70 years of relentless growth, we are now making more plastic per year than almost any other material. In 2017, annual global primary plastic production had reached 438 Mt, 348 Mt of which were polymer resins, 62 Mt were synthetic fibers, and 27 Mt were additives. The CAGR from 1950 to date is an astounding 8.3%. The

breakdown by polymer of 2017 production is as follows: LD & LLDPE 16%, HDPE 13%, PP 17%, PS 6%, PVC 9%, PET 8%, PUR 7%, PP&A 14%, other 4%, additives 6%. This means that eight polymer groups and the additives made up 96% of global plastics production in 2017. Polyethylene and polypropylene resins alone account for 45% of total production, even without any additives. Virtually all plastic production is fossil-based. The current global production capacity for bio-based plastic barely exceeds 2 Mt, about half of which is for biodegradable polymers (European Bioplastics 2018).

Today, plastic resin and fiber production is dominated by China and the rest of Asia (American Chemistry Council (ACC) 2013). The 2017 regional breakdown of resin production was China 29%, rest of Asia 21%, Europe 19%, NAFTA (North American Free Trade Agreement) 18%, and rest of world 13% (PlasticsEurope 2018; Plastemart 2016; Chemical and Petrochemicals Manufacturers' Association India (CPMA) 2015). In 2016, the regional breakdown of synthetic fiber production was China 64%, rest of Asia 22%, Europe 5%, North America 4%, and rest of world 5% (PCI Wood Mackenzie 2017; The Fiber Year 2017).

Global primary plastic waste generation in 2017 is estimated as 328 Mt. As mentioned earlier, plastic waste generation is lagging plastic production, which means that the in-use plastic stock has been growing continuously. In the year 2017, for example, 438 Mt was added, while only 328 Mt left it as waste. As a result, 110 Mt of plastic were added to the stock in use in 2017.

Total, i.e. annual primary and secondary waste generation, was 380 Mt in 2017. Around 70 Mt of this waste was recycled, 100 Mt incinerated, and the rest, i.e. 210 Mt, discarded (see Fig. 6). This means that global 2017 recycling, incineration, and discard rates were 18%, 26%, and 56%, respectively (see Fig. 5). As mentioned earlier, these numbers are quite uncertain, and the recycling and incineration rates may be overestimates.

Between 1950 and 2017 a global cumulative total of 9.2 billion metric tons of primary plastic have been produced. This is roughly the same mass as 900,000 Eiffel Towers, 88 million blue whales, or 1.2 billion elephants. Due to the stunning growth in annual output, half of the plastic humankind has ever made was produced in the last 13 years.

In stark contrast, only 700 Mt of secondary, i.e. recycled, plastic was produced since 1950. By the end of 2017 humankind had produced roughly ten billion metric tons of plastic, 92% from primary fossil resources, a meagre 8% from recycled plastic waste. Of this astonishing amount of total plastics, 2700 Mt of primary plastic and 200 Mt of secondary plastic were estimated to still be in use. The remainder, a breathtaking seven billion metric tons, had become plastic waste, 6500 Mt for the first time as primary waste, the other 500 Mt as secondary plastic waste. 5300 Mt of the 6500 Mt of primary plastic waste were plastic resins, around 850 Mt were synthetic fibers, and 350 Mt were additives. The polymer composition of the primary resin waste is 2200 Mt PE, 1200 Mt PP, 700 Mt PET, 400 Mt PS, 300 Mt PVC, 300 Mt PUR, and 200 Mt others.

Only 700 Mt of the 7000 Mt of plastic waste generated by humankind were recycled. This means that the estimated cumulative historical recycling rate of plastic

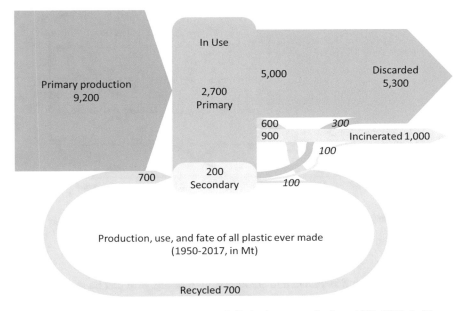

Fig. 7 Cumulative production, use, and fate of all plastic ever made, from 1950–2017, in Mt

is 10%. Another 1000 Mt of plastic waste are estimated to have been incinerated, which yields a cumulative historical incineration rate of 14%. The remainder, an estimated 5300 Mt of plastic waste, or 76% of cumulative plastic waste have thus been discarded and are now in landfills, dumps, or the natural environment. They will be with us for the foreseeable future.

Figure 7 is an illustration of the production, use, and fate of all plastic humankind has ever made (Geyer et al. 2015). It provides a visual overview of humankind's global plastic experiment. It is notable that, due to their lack of biodegradability, the only plastics that are no longer on the planet are the one billion metric tons estimated to have been incinerated. This means that there are currently an estimated 8.2 billion metric tons of plastics on our planet, none of which are biodegradable.

4 The Ghost of Plastics Future

Where are we headed? Currently, towards a future of even more plastic, since fossil-based primary plastic production still continues on its historical growth trend. Second- or third-order polynomial trend lines fit the data for annual global primary plastic production extraordinarily well. Figure 8 shows annual global primary plastic production in blue (resin, fibers, and additives) and the fitted trend curve in dashed red. 2015 was the last production year of our original study. Since then data for

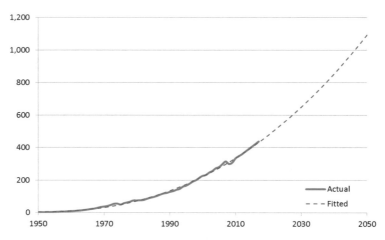

Fig. 8 Historical and projected annual global primary plastic production in Mt

2 more years became available and are also shown in Fig. 8. It can be seen that they are even slightly above the trend line values.

If the trend shown in Fig. 8 were to continue for the next 30 years, annual global primary plastic production would reach an astounding 1.1 billion metric tons in 2050 (Geyer et al. 2015). That is the same as the total amount of primary plastic we produced during the first 34 years of plastic mass production, i.e. from 1950 to 1983, produced in just 1 year. In this scenario, cumulative primary plastic waste generation would have reached 26 billion metric tons by 2050, four times the amount of the primary plastic waste we have generated to date. There are good reasons to assume that this would overwhelm the waste management systems of many, if not all, countries, who already struggle to cope with today's plastic waste volumes.

Figure 9 shows a simple linear forward projection of global historical recycling and incineration rate estimates (Geyer et al. 2015). If the actual rates were to follow these trend lines, the 2050 recycling and incineration rates would be 44% and 49%, respectively. As a result, the 2050 discard rate would be down to 7%. It is impossible to tell whether the development shown in Fig. 9 is likely, or even plausible. Only time will tell.

Figure 10 shows future plastic waste generation and management if we assume that plastic production and waste management rates follow the trends depicted in Figs. 8 and 9 (Geyer et al. 2015). Cumulative global plastic waste generation would reach 33 billion metric tons in 2050. Of this, 26 billion metric tons would be primary plastics waste and seven billion metric tons secondary plastic waste.

To meet the waste management rates shown in Fig. 9, the world would have to recycle a cumulative 8.5 billion metric tons of plastic and incinerate another 12.5 billion metric tons by 2050. Despite such an enormous global recycling and incineration effort, twelve billion metric tons of plastic waste would still end up in landfills, dumps, or the natural environment, more than double of what is already

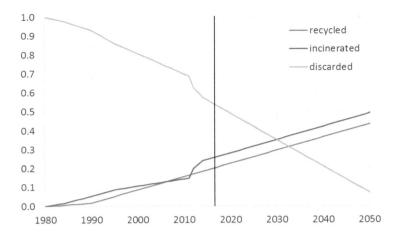

Fig. 9 Projection of global trends in recycling, incineration, and discarding of plastic waste; 1950 to 2017 are historical data, 2018 to 2050 are trend projections

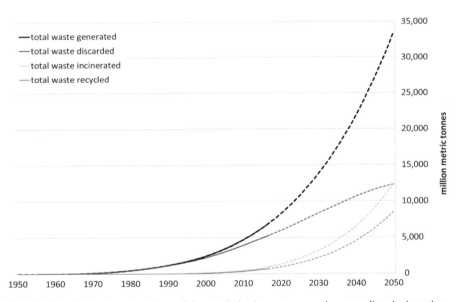

Fig. 10 Historical and projected cumulative total plastic waste generation, recycling, incineration, and discarding; solid lines show historical, dashed lines projected values

there. This suggests that recycling and incineration alone will not be enough to stem the tide of plastic waste.

At this point it is important to remember that plastic waste in the natural environment is just one of many environmental impacts generated by plastic. For example, in 2015 global primary plastic production emitted greenhouse gases

equivalent to well over one billion metric tons of CO_2, over 3% of global CO_2 emissions from fossil fuel combustion. The projection shown in Fig. 8 would triple annual greenhouse gas emissions from primary plastic production. Emissions from plastic recycling are lower, but still significant. Primary and secondary plastic production also has other environmentally significant emissions. The same is true for plastic incineration.

A truly sustainable use of plastic will therefore have to go beyond recycling and other waste management strategies and include serious efforts in source reduction, i.e. production and consumption of less plastic. Source reduction initiatives have started to spread around the globe and show that there are ample opportunities to cut down on plastic use without compromising quality of life. The only plastic that never becomes waste is the one we never made.

References

American Chemical Society (1993) Leo Hendrick Baekeland and the Invention of Bakelite. https://www.acs.org/content/acs/en/education/whatischemistry/landmarks/bakelite.html

American Chemistry Council (ACC) (2013) 2013 resin report: the annual statistical report of the north American plastics industry. ACC, Washington, DC, USA

Chemical & Petrochemicals Manufacturers' Association India (CPMA) (2015) Indian petrochemical industry: Country paper from India. Asia Petrochemical Industry Conference, May 2015, Seoul, Korea

China Ministry of Commerce (2016) Report of China renewable resource recycling industries development. http://f.boolv.com/News/Image/20160811/201608110819469264.pdf

Consultic (2015) Post-consumer plastics waste management in European countries 2014—EU28 + 2 countries. PlasticsEurope, Brussels, Belgium

Davis J, Geyer R, Ley J et al (2007) Time-dependent material flow analysis of iron & steel in the UK—part 2: scrap generation & recycling. Resour Conserv Recycl 51:118–140

Drycleaning Institute of Australia (2012) International fair claims guide for consumer textiles products. Drycleaning Institute of Australia, Alexandria, NSW, Australia

D-Waste (2019) Waste Atlas. http://www.atlas.d-waste.com/

European Bioplastics (2016) Fact sheet: what are bioplastics? European Bioplastics, Berlin, Germany

European Bioplastics (2018) Bioplastics market data 2018. European Bioplastics, Berlin, Germany

Freinkel S (2011) A brief history of plastic's conquest of the world. Sci Am. https://www.scientificamerican.com/article/a-brief-history-of-plastic-world-conquest/

Geyer R, Jackson T (2004) Supply loops and their constraints: the industrial ecology of recycling and reuse. Calif Manag Rev 40(2):55–73

Geyer R, Jambeck J, Lavender Law K (2015) Production, use, and fate of all plastics ever made. Sci Adv 3(7):e1700782

Geyer R, Kuczenski B, Zink T et al (2016) Common misconceptions about recycling. J Ind Ecol 20 (5):1010–1017

Global Industry Analysis (GIA) (2008) Plastic additives: a global strategic business report. MCP-2122. GIA, San Jose, CA, USA

Hoornweg D, Bhada-Tata P (2012) What a waste: a global review of solid waste management. Urban Development series knowledge papers. World Bank, Washington, DC, USA

Jambeck J, Geyer R, Wilcox C et al (2015) Plastic waste inputs from land into the ocean. Science 347:768–771

Kuczenski B, Geyer R (2010) Material flow analysis of polyethylene terephthalate in the US, 1996-2007. Resour Conserv Recycl 54:1161–1169

Kuczenski B, Geyer R (2013) PET bottle reverse logistics—environmental performance of California's CRV program. Int J Life Cycle Assess 18(2):456–471

Lebreton L, Andrady A (2019) Future scenarios of global plastic waste generation and disposal. Palgrave Commun 5:6

Linzner R, Salhofer S (2014) Municipal solid waste recycling and the significance of the informal sector in urban China. Waste Manag Res 32:896–907

Mutha NH, Patel M, Premnath V (2006) Plastics material flow analysis for India. Resour Conserv Recycl 47:222–244

National Bureau of Statics of China (2017) Annual Data, China Statistical Yearbook, 1996–2016. http://www.stats.gov.cn/ENGLISH/Statisticaldata/AnnualData/

National Development and Reform Commission of China (2014) Yearly report of resource comprehensive utilization in China. http://hzs.ndrc.gov.cn/zhly/201410/W020141015504221663989.pdf

PCI Wood Mackenzie (2017) Global Fibres supply demand report 2017. PCI Wood Mackenzie, Oberursel, Germany

Plastemart (2016) China leads in growth of polymers & plastic products. Plastemart, Mumbai, India. http://www.plastemart.com/upload/Literature/chineseplasticandpolymergrowth.asp

PlasticsEurope (2018) Plastics—the facts 2018: an analysis of European plastics production, demand and waste data. PlasticsEurope, Brussels, Belgium

PlasticsEurope (2019) European Plastic Industry Market Data. https://www.plasticseurope.org/en/resources/market-data

Rajaram S (2009) Plastic additives: the global market. PLS022B. BCC Research, Wellesley, MA, USA

The Coca-Cola Company (2012) PlantBottle: Frequently Asked Questions. https://www.coca-colacompany.com/stories/plantbottle-frequently-asked-questions

The Fiber Year (2017) The Fiber year 2017: world survey on Textiles & Nonwovens. The Fiber Year GmbH, Speicher, Switzerland

U.S. Environmental Protection Agency (EPA) (2014) Municipal solid waste generation, recycling, and disposal in the United States: tables and figures for 2012. U.S. EPA, Washington, DC, USA

U.S. Environmental Protection Agency (EPA) (2018) Advancing Sustainable Materials Management: 2015 Fact sheet. EPA530-F-18-004. U.S. EPA, Washington, DC, USA

Zalasiewicz J, Waters CN, Ivar do Sul JA et al (2016) The geological cycle of plastics and their use as a stratigraphic indicator of the Anthropocene. Anthropocene 13:4–17

Zhan-feng M, Bing Z (2009) China plastics recycling industry. China Plastics 23:7

Zink T, Geyer R (2018) Recycling and the myth of landfill diversion. J Ind Ecol 23:541. https://doi.org/10.1111/jiec.12808

Plastics and Microplastics: Impacts in the Marine Environment

Madeleine Steer and Richard C. Thompson

Abstract Accumulation of plastics and, more recently, microplastics, in the marine environment has become a global concern. Plastics are highly durable materials and this persistence coupled with increasing emissions to the environment has resulted in a wide-scale accumulation from shallow waters to the deep sea. However, it is important to recognise that plastic debris is a highly heterogeneous mix of different polymer types, sizes, shapes and sources, and all of these factors influence the type and probability of impact. A small proportion of these items is sufficiently large and they can be visualised by satellites from space, but it is now recognised that the most abundant size category are microplastics. Indeed, many scientists consider there will be even greater accumulations of plastic particles in the nano size range, but such particles are currently beyond the limit of analytical detection. There is clear evidence of impacts on wildlife, as well as economic harm, and there is growing concern about the potential for effects on human well-being. Over 700 species of marine organism are known to encounter plastics in the environment with clear evidence of physical harm from entanglement and ingestion. In addition, there is concern that plastics may present a toxicological hazard because they can transfer chemicals to organisms if ingested. However, there is currently little evidence that plastics provide an important vector for chemicals to wildlife compared to other pathways. There is also emerging evidence that plastic debris could have impacts on assemblages of organisms altering ecosystem processes. Despite this clear evidence of harm it is also clear that plastics as materials bring numerous societal benefits; however, unlike many of the challenges currently facing the ocean, the benefits of plastics could largely be achieved without emissions to the environment. In our view the solutions to this global environmental problem require a more responsible approach to the way we design, produce, use and dispose of plastics, so that we can realise the benefits of plastics without current levels of harm.

M. Steer (✉) · R. C. Thompson
University of Plymouth, Marine Biology and Ecology Research Centre, International Marine Litter Research Unit, Plymouth, UK
e-mail: madeleine.steer@plymouth.ac.uk; R.C.Thompson@plymouth.ac.uk

© Springer Nature Switzerland AG 2020
M. Streit-Bianchi et al. (eds.), *Mare Plasticum – The Plastic Sea*,
https://doi.org/10.1007/978-3-030-38945-1_3

Keywords Marine plastic · Marine litter · Entanglement · Plastic ingestion · Impacts of marine plastic · Macroplastics · Microplastics · Socio-economic impacts · Biological interactions

1 Introduction

Over the past 70 years plastic has revolutionised our lives. From medicine, computers, cars and food packaging many of us cannot imagine a life before plastic. Indeed, we rely on plastic so heavily now for convenience, low cost and performance in many cases; it would not be possible to replace it with any other material. Scientists have recognised for some time there is a need to better understand the biological implications of this durable synthetic polymer so widely used and often poorly disposed of. Its resistance to degradation and wide-ranging applications as a single-use material have resulted in an increasing volume of plastic entering into the marine environment as litter, as well as accidental loss and inputs through waste water (Jambeck et al. 2015; Napper and Thompson 2016). End-of-life consideration for plastic has not been a priority during the manufacturing process resulting in a large volume of single-use or unrecyclable plastic being manufactured. Through inadequate disposal and accidental loss plastic enters the marine environment at an ever-increasing rate. Lebreton and Andrady (2019) describe how, if no mitigation policies are introduced, global mismanaged plastic waste could increase from 60 and 99 million tonnes in 2015 to 155–265 million tonnes per year by 2060. Predictions such as these are modelled partially utilising long-term data series, of which few are available for marine plastic pollution. One such time series has recently been produced using data from the *Continuous Plankton Recorder* from 1957 to 2016 and covering over 6.5 million nautical miles. Based on records of when plastics have become entangled on a towed marine sampler, this consistent time series provides some of the earliest records of plastic entanglement, and is the first to confirm a significant increase in open ocean macroplastics (Ostle et al. 2019).

Marine plastic litter of all size classes is now recognised as a ubiquitous and potentially harmful pollutant worldwide in terrestrial, freshwater and marine environments (Lusher 2015; Hartmann et al. 2019) (Fig. 1). Pieces over 5 mm are termed macroplastic, but these will breakdown in size over time within the environment via the actions of UV, waves and through physical interaction with marine biota (Andrady 2011). Alternatively, marine plastics can enter the environment already microsized (<5 mm) via waste water and runoff (Jambeck et al. 2015). It is recognised that the most abundant size range of plastics in the oceans are the smallest (Browne et al. 2010); some scientists considering the greatest accumulation being in the nano size range (less than 0.1 μm), but below the levels of analytical detection (Science Advice for Policy by European 2019).

Once plastics enter the marine environment they become subject to the physical action of wind and ocean circulation, potentially transporting fragments over considerable horizontal and vertical distances (Galgani et al. 2015). Marine plastic litter

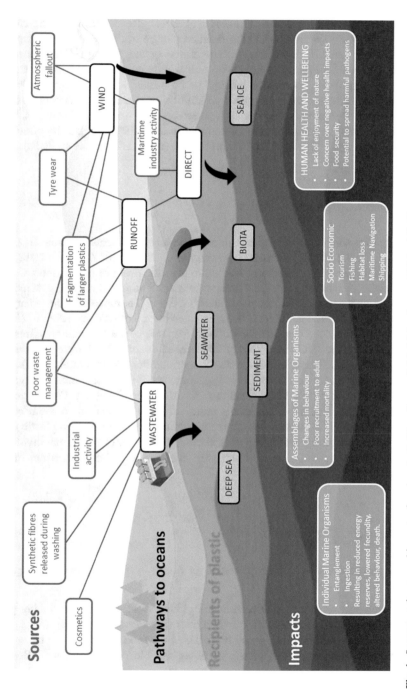

Fig. 1 Sources, pathways and impacts of marine plastic litter. (Image: © Madeleine Steer and Richard C. Thompson 2019. All rights reserved)

has been reported from the deepest ocean trenches to the polar ice in both Antarctica and the Arctic (Woodall et al. 2014; Lusher et al. 2015b; Reed et al. 2018). Scientific research is working towards building a detailed picture of the spatial and temporal fluctuations of plastic litter worldwide. The effects of this litter are also becoming apparent and include: biological effects on individuals such as ingestion and entanglement by organisms potentially leading to ill health, lower fecundity, altered behaviour and death and the subsequent possibility for ecological effects on assemblages; and socio-economic impacts such as effects on tourism and fishing, habitat loss, maritime navigation, shipping (Beaumont et al. 2019) and also the effect on human well-being (Wyles et al. 2016) and food security (Barboza et al. 2018).

2 Impacts on Marine Life

Interaction of marine biota with plastic litter are widely documented, increasing from 700 species in 2012 to 817 in 2016 (*Convention on Biological Diversity* 2012 and 2016) and can result in severe harm leading to possible death or more subtle effects on behaviour and other ecological interactions, potentially threatening sensitive populations and ecosystems (Gregory 2009; Gall and Thompson 2015). Many of the affected species are identified as being at some degree of risk according to *IUCN* (*International Union for Conservation of Nature*); 54% of the 120 marine mammals species listed on the *IUCN Red List of Threatened Species* 2014 were reported to have ingested and/or become entangled with marine litter (Werner et al. 2016). The impact of plastic varies according to the type and size of the debris and can occur at different levels of biological organisation in a wide range of habitats (Werner et al. 2016). It is likely that there are many more sublethal effects not recognised or unreported thus far. The severity of interactions between organisms and plastic litter depends on the physiology, feeding habit, size and behaviour of the animal involved, the location of the animal compared to plastic and the physical characteristics of the plastic itself.

2.1 Impacts of Macroplastic

Common interactions with macroplastic (over 5 mm in size) reported in literature include:

- Entanglement of large marine mammals in items such as discarded fishing gear (Stelfox et al. 2016) and suitably shaped litter (Werner et al. 2016).
- Ingestion of plastic particles possibly mistaken for food (Andrady 2011).
- Crustaceans choosing small plastic items as suitable portable shelters (Benton 1995).
- Hitch hiking of invasive species rafting on ocean plastic (Gregory 2009).

Studies have revealed interactions with plastics for 97 species in the Southeast Pacific, including 20 species of fish, 5 sea turtles, 53 seabirds, and 19 marine mammals (Thiel et al. 2018). It has been reported that 66% of cetaceans suffer adverse effects from plastic litter (Fossi et al. 2018), 55% of bird orders have been recorded as entangled in plastic with fishing gear accounting for 83% of the 265 species entangled in plastic. For example, over 95% of Northern Fulmars in the North Sea contain plastic litter in their stomachs, with 58% exceeding the *OSPAR Ecological Quality Objective (EcoQO)* of 0.1 g plastic per bird (van Franeker et al. 2011). Kühn et al. (2015) found in comparison to the comprehensive review by Laist (1997) the number of bird, turtle and mammal species with known entanglement reports increased from 89 (21%) to 161 (30%); 100% of marine turtles (7 of 7 species), 67% of seals (22 of 33 species), 31% of whales (25 of 80 species) and 25% of seabirds (103 of 406 species) with substantial increases in species records for fishes (89 species) and invertebrates (92 species). Baleen whales (69%; 9 of 13 species) and eared seals (100%, 13 of 13 species) appear to be the mammals most affected by entanglement.

2.1.1 Entanglement in Macroplastics

Specific examples of incidents of entanglement include over a thousand fur seals in Antarctica from 1989 to 2008 (Do Sul et al. 2011), 525 northern gannets over an 8 year period in Wales, UK (Votier et al. 2011), 53 sharks (acquainting to 0.18% of the sharks caught in nets protecting swimming beaches) in KwaZulu-Natal, South Africa (Cliff et al. 2002) and 58 grey seals between 2004 and 2008 in Cornwall, UK (Allen et al. 2012). Acute entanglement can cause an immediate (within hours) and serious health threat to animals (Fig. 2). For example, if a marine mammal suffers entanglement preventing it from surfacing it will drown or it could become much more susceptible to predators or ship strikes. It is likely that a larger number of individuals (many unreported (Kühn et al. 2015)) may suffer from chronic long-term effects of entanglement altering the biological and ecological performance of an individual over time in a potentially accumulating amount (Werner et al. 2016). A number of negative sublethal effects have been reported, including tissue damage (skin lesions, death of muscle tissue (Orós et al. 2005), infections from open wounds), reduced mobility, agility, ability to ingest food and ability to digest food, all of which lead to reduced fitness, reproductive success and mobility (Werner et al. 2016).

Incidents of entanglement rely upon detection of animals either in distress or perished, accurate reporting and the collation of data; therefore, it is possible that figures obtained from literature are an underestimate of the extent of the issue. Duncan et al. (2017) conducted a global review of turtle entanglement firstly via a literature review and secondly via a questionnaire directly to the lead authors of papers documenting the impacts of marine debris on turtles. The literature review yielded 23 reports of marine turtle entanglement in anthropogenic debris, which included records for 6 species, in all ocean basins. Numbers of stranded turtles

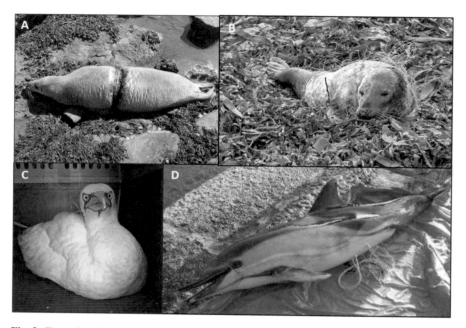

Fig. 2 Examples of entanglement and ingestion of macroplastics in the UK. (**a**) Juvenile grey seal in Northumberland with fatal entanglement injury, (**b**) grey seal pup near Polzeath, Cornwall, entanglement in monofilament netting, rehabilitated at the *Cornish Seal Sanctuary*, (**c**) gannet rescued from Falmouth, Cornwall, having swallowed a fishing hook with monofilament line attached. Rehabilitated by *Mousehole Bird Hospital*, Cornwall, (**d**) common dolphin, Porthleven, Cornwall. Long-term entanglement in fishing net caused very poor condition, so animal was euthanised by a vet. (Photo credit: © 2019 *British Divers Marine Life Rescue*. All Rights Reserved)

encountered by the 106 respondents to the questionnaire were in the thousands per year, with 5.5% of turtles encountered entangled, 90.6% of these dead. Of the experts questioned, 84% considered that entanglement could be causing population-level effects in some areas. Lost or discarded fishing materials, known as 'ghost gear', contributed to the majority of reported entanglements with debris from land-based sources in the distinct minority. Surveyed experts rated entanglement a greater threat to marine turtles than oil pollution, climate change and direct exploitation but less of a threat than plastic ingestion and fisheries bycatch.

2.1.2 Susceptibility of Entanglement with Macroplastics

The physical properties of plastics determine the likelihood and type of encounter with marine life. Shape, size, colour and polymer type will influence the capacity of an animal to become entangled. For instance, Butterworth et al. 2012 identified litter items that are most frequently associated with entanglement as net fragments, rope and line (e.g. gill and trawl nets, lost or discarded line for pots and traps),

monofilament line, packaging bands, plastic circular rings and packaging such as multipack can rings. Furthermore, the location of the plastic will influence its availability. By looking at available data, the aforementioned study also identified entanglement geographical hotspots, e.g. the North Sea for grey seals, minke whales and gannets. Fishing gear is widely reported as the most common source of entanglement litter, and with an estimated 640,000 tons of fishing gear lost, abandoned or discarded annually world-wide may continue to pose a threat through 'ghost' fishing and entanglement for decades (Cheshire et al. 2009). For example, Sancho et al. (2003) considered lost tangle nets to catch an equivalent of around 5% of the total commercial catch in northern Spain, and the decline of deep water sharks in the North Atlantic has been linked to ghost fishing in the North Atlantic, indicating the potential for a population-level impact (Large et al. 2009).

2.1.3 Ingestion of Macroplastics

Incidents of ingestion of marine plastic litter in wild organisms are now common in the literature with a growing body of research suggesting the possible effects of ingestion for individuals. Modelling can, to a limited extent, enable scientists to scale-up effects of ingestion to population level allowing predictions of a longer term wider scale impact from marine litter ingestion. Despite this, there remains a significant level of uncertainty surrounding effects of ingestion of marine plastic litter mainly due to the complexity of the interactions.

The size class of the plastic ingested relates directly to the size of the organism in question. Macroplastic is usually ingested by larger organisms such as large fish, marine mammals, seabirds (Fig. 2), turtles and sharks. The accidental, intentional or secondary ingestion of marine litter may also include other materials such as wood or cardboard but it is plastic that is by far the most reported material found ingested by marine organisms (up to 90%) (Gall and Thompson 2015; Werner et al. 2016). Identifying the sources of plastics ingested by organisms is harder than for entanglement due to the fragmentation and degradation of particles. Different species ingest different types of particles; for example, loggerhead turtles are susceptible to ingest plastic bags mistaking them for jelly fish (Camedda et al. 2014), whilst baleen whales are believed to indiscriminately ingest plastic litter whilst filter feeding from the water column (Lusher et al. 2015a). The feeding strategy of fish species has been identified as correlating to the types of plastic ingested (Anastasopoulou et al. 2013; Lusher et al. 2013; Romeo et al. 2015). Similarly, the presence of plastic in seabirds is clearly correlated to feeding strategy (Ryan 1987; Moser and Lee 1992).

Between 1997 and 2015 the number of species found to have ingested plastic litter increased from 177 to 331 (Laist 1997; Kühn et al. 2015). The observed increase in incidents is likely not only to be down to an ever-increasing volume of plastic in the oceans but also due to the substantial increase in research effort. Some groups have emerged as particularly susceptible to ingestion such as the tubenoses (Procellariiformes: albatrosses, shearwaters, petrels, storm- and diving-petrels;

84 out of 141), (Werner et al. 2016). Although this is a common finding in the literature, it is important to consider the possibility of limitations in research findings. The second most common group of birds to ingest plastic are the Charadriiformes, which include waders, skuas, gulls, terns and auks (55 of 139 species). It is noted that most tubenosed seabirds tend to retain debris in a muscular stomach for grinding and ultimate passage through the intestines whilst most Charadriiformes tend to regularly regurgitate poorly digestible components leading to the possibility that plastic is not readily retained but has been ingested. Other examples of macroplastic ingestion include all 7 species of turtle where in a review by Schuyler et al. (2016) the incidence of ingestion varied between species from 15% to 50%. Olive Ridley turtles were the most at-risk species and there was no difference in plastic ingestion rates between turtles stranded versus those caught as bycatch suggesting no bias in plastic ingestion for stranded animals. Stranded animals provide a unique opportunity to collect ecological data for species and habitats, including stomach contents for dietary analysis and marine debris ingestions. Such examples include sperm whales in the Mediterranean Sea (Unger et al. 2016), true beaked whales off the west coast of Ireland (Lusher et al. 2015a) and brown boobies (*Sula leucogaster*) and masked boobies (*Sula dactylatra*) on the Clipperton Atoll in the Pacific Ocean (Claro et al. 2019).

The direct effect of macroplastic ingestion is hard to evidence due to the common identification of multiple factors involved in mortality; therefore, producing a link between mortality or poor condition of individuals and plastic ingestion is rare in the literature. If the oesophagus, stomach or intestines become completely blocked with one or more particles, then rapid death is likely. This is likely to be more apparent during a necropsy than the multiple symptoms possibly present after long-term presence of plastic in an individual's digestive tract. For example, Brandão et al. (2011) report the perforation of the stomach wall in a Magellanic penguin (*Spheniscus magellanicus*) by a straw that had been ingested and subsequently caused acute and fatal injury. Whilst long-term exposure to plastic in the digestive tract could produce a number of symptoms such as poor condition, weight loss, parasites and lesions on stomach or gut wall. In this instance determining the plastic present in the stomach or gut during necropsy that was responsible for death is very challenging. Ultimately, other factors often play a role (such as age and diet) but the initial plastic ingested caused the problem that snowballed resulting in death.

2.1.4 Other Impacts of Macroplastic

Other impacts of macroplastic litter on marine life include its ability to act as a vector for transport of organisms. Some consider that the passage of non-native biota on litter floating in the water column across potentially large distances may pose a serious threat. The settlement of nonindigenous species has the potential to alter habitats, changing native species dynamics, killing large numbers of native species and/or competing with them, together with acting as vectors of diseases (Werner

et al. 2016). Organisms have been seen utilising marine plastic litter as substrates to hide in, adhere to or settle on resulting in transportation large distances across oceans to new habitats (Gregory 2009; Gall and Thompson 2015). This is not a new phenomenon as rafts of wood, seaweed and other marine debris provide similar substrates to organisms. Plastic is especially attractive to rafters because of its abundance, the variety of shapes and sizes adrift, its buoyant nature and the presence of a biofilm creating a proliferation of invasive species. A total of 387 taxa, including pro- and eukaryotic microorganisms, seaweeds and invertebrates have been found rafting on floating litter, with species of bryozoans, crustaceans, molluscs and cnidarians most frequently reported (Kiessling et al. 2015). Zettler et al. (2013) identified a diverse microbial community of heterotrophs, autotrophs, predators, and symbionts, a community referred to as the 'Plastisphere'. Pits visualised in the plastic litter surface conformed to bacterial shapes suggesting active hydrolysis of the hydrocarbon polymer. Plastisphere communities were distinct from surrounding surface water suggesting plastic litter provides a novel ecological habitat. Members of the genus *Vibrio* were present on some samples confirming the suggestion that harmful bacteria could be transported into fragile habitats.

Marine plastic litter can also modify species assemblages in habitats by introducing an unnatural percentage of hard substrate to an environment (e.g. benthic habitats), changing the species assemblage and dynamics (Green et al. 2015; Werner et al. 2016). Smothering is another effect of plastic film and sheets, leading to reduced fitness and even death of the organisms lying under the plastic through reduced oxygen levels and reduced photosynthesis, which in turn alters habitats and communities (e.g. coral (Richards and Beger 2011)).

2.2 Microplastics

Microplastics (between 0.1 μm and 5 mm) can be either manufactured small and are transported into the marine environment through waste water (primary) (Napper et al. 2015), run off and rivers or are the result of weathering and physical breakdown of larger macroplastic particles over time in the marine environment or on land (secondary) (Jambeck et al. 2015). Particles can range in shape (fragments, beads, films, fibres), colour and plastic characteristic known as polymer. The inherent microscopic nature of microplastic means that our knowledge on the scale and extent of the associated problems surrounding the pollutant decreases somewhat with the size of the plastic particles. There are significant challenges when trying to isolate microplastic particles from environmental substrates such as water, sediment and biota. That said, there is a growing body of research documenting the spatial and temporal trends in microplastics, its sources and its effects on biota (Cole et al. 2011).

2.2.1 Ingestion of Microplastics

Microplastic pollution (Fig. 3) poses a threat to marine life via ingestion and entanglement (Wright et al. 2013b). Continuous fragmentation and degradation of microplastics in the marine environment produces a wide range of particle sizes (Enders et al. 2015), which can be ingested by an equally large range of marine organisms, for example: humpback whales (Besseling et al. 2015), all 7 species of marine turtle (Duncan et al. 2017), harbour seal (Rebolledo et al. 2013), Humboldt squid (Braid et al. 2012), numerous pelagic and demersal small and large fish (Lusher et al. 2013; Nadal et al. 2016; Tanaka and Takada 2016), blue mussel and lugworms (Van Cauwenberghe et al. 2015), gooseneck barnacle (Goldstein and Goodwin 2013), Norway lobster (Murray and Cowie 2011), zooplankton (Desforges et al. 2015) (Fig. 4) and fish larvae (Steer et al. 2017). Trophic transfer is also

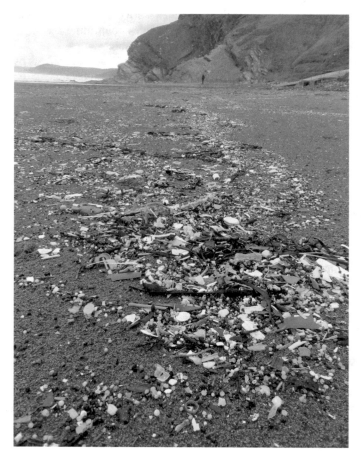

Fig. 3 Strandline covered in plastic. Tregantle beach, Whitsands, Cornwall, UK. (Photo credit:)

Fig. 4 Microplastics of different sizes can be ingested, egested and adhere to a range of zooplankton, as visualised using fluorescence microscopy using very high dose concentrations: (main picture) the copepod *Centropages typicus* containing 7.3 μm polystyrene (PS) beads (dorsal view); (top left) a D-stage bivalve larvae containing 7.3 μm PS beads (dorsal view); (bottom left) a Porcellanid (decapod) larvae, containing 30.6 μm PS beads (lateral view). (Reprinted with permission from Cole et al. (2013). Copyright 2013 *American Chemical Society*)

considered to be a significant pathway for microplastics in higher trophic levels (Lusher et al. 2015a; Nelms et al. 2018).

2.2.2 Impacts from Ingestion of Microplastics

Reports of ingestion of microplastics in wild organisms are now frequent in peer reviewed literature; however, less understood are the impacts of ingestion of these particles and fibres. The physiological impacts of ingestion of microplastic can be comparatively more subtle than macroplastic making it harder to detect and trace back to effects of the plastic itself. With such a large range of particle shapes, sizes and types of plastic present as marine litter, the resultant impacts from ingestion will vary greatly. To date some of the effects of microplastic ingestion on individual animals include decreased energy reserves (Wright et al. 2013a), inflammatory response (Von Moos et al. 2012), hepatic stress (Rochman et al. 2013), reduced reproduction and off spring performance (Sussarellu et al. 2016), inflammation in the liver and oxidative stress (Lu et al. 2016), decreased predatory performance (de Sá

et al. 2015) and decreased feeding, lipid accumulation and premature moulting in copepods (Cole et al. 2019).

Furthermore, the age of the microplastic (how long it has been in the marine environment for) will influence the characteristics of its associated biofilm and adhered chemicals (from the surrounding water) and the plastics' original use will determine the chemicals added during manufacture that can then leach out once ingested. This myriad of plastic characteristics will ultimately influence its impact, coupled with its temporal and spatial distribution compared to the organism in question and its feeding strategy. Deciphering this in situ in wild organisms is beyond the scope of current research techniques, so scientists currently rely on experimental approaches. Here, organisms are exposed to microplastics with variable characteristics under experimental conditions and physiological and/or behavioural responses are measured. Traditionally these experiments are run with concentrations of the toxin in question at low, moderate and high values. However with regard to microplastics it is possible that high concentrations are not relevant in determining the response to the pollutant in the wild, although not ruled out due to the constraints of current analytical methods for detection of microplastics in complicated environmental matrices (Science Advice for Policy by European 2019). It is critical that we start to understand the responses of individuals in the wild to the microplastics they are ingesting in order to enforce any mitigation plans. For this we need environmentally relevant experimental designs. By using the data produced from ingestion studies in the wild and reports of waterborne and sediment microplastic characteristics, scientists can develop experimental designs utilising the relevant size, shape, colour, age and concentration of microplastic particles, therefore reducing the number of caveats for the results obtained. In principle, this sounds relatively simple; however, in practice it is not that easy. One of the most challenging aspects of microplastic ecotoxicological experiments is preparing the plastic particles. Mirroring particles found in the natural environment is very challenging as there are so many variations. Some recent studies have started to examine fibres as these are more commonly reported ingested in wild organisms and in the water column (Jemec et al. 2016; Ziajahromi et al. 2017; Cole et al. 2019).

Accumulation and translocation of microplastics once ingested has the potential to affect the resultant physical impact (Wright et al. 2013b). Studies have generally concentrated on laboratory-based experiments on invertebrates, the first of which reported microplastic translocating to the circulatory system in mussels (Browne et al. 2008). Since then accumulation of microplastics have been observed in the gut, digestive tract and gills of species such as Eastern oyster, European green crab, purple sea urchin, European sea bass and the clam *Scrobicularia plana*. Accumulation of microplastic particles in the digestive system of organisms in the field has been observed in lug worm, Norway lobster, Atlantic deep sea scallop and the copepod *Tigriopus japonicas*. Accumulation of microplastics through translocation of particles into other tissues of the body has been observed in blue mussels (lymphatic system), zebra fish (liver), Mediterranean mussel (digestive tissues) and for nanoplastics in scallops (whole body) with retention of particles for as long as weeks (Al-Sid-Cheikh et al. 2018; Ribeiro et al. 2019). More research is required to

ascertain the effects of different polymer types and the implications of long-term exposure such as that experienced in the wild.

2.2.3 Associated Contaminants on Microplastics

In addition to the physical effects of plastic on organisms, there are concerns that plastics may act as a vector for the transport of persistent organic pollutants (POPs), including those from manufacture but also chemicals sorbed from sea water (Teuten et al. 2007; Andrady 2011). Toxicity of particles is related to:

1. Additives incorporated at the time of manufacture, e.g. flame retardants.
2. Sorbed chemicals (from surrounding water/sediment).

Sea water typically contains low levels of POPs such as polychlorinated biphenyls (PCBs), polybrominated diphenyl ethers (PBDEs) and perfluorooctanoic acid (PFOA); however, they have very large water-polymer distribution coefficients in favour of the plastic. This means that microsized plastic (with high surface area to volume ratio) can readily accumulate POPs (Andrady 2011), concentrating them several orders of magnitude higher than the levels found in their surrounding environment (Mato et al. 2001; Rodrigues et al. 2019). Modelling the transfer of sorbed organic contaminants from microplastics to marine life allows scientists to evaluate the risks to individuals and food webs. Bakir et al. (2016) suggest there is negligible impact on transfer to biota under both relevant and worst-case scenarios. Furthermore, Diepens et al. (2016) confirmed ingested microplastics can increase or decrease uptake of organic chemicals (dependent on polymer type, species properties, chemical characteristics and equilibrium state) and thus that the vector effect, if any, is context dependent. They also suggested that microplastics would not biomagnify in the food web (biomagnification is the increasing concentration of a substance in the tissues of tolerant organisms at successively higher levels in a food chain).

Microplastics also attract a rich diversity of microbes to their surface. Recent research has described particles providing a substrate for horizontal gene transfer that could distinctly affect the ecology of aquatic microbial communities on a global scale. The spread of antibiotic resistance through microplastics could have profound consequences for the evolution of aquatic bacteria and poses a neglected hazard for human health (Arias-Andres et al. 2018).

2.3 Nanoplastics

Once in the marine environment microplastics are exposed to mechanical weathering from UV exposure and wave action, and most probably further breaking down particles into nanoparticles (less than 0.1 μm). Current analytical methods are not able to identify and isolate nanoparticles from environmental matrices; however,

some experimental work has identified the possibility for nanoplastic to accumulate in the environment. Koelmans et al. (2015) demonstrated that expanded polystyrene would fragment into micro- and nanosize pieces in experiments involving a month of accelerated mechanical abrasion with glass beads and sand. Lambert and Wagner (2016) observed the formation of nanoplastics during the degradation of a polystyrene disposable coffee cup lid and Gigault et al. (2016) provided evidence of nanoplastic occurrence due to solar light degradation of marine microplastics under controlled and environmentally representative conditions. In addition, many manufactured products contain nanoplastic including paints, adhesives, coatings, biomedical products, electronics and cosmetics (Vance et al. 2015; Hernandez et al. 2017) which, due to their small size, are likely to enter the marine environment via rivers, run off and waste water. Given the durability of plastic and the rate at which plastic is entering the world's oceans, it is likely that significant accumulations of nanoplastics are mounting. A number of studies have assessed uptake and effects of nanoplastic on marine organisms; however they have used concentrations of particles up to seven orders of magnitude more than those predicted in the environment. Recently, Al-Sid-Cheikh et al. (2018) used environmentally relevant concentrations of radiolabelled nanopolystyrene to assess uptake, distribution and depuration of particles in the Scallop *Pecten maximus* (Fig. 5). Uptake was rapid and greater for 24 nm sized particles than for 250 nm particles. After 6 h, autoradiography showed accumulation of 250 nm nanoplastics in the intestine, whilst the 24 nm particles were dispersed throughout the whole body, possibly indicating some translocation across epithelial membranes. Depuration was also relatively rapid for both sizes; 24 nm particles were no longer detectable after 14 days, although some 250 nm particles were still detectable after 48 days. This move towards using environmentally relevant concentrations is an important step in our understanding of the ultimate impacts these plastics may have on all levels of biological organisation.

Fig. 5 Autoradiograph of nanoplastics ingested by Scallops (Al-Sid-Cheikh et al. 2018). (Reproduced with the permission of *ACS Publications*, please contact *ACS* for further reproduction)

2.4 Factors Influencing the Impact of Plastic in the Marine Environment

The abundance of plastic litter within habitats is the major driver in determining its impact on biota. Some areas are more heavily polluted than others, and if these areas coincide with significant populations of organisms vulnerable to interaction with plastic (correct size to ingest the particle, susceptible feeding strategy, highly mobile species with a high risk of entanglement), there will be a greater risk from the plastic litter than in areas of low concentrations of plastic pollution and animal populations. This is however a simplified outlook and, in reality, interactions are likely to be far more complicated. Plastics are considered very durable in the marine environment, can be transported across substantial distances and migrate vertically within the water column (Clark et al. 2016). For example, microplastics in arctic ice may be released on melting and so where they were previously inaccessible to organisms they can become bioavailable once more (Obbard et al. 2014; Bergmann et al. 2016). Likewise, plastic in the gut of an animal can remain in the animal for an extended period of time whilst being transported spatially, then either excreted or released when the animal dies, possibly sinking out of the epipelagic zone. One of the most compelling theories to date is that of the deep ocean plastic sinks (Woodall et al. 2014). Numerous reports have emerged suggesting that there are far higher concentrations of plastic in the deep ocean than coastal areas, suggesting a net transport and accumulation effect (Courtene-Jones et al. 2017; Bergmann et al. 2018).

3 Impact of Marine Plastics on Socio-economics, Human Health and Well-Being

Marine litter not only poses a threat to marine life but also has negative repercussions for the aesthetics of the oceans affecting tourism and recreation and directly or indirectly impacting upon productivity in terms of commercial fisheries and industrial productivity, termed socio-economic impacts. Marine ecosystems provide a number of ecosystem services (the benefits people obtain from nature) including food provision, carbon storage, waste detoxification and cultural benefits (Worm et al. 2006) and any threat to these provisions has the potential to impact human well-being (Naeem et al. 2016). Furthermore marine plastic is a trans-boundary problem, resulting in costs to countries that may be far from the point of origin of the debris.

3.1 Socio-economic

Historical studies have concentrated on the direct costs that are easily measured (McIlgorm et al. 2011) with very little research on the socio-economic impact on

ecosystem services and provisions. Kirkley and McConnell (1997) highlight the need to produce strategies which account for the economic loss due to decreased ecological function arising from marine debris and Richards and Beger (2011) identified a significant negative relationship between the level of marine debris cover and coral cover, with coral cover and species diversity decreasing with increasing debris abundance on Majuro Atoll. More recently, Beaumont et al. (2019) conducted a comprehensive literature review of global marine plastic research and produced a global assessment of the ecological, ecosystem service and social and economic impacts of marine plastic. The study identified impacts on three critical ecosystem services:

1. Provision of fisheries, aquaculture and materials for agricultural use.
2. Heritage (marine plastic pollution may result in a widespread negative impact on charismatic species, with an accompanying loss of human well-being).
3. Experiential recreation.

3.1.1 Fishing Industry

Demersal and pelagic fish stocks have considerable ecological and economic value, whilst also widely reported to have ingested microplastics (Lusher et al. 2013; Neves et al. 2015; Bellas et al. 2016). Global annual fisheries revenue fluctuate around US $100 billion supporting about 12% of the world population, and providing 2.9 billion people with 20% of their animal protein (Lam et al. 2016). The potential negative impact of marine plastic litter on fish stocks will grow as marine plastic concentrations increase. Furthermore, the direct costs to fishing boats from fouled propellers, obstructed cooling systems, lost gear, loss of earnings from reduced fishing time and poor catches due to litter fouling in nets are rarely studied. For example, it has been reported that the Scottish fishing industry suffer losses amounting to between US $15 million and US $17 million per year (Ten Brink et al. 2009) and 92% of Shetland (UK) fishermen report that they have experienced problems associated with accumulated debris in their nets (Hall 2000). Gilardi et al. (2010) assessed the ability of lost gill nets to ghost fish in Puget Sound, USA, and performed a cost-benefit analysis which reported that entanglement of Dungeness crab by a single net could cost the commercial fishery US $19,656, compared to US $1358 to remove the net and preventing it from ghost fishing. Aquaculture could also see a negative impact due to marine plastics as shellfish species such as mussels, oysters and scallops indiscriminately filter feed sea water in close proximity to sources of microplastics such as waste water and surface run off in coastal and estuarine regions.

3.1.2 Tourism

Loss of tourism as people choose less littered beaches and the cost of cleaning beaches of litter and its disposal are also a substantial negative impact from marine plastic. A study by Tudor and Williams (2006) in Wales, UK, report that beach choice was primarily determined by clean, litter-free sand and seawater and 67% of respondents rate a beach as 'important' or 'very important' to their holiday. There is a considerable economic cost involved in keeping beaches clean and safe from litter. With no standardised method for reporting costs, quantifying the data is however difficult. A 2009 estimate in the UK suggests the total cost of marine litter removal to all UK local authorities is approximately £14 million per year (OSPAR 2009); however, this figure is likely to have risen considerably in recent years due to the increase in plastics manufactured (348 million tonnes in 2017 compared to 335 million in 2016, not including polyethylene terephthalate, polyamide and polyacryl fibres) (Plastic Europe 2018). Volunteer beach cleans are becoming increasingly popular with a 109% increase in the number of people participating in beach cleans in the UK between 2017 and 2018 (Marine Conservation Society 2018).

3.1.3 Other Maritime Industry

Marine litter provides a navigational hazard to all maritime traffic, from shipping to recreational users. Entanglement in fishing gear, ropes and lines present a key concern, but also plastic bags can block water intakes for cooling systems and benthic debris can foul anchors and equipment endangering both the vessel and its crew (Fig. 6). In 2005, a Russian submarine became entangled in derelict fishing nets 180 m below the surface for 4 days until an international rescue effort managed to cut it free. A passenger ferry travelling off the west coast of Korea in 1993 became entangled in 10 mm nylon rope, which coiled around both propeller shafts and the right propeller causing the vessel to turn suddenly, capsize and sink, killing 292 of the 362 passengers on board (Mouat et al. 2010). In June 2017, whilst dredging the main channel into Warren Point Port, Carlingford Loch, Northern Ireland, the *Royal Boskalis Westminster* dredger '*Shoalway*' was fouled during dredging operations by substantial fishing gear. The steel wire reinforced nylon gear was drawn into the dredging apparatus which then fouled the propeller, stopping the engine immediately whilst the dredger was in the shipping lane. Unable to manoeuvre, the ship was at anchor for 2 days whilst a team of divers used welding gear to remove the melted wire and rope from the propeller and shaft at a total cost of over £100,000 in lost revenue and removing the fishing gear (personal communication).

Fig. 6 Plastic fouled intake of jet propulsion system of commercial survey boat in *Royal Clarence Marina*, Gosport, during Ministry of Defence survey, March 2018. Cost of fouling totalled £500 (half a day survey and lift out). (Photo credit: © 2019 Russ Craig. All rights reserved)

3.2 Human Health and Well-Being

Marine plastic litter also has the potential to have negative implications for human health. Wyles et al. (2016) describe how litter can undermine the psychological benefits that the coast ordinarily provides. The presence of microplastic in food could lead to concerns because of perceived rather than actual exposure of humans to the associated toxins. Fish and shellfish for human consumption have been found to contain microplastics, in particular fibres; however, in fish they are mostly contained within the stomach and intestines and therefore removed before human consumption. Shellfish such as mussels, oysters, scallops and small fish (e.g. anchovy) are of greater concern as we consume the whole animal (Cole et al. 2011). It is however important to consider the context of such ingestion and Catarino et al. (2018) describe how the potential for humans to ingest fibres is greater from household dust than from eating plastic contaminated mussels. Dris et al. (2015) report 29–280 particles, mostly fibres, in a square meter per day in Paris from atmospheric fallout, the sources of which could include synthetic textiles, erosion of synthetic rubber tyres, city dust, materials in buildings, waste incineration, landfills (Dris et al. 2016), synthetic particles used in horticultural soils (e.g. polystyrene peat), and sewage sludge used as fertiliser (Ng et al. 2018). Research into airborne plastics is however in its infancy and impacts on human health are currently uncertain.

4 Conclusion

There is no doubt that marine plastics pose a significant threat to marine life, the economy and human health and well-being. Moving forward there is a need to reduce these impacts, especially those from single-use plastics which offer short-lived benefit but considerable persistence as waste. This could be achieved by designing items to ensure the plastic has a higher value after use, therefore ensuring reuse. In short, we need to use plastic in a more circular manner decoupling consumption from fossil oil and gas and utilising end-of-life plastic as a feed stock for new production whilst also using less.

References

Allen R, Jarvis D, Sayer S, Mills C (2012) Entanglement of grey seals Halichoerus grypus at a haul out site in Cornwall, UK. Mar Pollut Bull 64(12):2815–2819

Al-Sid-Cheikh M, Rowland SJ, Stevenson K, Rouleau C, Henry TB, Thompson RC (2018) Uptake, whole-body distribution, and depuration of nanoplastics by the scallop pecten maximus at environmentally realistic concentrations. Environ Sci Technol 52(24):14480–14486. https://doi.org/10.1021/acs.est.8b05266. Accessed 6 Sep 2019

Anastasopoulou A, Mytilineou C, Smith CJ, Papadopoulou KN (2013) Plastic debris ingested by deep-water fish of the Ionian Sea (eastern Mediterranean). Deep-Sea Res I Oceanogr Res Pap 74:11–13

Andrady AL (2011) Microplastics in the marine environment. Mar Pollut Bull 62(8):1596–1605

Arias-Andres M, Klümper U, Rojas-Jimenez K, Grossart H-P (2018) Microplastic pollution increases gene exchange in aquatic ecosystems. Environ Pollut 237:253–261

Bakir A, O'Connor IA, Rowland SJ, Hendriks AJ, Thompson RC (2016) Relative importance of microplastics as a pathway for the transfer of hydrophobic organic chemicals to marine life. Environ Pollut 219:56–65

Barboza LGA, Dick Vethaak A, Lavorante BRBO, Lundebye A-K, Guilhermino L (2018) Marine microplastic debris: an emerging issue for food security, food safety and human health. Mar Pollut Bull 133:336–348

Beaumont NJ, Aanesen M, Austen MC, Börger T, Clark JR, Cole M, Hooper T, Lindeque PK, Pascoe C, Wyles KJ (2019) Global ecological, social and economic impacts of marine plastic. Mar Pollut Bull 142:189–195

Bellas J, Martínez-Armental J, Martínez-Cámara A, Besada V, Martínez-Gómez C (2016) Ingestion of microplastics by demersal fish from the Spanish Atlantic and Mediterranean coasts. Mar Pollut Bull 109(1):55–60

Benton T (1995) From castaways to throwaways: marine litter in the Pitcairn Islands. Biol J Linn Soc 56(1–2):415–422

Bergmann M, Peeken I, Beyer B, Krumpen T, Primpke S, Tekman M, Gerdts G (2016) Vast quantities of microplastics in Arctic Sea ice—a prime temporary sink for plastic litter and a medium of transport. Fate and impact of microplastics in marine ecosystems. pp 75–76

Bergmann M, Wirzberger V, Krumpen T, Lorenz C, Primpke S, Tekman MB, Gerdts G (2018). The Arctic Deep Sea-A Sink for Microplastic?

Besseling E, Foekema E, Van Franeker J, Leopold M, Kühn S, Rebolledo EB, Heße E, Mielke L, IJzer J, Kamminga P (2015) Microplastic in a macro filter feeder: humpback whale Megaptera novaeangliae. Mar Pollut Bull 95(1):248–252

Braid HE, Deeds J, DeGrasse SL, Wilson JJ, Osborne J, Hanner RH (2012) Preying on commercial fisheries and accumulating paralytic shellfish toxins: a dietary analysis of invasive Dosidicus gigas (Cephalopoda Ommastrephidae) stranded in Pacific Canada. Mar Biol 159(1):25–31

Brandão ML, Braga KM, Luque JL (2011) Marine debris ingestion by Magellanic penguins, Spheniscus magellanicus (Aves: Sphenisciformes), from the Brazilian coastal zone. Mar Pollut Bull 62(10):2246–2249

Browne MA, Dissanayake A, Galloway TS, Lowe DM, Thompson RC (2008) Ingested microscopic plastic translocates to the circulatory system of the mussel, Mytilus edulis (L.). Environ Sci Technol 42(13):5026–5031

Browne MA, Galloway TS, Thompson RC (2010) Spatial patterns of plastic debris along estuarine shorelines. Environ Sci Technol 44(9):3404–3409

Butterworth A, Clegg I, Bass C (2012) Untangled–marine debris: a global picture of the impact on animal welfare and of animal-focused solutions. World Society for the Protection of Animals, London, p 75

Camedda A, Marra S, Matiddi M, Massaro G, Coppa S, Perilli A, Ruiu A, Briguglio P, de Lucia GA (2014) Interaction between loggerhead sea turtles (Caretta caretta) and marine litter in Sardinia (Western Mediterranean Sea). Mar Environ Res 100:25–32

Catarino AI, Macchia V, Sanderson WG, Thompson RC, Henry TB (2018) Low levels of microplastics (MP) in wild mussels indicate that MP ingestion by humans is minimal compared to exposure via household fibres fallout during a meal. Environ Pollut 237:675–684

Cheshire A, Adler E, Barbière J, Cohen Y, Evans S, Jarayabhand S, Jeftic L, Jung R, Kinsey S, Kusui E (2009) UNEP/IOC Guidelines on Survey and Monitoring of Marine Litter. UNEP Regional Seas Reports and Studies

Clark JR, Cole M, Lindeque PK, Fileman E, Blackford J, Lewis C, Lenton TM, Galloway TS (2016) Marine microplastic debris: a targeted plan for understanding and quantifying interactions with marine life. Front Ecol Environ 14(6):317–324

Claro F, Fossi MC, Ioakeimidis C, Baini M, Lusher AL, Mc Fee W, McIntosh RR, Pelamatti T, Sorce M, Galgani F, Hardesty BD (2019) Tools and constraints in monitoring interactions between marine litter and megafauna: insights from case studies around the world. Mar Pollut Bull 141:147–160

Cliff G, Dudley SF, Ryan PG, Singleton N (2002) Large sharks and plastic debris in KwaZulu-Natal, South Africa. Mar Freshw Res 53(2):575–581

Cole M, Lindeque P, Halsband C, Galloway TS (2011) Microplastics as contaminants in the marine environment: a review. Mar Pollut Bull 62(12):2588–2597

Cole M, Lindeque P, Fileman E, Halsband C, Goodhead R, Moger J, Galloway TS (2013) Microplastic ingestion by zooplankton. Environ Sci Technol 47(12):6646–6655

Cole M, Coppock R, Lindeque PK, Altin D, Reed S, Pond DW, Sørensen L, Galloway TS, Booth AM (2019) Effects of nylon microplastic on feeding, lipid accumulation, and moulting in a coldwater copepod. Environ Sci Technol 53:7075–7082

Courtene-Jones W, Quinn B, Gary SF, Mogg AO, Narayanaswamy BE (2017) Microplastic pollution identified in deep-sea water and ingested by benthic invertebrates in the Rockall trough, North Atlantic Ocean. Environ Pollut 231:271–280

De Sá LC, Luís LG, Guilhermino L (2015) Effects of microplastics on juveniles of the common goby (Pomatoschistus microps): confusion with prey, reduction of the predatory performance and efficiency, and possible influence of developmental conditions. Environ Pollut 196:359–362

Desforges J-PW, Galbraith M, Ross PS (2015) Ingestion of microplastics by zooplankton in the Northeast Pacific Ocean. Arch Environ Contam Toxicol 69(3):320–330

Diepens NJ, Beltman WHJ, Koelmans AA, Van den Brink PJ, Baveco JM (2016) Dynamics and recovery of a sediment-exposed Chironomus riparius population: a modelling approach. Environ Pollut 213:741–750

Do Sul JAI, Barnes DK, Costa MF, Convey P, Costa ES, Campos LS (2011) Plastics in the Antarctic environment: are we looking only at the tip of the iceberg? Oecologia Australis 15 (1):150–170

Dris R, Gasperi J, Rocher V, Saad M, Renault N, Tassin B (2015) Microplastic contamination in an urban area: a case study in greater Paris. Environ Chem 12(5):592–599

Dris R, Gasperi J, Saad M, Mirande C, Tassin B (2016) Synthetic fibers in atmospheric fallout: a source of microplastics in the environment? Mar Pollut Bull 104(1–2):290–293

Duncan EM, Botterell ZLR, Broderick AC, Galloway TS, Lindeque PK, Nuno A, Godley BJ (2017) A global review of marine turtle entanglement in anthropogenic debris: a baseline for further action. Endanger Species Res 34:431–448

Enders K, Lenz R, Stedmon CA, Nielsen TG (2015) Abundance, size and polymer composition of marine microplastics ≥10µm in the Atlantic Ocean and their modelled vertical distribution. Mar Pollut Bull 100(1):70–81

Fossi MC, Baini M, Panti C, Baulch S (2018) Chapter 6: Impacts of marine litter on cetaceans: a focus on plastic pollution. In: Fossi MC, Panti C (eds) Marine mammal ecotoxicology. Academic Press, New York, pp 147–184

Galgani F, Hanke G, Maes T (2015) Global distribution, composition and abundance of marine litter. In: Marine anthropogenic litter. Springer, Cham, pp 29–56

Gall SC, Thompson RC (2015) The impact of debris on marine life. Mar Pollut Bull 92(1):170–179

Gigault J, Pedrono B, Maxit B, Ter Halle A (2016) Marine plastic litter: the unanalyzed nano-fraction. Environ Sci Nano 3(2):346–350

Gilardi KV, Carlson-Bremer D, June JA, Antonelis K, Broadhurst G, Cowan T (2010) Marine species mortality in derelict fishing nets in Puget Sound, WA and the cost/benefits of derelict net removal. Mar Pollut Bull 60(3):376–382

Goldstein MC, Goodwin DS (2013) Gooseneck barnacles (Lepas spp.) ingest microplastic debris in the North Pacific subtropical gyre. PeerJ 1:e184

Green DS, Boots B, Blockley DJ, Rocha C, Thompson R (2015) Impacts of discarded plastic bags on marine assemblages and ecosystem functioning. Environ Sci Technol 49(9):5380–5389

Gregory MR (2009) Environmental implications of plastic debris in marine settings—entanglement, ingestion, smothering, hangers-on, hitch-hiking and alien invasions. Philos Trans R Soc B 364(1526):2013–2025

Hall K (2000) Impacts of marine debris and oil: economic and social costs to coastal communities, Kommunenes Internasjonale Miljøorganisasjon

Hartmann NB, Hüffer T, Thompson RC, Hassellöv M, Verschoor A, Daugaard AE, Rist S, Karlsson T, Brennholt N, Cole M, Herrling MP, Hess MC, Ivleva NP, Lusher AL, Wagner M (2019) Are we speaking the same language? Recommendations for a definition and categorization framework for plastic debris. Environ Sci Technol 53(3):1039–1047

Hernandez LM, Yousefi N, Tufenkji N (2017) Are there nanoplastics in your personal care products? Environ Sci Technol Lett 4(7):280–285

Jambeck JR, Geyer R, Wilcox C, Siegler TR, Perryman M, Andrady A, Narayan R, Law KL (2015) Plastic waste inputs from land into the ocean. Science 347(6223):768–771

Jemec A, Horvat P, Kunej U, Bele M, Kržan A (2016) Uptake and effects of microplastic textile fibers on freshwater crustacean Daphnia magna. Environ Pollut 219:201–209

Kiessling T, Gutow L, Thiel M (2015) Marine litter as habitat and dispersal vector. In: Marine anthropogenic litter. Springer, Cham, pp 141–181

Kirkley J, McConnell KE (1997) Marine debris: benefits, costs, and choices. Springer, Marine Debris, pp 171–185

Koelmans AA, Besseling E, Shim WJ (2015) Nanoplastics in the aquatic environment. Critical review. In: Bergmann M, Gutow L, Klages M (eds) Marine anthropogenic litter. Springer International Publishing, Cham, pp 325–340

Kühn S, Rebolledo ELB, van Franeker JA (2015) Deleterious effects of litter on marine life. In: Marine anthropogenic litter. Springer, Cham, pp 75–116

Laist DW (1997) Impacts of marine debris: entanglement of marine life in marine debris including a comprehensive list of species with entanglement and ingestion records. Springer, Marine Debris, pp 99–139

Lam VW, Cheung WW, Reygondeau G, Sumaila UR (2016) Projected change in global fisheries revenues under climate change. Sci Rep 6:32607

Lambert S, Wagner M (2016) Characterisation of nanoplastics during the degradation of polystyrene. Chemosphere 145:265–268

Large PA, Graham NG, Hareide N-R, Misund R, Rihan DJ, Mulligan MC, Randall PJ, Peach DJ, McMullen PH, Harlay X (2009) Lost and abandoned nets in deep-water gillnet fisheries in the Northeast Atlantic: retrieval exercises and outcomes. ICES J Mar Sci 66(2):323–333

Lebreton L, Andrady A (2019) Future scenarios of global plastic waste generation and disposal. Palgrave Commun 5(1):6

Lu Y, Zhang Y, Deng Y, Jiang W, Zhao Y, Geng J, Ding L, Ren H (2016) Uptake and accumulation of polystyrene microplastics in zebrafish (Danio rerio) and toxic effects in liver. Environ Sci Technol 50(7):4054–4060

Lusher A (2015) Microplastics in the marine environment: distribution, interactions and effects. In: Marine anthropogenic litter. Springer, Cham, pp 245–307

Lusher AL, McHugh M, Thompson RC (2013) Occurrence of microplastics in the gastrointestinal tract of pelagic and demersal fish from the English Channel. Mar Pollut Bull 67(1):94–99

Lusher AL, Hernandez-Milian G, O'Brien J, Berrow S, O'Connor I, Officer R (2015a) Microplastic and macroplastic ingestion by a deep diving, oceanic cetacean: the True's beaked whale Mesoplodon mirus. Environ Pollut 199:185–191

Lusher AL, Tirelli V, O'Connor I, Officer R (2015b) Microplastics in Arctic polar waters: the first reported values of particles in surface and sub-surface samples. Sci Rep 5:14947

Marine Conservation Society (2018) 25th Great British Beach Clean 2018 Report. https://www.mcsuk.org/media/gbbc-2018-report.pdf. Accessed 25 June 2019

Mato Y, Isobe T, Takada H, Kanehiro H, Ohtake C, Kaminuma T (2001) Plastic resin pellets as a transport medium for toxic chemicals in the marine environment. Environ Sci Technol 35 (2):318–324

McIlgorm A, Campbell HF, Rule MJ (2011) The economic cost and control of marine debris damage in the Asia-Pacific region. Ocean Coast Manag 54(9):643–651

Moser ML, Lee DS (1992) A fourteen-year survey of plastic ingestion by western North Atlantic seabirds. Colon Waterbirds 15:83–94

Mouat J, Lozano RL, Bateson H (2010) Economic impacts of marine litter. Miljøorganisasjon, Kommunenes Internasjonale

Murray F, Cowie PR (2011) Plastic contamination in the decapod crustacean Nephrops norvegicus (Linnaeus, 1758). Mar Pollut Bull 62(6):1207–1217

Nadal M, Alomar C, Deudero S (2016) High levels of microplastic ingestion by the semipelagic fish Bogue Boops boops (L.) around the Balearic Islands. Environ Pollut 214:517–523

Naeem S, Chazdon R, Duffy JE, Prager C, Worm B (2016) Biodiversity and human Well-being: an essential link for sustainable development. Proc R Soc B Biol Sci 283(1844):20162091

Napper IE, Thompson RC (2016) Release of synthetic microplastic plastic fibres from domestic washing machines: effects of fabric type and washing conditions. Mar Pollut Bull 112(1):39–45

Napper IE, Bakir A, Rowland SJ, Thompson RC (2015) Characterisation, quantity and sorptive properties of microplastics extracted from cosmetics. Mar Pollut Bull 99(1):178–185

Nelms SE, Galloway TS, Godley BJ, Jarvis DS, Lindeque PK (2018) Investigating microplastic trophic transfer in marine top predators. Environ Pollut 238:999–1007

Neves D, Sobral P, Ferreira JL, Pereira T (2015) Ingestion of microplastics by commercial fish off the Portuguese coast. Mar Pollut Bull 101(1):119–126

Ng EL, Lwanga EH, Eldridge SM, Johnston P, Hu HW, Geissen V, Chen D (2018) An overview of microplastic and nanoplastic pollution in agroecosystems. Sci Total Environ 627:1377–1388

Obbard RW, Sadri S, Wong YQ, Khitun AA, Baker I, Thompson RC (2014) Global warming releases microplastic legacy frozen in Arctic Sea ice. Earth's Future 2(6):315–320

Orós J, Torrent A, Calabuig P, Déniz S (2005) Diseases and causes of mortality among sea turtles stranded in the Canary Islands, Spain (1998–2001). Dis Aquat Org 63(1):13–24

OSPAR (2009) Marine litter in the north-East Atlantic region: assessment and priorities for response. OSPAR, London, United Kingdom

Ostle C, Thompson RC, Broughton D, Gregory L, Wootton M, Johns DG (2019) The rise in ocean plastics evidenced from a 60-year time series. Nat Commun 10(1):1622

Plastic Europe (2018) The facts 2018. Plastic Europe. https://www.plasticseurope.org/application/files/6315/4510/9658/Plastics_the_facts_2018_AF_web.pdf. Accessed 25 June 2019

Rebolledo ELB, Van Franeker JA, Jansen OE, Brasseur SM (2013) Plastic ingestion by harbour seals (Phoca vitulina) in the Netherlands. Mar Pollut Bull 67(1–2):200–202

Reed S, Clark M, Thompson R, Hughes KA (2018) Microplastics in marine sediments near Rothera Research Station, Antarctica. Mar Pollut Bull 133:460–463

Ribeiro F, O'Brien JW, Galloway T, Thomas KV (2019) Accumulation and fate of nano- and micro-plastics and associated contaminants in organisms. TrAC Trends Anal Chem 111:139–147

Richards ZT, Beger M (2011) A quantification of the standing stock of macro-debris in Majuro lagoon and its effect on hard coral communities. Mar Pollut Bull 62(8):1693–1701

Rochman CM, Hoh E, Kurobe T, Teh SJ (2013) Ingested plastic transfers hazardous chemicals to fish and induces hepatic stress. Sci Rep 3:3263

Rodrigues JP, Duarte AC, Santos-Echeandía J, Rocha-Santos T (2019) Significance of interactions between microplastics and POPs in the marine environment: a critical overview. TrAC Trends Anal Chem 111:252–260

Romeo T, Pietro B, Pedà C, Consoli P, Andaloro F, Fossi MC (2015) First evidence of presence of plastic debris in stomach of large pelagic fish in the Mediterranean Sea. Mar Pollut Bull 95(1):358–361

Ryan PG (1987) The incidence and characteristics of plastic particles ingested by seabirds. Mar Environ Res 23(3):175–206

Sancho G, Puente E, Bilbao A, Gomez E, Arregi L (2003) Catch rates of monkfish (Lophius spp.) by lost tangle nets in the Cantabrian Sea (Northern Spain). Fish Res 64(2–3):129–139

Schuyler QA, Wilcox C, Townsend KA, Wedemeyer-Strombel KR, Balazs G, Van Sebille E, Hardesty BD (2016) Risk analysis reveals global hotspots for marine debris ingestion by sea turtles. Glob Chang Biol 22(2):567–576

Science Advice for Policy by European A (2019) A scientific perspective on microplastics. Nature and Society, Berlin

Secretariat of the Convention on Biological Diversity and the Scientific and Technical Advisory Panel—GEF (2012) Impacts of marine debris on biodiversity: current status and potential solutions. Montreal, Technical Series No 67:61

Steer M, Cole M, Thompson RC, Lindeque PK (2017) Microplastic ingestion in fish larvae in the western English Channel. Environ Pollut 226:250–259

Stelfox M, Hudgins J, Sweet M (2016) A review of ghost gear entanglement amongst marine mammals, reptiles and elasmobranchs. Mar Pollut Bull 111(1):6–17

Sussarellu R, Suquet M, Thomas Y, Lambert C, Fabioux C, Pernet MEJ, Le Goïc N, Quillien V, Mingant C, Epelboin Y (2016) Oyster reproduction is affected by exposure to polystyrene microplastics. Proc Natl Acad Sci 113(9):2430–2435

Tanaka K, Takada H (2016) Microplastic fragments and microbeads in digestive tracts of planktivorous fish from urban coastal waters. Sci Rep 6:34351

Ten Brink P, Lutchman I, Bassi S, Speck S, Sheavly S, Register K, Woolaway C (2009) Guidelines on the use of market-based instruments to address the problem of marine litter. Institute for European Environmental Policy (IEEP), Brussels

Teuten EL, Rowland SJ, Galloway TS, Thompson RC (2007) Potential for plastics to transport hydrophobic contaminants. Environ Sci Technol 41(22):7759–7764

Thiel M, Luna-Jorquera G, Álvarez-Varas R, Gallardo C, Hinojosa IA, Luna N, Miranda-Urbina D, Morales N, Ory N, Pacheco AS (2018) Impacts of marine plastic pollution from continental

coasts to subtropical gyres—fish, seabirds, and other vertebrates in the SE Pacific. Front Mar Sci 5(238)

Tudor DT, Williams AT (2006) A rationale for beach selection by the public on the coast of Wales, UK. Area 38(2):153–164

Unger B, Rebolledo ELB, Deaville R, Gröne A, Ijsseldijk LL, Leopold MF, Siebert U, Spitz J, Wohlsein P, Herr H (2016) Large amounts of marine debris found in sperm whales stranded along the North Sea coast in early 2016. Mar Pollut Bull 112(1):134–141

Van Cauwenberghe L, Claessens M, Vandegehuchte MB, Janssen CR (2015) Microplastics are taken up by mussels (Mytilus edulis) and lugworms (Arenicola marina) living in natural habitats. Environ Pollut 199:10–17

Van Franeker JA, Blaize C, Danielsen J, Fairclough K, Gollan J, Guse N, Hansen P-L, Heubeck M, Jensen J-K, Le Guillou G, Olsen B, Olsen K-O, Pedersen J, Stienen EWM, Turner DM (2011) Monitoring plastic ingestion by the northern fulmar Fulmarus glacialis in the North Sea. Environ Pollut 159(10):2609–2615

Vance ME, Kuiken T, Vejerano EP, McGinnis SP, Hochella MF Jr, Rejeski D, Hull MS (2015) Nanotechnology in the real world: redeveloping the nanomaterial consumer products inventory. Beilstein J Nanotechnol 6:1769–1780

Von Moos N, Burkhardt-Holm P, Köhler A (2012) Uptake and effects of microplastics on cells and tissue of the blue mussel Mytilus edulis L. after an experimental exposure. Environ Sci Technol 46(20):11327–11335

Votier SC, Archibald K, Morgan G, Morgan L (2011) The use of plastic debris as nesting material by a colonial seabird and associated entanglement mortality. Mar Pollut Bull 62(1):168–172

Werner S, Budziak A, Franeker JAV, Galgani F, Hanke G, Maes T, Matiddi M, Nilsson P, Oosterbaan L, Priestland E, Thompson R, Veiga J, Vlachogianni T (2016) Harm caused by marine litter. European Union, Luxembourg

Woodall LC, Sanchez-Vidal A, Canals M, Paterson GLJ, Coppock R, Sleight V, Calafat A, Rogers AD, Narayanaswamy BE, Thompson RC (2014) The deep sea is a major sink for microplastic debris. R Soc Open Sci 1(4):140317

Worm B, Barbier EB, Beaumont N, Duffy JE, Folke C, Halpern BS, Jackson JB, Lotze HK, Micheli F, Palumbi SR (2006) Impacts of biodiversity loss on ocean ecosystem services. Science 314(5800):787–790

Wright SL, Rowe D, Thompson RC, Galloway TS (2013a) Microplastic ingestion decreases energy reserves in marine worms. Curr Biol 23(23):R1031–R1033

Wright SL, Thompson RC, Galloway TS (2013b) The physical impacts of microplastics on marine organisms: a review. Environ Pollut 178:483–492

Wyles KJ, Pahl S, Thomas K, Thompson RC (2016) Factors that can undermine the psychological benefits of coastal environments: exploring the effect of tidal state, presence, and type of litter. Environ Behav 48(9):1095–1126

Zettler ER, Mincer TJ, Amaral-Zettler LA (2013) Life in the "plastisphere": microbial communities on plastic marine debris. Environ Sci Technol 47(13):7137–7146

Ziajahromi S, Kumar A, Neale PA, Leusch FD (2017) Impact of microplastic beads and fibers on waterflea (Ceriodaphnia dubia) survival, growth, and reproduction: implications of single and mixture exposures. Environ Sci Technol 51(22):13397–13406

The (Un)Natural History of the "Plastisphere," A New Marine Ecosystem

Erik R. Zettler and Linda A. Amaral-Zettler

Abstract The presence of a microbial biofilm on marine plastic was described in the pages of *Science Magazine* over 45 years ago in one of the very first publications reporting plastic in the ocean (Carpenter and Smith, Science 175:1240–1241, 1972). After these early reports, the microbial communities associated with plastic lost attention until about 7 years ago when modern DNA sequencing began revealing the details of this "invisible" world in finer detail. The Plastisphere, or thin layer of microbial life that surrounds plastic in aquatic environments, occurs on every one of the trillions of small pieces of plastic in the ocean. This miniature ecosystem includes primary producers using sunlight and inorganic chemicals to grow, grazers feeding on these "fields" of primary producers, predators killing and eating other cells, parasites, symbionts living together with their hosts, and degraders recycling biomass and chemicals for reuse in the system. Despite the quantities of plastic documented in the ocean, the actual impact of plastic on marine ecosystems is largely unknown. The Plastisphere could play a role in the fate and impact of plastic in our environment, including increasing the productivity of open ocean environments (Bryant et al., mSystems 1:1, 2016), generating greenhouse gases (Royer et al., Plos One 13:e0200574, 2018), influencing ingestion and settling by animals (Hadfield, Ann Rev Mar Sci 3:453, 2011; Savoca et al., Sci Adv 2:e1600395, 2016), determining how long plastic takes to break down and sink (Ye and Andrady, Mar Pollut Bull 22:608–613, 1991), and transporting invasive species including potentially harmful microbes (Zettler et al. 2013. Environ Sci Technol 47:7137–7146, 2013).

E. R. Zettler
Department of Marine Microbiology and Biogeochemistry, NIOZ Royal Netherlands Institute for Sea Research & Utrecht University, Texel, The Netherlands
e-mail: erik.zettler@nioz.nl

L. A. Amaral-Zettler (✉)
Department of Marine Microbiology and Biogeochemistry, NIOZ Royal Netherlands Institute for Sea Research & Utrecht University, Texel, The Netherlands

Department of Freshwater and Marine Ecology, Institute for Biodiversity and Ecosystem Dynamics, University of Amsterdam, Amsterdam, The Netherlands
e-mail: linda.amaral-zettler@nioz.nl

© Springer Nature Switzerland AG 2020
M. Streit-Bianchi et al. (eds.), *Mare Plasticum – The Plastic Sea*,
https://doi.org/10.1007/978-3-030-38945-1_4

We are now in the midst of a "great experiment" where massive amounts of a refractory surface substrate are being introduced into habitats where it previously never existed.

(Mincer et al., Hazardous chemicals associated with plastics in the marine environment, Springer International Publishing, Switzerland, 2016)

Keywords Plastisphere · Plastic · Microbes · Biofilms · Marine debris

1 Introduction

The Plastisphere refers to the thin layer of life on the outside of plastic debris, analogous to the biosphere, the thin coating of life on the outside of our planet (Fig. 1). Introduced in 2011 to refer to microbial life on marine plastics, use of the term "Plastisphere" has since been expanded beyond microbiology to include interactions of any organism with plastic. The concept of a new ecosystem centered on anthropogenic debris mass-produced within the last 80 years has captured the imagination of artists (e.g., https://pinaryoldas.info/Ecosystem-of-Excess-2014) and journalists (e.g., https://soundcloud.com/plastisphere-podcast) and stimulated scientific inquiry in aquatic and terrestrial fields alike. Although scientists first described microbes associated with marine plastic in 1972 (Carpenter and Smith 1972), and a few years later showcased beautiful and informative scanning electron microscopy (SEM) images (Sieburth 1975), interest in the topic languished until the first results

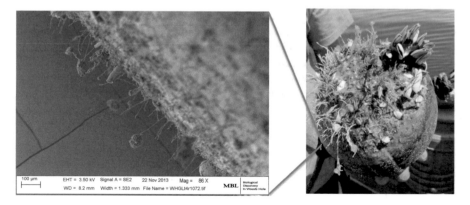

Fig. 1 The "Plastisphere" nicely illustrated by life on an expanded polystyrene foam buoy (right panel) collected between Bermuda and Woods Hole, MA, USA. The top of the buoy is the surface that was under water, and shows attached macroalgae and invertebrates including gooseneck barnacles, transitioning to smaller organisms and a microbial biofilm where the water level would have been originally. If we were to take a tiny sample of the slimy surface just below the waterline (blue lines) and observe it under a scanning electron microscope (SEM), we would see something like the image on the left, zooming in on the microscopic community on another piece of plastic, showing that even at this scale (the 100 μm bar in the lower left is 1/10 of a millimeter), there are organisms attached creating a 3D layer of life. (© E.R. Zettler 2019. All Rights Reserved)

Fig. 2 The microplastic pieces collected from a single net tow in the South Atlantic Subtropical Gyre in 2019. This particular net tow had 107 pieces, representing 80,000 per square kilometer of surface ocean. The coin is a South African 5-Rand coin for scale (26 mm or just over 1 in. in diameter). Each tiny piece of plastic in this image can have a microbial community made up of over a thousand different species. Microplastics in the ocean can thus be thought of as a fleet of tiny vessels moving around the world's ocean transporting thousands of species of trillions of microbial passengers. (plastic arrangement courtesy of Ethan Edson, © E.R. Zettler 2019. All Rights Reserved)

from modern high-throughput sequencing (Zettler et al. 2013) combined with SEM sparked renewed interest.

This study revealed the diversity of this miniature ecosystem even in the "pristine" open ocean and suggested that the huge number of plastic fragments in the world's ocean represents a new and unique microbial habitat (Fig. 2).

Two thirds of the global population live near the coast (www.oceansatlas.org/facts/en/), but the prevalence of plastic marine debris (PMD) in the ocean was not widely recognized until Charles Moore brought the message to the public, culminating with his book *"Plastic Oceans"* (Moore and Phillips 2011). Iconic images of marine animal ingestion and entanglement of larger pieces of plastic played a major role in awakening public concern to the problem of plastic pollution in the environment, but the microscopic Plastisphere has surprisingly also captured public attention, in part because of the hope that it might help ameliorate the plastic pollution problem via microbial degradation of plastic, but also the fear that it might carry unwanted "hitchhikers" including disease-causing pathogens.

Despite the tiny size of microbes, this invisible "majority" occurs in almost incomprehensible numbers: An estimated 10^{29} or one hundred octillion in seawater,

or 10^9 (one billion) bacteria for every star in the universe (Flemming and Wuertz 2019). Translated into weight, bacteria account for more biomass than any group of organisms other than plants, and over 1000 times more than the weight of all humans combined (Bar-On et al. 2018)!

2 Role of the Plastisphere

Why do we care about invisible microbes on tiny pieces of plastic we can barely see? The Plastisphere influences the fate of plastic in the ocean, including how animals perceive it (encouraging them to eat it or settle on it), whether plastic floats or sinks, the long-term breakdown of plastic, transport of non-native species, and the fact that some of the microbial "hitchhikers" may contribute to diseases in marine animals or even humans. For example, the Columbus crab (*Planes minutus*) that typically associates with the open ocean floating macroalgae *Sargassum* has adopted ghost nets and other marine debris as a new habitat (Fig. 3). With this crab and any other animal that attaches to PMD comes its "microbiome" or the collection of microbes associated with the organism; therefore not only the hosts but also their microbiome—both good and "bad" microbes—go along for the ride.

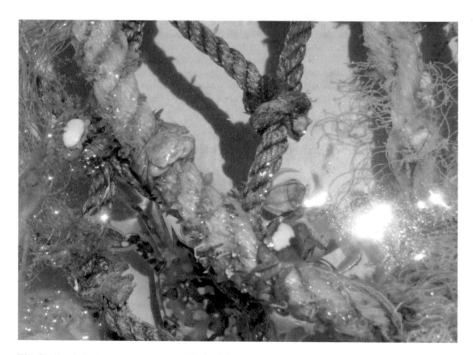

Fig. 3 Plastic in the open sea attracts life, both larger organisms like fish and smaller organisms like invertebrates and even microbes. The plastic provides a solid substrate and concentrates nutrients and food. Hitchhikers on a floating "ghost" net, abandoned in the North Atlantic Ocean: Small gooseneck barnacles (in "grooves" of rope) and Columbus crabs (*Planes minutus*), a pelagic crab often associated with the brown alga *Sargassum*. (© E.R. Zettler 2019. All Rights Reserved)

Sometimes you hear the phrase "plastic is forever"; that is not really true because eventually microorganisms break down almost any chemical compound, but it is a slow process. Plastic can therefore last a long time in the ocean. We do not really know how long because we only began producing significant quantities of plastic after 1950. Also, most pieces in the ocean are fragments we cannot identify, and it is difficult even for chemists to determine how long a piece of plastic has been exposed in the environment. However, plastic in the ocean certainly lasts decades, and in some environments could last hundreds or even thousands of years (Barnes et al. 2009). An example of a long-lived piece of marine plastic is described in Fig. 4.

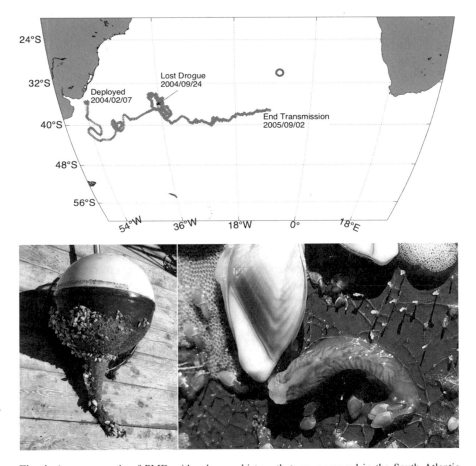

Fig. 4 A rare example of PMD with a known history that we recovered in the South Atlantic Ocean. Because it was the remains of a scientific experiment to study ocean currents using buoys outfitted with satellite trackers, we know it was launched on 7 February 2004 and where it went until the transmitter stopped working on 2 September 2005 (top panel). We recovered it at 29.87° S × 7.98° W (red circle) on 15 January 2019, so it had been drifting for almost 15 years. As you can see from the photo it had a rich Plastisphere community; zooming in we can see gooseneck barnacles, white lacelike colonies of bryozoans, small stalked hydroids sprouting from the brown surface network, and a colorful striped nudibranch or "sea slug". (© E.R. Zettler 2019. All Rights Reserved; thanks to Doug Wilson for plot of drifter buoy track)

Studying the Plastisphere

To study the Plastisphere, we use a combination of field collections, "natural" experiments exposing plastic to different environments in the ocean, and laboratory experiments under controlled conditions. We began more than 10 years ago when we wondered what kind of microbial community might exist on the pieces of plastic we were collecting in surface plankton nets in the Atlantic, and net tows continue to be a standard way to collect and quantify plastic. Surface neuston or manta nets (Fig. 5a) collect pieces from about 1/3 mm (the net mesh size) up to pieces the size of a 1 L bottle. The net is towed at the surface and skims the upper 10–20 cm of the water, collecting anything that floats. Because we know how far we tow the net and the size of the net mouth, we can calculate the number of plastic pieces per square meter (area) or cubic meter (volume). More recently we and other scientists have begun to explore other categories of plastics including those below the surface using systems with multiple nets that can be opened and closed at selected depths (Fig. 5b), pumps that filter thousands of liters of seawater deep in the ocean through fine sieves to collect particles that pass through nets (Fig. 5c), and looking for plastic particles in the sediment from the bottom of the ocean (Fig. 5d). These alternate techniques are more difficult and require developing new methods, but they allow us to investigate plastic beyond the larger pieces at the surface, and hopefully discover the location of the "missing" plastic.

The increase in this long-lived, solid substrate made up of floating particles could also change the metabolism of microbial communities, and thus the biogeochemistry of the marine areas where it is accumulating. Zobell was a microbiologist who back in the 1930s described how the metabolism of bacteria increases on surfaces relative to when the cells are suspended in a liquid medium (Zobell and Anderson 1936). This "Zobell" effect or "bottle" effect has been borne out consistently in modern studies. The addition of trillions of pieces of plastic to the ocean provides a solid substrate for the attachment of microbes and permits the formation of biofilms. The biomass on a 1 g piece of PMD can represent more carbon than is present in a 1000 L of seawater (Mincer et al. 2016), so biofilm-coated PMD represents patches of high biomass and high nutrient availability in an otherwise nutrient-limited, low biomass oligotrophic ocean. Plastic is also not just "another surface," because the microbial communities that develop on plastic are often different than those that develop on natural particles (Dussud et al. 2018) and surfaces like algae (Sieburth 1975) (Fig. 6). This means that plastic in the ocean can act as a "selective" medium, encouraging the growth of organisms that might otherwise not occur or would be rare in that environment. Furthermore, recent studies demonstrate that plastic marine debris releases greenhouse gases (CO_2 and Ethylene) that may also stimulate microbial metabolism or impact global climate scenarios (Royer et al. 2018).

Fig. 5 (**a**) Manta trawl net for collecting surface plastic; (**b**) multinet to sample at up to five different depths beneath the surface; (**c**) submersible pump and filtration unit; (**d**) sediment sample collected with a cylindrical box corer. (© E.R. Zettler 2019. All Rights Reserved)

3 Missing Plastic and the Role of Size

The Plastisphere has been studied mostly on floating pieces of plastic that accumulate on the ocean surface, consisting primarily of polyethylene (PE), polypropylene (PP), and expanded polystyrene (EPS). Much less is known about microbial communities associated with plastic pieces of neutral or negative buoyancy including polyethylene terephthalate (PET) that is used for most bottled water, polystyrene (PS), and most of the newer family of bioplastics such as polylactic acid (PLA), polyhydroxyalkanoate (PHA), and others. These sink in seawater into the intermediate layers of the ocean or all the way to the sea floor making them more challenging to study and count. We also know much more about pieces of plastic that are visible to the naked eye, in the size range of about 1 mm and larger. You may have heard discussion of the "missing plastic"; this refers to the fact that we estimate that humans release approximately ten million metric tons of plastic into the ocean each year (Jambeck et al. 2015), but when we do surveys based on what we can see at the surface, we can account for only about 1% of the plastic we think should be in the ocean (Van Sebille et al. 2015).

| 2 µm | Width = 51.24 µm | EHT = 5.00 kV | Signal A = SE2 | Date :5 Apr 2011 |
| | File Name = Sarg-seq049.tif | WD = 9.9 mm | Signal B = InLens | Mixing = Off |

Fig. 6 Bacteria and protists living on the surface of the open-ocean macroalga *Sargassum natans*. SEM image showing coccoid and rod-shaped bacteria. (© E.R. Zettler 2019. All Rights Reserved)

Theories about where the "missing" plastic is, include: On the bottom or buried in sediments having been weighed down by animals like barnacles and other shell-producing organisms (Ye and Andrady 1991); dispersed after breaking into pieces too small for us to accurately count or capture with our current net mesh sizes; and in the stomachs and fecal pellets of organisms that have ingested it. The Plastisphere community associated with the smaller pieces of plastic that are difficult to collect and study are also relatively unknown. An interesting question is the theory of island biogeography, predicting that islands or environments of different sizes have different levels of biodiversity based on rates of colonization and extinction. Plastic pieces floating in the ocean can be considered "islands" from a microbial point of view, and there is some evidence for community richness (number of species) of invertebrates associated with PMD being related to the size of the piece of plastic (Gil and Pfaller 2016). As plastic pieces become increasingly smaller, the number of organisms that can attach decreases, and at some point the plastic particle will be too small for even a microbe to attach (Fig. 7). Nevertheless, microbes can still interact with these smallest particles by engulfing them or when the particles stick to the outside of the cell (Feng et al. 2019).

Fig. 7 As PMD breaks down into micro- and nano-sized particles, eventually particles become smaller than a bacterial cell and can no longer be colonized. (© E.R. Zettler 2019. All Rights Reserved)

4 Biodiversity and Structure of the Plastisphere

Early studies relied on microscopy to describe and quantify the community. However, most microbes cannot be identified morphologically, so we did not become aware of the diversity of the Plastisphere community until we started using what is called "high-throughput" or "next-generation" sequencing. For these studies, the DNA of the entire community is extracted from the cells growing on the plastic. A specific fragment of the DNA, the gene coding for the ribosomal RNA (rRNA), is then sequenced. Because this gene is found in all living cells (including your own), but also varies between most species, we can examine the diversity of rRNA gene sequences and use that as a proxy for the diversity of microbial species. In addition, the rRNA gene sequences of thousands of organisms are available in public databases, so we can also get some idea of "who" is there and their relative abundance, allowing us to learn something about the ecology of the community. For example, when we compare the microbial profiles of samples from seawater versus those from microplastics, even those collected from the same net, we find that the communities from seawater from completely different oceans can look more similar than those collected from microplastics from the same net tow (Fig. 8).

16S rRNA V6 Amplicon-Based Bacterial Community Structure

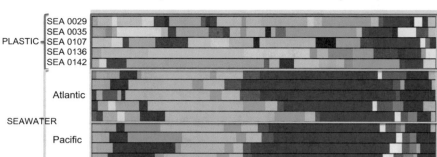

Fig. 8 Comparison of microbial communities on microplastics collected in the Atlantic accumulation zone versus microbial communities from the surrounding seawater in both the Atlantic and Pacific Ocean. Each bar represents a sample, and each color represents a different group of microbes. The width of the color segment represents the relative proportion of the total microbial population that group contributes. The top five bars are the microbial communities on different pieces of plastic, showing some shared taxa, but very different proportions. The bottom nine bars show five seawater samples from the Atlantic and four seawater samples from the Pacific. Even though the seawater samples are from very different areas, they are dominated by very similar groups of microbes. (© E.R. Zettler 2019. All Rights Reserved)

Finally, we can also sequence ALL of the DNA (or metagenome) rather than just the rRNA genes; this tells us not only who is there but gives us some sense of what they are capable of doing (Bryant et al. 2016). For instance, do we see genes that represent antibiotic resistance or the ability to degrade plastic? The most powerful approach is to combine DNA sequencing with microscope imaging of the same piece of plastic. The DNA tells us who is there and what they are capable of metabolically, but nothing about what the community looks like. The microscope images can provide information about the physical arrangement of cells on the surface of the plastic (Fig. 9): Do certain cells occur alone or in patches? Are they associated with or interspersed with other types of cells? Are there three-dimensional structures as part of the biofilm that would provide different habitats for different kinds of microbes? Do we see evidence of predation, grazing, or plastic breakdown?

Plastic in the marine environment can be thought of as a sort of microbial "reef" (Zettler et al. 2013) in that it provides hard substrate for the attachment of organisms in the open ocean, a huge portion of the planet surface that has very limited surfaces available for colonization. In the relatively unproductive waters of the open ocean, the microbial communities on plastic can represent a substantial increase in the biomass in the upper waters, and potentially impact nutrient cycling (Mincer et al. 2016). So, what are these microbes in the Plastisphere doing? Some are attached to the surface, so in intimate contact with the plastic and any chemicals associated with it. We know that some microbes can degrade some plastics (Krueger et al. 2015), and there is microscopy and molecular evidence that microbes on PMD can break down plastic (Zettler et al. 2013). Plastic can contain a number of toxic chemicals

Fig. 9 Series of micrographs zooming in on a piece of PP from the North Atlantic, showing: (**a**) cracked plastic surface with diatoms, filaments, and predatory suctorian ciliates *Ephelota* attached to surface; (**b**) greater detail of central portion of image showing single suctorian in center attached to plastic surface; (**c**) close-up showing the bare suctorian stalk while the "bell" is covered with epibiont bacteria demonstrating a close association between a bacteria and protist in the Plastisphere. (© E.R. Zettler 2019. All Rights Reserved)

including persistent organic pollutants (POPs). Some are left over from the manufacturing process, and others transfer from seawater to the plastic, which can act like a sponge to absorb lipophilic compounds like DDT (Dichlorodiphenyltrichloroethane) and PCBs (polychlorinated biphenyls) that accumulate in fats. Microbes are metabolically very diverse, and some can degrade some of these POPs (T. Zacharia 2019) over time, but that is certainly not a solution to plastic contamination in the ocean.

Microbes Are Not the Solution to Plastic in the Ocean

Plastic "eating" microbes will not solve the problem of plastic accumulation in the environment. We are often asked whether we are trying to discover or develop microbes that metabolize or "eat" plastic. Microbes do have a very broad range of metabolic capacity, and plastic does represent a source of carbon for organisms that may be able to break it down. We and others have found evidence that microbes are contributing to plastic degradation in the ocean, including microbial cells embedded in "pits" in the plastic surface that they apparently created and DNA evidence that there are genes for breaking down hydrocarbons like plastic. In addition, there are recent studies showing that some bacteria can degrade some kinds of plastic in laboratory settings. However, these processes in the ocean are VERY slow because the temperatures and nutrient concentrations are generally much lower than in commercial composting systems. In our opinion, microbial degradation is an important consideration for the breakdown of certain plastics in commercial settings, but it will never keep up with the input of plastic into the ocean. The only way we will eliminate plastic in the ocean is to stop putting it there. Then, over decades and centuries, the microbes will slowly degrade the plastic that is already there.

5 Ingestion and Microbes

The more scientists search, the more we realize that many animals at all levels of the food web are eating plastic. Some are non-discriminate feeders that eat anything they filter from the seawater, but many choose their food the same way we do, based on visual and chemosensory cues: Does it look like food? Does it smell like food? Does it taste like food? Even some of the discriminating animals are eating plastic, suggesting that perhaps plastic can mimic food items. If you have ever picked up a piece of plastic that has been immersed in marine or fresh water, you may have noticed that it feels slimy and has a distinct smell, almost like the smell of fish. That sliminess and smell is due to the Plastisphere organisms and the biofilm they produce. A biofilm is composed of the microbial cells themselves, as well as the EPS (extracellular polymeric substances; a slimy mix of things excreted from or leaking out of cells, including polysaccharides, proteins, lipids, and other chemicals) that changes the surface characteristics of the plastic. A biofilm provides chemical cues that have been shown to encourage the settlement of invertebrate larvae (Hadfield 2011). In addition, it makes plastic smell and taste like food (Fig. 10). There is some evidence to support this from studies with seabirds where the chemical signal produced by diatoms (a type of photosynthetic microbe that is very common

Fig. 10 Larger pieces of PMD often show evidence of bite marks. This example shows triangular bite marks on a sheet of plastic from the South Atlantic covered with biofilm; inset shows the mouth of a porcupine fish that was caught in the same area. The shape of the "beak" of the porcupine fish is very similar to the bite marks. (© E.R. Zettler 2019. All Rights Reserved)

on PMD) can serve as an olfactory feeding cue to marine birds (Savoca et al. 2016) and fishes (Savoca et al. 2017).

Another concern often voiced both in the media and in scientific publications is the potential for microbes on plastic to harm marine animals or even humans by causing diseases. Harmful algal blooms (HABs, such as "red tides" as they are commonly referred to) are caused by photosynthetic protists, or single-celled algae that produce toxins that can build up in shellfish and fin-fish. When other organisms such as marine mammals or humans eat these contaminated animals, the accumulated toxin can cause illness or death, for instance due to "Paralytic Shellfish Poisoning." The types of algae that cause HABs have been shown to attach to plastic in the Mediterranean (Masó et al. 2003, 2016). In addition, a number of studies have reported bacteria of the genus *Vibrio* on plastic (Curren and Leong 2019; Kirstein et al. 2016; Schmidt et al. 2014; Zettler et al. 2013), sometimes in quite high concentrations (De Tender et al. 2017; Zettler et al. 2013). Vibrios are common bacteria endemic to the marine environment, and most are harmless, but a subset of *Vibrio* species can cause diseases in marine animals and constitute a serious problem for aquaculture facilities. Some *Vibrio* species can also cause diseases in humans, ranging from intestinal disturbances to more serious problems (Cholera is caused by a type of *Vibrio*). It should be stressed that there has been no confirmation that any of the *Vibrio* or other microbes described from marine plastic can cause disease, but different *Vibrio* species can be isolated from marine plastic than from natural substrates such as seaweeds (Fig. 11), so this is certainly a topic worthy of further study. For example, plastic has been shown to increase the risk of disease in reef corals in a large study in the Pacific (Lamb et al. 2018), where contact with plastic increased the likelihood of disease in corals from 4% to 89%.

Fig. 11 Culture and isolation of bacteria from PMD. There are differences between microbes that grow on plastic compared to other solid surfaces in the ocean. The left image shows different kinds of bacterial colonies growing on two Petri plates that were rubbed with samples from the same net tow; top plate was rubbed with the brown macroalga *Sargassum* vs. bottom plate was rubbed with plastic. The middle image shows a test tube with a single kind of *Vibrio* bacteria that was isolated from one of the PMD samples, growing on HDPE plastic beads. The far-right image is an SEM image showing individual *Vibrio* bacteria cells attached to the plastic bead after only 6 h of growth. (© E.R. Zettler 2019. All Rights Reserved)

Most microbes on plastic are not harmful except perhaps to other residents of the Plastisphere. The community varies with geographic region (Amaral-Zettler et al. 2015) and with season (Oberbeckmann et al. 2016), but there are certain "core" members of the community that are commonly found, including some of the predatory microanimals and protists (Fig. 12).

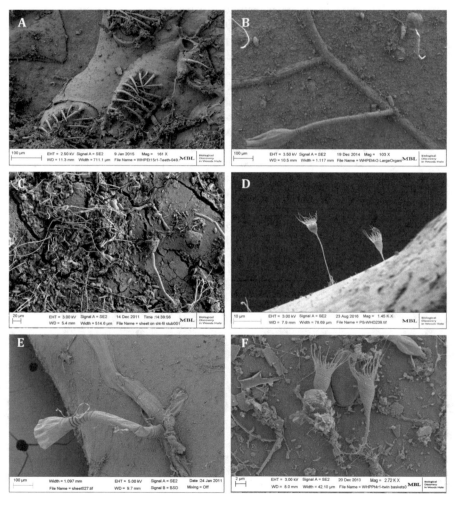

Fig. 12 Examples of some of the miniature predators attached to the Plastisphere: colonial animals bryozoans (**a**) and hydroids (**b**, **e**), and protistan ciliates like the suctorian *Ephelota* (**c**) and choanoflagellates and other organisms extending from surface of plastic (**d**, **f**), demonstrating the 3D nature of the Plastisphere. (© E.R. Zettler 2019. All Rights Reserved)

6 Conclusions and Reflection

The introduction of huge numbers of plastic particles into the world ocean over the last 70 years represents a novel habitat for microscopic marine life. These particles are colonized within hours leading to a succession of different species over time, as well as ingestion by animals that think they are food. These plastic "islands" can be selective, supporting the growth of distinct communities, and long-lived compared to other "natural" substrates like seaweed, wood, and feathers. So PMD is not just like any other floating substrate in the ocean because it persists much longer than biologically derived ones, allowing the Plastisphere community and associated "hitchhikers" to travel long distances across entire ocean basins. While plastic is a product of the Anthropocene, microbial life has existed for the better part of Earth's 4.5 billion year-old history and can readily adapt to our changing environment—so microbes will be around long after other life forms have gone extinct. The rising awareness of plastic in the ocean was popularized by the visible traces of pollution that has been commonplace in coastal environments and now ever-present as "plastic soup" in our open ocean far from human reach. The Plastisphere has put us in touch with the "invisible" life that now calls a by-product of marine pollution "home," but what we have studied thus far is less than 1% of plastic we estimate actually exists in the ocean. Bringing the "invisible" into the limelight is an important first step in this "great experiment" we have begun, moving us beyond the age of discovery to the important next stages of research that will explore the function of the Plastisphere and how it impacts marine ecosystems, to guide future scientific inquiry and policy decisions.

References

Amaral-Zettler LA, Zettler ER, Slikas B et al (2015) The biogeography of the Plastisphere: implications for policy. Front Ecol Environ 13:541–546

Barnes DKA, Galgani F, Thompson RC, Barlaz M (2009) Accumulation and fragmentation of plastic debris in global environments. Philos Trans R Soc B 364:1985–1998

Bar-On YM, Phillips R, Milo R (2018) The biomass distribution on Earth. Proc Natl Acad Sci U S A 115:6506–6511

Bryant JA, Clemente TM, Viviani DA et al (2016) Diversity and activity of communities inhabiting plastic debris in the North Pacific Gyre. mSystems 1:1. https://doi.org/10.1128/mSystems.00024-16

Carpenter EJ, Smith KL (1972) Plastics on the Sargasso Sea surface. Science 175:1240–1241

Curren E, Leong SCY (2019) Profiles of bacterial assemblages from microplastics of tropical coastal environments. Sci Total Environ 655:313–320

De Tender C, Schlundt C, Devriese LI et al (2017) A review of microscopy and comparative molecular-based methods to characterize "Plastisphere" communities. Anal Methods 9:2132–2143

Dussud C, Meistertzheim AL, Conan P et al (2018) Evidence of niche partitioning among bacteria living on plastics, organic particles and surrounding seawaters. Environ Pollut 236:807–816

Feng L-J, Li J-W, Xu EG et al (2019) Short-term exposure to positively charged polystyrene nanoparticles causes oxidative stress and membrane destruction in cyanobacteria. Environ Sci: Nano 6:3072. https://doi.org/10.1039/c9en00807a

Flemming HC, Wuertz S (2019) Bacteria and archaea on Earth and their abundance in biofilms. Nat Rev Microbiol 17:247. https://doi.org/10.1038/s41579-019-0158-9

Gil MA, Pfaller JB (2016) Oceanic barnacles act as foundation species on plastic debris: implications for marine dispersal. Sci Rep 6:19987

Hadfield MG (2011) Biofilms and marine invertebrate larvae: what bacteria produce that larvae use to choose settlement sites. Annu Rev Mar Sci 3:453–470

Jambeck JR, Geyer R, Wilcox C et al (2015) Plastic waste inputs from land into the ocean. Science 347:768–771

Kirstein IV, Kirmizi S, Wichels A et al (2016) Dangerous hitchhikers? Evidence for potentially pathogenic *Vibrio* spp. on microplastic particles. Mar Environ Res 120:1–8

Krueger MC, Harms H, Schlosser D (2015) Prospects for microbiological solutions to environmental pollution with plastics. Appl Microbiol Biotechnol 99:8857–8874

Lamb JB, Willis BL, Fiorenza EA et al (2018) Plastic waste associated with disease on coral reefs. Science 359:460–462

Masó M, Garcés E, Pagès F, Camp J (2003) Drifting plastic debris as a potential vector for dispersing harmful algal bloom (HAB) species. Sci Mar (Barc) 67:107–111

Masó M, Fortuño JM, De Juan S, Demestre M (2016) Microfouling communities from pelagic and benthic marine plastic debris sampled across Mediterranean coastal waters. Sci Mar 80:117–127

Mincer TJ, Zettler ER, Amaral-Zettler LA (2016) Biofilms on plastic debris and their influence on marine nutrient cycling, productivity, and hazardous chemical mobility. In: Takada H, Karapanagioti HK (eds) Hazardous chemicals associated with plastics in the marine environment. Springer International Publishing, Switzerland, pp 221–233

Moore C, Phillips C (2011) Plastic ocean. New York: Penguin. ISBN 9781101517789

Oberbeckmann S, Osborn AM, Duhaime MB (2016) Microbes on a bottle: substrate, season and geography influence community composition of microbes colonizing marine plastic debris. PLoS One 11:e0159289. https://doi.org/10.1371/journal.pone.0159289

Royer SJ, Ferron S, Wilson ST, Karl DM (2018) Production of methane and ethylene from plastic in the environment. PLoS One 13:e0200574

Savoca MS, Wohlfeil ME, Ebeler SE, Nevitt GA (2016) Marine plastic debris emits a keystone infochemical for olfactory foraging seabirds. Sci Adv 2:e1600395

Savoca MS, Tyson CW, McGill M, Slager CJ (2017) Odours from marine plastic debris induce food search behaviours in a forage fish. Proc Biol Sci 284:20171000. https://doi.org/10.1098/rspb.2017.1000

Schmidt VT, Reveillaud J, Zettler E et al (2014) Oligotyping reveals community level habitat selection within the genus *Vibrio*. Front Microbiol 5:563

Sieburth JM (1975) Microbial seascapes: a pictorial essay on marine microorganisms and their environments. University Park Press, Baltimore, Maryland

van Sebille E, Wilcox C, Lebreton L et al (2015) A global inventory of small floating plastic debris. Environ Res Lett 10:124006

Ye S, Andrady AL (1991) Fouling of floating plastic debris under Biscayne Bay exposure conditions. Mar Pollut Bull 22:608–613

Zacharia JT (2019) Degradation pathways of persistent organic pollutants (POPs) in the environment. IntechOpen. https://doi.org/10.5772/intechopen.79645

Zettler ER, Mincer TJ, Amaral-Zettler LA (2013) Life in the "plastisphere": microbial communities on plastic marine debris. Environ Sci Technol 47:7137–7146

Zobell CE, Anderson DQ (1936) Observations on the multiplication of bacteria in different volumes of stored water and the influence of oxygen tension and solid surfaces. Biol Bull 71:324–342

Polarquest 2018 Expedition: Plastic Debris at 82°07' North

Stefano Aliani, Gianluca Casagrande, Paola Catapano, and Valeria Catapano

Abstract Many human perturbations have the potential of destabilizing the present functioning of the environment and marine plastic is one of them. Plastic debris was found everywhere on Earth, including polar waters. The Polarquest 2018 expedition around Svalbard (July and August 2018) used sustainable sail vessel *Nanuq* as a platform to sample microplastic in seawater and macro debris stranded on beaches.

Eight stations were sampled trawling a Manta net in the top 50 cm of surface water and four stations filtering surface seawater from buckets. A record-breaking Manta net sample was carried out on the edge of the North Pole ice shelf at a latitude of 82°07' N. Flying drones made visual observations of debris on beaches of Alpiniøya island (North-East Svalbard) with ground truth by human visual sightings.

Citizen science cruises in the Arctic are likely to increase in the next years due to ice-free ocean parallel to growing interest in plastic in the ocean. The number of clean-ups and microplastic surveys are likely to increase as well and Polarquest 2018 was the first expedition of this kind to reach and sample beyond 82° N.

Keywords Arctic · Microplastic · Marine environment · North Pole · Polar ice shelf · Polar drones · 82nd parallel North · Svalbard

S. Aliani (✉) · V. Catapano
ISMAR Institute of Marine Science, CNR National Research Council, La Spezia, Italy
e-mail: stefano.aliani@sp.ismar.cnr.it; v.catapano@campus.unimib.it

G. Casagrande
Università Europea Roma, Geographic Research and Application Laboratory (GREAL), Rome, Italy
e-mail: Gianluca.Casagrande@unier.it

P. Catapano
CERN—European Organization for Nuclear Research, Geneva, Switzerland
e-mail: Paola.Catapano@cern.ch

© Springer Nature Switzerland AG 2020
M. Streit-Bianchi et al. (eds.), *Mare Plasticum – The Plastic Sea*,
https://doi.org/10.1007/978-3-030-38945-1_5

1 Introduction

"The barrenness of the country and the severe weather conditions had attached to North East Land a peculiarly evil reputation, increased by the disappearance of Schroeder Stranz and three other members of the German Arctic Expedition in 1913, and by the Nobile disaster of 1928".

 R. A. Glen, *Under the Pole Star.*

It is hard to imagine anything more remote and wilder than the Svalbard islands. The surrounding waters are uncharted and it takes some luck to set foot on Svalbard's northernmost islands: the weather is often bad, or the shore is blocked by ice or the beach is occupied by a polar bear or you can run onto an uncharted rock... It is amazing how many things can go wrong in these remote places.

For many years and well into the 1990s, it would have been impossible to sail this route especially with a 60-foot (18.2 m) yacht, closed off as it was by dense drift ice for most of the year. Reaching the 82nd parallel on a sailboat and completing the circumnavigation of Svalbard archipelago around the ill-famed East coast of Nordaustlandet, was not just the work of the Arctic expertise, sailing ability and exploration talent of skipper and yacht builder Peter Gallinelli. Polarquest 2018 could sail to as high as 82°07' N, less than 900 km from the North Pole because the ocean was completely ice-free. Of course, 2018 has been an exceptionally warm year compared to the past and short-term fluctuations have been known since navigation in these waters started. But the exceptionally ice-free summer of 2018 is more likely not to remain an exception (Fig. 1).

Fig. 1 Image of summer 2018 ice cover in the Arctic region superimposed to average data from 1981 to 2010 (red line) (Image from NASA https://svs.gsfc.nasa.gov/4684)

The Polarquest 2018 expedition programme included historical exploration, cosmic rays measurements, drone mapping of uncharted land territories and plastic debris sampling.

Historical documents and the chronicles of survivors show that on May 25, 1928, the airship *Italia* crashed on ice. *Italia* was the very first airborne scientific laboratory flying over the North Pole, led by Air Force General and airship engineer Umberto Nobile in 1928, and crashed onto ice some 120 km Northeast of Nordaustlandet, Svalbard, on its return journey from the first airborne circling of the North Pole. The survivors radioed the coordinates (81°14' N, 25°25' E) and eight of them were rescued after an unprecedented international rescue expedition effort. In summer 2018, the sea surface North of Svalbard was ice-free and taking advantage of this unusual situation, Polarquest 2018 echo-surveyed the sea bottom for metallic wreckage using an experimental 3D multi-beam sonar from *NORBIT Subsea* (a case study will be soon published on https://norbit.com/subsea/case-studies/).

Cosmic ray showers have been measured using a muon detector built in collaboration with *CERN (European Organization for Nuclear Research)* by high school students supervised by scientists. The project had a strong education and communication dimension, with the involvement of 18-year-old students from Norway, Switzerland and Italy. The detector onboard *Nanuq* took data almost continuously, integrating at the end about 861 h of data with a global efficiency of about 91% and the saturation of the cosmic ray flux at ground level has also been measured in these extreme regions near the North Pole.

The presence of microplastic debris on the ocean surface and macro debris stranded on beaches in the Northern and North-Eastern regions of the Svalbard archipelago, very rarely accessible due to sea ice, have been assessed. Floating microplastics were sampled filtering seawater and the presence of macro debris on beaches was checked by sightings and by visible, infrared and near-infrared surveying performed with commercial drones.

1.1 Marine Litter in the Ocean and a Change in Public Awareness

The plastic itself is not intrinsically bad and it is conceivable that our dependence on it will still grow in the second part of the current century, given its durability, among other unique features. To understand the root of the plastic crisis today, it is worth dwelling a little on this exceptional material and the features that make it at the same time so unique.

Plastic makes up the largest quantity of the non-biodegradable human-produced material on Earth and has become a huge environmental concern. Because of its longevity, it can travel over great distances from its origin with sea currents and accumulate in remote places such as the Poles, a crucial area for the balance of our planet's sustainable future. Once in the ocean, physical and biological processes

cause plastic debris to break down into microplastics, i.e. smaller than a few millimetres, which are difficult to remove from the ocean.

"Plastic" is a common way to describe polymers we are familiar with. They are usually artificially produced from petroleum or natural gas and are long-chain molecules made of hundreds to thousands of links of single portions called monomers. Important physical properties such as strength and toughness, which short molecules simply cannot match, are the result of long-chain polymers. These peculiar durability properties are greatly appreciated in products but become a problem when dealing with waste management. As a result, improperly managed plastic waste is lost in the environment and as its ultimate destiny it ends up in the ocean, even if released thousands of kilometres far from the coast (Lebreton et al. 2017).

Many other human perturbations have the potential of destabilizing the normal functioning of the environment, and, if these perturbations are global, pervasive, widespread, abundant and persistent, they are accounted for global change Planetary Boundaries (Galloway and Lewis 2016). Nine planetary processes have been identified whose changes can drive the Earth system into a new state (Will et al. 2015), affecting basic functioning processes all over the planet. The most critical at present are climate change, biodiversity loss, nitrogen and phosphorus cycles, ocean acidification, land use, freshwater, ozone depletion, atmospheric aerosols and chemical pollution. The latter also includes a new category of pollutants: marine debris.

Floating litter in the oceans of the Earth has for a long time been considered a natural phenomenon and not necessarily as harmful pollution.

As late as 1974, Willard Bascom, a mining engineer turned oceanographer and at the time director of the *Southern California Coastal Water Research Project*, wrote in a *Scientific American* article (Bascom 1974) that:

"Contrary to some widely held views, the oceans are the plausible place for man to dispose of some of his wastes. If the process is thoughtfully controlled, it will do no damage to marine life".

In the same article, Bascom goes as far as stating that:

"Man must do something with his wastes, and the ocean is a logical place for some of them. Littering is an aesthetic problem rather than an ecological one."

He argued that most of the substances that are called pollutants are already present in the ocean in vast quantities: sediments, salts, dissolved metals and all kinds of organic material. According to Bascom, the ocean can tolerate more of them; the question is how much more it can tolerate without damage. Such a statement certainly sounds preposterous today, but at the time, when the world population was almost half of today's, positions like Bascom's were respected enough to deserve publishing on *Scientific American* and surely shared by most (Fergusson 1974). Although not by everyone.

Already in 1962, Rachel Carson had laid the foundations of the contemporary environmental movement with her seminal book *"Silent Spring"*, in which she describes the damage of DDT to all natural systems and to human health (Worm

2015). Carson, a born ecologist and a passionate marine biologist, had become internationally famous in 1951 with her bestseller *"The Sea Around Us"*, for which she is remembered as the finest nature writer of the twentieth century, combining as she did scientific concern for the environment and human health with a sense of wonder for nature. This classic biography of the sea, still relevant today, was completed by two more science popularization chefs-d'œuvre, *"Under The Sea"* and *"The Edge of The Sea"*. With her trilogy of the sea, Carson pioneered an environmental ethic leading to sustainability and anticipated the dangers of human impact on the sea as a threat to life itself. In the preface to the 1961 edition of *"The Sea Around Us"* she wrote:

> "By its very vastness and its seeming remoteness, the sea has invited the attention of those who have the problem of disposal, and with very little discussion and almost no public notice, at least until the late fifties, the sea has been selected as a "natural" burying place for . . . rubbish and other low-level wastes. . ."

Rachel Carson spent most of her life engaging citizens from all walks of life with her sense of wonder for the beauty of the sea, making them aware at the same time of the dangers of reckless consumption of resources and the wastes they generate. Unfortunately, also Bascom's position, typical of the first ages of plastic, has had many supporters and a proper estimate of the dimensions of the problem is quite recent after the sea has become the largest waste disposal in the world. This is especially true for marine litter and plastics.

According to the widely accepted definition proposed by *UNEP* (*The United Nations Environment Programme*) and also adopted by the European Commission, marine litter is defined as "any persistent, manufactured or processed solid material discarded, disposed of, or abandoned in the marine and coastal environment". Litter consists of items that have been made or used by people and have been deliberately discarded or unintentionally lost in the sea or on beaches, including materials transported from land into the marine environment by rivers, run-offs, sewage systems or winds.

Today, we are all very familiar with floating macroscopic litter in the sea. Litter has become a common element of our beaches and coasts' landscapes and everyone has the direct experience of personal sightings of marine plastic debris. Synthetic polymers have joined the family of natural litter and the quantity of plastic in the sea largely outnumbers natural detritus such as wood, weeds and pumice. Plastic production has seen exponential growth since its entrance on the consumer stage, rising from a million tons in 1945 to about 350 million tons in 2017 (*Plastic Europe* 2018), an 8% Compound Annual Growth Rate (CAGR). The trend is increasing with an annual growth rate of 3.5% and more plastic was produced in the twenty-first century so far than in the whole twentieth century (Geyer et al. 2017).

Current estimates of floating marine debris in the ocean report millions of metric tons and we are now aware that considerable quantities of plastics contaminate the marine environment (Cózar et al. 2017; Jambeck et al. 2015). This pervasive and persistent pollutant is widely dispersed and its occurrence has been demonstrated worldwide, from densely populated areas to remote regions.

At first, the possibility of plastic accumulation at polar latitudes has been overlooked because of the lack of nearby pollution sources. For example, Jambeck and co-workers used estimates of coastal population densities to calculate plastic inputs into the ocean with impressive results. But the number of persons living near the coastline normalized by the marine surface area was extremely low for the Arctic Ocean, out of the range estimated for the rest of the world's ocean basins. While subtropical ocean gyres have been recognized as major marine accumulation zones of floating plastic debris and a lot of scientific and public interest arose on these accumulation areas, the possibility of large plastic accumulation at polar latitudes has been initially overlooked because of the lack of nearby pollution sources.

Nowadays, there are some clues that densities may be relevant in the Arctic as well (Cózar et al. 2017) and modelling experiments suggest that there is a possibility that a future sixth gyre of accumulation may develop in the Barents Sea (Van Sebille et al. 2012).

1.2 The Arctic Today and How Marine Debris Gets There

The Arctic Ocean has been an integral part of the Earth's history for the past 130 million years and contributes substantially to the current functioning of the planet and life as we know it. It is a closed basin, connected to the Pacific Ocean by the Bering Strait, to the Atlantic Ocean by the Fram Straits and the Barents Sea and through the Canadian Arctic Archipelago of the Baffin Bay. It has an area of about 15,558,000 km^2 and a total volume of 18,750,000 km^3, which represents 4.3% of the total area of the world oceans and 1.4% of the volume (Amante and Eakins 2015). This difference is because the continental shelf is about 70% of the Arctic Ocean: along the American side it is about 50–90 km wide, and on the Siberian side it is over 800 km. Apart from the central part of the basin, water depth is usually low and ranges from 20–60 m in the Chukchi Sea and probably in Siberia, to 10–40 m in the Laptev Sea, 100 m in the Kara Sea and 100–350 m in the Barents Sea. Many rivers flow into the Arctic, lowering salinity and greatly influencing the properties of its surface waters.

Floating marine debris is advected by surface currents and by winds; therefore the knowledge of surface water dynamic patterns is mandatory to understand how plastic debris arrives in the Arctic and how it leaves the Arctic.

The surface circulation within the Arctic basin has two main currents: the Transpolar Drift from the East Siberian continental shelf to East Greenland through the North Pole and the vortex of Beaufort (Beaufort Gyre) which, looking from the North Pole, usually turns clockwise in the Beaufort Sea, in the North of Alaska. The water trapped in the Beaufort Gyre can circulate the Arctic for many years while if it is trapped in the Transpolar Drift usually leaves the Arctic quickly, on average a couple of years.

The only passage between the Arctic and the Pacific is the Bering Strait, ~85 km wide and ~55 m deep. Although the total volume exchange is not very high if

compared to deeper passages, Pacific waters have been regularly detected in the Atlantic due to their peculiarly high phosphate concentration relative to nitrite (Jones 2001).

The existence of Arctic pathways between the two oceans was also demonstrated by the floating plastic duck toys lost in the Pacific by container ship *Ever Laurel* on 10 January 1992 on its route from Hong Kong to Tacoma. Once a number of these plastic ducks were found stranded all over the Pacific, the oceanographers Curtis Ebbesmeyer and James Ingraham predicted that after 6 years some would be found in the Atlantic as well (Ebbesmeyer and Ingraham 1994). Media gave a lot of attention to the lost plastic ducks and the public was involved in their search along the US and UK coasts as one of the first examples of citizen science applied to plastic debris.

The exchanges of the Arctic to and from the Atlantic are more complex as they don't take place across a single gateway but involve different water basins and passages (Beszczynska-Möller et al. 2011).

The Central Arctic Basin exports water to the North West Atlantic through the famous North West Passage across the Canadian Archipelago and the Labrador Sea between Canada and Greenland. These basins have complex ocean dynamics and are the final passages to the Atlantic. Inputs of surface Atlantic waters through this passage are reported and a westward branch of warm waters can recirculate in a gyre within the Labrador Sea where there are evidences of plastic pollution in seabirds (O'Hanlon et al. 2017; Provencher et al. 2015; Avery-Gomm et al. 2018; McWilliams et al. 2018) and on the shore (McWilliams et al. 2018).

The major surface outputs from the Arctic are on the western side of the Fram strait along the East Greenland coast, as a southward virtual continuation of the Transpolar Drift, which brings ice and cold water to the East Coast of North America. Information on the presence of marine debris along this entire pathway come from spotted records (Morgana et al. 2018). Another output of Arctic waters is in the Barents Sea along the Eastern coast of Svalbard.

Major inputs to the Arctic Ocean come from along the Eastern side of the Fram strait and through the Central and Eastern parts of the Barents Sea. The northernmost vein of the warm surface water originated in the tropical Atlantic, which had flown along the heavily industrialized Western European Coasts, enters the Arctic basin in two separate branches: one directed northward to Svalbard and another directed eastward through the Barents Sea.

There are a lot of papers about the circulation in the Arctic, especially in surface waters, and descriptions more detailed than what is reported here can be found in literature (Woodgate 2013; Beszczynska-Möller et al. 2011; Jones 2001; Østerhus et al. 2019; Rudels 1995). Figure 2 provides a graphical representation (Stiansen et al. 2009; Rudels 1995).

Recently, there have been signs of changes in the Arctic suggesting that the planet's near future may be different from the present and the recent past. For example, satellite data show that the summer ice cover keeps decreasing to the lowest levels since the beginning of instrumental surveying. In September 2018, the sea ice extent, that is, the integral sum of the areas of all satellite grid cells with at

Fig. 2 Schematic map of surface currents in the Arctic region reconstruction from *AMAP* and National Snow and Ice Data centre websites, Arneberg et al. (2009); Rudels (1995)

least 15% ice concentration, dramatically decreased. 2018 effectively tied with 2008 and 2010 as the sixth lowest summertime minimum extent in satellite record (https:// svs.gsfc.nasa.gov/4684; see Fig. 1). Many scientists now predict an ice-free Arctic within a few decades, much earlier than anticipated by previous *IPCC* (*Intergovernmental Panel on Climate Change*) predictions.

Invasive species, biodiversity loss at low and high trophic levels, acidification and new pollutants including marine litter have been reported in many areas of this basin.

The environmental and social implications are enormous because these changes, which are appearing faster than expected, catch many largely unprepared. Marine litter is one of the drivers of changes in the Arctic.

1.3 History of Plastic Studies in the Arctic

Some of the world's first observations about plastics at sea and its consequences for marine life were made in the North Pacific and Alaska (Fowler 1987; Laist 1987, 2011; Merrell 1980, 1984; Day 1980; Threlfall 1968).

The European Arctic counterpart did not receive comparable attention in the past, but more recently a high number of studies on marine litter in the European Arctic have been published focusing on the presence of marine plastics in the ocean, in the fauna, especially birds, and the consequences for the environment (Buhl-Mortensen and Buhl-Mortensen 2017; Hallanger and Gabrielsen 2018; Trevail et al. 2015a; Bergmann et al. 2016, 2017; Bergmann and Klages 2012). Dedicated working groups within the Arctic Council are now focusing on marine plastic. A panarctic review paper is under preparation under the coordination of *AMAP* (*Arctic Monitoring and Assessment Programme*) and *PAME* (*Protection of the Arctic Marine Environment Working Group*) and many Governments of Arctic states are now putting forward regional action plans for management and mitigation actions to reduce this pollution in the Arctic. An updated list of papers on plastic in the Arctic is reported in a recent desktop study (PAME 2019).

In the Fram strait and in the Barents Sea, plastic debris has been studied during an *AWI* (*Alfred Wegener Institute*) *Polarstern* expedition (Bergmann et al. 2016). They used visual sightings from the ship and helicopters to spot floating marine litter. Surface and subsurface microplastic was reported from the Fram strait and along the path from Europe to the Arctic in the warm Atlantic surface current (Lusher et al. 2015). Plastic was also found in the sediments at the deep sea Hausgarten observatory in the Fram Strait (Bergmann and Klages 2012; Bergmann et al. 2016). Compared to the water column, sea ice and deep-sea sediments have microplastic concentrations that are several orders of magnitude higher.

Entanglement and ingestion of plastic by marine animals has been reported for hundreds of species (Laist 1987, 2011) all over the Arctic. Seabirds are a particularly good indicator or sentinel species for marine plastics because birds can forage over large areas, essentially sampling for plastics over their entire living range (OSPAR 2016; Franeker et al. 2011; Jambeck et al. 2015). Additionally, many seabirds breed in colonies that are relatively easy to access for study purposes (Piatt et al. 2007; Provencher et al. 2019). The impact of plastic on seabirds is still uncertain, but may include chemical exposure (Carpenter and Smith 1972; Ryan 1987; Mato et al. 2001) and is pervasive and global (Wilcox et al. 2015). Other animals that suffer from entanglements are seals, polar bears and reindeers with many pictures on the web showing these species dealing with plastic macro debris.

Recent analyses of four ice cores collected across the Arctic Circle pointed out a considerable abundance of microplastics in the sea ice (Obbard et al. 2014). Annual sea ice is formed when the ocean surface freezes because of low air temperature. Nearly fresh water ice crystals are produced from saltier seawater, and thicken primarily by downward growth through a process called accretion. In the initial stages, small (<1 mm) ice crystals called frazil ice gather at the surface, aggregate,

and grow. As they do, they tend to scavenge particulates in the water column, including floating microplastic that is then trapped and advected in ice.

A variable portion of this annual ice becomes multiannual, i.e. the quasi-permanent sea ice in the Arctic, and plastic therein is therefore the result of many years of plastic sequestration. Unfortunately, global warming has increased ice melting and we expect to have a massive reduction in sea ice cover in the next years, with consequent release of the microplastic trapped in the melting ice (Obbard et al. 2014). Peeken et al. (2018) found several orders of magnitude higher concentrations of microplastic in the sea ice than in sea water. Particularly abundant were the small particles (11 μm), which are a major concern as they can be more easily taken up within the lower levels of the food web.

The possibility that plastic pollution affects the Arctic food web is worthy of further consideration. Plastic ingestion in northern fulmars (*Fulmarus glacialis*) from the Svalbard Islands, between the Greenland and Barents Seas, has already been reported to exceed the recommendations for an acceptable ecological status (Trevail et al. 2015b). The growing level of human activity in an increasingly warm and ice-free Arctic, with wider open areas available for the spread of microplastics, suggests that high loads of marine plastic pollution may become prevalent in the Arctic in the future.

1.4 Sources of Plastic in the Arctic: Long Distance vs. Local

Although human population North of 60° latitude is relatively low, ocean circulation models predict a plastic accumulation zone within the Arctic Polar Circle, especially in the Barents Sea, and a Garbage-Patch-like scenario in 20 years (Van Sebille et al. 2012). But numerical observations have to be validated by real data. The longevity of plastic and microplastic means that they can be distributed over huge distances from their origin, and accumulate in remote areas. Sea currents are the highways of the oceans (Van Sebille et al. 2020). Nowadays, the Arctic cannot be considered a pristine remote environment, with accumulations in the Greenland and Barents seas, which may constitute a dead end for the surface transport of floating debris produced at lower latitudes (Cózar et al. 2017).

Marine and maritime operations in the Arctic have recently increased following the increase in the exploitation of natural resources, so the economic ties between the Arctic and the global economy are due to expand. The reason is certainly to be found in the effects that global warming is showing on the sea ice coverage, which has always been the major limit to the exploration of this region of the planet, but it is also to be linked to the development of technology and science that mitigates some of the problems related to this extreme environment. Both trends are expected to continue soon. With the withdrawal of sea ice in the Arctic, greater access to the sea is expected, and potentially longer seasons are envisaged with greater possibilities for navigation and maritime operations. Among the emerging maritime activities in the Arctic are: new marine systems and platforms that support the development of

offshore hydrocarbon research and resources; the expansion of marine tourism; summer transport routes at sea to support the mining and transportation of minerals, but also modest levels of growth of the trans-Arctic cargo movement; potential increases in fishing in coastal waters such as the Baffin Bay or the Davis Strait; a general increase in the summer presence of a large variety of ships of all sizes throughout the Arctic Basin and more and more scientific expeditions in the central part of the Arctic Ocean.

Therefore, also local sources of plastic pollution are not negligible in the Arctic. Any human settlement has an impact on the environment and in the past small communities had small frozen dump permanently stored in permafrost. The release of amounts of plastic in the sea from these sources was probably insignificant in the past but these traditional sources are now confronted with global change. For example: melting of old dumping sites that used to be frozen in permafrost and now are free to diffuse plastic; wastewater treatments plants that cannot sustain summer tourist blooms.

New sources have to be added to the traditional local inputs. The number of cruise and commercial ships in the Arctic has overgrown and in spite of *MARPOL* (*International Convention for the Prevention of Pollution from Ships*) *V* and *Polar Code* accidental plastic release has to be expected following accidents such as mismanagement of paint, wax or ballast water. The number of offshore rigs is on a rise as the sea becomes more and more ice-free, and we depend on industry regulations more than on laws to protect the sea, being industry often stricter than the law itself.

Safety and environmental protection in the Arctic will be significantly improved with the adoption and full implementation of *IMO* (*International Maritime Organization*) *Polar Code* obligation by *IMO* member states. Defining the risks for the various classes of ships in the ice-covered and ice-free polar waters is challenging, and particular attention has been paid to identifying hazards and consequences, including plastic.

There is an urgent need to assess the levels of plastic pollution in the Arctic, to allow for future monitoring and to assess the risk of the potential impacts of decreasing sea ice, increasing shipping and commercial activity in the area, as well as a need for a pervasive public awareness effort. Although climate change made the Arctic less extreme than before, it remains a remote harsh environment where monitoring is not an easy task and the few field studies available have not yet fully validated models of microplastic distribution. Long-term environmental time-series data and improved modelling capabilities are necessary to enhance our predictive capacities. A significant investment in time and money is required to upgrade and expand the existing observing infrastructure, to support research and the sharing of data and information.

The management of plastic pollution in the Arctic is a complex issue. For example, burning plastic in situ is a global countermeasure to control marine debris, but not suitable for the Arctic because of the resulting increase of black carbon and other pollutants. The impact of black carbon on the ice needs special controls, which makes burning plastic probably not a suitable way to manage it.

Every country with commercial interests and consequent environmental responsibilities must have a long-term plan for Arctic research on potential pollution. *PAME* supported a desktop study (PAME 2019) summarizing present-day knowledge of marine plastic in the Arctic and is the baseline for a Regional Action Plan on Marine Litter under preparation. The plan should include an assessment of response technologies and related logistics, improving forecasting models and associated data. Industry, academia and governments should be included in the programme, to be developed with peer review and transparency as working methods. Many countries already support polar research and several international initiatives are in progress. Collaborative mechanisms provide a solid platform but the pace of progress, the level of investment, and the extent of collaboration must increase significantly.

Public awareness and interest to collaborate and take part are growing, as many pan-Arctic citizen-science initiatives have demonstrated. Surfing the web, one quickly realizes that citizens in Alaska and Norway are among the most involved in monitoring and clean-up programmes (or have a higher web presence). But citizens from other countries and not necessarily form Arctic regions only, are also increasingly involved and aware.

2 Polarquest 2018

2.1 Citizen Science Exploration Projects in the Extreme Arctic

The famous first historical polar expeditions were privately funded, or as we say now, they were a kind of Citizen Science. For example, Lincoln Ellsworth spent US$ 100,000 to fund Roald Amundsen's 1925 attempt to fly from Svalbard to the North Pole. Nobile's expedition was funded largely by the press and families from Milan, an early example of crowdfunding. Shackleton's Antarctic trip was funded by three major private sponsors, Stancomb Wills, Dudley Docker and James Caird and the *Endurance*'s lifeboats were named after them.

The recent *Tara* Oceans Arctic polar expedition was funded by the private foundation *Tara* (https://oceans.taraexpeditions.org) and several scientists supported by citizens sampled the Arctic also for floating plastic debris. From the Greenland Sea, the expedition circumnavigated the Arctic Ocean to the Labrador Sea. From June to October 2013 plastic samples were collected from 60° to 80° latitude North. To provide a first assessment of the plastic load in the Arctic surface waters, the Arctic Polar Circle was divided into two more uniform sectors in relation to plastic pollution: a highly polluted sector from the 35th meridian of longitude West to the 74th meridian of longitude East (Greenland and Barents Seas; including 17 net tows) and a less-polluted sector accounting for the rest of the Arctic Circle (including 21 net tows). The fragmentation and typology of the plastic suggested an abundant

presence of weathered debris that mainly originated from distant sources. Some of these findings are summarized in Cózar et al. (2017).

Sailing yachts *Bagheera* and *Snow Dragon II* were on an Arctic Mission and on 29 August 2017 they reached their northernmost site at 80°10' North, 148°51' West. Sailing vessel *Bagheera* also sailed as far north as 82°26' in 2004, 2005 and 2006 and again as far as 80° N in the summer of 2017 in the Central Arctic Ocean, sailing from Alaska. The expedition was led by Timothy Gordon and hosted a microplastic project from Exeter University. This information is available on YouTube, Facebook and the website https://bagheerasailing.com/.

Another expedition in 2018 took place on board of *Blue Clipper*, a 33 m tall ship where scientists, media experts and artists focus on plastic pollution in a cruise named *Sail Against Plastic*. The scientific direction was again from students and postdocs of Exeter University and the team included representatives from *Surfers Against Sewage*, the *Marine Conservation Society* and *Marine Megafauna Foundation*, which are well web-represented organizations against marine litter (https://www.sailagainstplastic.com/).

The *Alfred Wegener Institute* (Germany) also endorsed expeditions in Svalbard run by *OceanExpeditions*, which included beach marine litter monitoring and clean-ups and resulted in scientific papers (Bergmann et al. 2017).

An ice-free Arctic will become a regular scenario in the next years, and considering the explosion of interest from the media about marine litter, it's easy to foresee that the number of boats sampling the ocean for litter will increase.

Given the current relatively easy access to high latitudes, many commercial touristic expeditions offer sailing trips to the extreme North. These boats are rented by tourists to sail to northernmost latitudes and people on board are keen to provide some contribution, especially after the recent high interest of media on plastic studies. Cruises often have educational purposes but, without clear scientific objectives and comprehensive sampling design, the possibility to exploit their collected data for research may be affected. For example, the samples may not have sufficient quality to be used for scientific purposes due to contamination, which is a major issue when sampling microplastic. Even managing metadata and cruise logbooks may become a not-so-easy task for non-specialists.

Nevertheless, it's easy to foresee that the number of boats sampling the ocean for litter will increase. The *Association of Arctic Expedition Cruise Operators* (AECO) is an international association for expedition cruise operators operating in the Arctic and others with interests in this industry. *AECO* is working to drastically cut back on single-use plastics on Arctic expedition cruise vessels, as well as enhance cruise passengers' involvement in regular beach clean-ups, but they have limited control over small vessels. Are small sailing boats suitable vessels to collect data about plastic in the Arctic? The experience of Polarquest 2018 and some recommendations from that experience may help similar future expeditions.

2.2 Polarquest 2018

In summer 2018 the Polarquest 2018 expedition on board of the sustainable sailboat *Nanuq* sailed to the edge of the Arctic ice-shelf reaching the northernmost part of the Svalbard Archipelago and circumnavigating the two largest islands of Spitsbergen and Nordaustlandet.

Nanuq (meaning polar bear in the Inuit language) is a 60-foot *Grand Integral* sailboat designed, built and skipped by architect Peter Gallinelli (Geneva, Switzerland) to explore polar regions and withstand arctic winters in a self-sufficient mode, using renewable energies (sun, wind, environmental heat), thanks to its innovative thermal insulation and heat recovery systems, coupled with an optimized energy management system (Fig. 3). This "passive floating igloo" is a minimal habitat designed to serve as a mobile scientific base camp and dwelling to accommodate, in complete self-sufficiency, a team of six scientists also during winters in Arctic regions. *Nanuq* is a demonstration pilot project that illustrates how simple, robust, constructive and technical solutions may challenge low-cost energy scarcity in a credible way.

Fig. 3 *Nanuq*, the Polarquest 2018 sampling platform, is designed to explore polar regions and withstand arctic winter in a self-sufficient mode, using renewable energies and thanks to its innovative thermal insulation and heat recovery systems, coupled with an optimized energy management system. It is an aluminium sailing boat with an extremely low carbon fingerprint. (Photo: © Michael Struik 2019. All rights reserved)

The ultimate objective of this expedition was also to contribute to improve public awareness in non-Arctic countries of the far-reaching impact of human activities on our planet.

2.3 Description of the Polarquest 2018 Expedition

The Polarquest 2018 cruise started in Isafjordùr (North Iceland) and the boat sailed to Longyearbyen (Svalbard) via Greenland, but unfortunately sampling of plastic was not possible during this first leg. Its main path was the circumnavigation of Svalbard's archipelago.

The expedition was organized by the Swiss cultural association *Polarquest 2018*. It was carried out by an international crew, led by Peter Gallinelli (Australia and Italy, skipper and expedition leader), Paola Catapano (Italy and Switzerland, project leader and science communicator) and Michael Struik (Netherlands and Switzerland, technical coordinator). It included three crew members: Remy Andrean (France, ITC expert, boatbuilder and sailor), Mathilde Gallinelli Gonzalez (Switzerland, co-skipper, sailor, manta operator) and Dolores Gonzalez (Spain and Switzerland, architect and sailor) and three scientific operators: Safiria Buono (Italy and Switzerland, Manta net technical operator), Gianluca Casagrande (Italy, geographer) and Ombretta Pinazza (Italy, physicist) and one photographer/cameraman: Alwin Courcy (France).

After leaving Longyearbyen, the expedition sampled microplastic from *Nanuq* in eight locations during its circumnavigation of the Svalbard archipelago's main islands: Spitsbergen and Nordaustlandet (Fig. 4a, b). The presence of macro debris on sea surface and beaches in remote zones was explored by non-quantitative visual sightings and by drones flying over beaches.

Microfibres and microplastics were collected trawling a manta net according to standard monitoring protocols and filtering surface water collected in a 10 L metal bucket.

The manta net had a metal rectangular opening of 0.7 m × 0.5 m and two lateral floats of 0.1 m in diameter, one for each side. It was equipped with a 330 μm mesh 2.5 m long. The cod-end was fixed to the Manta with a metal ring. The nets were towed behind the boat for about 30 min at a vessel speed of around 3–4 knots (except for Manta #3 which was towed at approximately 7 knots) (Fig. 5). Coordinates and time of starting and ending sampling points were recorded along with sea state conditions and water temperature. After retrieving the net from the sea, the cod-end was removed and transferred to clean jars and stored for laboratory analysis. It was possible to collect eight manta samples and they were stored in eight different cod-end nets (Fig. 6). Two cod-ends were lost during the sampling process due to bad weather and limited operator experience.

Bulk surface seawater was sampled using a 10 L metal bucket (Fig. 7). The water was gravity filtered through a 28 μm mesh and remaining particles were trapped in the 3 cm diameter metal filter that was put in closed envelopes after filtration. The

samples have been opened again only in the laboratory for sorting and FTIR
analysis.

Polarquest 2018 succeeded to collect samples and sightings and we can consider
the expedition on small sailing boat *Nanuq* as a successful way to collect this kind of
samples from the Arctic. Management of toxic chemicals created some problems in a
small private owned boat, so no preservatives were used onboard and bulk samples
were frozen after the end of the cruise. This was not critical during the expedition as
Arctic low temperatures helped to keep samples intact, but it became an issue when

Fig. 4 (**a**) Polarquest 2018 expedition route from Iceland to the circumnavigation of Svalbard. (**b**)
Polarquest 2018 expedition: position of manta sampling stations

Fig. 4 (continued)

samples reached lower latitudes. Our experience suggests that citizen science sampling projects shall put proper effort and attention to the management of chemicals. Polarquest 2018 plastic samples were not affected by lack of preservatives but processing in the lab was not comfortable.

Training courses, and possibly training tests, are also recommended when sampling is carried out by unskilled persons. In our experience, two manta cod-ends were lost due to inexperienced staff and rough sea.

Microplastic and fibres were found in all samples and macro debris was visible to the naked eye throughout our entire circumnavigation of the islands.

Every day, we saw floating plastic in the open sea; even while sampling seawater on the rim of the Arctic ice-shelf (82°07' N), our Manta net caught a visible piece of blue plastic and many microplastic pieces. At each landing, incredible amounts of plastic rubbish amidst tons of driftwood were lying on these remote beaches, which have rarely seen human feet (Fig. 8).

Fig. 5 Recovery of the manta net after towing. (Photo: © Michael Struik 2019. All rights reserved)

Fig. 6 Separation of the manta cod-end before storage. (Photo: © Michael Struik 2019. All rights reserved)

Fig. 7 Filtering of microplastic from a 10 L metal bucket. (Photo: © Michael Struik 2019. All rights reserved)

Fig. 8 A plastic tank with the bite of a polar bear found on Kapp Rubin (80° N). (Photo: © Michael Struik 2019. All rights reserved)

Sightings of marine debris are common to assess the amount of macro debris at sea and on beaches. Direct observations are the simplest tool and many guidelines for beach survey have been improved by *OSPAR, UNEP, NOAA* (*National Oceanic and Atmospheric Administration*) and *EU-Marine Strategy Framework Directive* with human observers on land as the core of these guidelines. Only recently there has been interest in remote sensing of marine litter (Maximenko et al. 2019).

The tools under development use high technology and complex airborne and satellite images and only a small part makes references to drones, especially low-cost drones at the consumer level, i.e. the level of drones usually available to Citizen Science.

During Polarquest 2018 the subproject *AURORA* (*Accessible Unmanned aerial vehicles for Research and Observation in Remote Areas*), led by Gianluca Casagrande (European University of Rome, IT), used flying drones of consumer level to make visual observations of the Svalbard coastline.

Images in the visible spectra were used for analysis and some preliminary results are presented here. Four "off-the-shelf" drones in standard commercial configurations were released from *Nanuq* in several occasions when the boat was close to the coast or during on-land observation sessions. Video and still digital images from the flights were used to produce 3D models, orthophotos, audiovisual material and other types of documentation. Images were stored onboard the drones and processed after the end of the cruise.

One of the specific tests involved the possibility of spotting and mapping macroplastics scattered in various locations of environmental interest in northern Svalbard. The beaches of Alpiniøya (North-East Svalbard) have been particularly explored for this specific type of pollution.

The minimum survey flight height was set to 100 m above ground level and the minimum debris size that we considered useful for reliable identifications was 30–50 cm. Drones flew for about 2.5 h in total covering about 1.6 km^2. Fragments of macroplastics spread along the beach-line were identified in the 20 megapixel images from the drones down to few decimetres size.

Wood and trunks (also known as "driftwood") were very common and abundant, suggesting long-distance sources of floating items because the Svalbard archipelago has no forests at present (Fig. 9). Most of man-made macro debris visible from drones was accounted for lost fishing gears (fragments of nets, small buoys, boxes, tanks for fluids). In situ observations during walks on the beach (Figs. 10 and 11) had higher resolution and smaller spatial scale coverage, providing criteria for identification of items and ground truth.

Figure 12 reports one example of pixel anomalies in drone images that were identified and verified. Several plastic pieces were identified and most common items were fluid tanks/containers, boxes, fragments of fishing nets, fishing net floaters and buoys, possible bucket covers, bottles (of different sizes) and tarpaulin fragments.

Fig. 9 Polar bear on Storoya (80°20'N, 27°85'E) surrounded by wood and plastic debris—screenshot from drone video. (Photo: © Michael Struik 2019. All rights reserved)

Box 1: From *Nanuq's* Logbook, by Safiria
Sampling microplastic in the Arctic, 31 July 2018, South Svalbard

One fact about microplastic sampling: I fought a little war during this past 24 h with some yellow algae or organism. The accumulation of this yellow little thing on my really thin filter obstructed it and water couldn't pass through anymore! So, the first 7 L of water were filtered almost drop by drop, then I had to change the filter to filter the 3 L left. In total, it took me more than 1 h. Also, to complete the misadventure, it was 4 a.m., it was freezing outside, water was at 3 °C, we had more than 1-m waves and 20 knots of wind freezing my naked, wet fingers. Positive fact: now every other sampling since seems fast to me! Another fact about plastic: we saw during our shifts a bit less than 10 big pieces of floating plastic in 7 days. The probability to encounter plastic so frequently in the open sea in the Arctic, so far from sources of pollution, is thin. So, that means two things: (1) There is a lot of plastic waste even in the Arctic; (2) Plastic travels a lot. Of course, we already knew it, but to see it is another thing: there are no airplanes, no boats, nothing, no trace of any other human being but us, except for one little detail: human pollution.

Fig. 10 Examples of debris items on the beach of Alpiniøya island, North Svalbard. Lost fishing gears were common. (Photos: © Gianluca Casagrande 2019. All rights reserved)

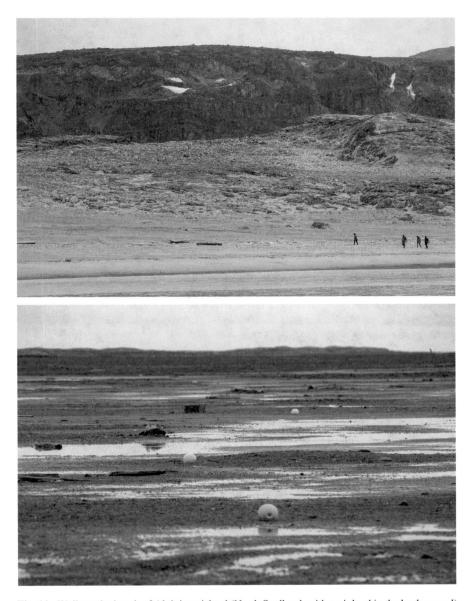

Fig. 11 Walk on the beach of Alpiniøya island (North Svalbard, with mainland in the background) and plastic debris at Kapp Borthen in the south of Svalbard. (Photos: © Michael Struik 2019. All rights reserved)

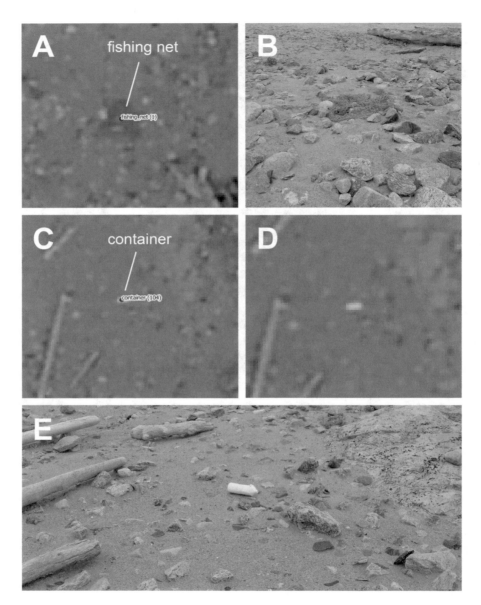

Fig. 12 Macroplastic debris, as recognized on the orthophoto based on data and criteria established during the ground-truth session (**b**, **e**) were documented in a basic GIS (**a**, **c**). General classification data/descriptions were then input in the attribute table associated to the documentation layer. The object in E was observed in the ground truth session but due to its small size (less than 30 cm in length) proved difficult to identify and recognize on the orthophoto (**d**): this meant that in this particular survey, all objects whose dimensions did not exceed 30 cm per side would be identified with uncertainty, or proved impossible to be identified (Aerial pictures: Michael Struik; orthophoto and GIS processing: Gianluca Casagrande). (Photos: © Michael Struik and Gianluca Casagrande 2019. All rights reserved)

Box 2: From *Nanuq's* Logbook, by Safiria
The Northernmost Microplastic sample, 13 August 2018,
Edge of the Polar iceshelf, 82°07' N (876 km from the geographic North Pole)

Today, 13 Aug 2018, we went up to 82°7' N, where I carried out what seems to be the northernmost microplastics sampling next to the ice shelf. We found a piece of blue plastic in the manta net filter, just next to a bird feather and other things that stink tremendously every time I open the box in which I collect the filters (often full of phytoplankton, algae, etc.). I swear I'm going to pass out after filter number 20. It was so cold during the sampling: my hands were hurting so much (I only had some blue latex gloves), that I had tears streaming down my cheeks and freezing after a while. They were so frozen that I couldn't grab the bottle anymore, or unhook my lifeline to go inside.

Besides that, Mathilde and I are spending time reading the same books, creating crosswords, playing card games or memorizing all the possible historical dates we can (don't ask us why, we do what we can to have fun, and we enjoy it).

We are now heading South again. Direction: Alpiniøya.

3 Recommendations from Polarquest 2018 Experience for Sustainable Development

Polarquest 2018 confirmed that the presence of plastic debris extends up to remote Arctic waters, emphasizing the global scale of marine plastic pollution and suggesting the role of global oceanic circulation patterns in the redistribution of these persistent pollutants. The uniqueness of the Arctic ecosystem makes the potential ecological implications of exposure to plastic debris of special concern.

Monitoring is not a goal in itself, but a way to show the scale of the problem, and start to try and solve it.

Plastic is necessary for our modern technologies. Its production and industry have grown fast and plastic is now a pillar of our economy and society. Most of macro debris found in northern Svalbard was single-use domestic plastics and fishing gears, i.e. nothing that proper management cannot keep out of our ocean.

Citizen science cruises in the Arctic are likely to increase in the next years due to ice-free ocean parallel to growing interest in plastic in the ocean. The number of clean-ups and microplastic surveys are likely to increase as well and Polarquest 2018 was the first expedition of this kind to reach and sample at 82° N and future cruises would benefit of the experience of Polarquest. Through a heavy media presence and communication activity, also the citizens of non-Arctic European countries have been made aware of the presence of our litter as far as the boundary between the ocean and the Arctic permanent sea ice.

In 1921, Vilhjalmur Stefansson famously predicted that the Arctic would soon become a region of great strategic and commercial importance (Lajeunesse 2012). Continuously crossed by the air and sea traffic of many nations, the region is expected to be the Mediterranean of the modern age. While Stefansson's prediction was certainly premature, recent economic and environmental developments suggest that a sea change may finally be taking place and plastic pollution is one among many priority challenges of the twenty-first century the Arctic has to face.

Acknowledgments We would like to thank Safiria Buono, Manta net operator and crew member of the Polarquest 2018 expedition; Peter Gallinelli (Sailworks), skipper and designer of sailboat *Nanuq* and expedition leader and Frederic Gillet (University of Savoie), *Nanuq*'s scientific coordinator, for their invaluable participation and supervision of the microplastic sampling campaign on board *Nanuq* during the Polarquest 2018 expedition.

References

Amante C, Eakins B (2015) ETOPO1 1 arc-minute global relief model: procedures, data sources and analysis. National Geophysical Data Center, NOAA Technical Memorandum NESDIS NGDC-24

Avery-Gomm S et al (2018) Plastic pollution in the Labrador Sea: an assessment using the seabird northern fulmar Fulmarus glacialis as a biological monitoring species. Mar Pollut Bull 127:817–822

Bascom W (1974) The disposal of waste in the ocean. Sci Am 231(2):16–25

Bergmann M, Klages M (2012) Increase of litter at the Arctic deep-sea observatory HAUSGARTEN. Mar Pollut Bull 64:2734–2741

Bergmann M et al (2016) Observations of floating anthropogenic litter in the Barents Sea and Fram Strait, Arctic. Polar Biol 39(3):553–560

Bergmann M et al (2017) Citizen scientists reveal: marine litter pollutes Arctic beaches and affects wild life. Mar Pollut Bull 125(1–2):535–540

Beszczynska-Möller A et al (2011) A synthesis of exchanges through the Main oceanic gateways to the Arctic Ocean. Oceanography 24(3):82–99

Buhl-Mortensen L, Buhl-Mortensen P (2017) Marine litter in the Nordic seas: distribution composition and abundance. Mar Pollut Bull 125(1–2):260–270

Carpenter EJ, Smith KL (1972) Plastics on the Sargasso Sea surface. Science 175(4027):1240–1241

Cózar A et al (2017) The Arctic Ocean as a dead end for floating plastics in the North Atlantic branch of the thermohaline circulation. Sci Adv 3(4):1–9

Day RH (1980) The occurrence and characteristics of plastic pollution in Alaska's marine birds. Master Thesis, University of Fairbanks, Alaska. https://scholarworks.alaska.edu/handle/11122/7361. Accessed 10 Sep 2019

Ebbesmeyer CC, Ingraham WJ (1994) Pacific toy spill fuels ocean current pathways research. EOS Trans Am Geophys Union 75(37):425–430

Fergusson W (1974) Summary. In: Staudinger J (ed) Plastics and the environment. Hutchinson and Co, London, UK, p 2

Fowler C (1987) Marine debris and northern Fur seals. Mar Pollut Bull 18(6):326–335

Franeker JA et al (2011) Monitoring plastic ingestion by the northern fulmar Fulmarus glacialis in the North Sea. Environ Pollut 159(10):2609–2615

Galloway TS, Lewis CN (2016) Marine microplastics spell big problems for future generations. PNAS 113(9):2331–2333

Geyer R, Jambeck JR, Law KL (2017) Production, use, and fate of all plastics ever made. Sci Adv 3 (7):e1700782

Hallanger I, Gabrielsen GW (2018) Plastic in the European Arctic. https://data.npolar.no/publica tion/586ecfcc-676c-4cd1-b552-2aa43241f3e0. Accessed 5 Sep 2019

Jambeck JR et al (2015) Plastic waste inputs from land into the ocean. Science 347(6223):768

Jones EP (2001) Circulation in the Arctic Ocean. Polar Res 20(1):139–146

Laist DW (1987) Overview of the biological effects of lost and discarded plastic debris in the marine environment. Mar Pollut Bull 18(6 Suppl B):319–326

Laist DW (2011) Impacts of marine debris: entanglement of marine life in marine debris including a comprehensive list of species with entanglement and ingestion records. In: James MC, Donald BR (eds) Marine debris. Springer, Cham, pp 99–139

Lajeunesse A (2012) A new Mediterranean? Arctic shipping prospects for the 21st century. J Maritime Law Commerce 43(4):521–537

Lebreton LCM et al (2017) River plastic emissions to the world's oceans. Nat Commun 06 (8):15611EP

Lusher AL et al (2015) Microplastics in Arctic polar waters: the first reported values of particles in surface and sub-surface samples. Sci Rep 5:1–9

Mato Y et al (2001) Plastic resin pellets as a transport medium for toxic Chemicals in the Marine Environment. Environ Sci Technol 32(2):318–324

Maximenko N et al (2019) Towards the integrated marine debris observing system. Front Mar Sci 6:447

McWilliams M, Liboiron M, Wiersma Y (2018) Rocky shoreline protocols miss microplastics in marine debris surveys (Fogo Island, Newfoundland and Labrador). Mar Pollut Bull 129 (2):480–486

Merrell TR (1980) Accumulation of plastic litter on beaches of Amchitka Island, Alaska. Mar Environ Res 3(3):171–184

Merrell TR (1984) A decade of change in nets and plastic litter from fisheries off Alaska. Mar Pollut Bull 15(10):378–384

Morgana S et al (2018) Microplastics in the Arctic: a case study with sub-surface water and fish samples off Northeast Greenland. Environ Pollut 242(B):1078–1086

O'Hanlon NJ et al (2017) Seabirds and marine plastic debris in Scotland: a synthesis and recommendations for monitoring. EU Project Report. http://www.circularocean.eu. Accessed 10 Sep 2019

Obbard RW et al (2014) Global warming releases microplastic legacy frozen in Arctic Sea ice. Earth's Future 2(6):315–320

OSPAR (2016) Litter, monitoring marine and area, Ospar Maritime. OSPAR Commission, London, United Kingdom. https://www.ospar.org/. Accessed 5 Sep 2019

Østerhus S et al (2019) Arctic Mediterranean exchanges: a consistent volume budget and trends in transports from two decades of observations. Ocean Sci 15:379–399

PAME (2019) Desktop Study on Marine Litter including microplastic in the Arctic. https://www. pame.is/. Accessed 5 Sep 2019

Peeken I et al (2018) Arctic Sea ice is an important temporal sink and means of transport for microplastic. Nat Commun 9(1):1505

Piatt JF, Sydeman W, Wiese F (2007) Introduction: a modern role for seabirds as indicators. Mar Ecol Prog Ser 352:199–204

Provencher JF et al (2019) Recommended best practices for plastic and litter ingestion studies in marine birds: collection, processing, and reporting. FACETS 4:111–130

Provencher JF, Bond AL, Mallory ML (2015) Marine birds and plastic debris in Canada: a national synthesis and a way forward. Environ Rev 23(1):1–13

Rudels B (1995) The thermohaline circulation of the Arctic Ocean and the Greenland Sea. Philos Trans R Soc Lond A 352(1699):287–299

Ryan PG (1987) The effects of ingested plastic on seabirds: correlations between plastic load and body condition. Environ Pollut 46(2):119–125

Stiansen JE et al, (2009) Joint Norwegian-Russian environmental status 2008. Report on the Barents Sea ecosystem. Part II complete report. Korneev O, Titov O, Arneberg P (eds), Filin A, Hansen JR, Høines Å, Marasaev S (co-eds). IMR/PINRO Joint Report Series, 2009 (3): pp 1–375

Threlfall W (1968) The food of three species of gulls in Newfoundland. Canadian Field-Naturalist 82:176–180

Trevail AM et al (2015a) Elevated levels of ingested plastic in a high Arctic seabird, the northern fulmar (Fulmarus glacialis). Polar Biol 38(7):975–981

Trevail AM et al (2015b) The state of marine microplastic pollution in the Arctic. Norwegian Polar Institute, Tromso. ISBN: 978-82-7666-320-4

Van Sebille E, England MH, Froyland G (2012) Origin and evolution of the ocean garbage patches derived from surface drifter data. Environ Res Lett 7(4):0440040

Van Sebille et al (2020) The physical oceanography of the transport of floating marine debris. Environ Res Lett 15(2):023003

Wilcox C, Van Sebille E, Hardesty BD (2015) Threat of plastic pollution to seabirds is global, pervasive, and increasing. Proc Natl Acad Sci 112(38):11899–11904

Will S et al (2015) Planetary boundaries: guiding human development on a changing planet. Science 347(6223):1259855

Woodgate R (2013) Arctic Ocean circulation: going around at the top of the world. Nat Educ Knowl Project 4:1–12

Worm B (2015) Silent spring in the ocean. Proc Natl Acad Sci 112(38):11572–11573

The Impact of Marine Litter in Marine Protected Areas (MPAs) in the Mediterranean Sea: How Can We Protect MPAs?

Maria Cristina Fossi and Cristina Panti

Abstract The Mediterranean Sea is one of the most affected areas by marine litter in the world. Marine litter and in particular floating plastics have been found in the Mediterranean Sea in comparable quantities to those found in the five oceanic garbage patches and affect ecosystems and several species at different trophic level. A harmonized and integrated way to monitor, assess, and manage marine litter at Mediterranean level, particularly in areas of high ecological values as Marine Protected Areas (MPAs), can help to monitor and develop mitigation measures to tackle this issue. Integrated monitoring tools that provide the necessary information to design and implement mitigation actions against marine litter in the Mediterranean basin are, therefore, needed also to support the current directives and regional action plans and have been developed. Actions that address the whole management cycle of marine litter, from monitoring and assessment to prevention and mitigation, as well as actions to strengthen networking between and among pelagic and coastal MPAs are needed.

Keywords Marine litter · Microplastic · Marine Protected Areas · Mediterranean Sea · Bioindicators

1 The Mediterranean Sea: A Hot Spot of Marine Litter

Recent estimations show that between 4 and 12 million tonnes of plastic enter the world's oceans and seas annually (Jambeck et al. 2015). The Mediterranean Sea is one of the most affected areas by marine litter in the world. Plastics and other artificial polymer materials are the most common types of marine litter, representing some 80% of the items found. As larger pieces of plastic debris fragment into smaller pieces, the abundance of microplastics (plastic fragments

M. C. Fossi (✉) · C. Panti
Department of Environment, Earth and Physical Sciences, Università degli Studi di Siena, Siena, Italy
e-mail: fossi@unisi.it; panti4@unisi.it

© Springer Nature Switzerland AG 2020
M. Streit-Bianchi et al. (eds.), *Mare Plasticum – The Plastic Sea*,
https://doi.org/10.1007/978-3-030-38945-1_6

smaller than 5 mm) in marine habitats increases; 115,000–1,050,000 particles/km^2 are estimated to float in the Mediterranean Sea (Fossi et al. 2012; Suaria and Aliani 2014; Suaria et al. 2016; UNEP/MAP 2015; Zeri et al. 2018). The marine litter problem in the Mediterranean is exacerbated by the basin's limited exchanges with other oceans, highly developed coastal tourism, densely populated coasts, busy offshore waters (with 30% of the world's maritime traffic), waste disposal sites often located close to the coast, heavy maritime traffic, high temperatures accelerating litter degradation into secondary products that are difficult to collect or treat, and inputs of litter from large rivers.

Marine litter and in particular floating plastics have been found in the Mediterranean Sea in comparable quantities to those found in the five oceanic garbage patches (Cózar et al. 2015). In this respect, studies based on global models have proposed the Mediterranean Sea as the sixth greatest accumulation zone for marine litter worldwide (van Sebille et al. 2015; Suaria et al. 2016; Panti et al. 2015; Fossi et al. 2017; Baini et al. 2018). The ingestion of plastics by marine species is one the most documented impacts in the Mediterranean (Fossi et al. 2018a, b). In the last 5 years, more than 40 papers on the incidence of marine litter ingestion in marine organisms in the Mediterranean basin, including in Marine Protected Areas (MPAs), have been published. Most of the research was carried out in the Western Mediterranean Sea, whereas the Ionian Sea and the Central Mediterranean Sea, the Adriatic Sea, and the Aegean Levantine Sea were less investigated. Over the same period, litter ingestion has been documented for 84 Mediterranean species belonging to different taxonomic groups including invertebrates, fish, sea turtles, seabirds and marine mammals (Compa et al. 2019).

This chapter lists the diverse and wide-ranging scope of actions that have been implemented at Mediterranean scale with the aim to contribute to a harmonized and integrated way to monitor, assess, and manage marine litter at Mediterranean level, particularly in Marine Protected Areas.

2 How to Detect the Harmful Effects of Plastic Litter on Biodiversity in Mediterranean MPAs

The Mediterranean basin, a worldwide biodiversity hotspot, as previously underlined, is one of the world seas most affected by marine litter, including microplastics (van Sebille et al. 2015; Suaria et al. 2016; Fossi et al. 2017). Recent studies in the different regions of the basin suggest that some areas, including important MPAs and Specially Protected Areas of Mediterranean Importance (SPAMI) such as the Pelagos Sanctuary, are affected by important concentrations of microplastics and plastic additives, representing a potential risk for endangered species (baleen whales, sea turtles, filter feeder sharks) (Fossi et al. 2012, 2014, 2016, 2017, 2018a; Baini et al. 2017; Germanov et al. 2018) living in this area and for the all Mediterranean biodiversity (Galgani et al. 2014; Romeo et al. 2015;

Deudero and Alomar 2015; Compa et al. 2019). To address the current knowledge gaps on this issue a harmonized methodological approach for the assessment of marine litter impact on Mediterranean biodiversity is needed (Claro et al. 2018).

In the whole Mediterranean basin 1231 MPAs and OECMs (Other Effective area-based Conservation Measures) cover 179,798 km^2, for a total surface of 7.14% under a legal designation. Many of these areas are heavily subjected to marine litter pressure (Fig. 1). To understand the problem of marine litter's effects on biodiversity and to address regional gaps, bioindicator species must be selected and routinely monitored, enabling the assessment of the status of the different marine ecosystems in terms of marine litter pollution. An important aspect to be developed in the conservation of these areas consists in how to detect the harmful effects of plastic litter on biodiversity in these protected areas. A new integrated monitoring tool that provides the necessary information to design and implement mitigation actions against marine litter in the Mediterranean basin is, therefore, needed.

The quantification of marine litter/microplastics in the marine environment can depend on several environmental factors and change according to multiple oceano-graphic features, and therefore cannot reflect, as a simple environmental measure, the potential impact on organisms and ecosystems. The information obtained by bioindicator species could better integrate the spatial and temporal presence of marine litter/microplastics in the marine environment. In a recent paper, Fossi et al. (2018a, b) proposed different bioindicator species as sensitive indicators of the presence and effects of marine litter in different ecological compartments (sea surface, coastal waters, open waters, seafloor, coastline) based on the data available on the interaction of marine litter (including microplastics) with Mediterranean marine organisms and the biological and ecological criteria for the choice of sentinel species. Bioindicator organisms have also been selected on the basis of their different home ranges: small scale (FAO Geographical subareas, GSAs), medium scale (Mediterranean UN Environment/MAP subregions) and large scale (whole Mediterranean Basin), to serve as sentinels of the Mediterranean environment at different geographical scales. In addition, the use of the selected bioindicator species can allow the determination of the occurrence of marine litter in marine species and the marine environment as well as the assessment of the threat posed to organisms via the measurement of contaminants and/or any related biological effects (Fossi et al. 2016, 2018a; Baini et al. 2017; Casini et al. 2018). The impact of ingested marine litter on marine organisms should be assessed using a threefold monitoring approach, which combines (a) an accurate measurement of marine litter and microlitter loads in organisms, (b) the evaluation of plastic additives and (c) POPs (Persistent Organic Pollutants) levels in tissues and the related toxicological effects (Fig. 2).

Recent studies suggest that debris, including micro-plastics and chemical additives (e.g., phthalates), tend to accumulate in pelagic areas in the Mediterranean (Panti et al. 2015; Pedrotti et al. 2016), indicating a potential overlap between debris accumulation areas and endangered species' feeding grounds (Fossi et al. 2016). This fact highlights the potential risks posed to endangered, threatened and endemic species of Mediterranean biodiversity. In one of the most biodiverse areas of the

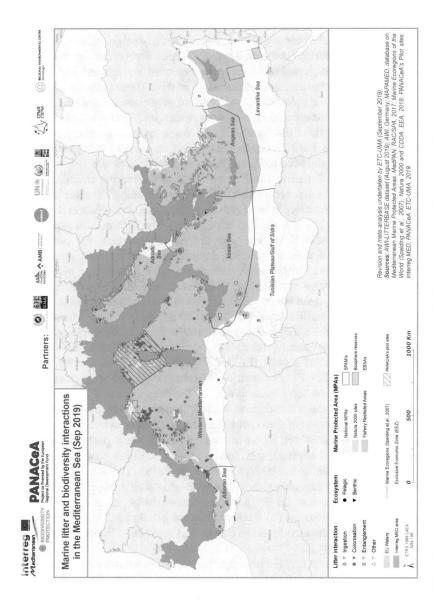

Fig. 1 Spatial distribution of monitored sites with reported marine litter and biodiversity interactions in four categories (ingestion, entanglement, colonization and others) created after the meta-analysis undertaken by *ETC-UMA* (September 2019), from Guitart et al. 2019. (Copyright 2019, *PANACeA project/ETC-UMA*; http://www.etc.uma.es/wp-content/uploads/Mapping_knowledge_marine_litter_biodiversity_interactions.pdf)

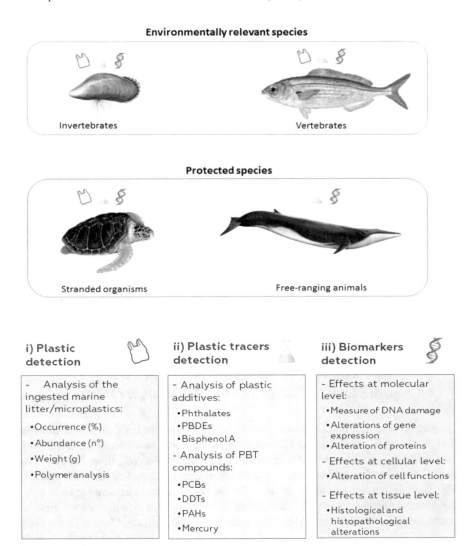

Fig. 2 The threefold monitoring approach to detect marine litter presence and impact in bioindicator organisms

Mediterranean Sea, the Pelagos Sanctuary, cetaceans coexist with high human pressure and are subject to a considerable amount of plastic debris, including microplastics (Collignon et al. 2014; Cózar et al. 2014).

In these protected areas the interactions between endangered species, such as cetaceans, and micro-debris items have been investigated in free-ranging fin whales, in which this methodology (the threefold monitoring approach) was applied using skin biopsy, comparing populations living in two semi-enclosed basins, the

Mediterranean Sea (Pelagos Sanctuary) and the Sea of Cortez (Gulf of California) (Fossi et al. 2016). Fin whales are resident in both the Mediterranean and the Sea of Cortez. As a result, fin whales are exposed to a high potential risk of micro-debris ingestion in their feeding grounds due to the ingestion of contaminated prey and the direct ingestion of floating debris items. In this case study, a considerably higher abundance of micro-debris and plastic additives were demonstrated in zooplankton samples from the Pelagos Sanctuary of the Mediterranean Sea compared to samples from the Sea of Cortez. Given the abundance of plastics in the Mediterranean environment (Fossi et al. 2016), high concentrations of PBT chemicals (Persistent, Bioaccumulative and Toxic substances), and biomarker responses detected in the biopsies of Mediterranean whales compared to whales inhabiting the Sea of Cortez, the exposure of Mediterranean whales to micro-debris because of direct ingestion and consumption of contaminated prey appears to pose a major threat to the health of fin whales in this region. This scientific topic is also developed in the project *Plastic Busters MPAs* (https://plasticbustersmpas.interreg-med.eu/), recently financed by EU (*Med-Interreg*), focused on the study of the impact of microplastics on cetaceans inhabiting the Mediterranean SPAMI Pelagos Sanctuary (Fig. 3).

3 Monitoring and Specific Reduction Measures Within *Marine Strategy Framework Directive* and Through the Implementation of the Regional Action Plan on Marine Litter Management in the Mediterranean

Despite the recent advances made within the framework of the *Barcelona Convention Regional Plan for Marine Litter Management* in the Mediterranean and the *EU Marine Strategy Framework Directive (MSFD) (Descriptor 10)*, there is still a long way ahead to tackle marine litter in the Mediterranean and reduce the risks posed to Mediterranean marine wildlife. In line with the urgent need to act at a regional level, the Contracting Parties to the *Barcelona Convention* (all Mediterranean riparian countries and the EU) agreed in 2013 on a *Regional Plan on Marine Litter Management in the Mediterranean*. The regional plan, which is the first legally binding instrument at Regional Seas level, aims to minimize the marine litter presence and impacts in the Mediterranean. It also specifies in its *Article 18* that its implementation necessitates the cooperation among regional partners and actors. This requirement is also featured in the *MSFD* under *Article 5(2)*. Member States sharing a marine region or subregion are urged to cooperate and implement their monitoring programmes and programmes of measures in a coherent and coordinated way. Periodic assessments of the state of the marine environment, monitoring and the formulation of environmental targets are perceived as part of the continuous management process within the *EU Marine Strategy Framework Directive (MSFD)*. Of the 11 descriptors listed in *Annex I* of the *MSFD* for determining *Good Environmental Status (GES)*, *Descriptor 10* has been defined as *"Properties and quantities*

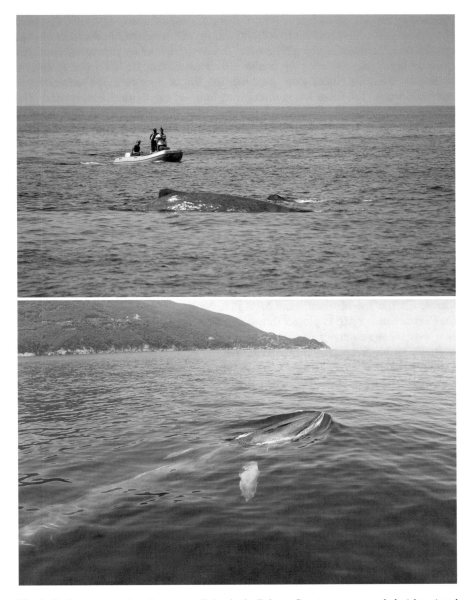

Fig. 3 Endangered species of cetaceans living in the Pelagos Sanctuary: sperm whale (above) and fin whale (below). The biopsy of their skin allows an indirect identification of the exposure of the organism studied to plastic additives (Godard-Codding and Fossi 2018; photos: Cristina Panti)

of marine litter do not cause harm to the coastal and marine environment". In 2016, the *Revised Commission Decision* identified four indicators for *Descriptor 10*, of which two are focusing on harm considering (a) *the amount of litter and micro-litter*

ingested by marine animals is at a level that does not adversely affect the health of the species concerned (*indicator 10DC3*) and (b) *the number of individuals of each species which are adversely affected due to litter, such as by entanglement, other types of injury or mortality, or health effects* (*indicator 10DC4*). For these two indicators, Member States shall establish the list of species to be assessed and threshold values for these levels through regional or subregional cooperation. The entire approach should give rise to better information in support of the measures to reduce marine litter that will be implemented in the future. It will also enable to monitor the efficiency of prevention and reduction measures that focus on specific items that cause impacts, i.e. the ban of plastic bags (for ingestion and entanglement) or of certain fishing gears (for entanglement mainly).

4 How Preserve Biodiversity in Mediterranean MPAs: The *Plastic Busters MPAs* Project

A concrete example of Mediterranean partnership that consolidates the fight against marine litter in the Mediterranean MPAs on the science-policy-society interface is the *Plastic Busters MPAs* project (https://plasticbustersmpas.interreg-med.eu/). This is a 4-year-long *Interreg Mediterranean* funded project aiming to contribute to maintaining biodiversity and preserving natural ecosystems in pelagic and coastal marine protected areas (MPAs), by defining and implementing a harmonized approach against marine litter. The project entails actions that address the whole management cycle of marine litter, as well as actions to strengthen networking between and among pelagic and coastal MPAs. This project is one of the few showcases at Mediterranean scale that focus on bridging the gap between science, policy and society and connecting the information production and knowledge generation to its use in the decision-making process at different levels. The project deploys the multidisciplinary strategy and common framework of action developed within the *Plastic Busters* initiative, the *UN Mediterranean Sustainable Development Solutions Network* flagship project. This initiative frames the priority actions needed to tackle marine litter in the Mediterranean and was labelled under the *Union for the Mediterranean* in 2016, gathering the political support of 43 EuroMediterranean countries.

Bioindicator species for different habitats and spatial scale were selected into the *Interreg Med* project, applying ecological and biological criteria (Fossi et al. 2018a, b). To assess the harm by marine debris ingestion the above-mentioned threefold approach can provide the harm and the sublethal effects to organisms due to marine litter ingestion (Fig. 2). This way, *Plastic Busters MPAs* project tackles the above-mentioned key challenge of our time: to bridge the gap between science, policy and society and connect the information production and knowledge generation to its use in the decision-making process at different levels. The gaps pointed out by this project and the bioindicator species selected could represent a

step forward for the implementation of *Descriptor 10 (D10)* in *MSFD* (Galgani et al. 2014), *Integrated Monitoring and Assessment Programme (IMAP)* indicators, and the implementation of mitigation measure for habitat and species affected by marine litter ingestion in the Mediterranean area (RAC/SPA 2017).

In detail, the main objectives of the project are to realize a quantitative and qualitative diagnosis of the impacts of marine litter in Mediterranean MPAs and on marine biodiversity. In order to contribute to the increase of MPAs meeting their conservation goals and objectives, via the reduction of the anthropogenic impacts of marine litter, it is essential to diagnose the extent and nature of the impact (baseline values of pressure and risk related to marine litter).

This will be achieved by producing:

(a) A comprehensive assessment of the status of amounts, composition and impacts on marine species of marine litter in pelagic and coastal MPAs.
(b) A hotspot analysis/mapping of marine litter accumulation areas, based on ocean currents and convergence areas and state-of-the-art modelling and satellite-based tools to support the implementation of targeted marine litter management measures in the most affected sites in the MPAs.
(c) The characterization of marine litter, micro- and macro-plastics and assessment of their abundance in the oceanographic structures (convergence areas) (Fig. 4) identified by the model and identification of marine litter sources in order to design targeted prevention mitigation actions in the MPAs.
(d) The establishment of the impact of marine litter on biota, including target endangered and sentinel species (cetaceans, sea turtles, large pelagic fish, sea birds, and other sentinel species) according to the trophic level and feeding habits.
(e) The definition of the occurrence and typology of marine litter in order to design specific mitigation actions.

Actions that address the whole management cycle of marine litter, from monitoring and assessment to prevention and mitigation, as well as actions to strengthen networking between and among pelagic and coastal MPAs are needed.

Fig. 4 Sampling and characterization of marine litter (micro- and macroplastics) and assessment of their abundance in the oceanographic structures (Photos: Maria Cristina Fossi)

Acknowledgments The authors would like to thank all the people involved in the *"Plastic Busters"* initiative and the *Interreg-Med* project *"Plastic Busters MPAs: preserving biodiversity from plastics in Mediterranean Marine Protected Areas"*, co-financed by the *European Regional Development Fund (project n. 3040, grant agreement n. 4MED17_3.2_M123_027).*

References

Baini M, Martellini T, Cincinelli A et al (2017) First detection of seven phthalate esters (PAEs) as plastic tracers in superficial neustonic/planktonic samples and cetacean blubber. Anal Methods 9 (9):1512–1520

Baini M, Fossi MC, Galli M et al (2018) Abundance and characterization of microplastics in the coastal waters of Tuscany (Italy): the application of the MSFD monitoring protocol in the Mediterranean Sea. Mar Pollut Bull 133:543–552

Casini S, Caliani I, Giannetti M et al (2018) First ecotoxicological assessment of *Caretta caretta* (Linnaeus, 1758) in the Mediterranean Sea using an integrated nondestructive protocol. Sci Total Environ 631–632:1221–1233

Claro F, Pham C, Liria Loza A et al (2018) State of the art: entanglement with marine debris by biota. Implementation of the indicator of marine litter on sea turtles and biota in regional seas conventions and MSFD areas. In: report of the European project INDICIT (indicit-europa.Eu), 54 pages (in press)

Collignon A, Hecq J-H, Galgani F, Collard F, Goffart A (2014) Annual variation in neustonic micro- and meso-plastic particles and zooplankton in the Bay of Calvi (Mediterranean–Corsica). Mar Pollut Bull 79:293–298

Compa M, Alomar C, Wilcox C et al (2019) Risk assessment of plastic pollution on marine diversity in the Mediterranean Sea. Sci Total Environ 678:188–196

Cózar A, Echevarría F, González-Gordillo JI, Irigoien X, Úbeda B, Hernández-León S, Palma AT, Navarro S, García-de-Lomas J, Ruiz A, Fernández-de-Puelles ML, Duarte CM (2014) Plastic debris in the open ocean. PNAS 111:10239–10244

Cózar A, Sanz-Martín M, Martí E et al (2015) Plastic accumulation in the Mediterranean Sea. PLoS One 10(4):e0121762. https://doi.org/10.1371/journal.pone.0121762

Deudero S, Alomar C (2015) Mediterranean marine biodiversity under threat: reviewing influence of marine litter on species. Mar Pollut Bull 98:58–68

Fossi MC, Panti C, Guerranti C et al (2012) Are baleen whales exposed to the threat of microplastics? A case study of the Mediterranean fin whale (*Balaenoptera physalus*). Mar Pollut Bull 64:2374–2379

Fossi MC, Coppola D, Baini M et al (2014) Large filter feeding marine organisms as indicators of microplastic in the pelagic environment: the case studies of the Mediterranean basking shark (*Cetorhinus maximus*) and fin whale (*Balaenoptera physalus*). Mar Environ Res 100:17–24

Fossi MC, Marsili L, Baini M et al (2016) Fin whales and microplastics: the Mediterranean Sea and the sea of Cortez scenarios. Environ Pollut 209:68–78

Fossi MC, Romeo T, Baini M et al (2017) Plastic debris occurrence, convergence areas and fin whales feeding ground in the Mediterranean marine protected area Pelagos sanctuary: a modeling approach. Frontiers in marine science, 31 may 2017, art. no. 167. doi:https://doi. org/10.3389/fmars.2017.00167

Fossi MC, Panti C, Baini M et al (2018a) A review of plastic-associated pressures: cetaceans of the Mediterranean Sea and eastern Australian shearwaters as case studies. Frontiers in marine science, 5 May 2018, art. no. 173. doi:https://doi.org/10.3389/fmars.2018.00173

Fossi MC, Pedà C, Compa M et al (2018b) Bioindicators for monitoring marine litter ingestion and its impacts on Mediterranean biodiversity. Environ Pollut 237:1023–1040. https://doi.org/10. 1016/j.envpol.2017.11.019

Galgani F, Claro F, Depledge M, Fossi MC (2014) Monitoring the impact of litter in large vertebrates in the Mediterranean Sea within the European marine strategy framework directive (MSFD): constraints, specificities and recommendations. Mar Environ Res 100:3–9

Germanov ES, Marshall AD, Bejder L et al (2018) Microplastics: no small problem for filter-feeding megafauna. Trends Ecol Evol 33(4):227–232

Godard-Codding CAJ, Fossi MC (2018) Chapter 9: Field sampling techniques and ecotoxicological biomarkers in cetaceans. In: Fossi MC, Panti C (eds) Marine mammal ecotoxicology. Elsevier,

Academic Press, Amsterdam, pp 237–259. https://doi.org/10.1016/B978-0-12-812144-3. 00009-7

Guitart C et al (2019) Mapping the state of knowledge on marine litter and biodiversity interaction in the Mediterranean Sea. PANACeA project report. http://www.etc.uma.es/wp-content/ uploads/Mapping_knowledge_marine_litter_biodiversity_interactions.pdf (in process of publication)

Jambeck JR, Geyer R, Wilcox C et al (2015) Plastic waste inputs from land into the ocean. Science 347:768–771

Panti C, Giannetti M, Baini M et al (2015) Occurrence, relative abundance and spatial distribution of microplastics and zooplankton NW of Sardinia in the Pelagos sanctuary protected area, Mediterranean Sea. Environ Chem 12(5):618–626

Pedrotti ML, Petit S, Elineau A, Bruzaud S, Crebassa J-C, Dumontet B, Martí E, Gorsky G, Cózar A (2016) Changes in the floating plastic pollution of the Mediterranean Sea in relation to the distance to land. PLoS One 11(8):e0161581

RAC/SPA (Regional Activity Center for Specially Protected Areas Protocol-Barcelona Convention) (2017) Defining the Most representative species for IMAP common Indicator 18. RAC/SPA, Tunis, 37 pages

Romeo T, Pietro B, Pedà C et al (2015) First evidence of presence of plastic debris in stomach of large pelagic fish in the Mediterranean Sea. Mar Pollut Bull 95(1):358–361

Suaria G, Aliani S (2014) Floating debris in the Mediterranean Sea. Mar Pollut Bull 86 (1–2):494–504

Suaria G, Avio CG, Mineo A et al (2016) The Mediterranean plastic soup: synthetic polymers in Mediterranean surface waters. Sci Rep 6:37551

UNEP/MAP (2015) Marine litter assessment in the Mediterranean. Athens 2015. ISBN: 978-92-807-3564 2

Van Sebille E, Wilcox C, Lebreton L et al (2015) A global inventory of small floating plastic debris. Environ Res Lett 10(12):124006

Zeri C, Adamopoulou A, Bojanic Varezic D et al (2018) Floating plastics in Adriatic waters (Mediterranean Sea): from the macro- to the micro-scale. Mar Pollut Bull 136:341–350

Plastic in China: A Short History of a Crisis

Isabel Hilton

Abstract 90% of the world's plastic pollution can be attributed to just ten rivers, eight of them in Asia and three of those in China. Like other Asian countries, China has an immense waste management problem: according to the World Bank, China produces 200 million tonnes of garbage a year and shortcomings in waste management in inland China result in large-scale river and ocean pollution. The Yangtze River alone delivers an annual 1.6 million tons of plastic waste into the ocean. Landfill sites are overflowing and there is popular opposition both to incineration and to the many waste-to-energy plants China is building. We examine the causes of China and Asia's plastics problem and what is being done to tackle it.

Keywords China · Plastic waste · Waste management

In January 2018, China instituted an import ban on 24 kinds of solid waste. The ban, announced the previous year, included eight types of plastic scrap, one type of unsorted scrap paper, eleven of scrap textile materials and four types of metal slag containing vanadium.[1] Of that list, the items that caught international attention were the plastics: once the largest importer of waste plastics, China was signalling to the world in the strongest terms that it no longer wanted—or would accept—foreign trash.

The impacts of that long-signalled decision rolled around the world, upending established trade routes, creating bottlenecks of rotting bales of plastic rubbish, and illuminating for consumers, sometimes for the first time, some unpleasant realities behind many recycling schemes. In most advanced economies, citizens had lived with the illusion that when their carefully sorted garbage was collected for recycling,

[1]https://www.recyclingtoday.com/article/plastic-scrap-china-import-ban-2018-mixed-paper/. Accessed 16 June 2019

I. Hilton (✉)
Chinadialogue, London, UK
e-mail: isabel.hilton@chinadialogue.net

© Springer Nature Switzerland AG 2020
M. Streit-Bianchi et al. (eds.), *Mare Plasticum – The Plastic Sea*,
https://doi.org/10.1007/978-3-030-38945-1_7

it would be recomposed, with minimal environmental impact, into new objects of consumption.

In Japan, where garbage collection is so orderly that a different, designated category of waste is picked up each day from millions of homes, few householders were aware that 90% of their discarded plastic was being shipped directly to China. For much of the EU too—collectively the biggest producer of waste plastic, where garbage disposal is governed by regulation and recycling is mandated by EU wide rules—a large percentage of plastic that was categorised as recyclable was loaded into the same containers that had delivered Chinese goods to European ports. The return journey was cheap and shipping the plastics to China was the low-cost practice that lay behind the claims of some EU countries that they achieved a 90% recovery rate for their used plastic.

When the Chinese government shut the door to the world's plastic garbage, these illusions were destroyed and China's decision shone a spotlight on a global plastic crisis that had been building over decades as the volume of plastic the world used and discarded grew. In the 1950s, global plastic production was two million metric tons a year. By 2015, it had reached 322 million metric tons, a staggering growth that had been achieved without serious attention being given to the problems that this volume of a highly durable material was creating. By 2018, the results of that neglect were unavoidable, and no corner of the planet had escaped the impacts: that year, the journal *Marine Policy* reported that remnants of plastic bags had been discovered deep in the Mariana Trench, approximately 10,898 m below the surface. Plastic pollution had reached the farthest depths of the ocean.

The story of how China had become the place where plastic went to die could also be read as an unintended consequence of success. In the early 1970s, a visitor to Mao's China could spend a year there without ever seeing a plastic bag. Food was sold wrapped in paper; customers bought vegetables and fruit loose, taking them home in their own shopping bags; people drank yoghurt from returnable ceramic pots, stamped with the name of the dairy, and they poured beer from large, returnable glass bottles; they drank boiled water from large thermos flasks, and if they wanted to post a parcel, they sat in the post office sewing their goods into white cotton bags that the post office supplied, along with large needles, coarse thread and brushes and ink with which to write the address. None of these activities involved plastic.

But this was no utopian idyll. China was poor and there was little to buy. Basic necessities such as cotton, cooking oil, grain and meat were strictly rationed and other goods—imported fruit, coffee or electronics for example—were simply unavailable. Shopping was seasonal and mostly a matter of tracking down necessities that were in limited supply. Consumption was driven by need more than desire: few goods were elaborately packaged, and none were advertised.

Today's China is many times more prosperous and living standards for most people have improved immeasurably, bringing a spectacular growth in consumption and an explosion in the use of plastic. Over the nearly five decades since the death of Mao Zedong in 1976, and in particular after China joined the World Trade Organization in 2001, China's exports—and its demand for plastic—boomed. By the 1990s, China had gone from a country that produced and consumed almost no

Fig. 1 Women sorting plastics for melting. Outskirts of Guangzhou, China. Photo: *baselactionnetwork*, 2013. Creative Commons Attribution-NoDerivs 2.0 Generic (CC BY-ND 2.0) (https://www.flickr.com/photos/basel-action-network/9263497084/in/album-72157634590265221/. Accessed 16 July 2019)

plastic to be the world's biggest producer, and consequently among the world's top five sources of ocean plastic pollution.

This was no longer an issue confined to China. China's industrial sector had expanded fast as China became the world's factory: demand for energy and raw materials soared and demand for plastic outstripped China's capacity to produce it. China's solution was to import waste plastic from the more advanced economies that were, in turn, both more addicted to plastic use and increasingly concerned about the state of their environment.

The export trade seemed to offer a neat solution. Recycling plastic demanded that it be sorted, and China had the cheap labour that made it economical to do by hand. The waste plastic from wealthier countries that poured into China in the 1980s and 1990s was distributed by a network of agents to thousands of small enterprises, generally family businesses, where some of China's poorest workers hand-sorted the plastics to search for recoverable value. An estimated five million people found employment in these small, informal workshops, and from them emerged the raw material that would be fed into the manufacture of new plastic items such as footwear, bottles, hoses, and hundreds of other products (Fig. 1).

At first glance, it seemed like an arrangement that benefited both sides: it answered the demand for higher environmental standards from consumers in advanced economies, it satisfied China's need for feedstock, and it kept an abundant supply of cheap labour employed. But there were important downsides: solutions to plastic waste are complex and potentially expensive, and the low cost of shipping waste to China was a disincentive in advanced economies to the development of sustainable recycling systems for plastic waste at home: any solution would be more

costly than exporting. The fact that the export trade effectively rendered the problem invisible to consumers and regulators also made it harder to achieve reduced usage or effective recycling.

Nor was it an entirely happy story for China. Not all of the plastic waste that China was importing could be recycled. There were problems of contamination and of banned materials hidden inside containers of usable plastics; shipments could be highly variable, with material of mixed value—some worth recovering, much of it not. In an informal industry with low margins, material that was not worth recycling tended to find the cheapest solution—it was dumped and became part of China's own growing problem of plastic pollution.

By 2015, it was estimated that only 9% of the plastic waste the world had produced had been recycled; by that year, 80% of global plastic waste was being landfilled or was ending up dumped in the wider environment, resulting in an estimated 4–12 million metric tons of waste plastic entering the oceans annually. China is reckoned to be the source of some 3.5 million tons, nearly 30% of the total, and despite the fact that the import trade had spawned a large sector devoted to plastics recycling, China's recycling rate for its own plastic waste averaged only 25%, lower than the EU's average of 30%. That begs the question: why did China need to continue to import when it was already producing large quantities of plastic waste at home?

The answer lay partly in quality—despite the many problems of contamination, imported waste was still of higher quality than domestic plastic waste. In 2018, researchers at China's Academy of Sciences (CAS) analysed (Deng et al. 2018) China's plastic waste and identified three main types—plastic fast food boxes, plastic bags and agricultural plastic film—as the most important sources of indigenous waste.

Plastic food boxes had first come to official notice after 1986, when China Railways began to use them in their onboard meal service. As a result, large quantities of discarded plastic boxes began to accumulate along railway routes, causing what became known as "white pollution". In May 1995, the researchers at CAS noted, the government banned the use of non-degradable fast food boxes on the railway in favour of more easily degradable and recyclable boxes, but the measure had little impact on the problem.

The second major source of domestic pollution—the ubiquitous plastic bag—began to be widely used in the retail trade in the 1990s. Cheap plastic bags were generally discarded without further treatment, polluting roads, river banks, and land in urban areas. The authorities again sought to address the problem through regulation, without much success.

The use of plastic sheeting in agriculture dated back to the early 1950s, but it was in the 1970s that its use accelerated with the introduction of plastic film technology from Japan, as part of the effort to raise China's agricultural output.

All three forms of plastic identified by the CAS researchers had low recycling value, which meant that most of it was discarded into the environment to break down, eventually, into fragments and micro-plastics. The failure to manage the large volume of waste that the use of agricultural plastic generated had an increasingly

negative effect on soil health and productivity, and crops grown on contaminated soil represented a potential risk to human health.

The agricultural waste problem is the more challenging because China's national average recycling rate of 25% conceals wide discrepancies between prosperous, coastal, mostly urban China, and the rural hinterland.[2] In the cities, recycling rates can reach 65%. In contrast, in rural areas they are commonly as low as 5%.[3] This is partly because the relatively low density of waste in the countryside can render it uneconomic to collect.

In the absence of any formal system for waste management, China's rural residents have traditionally resorted to informal disposal, burning their rubbish or dumping it in rivers.

In the days before ubiquitous plastic, this system was more or less sufficient: little was wasted in China's impoverished countryside and little consumed. Today, however, the 95% of rural waste that is not collected for treatment is highly likely to be dumped in China's rivers and to make its way to the ocean. And it is likely to contain a high percentage of plastic.

Three of China's great rivers have been identified as among the world's top five sources of plastic pollution and China's coastal environment is the first to suffer.[4] Every year since 2007, China's *Marine Environment Quality Bulletin* had reported on the nation's marine pollution, including plastic. Officials monitor floating garbage, beach garbage and submarine garbage at nearly 50 coastal stations, to record and analyse the scale of the waste pollution. In the 2017 edition,[5] they reported that plastics accounted for 87% of China's marine floating garbage, 76% of beach garbage and 74% of submerged marine garbage, the highest proportion of any material in each category.

That same year, marine departments also reported concentrations of microplastics in the Bohai Sea, the Yellow River, the East China Sea and the northern South China Sea, averaging $245/m^2$, but in some places reaching $504/m^2$.

Other countries in Asia suffer from similarly poor waste management: over half of the plastic waste that leaks from land into the ocean each year originates in just five Asian countries: China, Indonesia, the Philippines, Thailand, and Vietnam, all of which have failed to manage the waste that the rapid growth of their economies has generated. Like China, they suffer from low collection rates and high leakage of uncollected waste, but also like China, from leakage from within poorly managed waste collection systems. This post-collection leakage can be due to improper dumping, and to poorly located or uncontrolled dump sites.

[2]https://oceanconservancy.org/wp-content/uploads/2017/04/full-report-stemming-the.pdf. Accessed 16 June 2019

[3]https://oceanconservancy.org/wp-content/uploads/2017/04/full-report-stemming-the.pdf. Accessed 16 June 2019

[4]http://ec.europa.eu/environment/marine/good-environmental-status/descriptor-10/pdf/GESAMP_microplastics%20full%20study.pdf. Accessed 16 June 2019

[5]http://www.nmdis.org.cn/gongbao/nrhuanjing/nr2017/201806/t20180625_37509.html. Accessed 16 June 2019

Public concern about the impacts of plastic waste on China's environment had been evident for some time, stimulated in part by a growing environmental movement and also by the impact of two documentaries that exposed appalling conditions in China's informal waste management sector. The director of both documentaries, the photographer and film director Wang Jiuliang, began to look at conditions in informal waste management around Beijing in 2008. He investigated more than 500 landfill sites for his 72-minute film, *Beijing Besieged by Waste.*[6] It had an immediate effect: for the first time, Beijing's authorities felt pressure to take responsibility for the state of the more than 1000 landfills that surrounded the city, budgeting RMP10 billion yuan in 2010 to clean up the sites. Revisiting sites in 2011 and 2012, Wang found that in many a cleanup and remediation was underway.

By 2014, he had completed his second documentary, *Plastic China,* the product of a further 3 years of filming and interviews with people in the informal waste plastic sector. He focused on a migrant family whose father never earned enough to keep his promise to send his 11-year-old daughter to school. Instead, his daughter was obliged to work alongside him processing waste plastic. The film went viral on the Chinese internet until it abruptly vanished.[7] It was shown at the *International Documentary Film Festival in Amsterdam* in November 2016, and subsequently at the *Sundance Film Festival* in 2017.

Plastic China exposed the harsh reality behind China's position as the world's garbage dump, and the failure of repeated official attempts to control the negative impacts of the trade. In 2008 and 2009, the then Ministry of Environmental Protection, concerned, amongst other issues, about the problem of contamination, had issued regulations aimed at restricting the import of solid waste for recycling. Four years later, in 2013, an initiative called *Green Fence* signalled another attempt to get control of the trade, introducing new rules on plastic imports. The aim was to reduce contamination levels and the smuggling of unusable materials inside bales of waste, and to eliminate unregistered consignments entirely.

Green Fence was generally judged more successful than earlier efforts and resulted in a reduction of the amount of waste accepted at the border in 2013. Some shipments were even returned to source countries and the plastics trade with China began to shrink. Five years later, China resolved to eliminate it entirely.

The 2018 waste ban had global impacts, but not the positive effects that many hoped for. Researchers at the University of Georgia predicted (Brooks et al. 2018) that the world could have 111 million metric tons of excess plastic trash by 2030 as a result of China's 2018 ban on "foreign garbage", but instead of improving domestic recycling, exporting countries once again began to look for alternative markets. In

[6]https://www.chinadialogue.net/culture/6947-Film-How-China-became-the-world-s-rubbish-dump/en. Accessed 16 June 2019

[7]https://www.nytimes.com/2017/04/28/world/asia/chinas-environmental-woes-in-films-that-go-viral-then-vanish.html. Accessed 19 June 2019

the months following the Chinese ban, plastic waste problems began to be reported from Vietnam, Malaysia[8] and the Philippines.

Of course, the import ban did not solve China's indigenous waste problems, but those problems had attracted high-level attention: President Xi Jinping issued an order in 2019 that China should be sorting its own waste. Under a new law, 46 Chinese cities were ordered to recycle 35% of their commercial and government sector waste by 2020.

Household waste remains outside the target, and critics point out that it is unclear how the targets will be monitored and enforced. Chen Liwen, an expert on China' waste management systems, complained to the producers of the podcast *8 million*[9] that the regulations are incomplete, as the 35% recycling regulation does not clearly state what should be included, and since China's garbage statistics are inaccurate, even a base line against which to measure the 35% rate was lacking.

Since the early efforts to deal with the sudden tide of plastic food boxes along China's railways, the authorities have repeatedly attempted to regulate domestic plastic pollution, but so far, the volume of domestic waste has continued to defy their attempts at control.

In 2007, regulations on single-use plastic bags had a brief effect, but they were ignored in China's informal markets and the impact was swiftly overtaken by the growth in online shopping and food delivery, each of which generated new volumes of plastic.

The Chinese Academy of Science estimated that China's express delivery industry used about 14.7 billion plastic bags in 2016. In 2017, Chinese consumers spent RMB200 billion yuan on food takeaways, all of which used plastics. By 2017, China's express delivery business accounted for 40 billion bags, which represented an annual output of eight million tons of garbage. CAS researchers have detailed a series of laws, administrative regulations and industry standards on plastic waste management that have been promulgated since 1995, but diligent though China's regulators may have been, their efforts have failed to keep up with the speed of expansion of China's plastic problem. A number of shortcomings in the laws and regulations limit their effect: they often contain vague statements of principle rather specific provisions or penalties, which makes them ineffective in practice; accountability is not helped by a failure to assign clear responsibilities to government departments, including those that have a specific mandate for environmental protection, or are involved with market management, agriculture and construction, all of which contributed to the problem. Finally, the costs of managing the waste are not borne by the polluters.

Nor did the regulatory environment create effective incentives for the informal sector, according to Chen Liwen. Even when China imposed a charge for plastic bags, she argues, the revenue generated by supermarkets did not translate into the

[8]https://www.weforum.org/agenda/2018/10/swamped-with-plastic-waste-malaysia-struggles-as-global-scrap-piles-up/. Accessed 16 June 2019

[9]https://sustainableasia.co/eight-million-episode-3. Accessed 16 June 2019

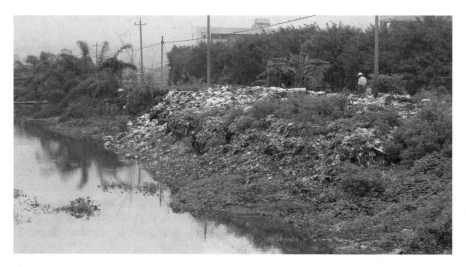

Fig. 2 Typical of thousands of local waste dumps. Guiyu, China. Photo: *baselactionnetwork*, 2013. Creative Commons Attribution-NoDerivs 2.0 Generic (CC BY-ND 2.0) (https://www.flickr. com/photos/basel-action-network/9260719493/in/album-72157634590265221/. Accessed 16 July 2019)

cost of recycling and treatment of the bags. As a result, the informal waste sector, which is unpopular with urban planners who often fail to provide it with working space in the cities, and which struggles to make a profit, is shrinking.

Because of the low value of the refuse, most of it is disposed of in landfill, even where collection is efficient. These plastics continue to pose an environmental risk to water and soil as they slowly degrade. To try to improve the deteriorating state of its rivers, the government has implemented a new system of responsibility for river management. At the end of 2017, the Central Committee of the Communist Party and the State Council issued the *Opinion on Comprehensively Promoting the River Chief System*[10] which assigned responsibility to local government leaders for pollution incidents in rivers and lakes. As a study of the treatment of rural domestic waste in China notes, treatment rates have risen (Fig. 2).

In the view of the *China Association for the Circular Economy*,[11] the options for the treatment of waste plastics remain recycle, landfill or incineration.[12] In the past decade incineration has been the fastest growing of the three, despite its controversial history in China.

[10]http://www.china.com.cn/zhibo/zhuanti/ch-xinwen/2016-12/12/content_39896976.htm. Accessed 18 June 2019

[11]http://www.chinacace.org/news/view?id=9083. Accessed 15 June 2019

[12]http://www.chinacace.org/news/view?id=9083. Accessed 19 June 2019

Public protests against proposed incineration plants date back to June 2007[13] when local people objected to a facility at Liulitun[14] in Beijing. Since that small demonstration, protests have become commonplace. Seven further protests erupted in the following 6 months in Beijing, Jiangsu, Guangdong and Shanghai, China's most developed cities where residents have higher levels of environmental awareness.

In 2008, despite the public disquiet and fierce debates about environmental damage, the government decided to invest in incineration to cope with the annual 350 million tonnes of waste that China was producing. It was growing at an annual rate of 8% and since there was more than could be treated, the government saw incineration as a solution that could both provide energy and solve the waste disposal problem especially in cities where land is scarce and garbage abundant.

The government set a national target of increasing China's waste-processing capacity by 400,000 tonnes over the period of *12th Five Year Plan* (2011–2015) and RMB140 billion yuan (US$22 billion) of new investment was promised, to bring total spending on waste-disposal to RMB260 billion yuan (US$41 billion). More than RMB100 billion yuan of that was reported to be for 300 new waste incinerator power plants, which would be capable of handling around 30% of China's garbage.

The provinces of Shandong and Zhejiang made plans for 20 new plants each; Fujian Province planned 17, Jiangsu 14 and Guangdong 13, but as the sector expanded, so did the protests. The first plants leaked fumes and bad smells, which further convinced protesters that they were likely also to be leaking harmful dioxins.[15] There was little confidence that local governments would supervise them effectively, especially given that many had conflicts of interest with regard to the plants.[16]

The *Wuhu Ecological Centre* in Anhui province criticises the industry for its failure even to publish emissions data. In 2016, only 77 of the 230 incinerators agreed to disclose data, and a quarter of them failed the emission standards. According to business professionals, new plants, built with the latest technology, have significantly reduced emissions.

The sector did not have a regulatory framework until 2012 and operated under out of date and vague standards that dated from the 1990s, which meant that what was burned was also poorly regulated. Unlike in the informal waste sector, however, the regulatory framework for incineration allowed the industry to become highly profitable. Once the capital cost had been repaid, the operating costs were low and the

[13]https://www.chinadialogue.net/article/show/single/en/1117-Small-yet-brave. Accessed 15 June 2019

[14]https://www.chinadialogue.net/article/show/single/en/4414. Accessed 19 June 2019

[15]https://www.who.int/en/news-room/fact-sheets/detail/dioxins-and-their-effects-on-human-health. Accessed 19 June 2019

[16]https://www.chinadialogue.net/article/show/single/en/8971-The-waste-to-power-reality-faked-emissions-data-and-huge-profits. Accessed 15 June 2019

plants had steady income from garbage-disposal fees and from electricity sales, along with generous tax breaks and opportunities for the sale of by-products. Licenses were granted for up to 30 years, offering an investor 20 years of stable returns.

The government continued to back the expansion of the sector[17] and had set a target for 2020 of 600,000 tonnes a day in garbage power generation, according to the *Thirteenth Five-Year Plan* for the *Construction of National Urban Domestic Waste Harmless Treatment Facilities*.[18] Protests continue, but officials continue to regard waste incinerators as environmentally friendly and have begun to promote incineration as part of China's growing circular economy. Waste-to-power plants are less expensive to build than wind and solar power stations, with easily available technologies. But the industry was plagued with a reputation for corruption and, as it expanded, with problems of garbage supply. Some plants, like a waste-to-power plant in Xingyi, Guizhou, designed and operated by the *Hongda Environmental Electricity Group*, had been built to produce both electricity and building materials and to dispose of 700 tonnes of waste daily, but the company found it was unable to source more than 500 tonnes of waste a day, below the threshold estimated as break even.[19]

In more rural areas, plants regularly found they could generate power only 35% of the time and waste disposal subsidies were often paid late. Where projects were likely to be unprofitable, companies sometimes took advantage of protests to shelve them after winning the contract, using the finance for other projects. Public suspicion remains high, as plants are suspected of misreporting emissions. In 2014, the Ministry of Environmental Protection issued a pollution standard for incineration plants, but industry insiders acknowledge that results can be manipulated, and dioxin pollution can be hard to detect.

The *2005 Renewable Energy Law* was key to the stimulus of waste to energy plants in China, but China still lacks a sustainable infrastructure for waste treatment. The lack of effective sorting means that wet waste arrives in incinerators, which requires higher temperatures, lowers the waste-to-energy ratio and releases more toxins.

For those who oppose this heavy investment in incineration, there is concern that it reduces the incentive to reduce plastic usage. Mao Da, co-founder of *Zero Waste Alliance*, argued in the podcast *8 million*[20] that waste-to-energy can be a good solution to dispose of material where the only other option is landfill, but that recycling and reducing are better.

[17]http://www.ndrc.gov.cn/zcfb/zcfbghwb/201701/W020170123357045898302.pdf. Accessed 15 June 2019

[18]http://www.ndrc.gov.cn/zcfb/zcfbghwb/201701/W020170123357045898302.pdf. Accessed 19 June 2019

[19]https://www.chinadialogue.net/article/show/single/en/8971-The-waste-to-power-reality-faked-emissions-data-and-huge-profits. Accessed 15 June 2019

[20]https://sustainableasia.co/eight-million-episode-5. Accessed 15 June 2019

In other policy moves, in January 2019, the government announced a *"zero waste city"* pilot project, aimed at developing an urban environment model that minimises landfill by promoting green development and lifestyles. It also aims to transform solid waste into useful resources. Ten cities will be selected for the pilot, with ambitions to develop an index system, an integrated management system and a technical system for the construction of cities without waste by 2020.

The *zero-waste city* pilot[21] and the *Domestic Waster Classification System Implementation Scheme*[22] require compulsory domestic waste classification in 46 cities throughout the country; it will be difficult to avoid the need for effective waste recycling systems and plastic waste is likely to be a top priority. Until China builds a more effective circular economy, however, incineration may be the best option.

References

Brooks AL, Wang S, Jambeck JR (2018) The Chinese import ban and its impact on global plastic waste trade. Sci Adv 4(6):eaat0131. https://advances.sciencemag.org/content/4/6/eaat0131.full. Accessed 11 July 2019

Deng Y, Lei K, An L et al. (2018) Countermeasures for source control of plastic waste and microplastic pollution. http://www.bulletin.cas.cn/publish_article/2018/10/20181005.htm. Accessed 16 June 2019

[21] http://www.chinacace.org/news/fieldsview?id=10380. Accessed 19 June 2019

[22] http://www.ndrc.gov.cn/zcfb/zcfbqt/201703/W020170331310014947378.pdf. Accessed 15 June 2019

"Down by the River": (Micro-) Plastic Pollution of Running Freshwaters with Special Emphasis on the Austrian Danube

Aaron Lechner

Abstract The significance of rivers and streams as transport vectors of terrestrial plastic debris has long been neglected. It is now known, however, that flowing waters have high concentrations of a variety of plastics, differing in chemical composition, physical properties and size. Especially microplastics, fragments smaller than 5 mm in diameter, pose a complex risk to lotic ecosystems all over the world. Amongst other effects, these particles are ingested by various aquatic organisms, leach endocrine-disruptive compounds and act as vectors for waterborne contaminants, pathogens and alien species.

In this chapter, we track microplastic particles in running waters from their potential sources (e.g. plastic production sites, wastewater treatment plants), to their probable final sinks: the world's oceans. En route, they potentially become ingested, colonized, collected or deposited. A plethora of peer-reviewed publications constitute the scientific background of this journey, giving insights into a current hot topic of environmental pollution research.

A case study of the River Danube is included. Pioneering research on plastic contamination in the Austrian section of the river, dealing with microplastic origin, -abundance and -input to the Black Sea, provided a prelude for a holistic examination of freshwater plastic pollution.

Keywords Microplastics · Rivers · Danube · Freshwater pollution

1 Introduction

> Don't go near the water
> Don't you think it's sad
> What's happened to the water
> Our water's going bad
> (The Beach Boys)

A. Lechner (✉)
District authority Bludenz, Department of Economy and Conservation, Bludenz, Austria
e-mail: aaron.lechner@protonmail.com

If you are looking for plastic waste in the environment you will find some on remote beaches in the Hawaiian archipelago (McDermid and McMullen 2004), in the Sonoran Desert (Zylstra 2013), in deep-sea sediments (Woodall et al. 2014), embedded in the Arctic ice (Obbard et al. 2014), in subalpine lakes (Imhof et al. 2013) or in groundwater systems (Panno et al. 2019). Plastic has virtually contaminated all ecosystems (terrestrial and aquatic), but especially the world's oceans act as catch basins for plastic material.

The growing awareness of marine plastic pollution has gone hand-in-hand with a rapidly increasing number of relevant scientific publications since the 1980s (Blettler et al. 2018).

Various studies on abundance and distribution patterns of plastic litter (Law et al. 2010; Galgani et al. 2015), impacts on a broad range of organisms (from bacteria to whales: Zettler et al. 2013; de Stephanis et al. 2013), ecological effects and socio-economic/political aspects (Rochman et al. 2013a; Villarrubia-Gómez et al. 2018) have shed a light on what is considered one of the most serious threats for the oceans worldwide.

Actually just a small proportion of the plastic (approx. 20%) enters the oceans directly (via fishing industry, beach tourism, etc.) and the larger part (approx. 80%) stems from land-based sources (Andrady 2011). More recently, running freshwaters have been identified as major carriers of this terrestrial plastic load into the seas (Moore et al. 2011; Lechner et al. 2014). These findings revealed a previously undetected (or ignored) environmental issue, the severe contamination of our rivers with artificial polymers, and triggered the implementation of relevant research. Still, a wide knowledge gap exists between limnic and marine ecosystems regarding all aspects of plastic pollution. This is, inter alia, reflected in the uneven distribution of aquatic plastic pollution studies between the years 1980 and 2018, with 87% being related to oceans and 13% deriving from freshwaters only (both lentic and lotic; Blettler et al. 2018). The state of scientific output, considering rivers and streams exclusively, is plotted in Fig. 1. Though a steady rise in publication numbers can be observed lately (since 2014), the current data situation does not match the environmental priority of the topic by far.

The existing literature, however, clearly indicates that the presence of plastic waste in rivers, the corresponding impacts on stream biota, and ecological consequences are similarly far-reaching as reported for marine habitats (Dris et al. 2015a). A synopsis of the data on riverine plastic pollution is provided in Tables 1–6, including information on litter abundance, litter size, litter genesis, litter type and sampling methods. These tables will be referenced throughout the whole chapter.

Plastic pollution research in rivers has put the focus on *microplastics* (hereinafter termed MP; Eerkes-Medrano et al. 2015; Tables 1–6), which includes, according to several classification schemes, particles between 1 μm and 5 mm in diameter (Hidalgo-Ruz et al. 2012). Larger items are usually categorized *mesoplastics* (5–25 mm) or *macroplastics* (larger than 25 mm) (Blair et al. 2017), and particles <1 μm are referred to as *nanoplastics* (Gigault et al. 2018).

A further separation between *primary* and *secondary* MP is based upon the genesis of the material. Primary MP is specifically manufactured to be of small

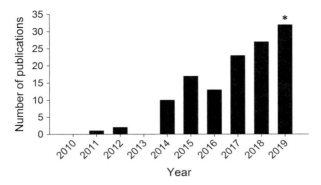

Fig. 1 Scientific output on plastic pollution of running freshwaters in the last decade. The chart is based upon a request in the database *Google Scholar©* (search terms = "freshwater", "river", "stream", "plastic pollution", "microplastics", "macroplastics"). For 2019, all available papers up to and including the 20th of May (∗) are considered

size for various applications. For example, it comprises the abrasive material in cleaning-, personal care- and cosmetic products (i.e. scrubbers, micro-beads) as well as the precursors in plastic production industry (resin pellets) (Cole et al. 2011). Secondary MP is a decay product, resulting from the breakdown of meso- and macroplastic items by processes such as biodegradation, photodegradation and mechanical abrasion. A sub-category of secondary MP, including particles that arise as a consequence of wear during the product lifetime instead of environmental weathering (e.g. synthetic fibres from textiles, abrasion from car tyres and synthetic paints), was proposed by Eerkes-Medrano and Thompson (2018). In general, MP litter occurs in a variety of colours and forms but a coarse division in *fibres* (one dimension larger than the two other dimensions), *fragments* (two dimensions are large in contrast to a small third dimension) and *spherules* (similar extent of all three dimensions), as applied by Dris et al. (2015a, b), seems adequate (*see* Tables 1–6). Additionally, *film* (thin, with two smooth planes) and *foam* (various shapes) are regularly detected MP types (Faure et al. 2015; Battulga et al. 2019).

The particular scientific attention for MP is based on its high abundance in rivers (Baldwin et al. 2016) and some of its properties are that:

1. The hydrophobic surface of plastic adsorbs hydrophobic organic contaminants (HOCs) from the surrounding water, comprising chemicals (e.g. polychlorinated biphenyls; PCBs) and heavy metals (e.g. Cu, Zn) that are evidentially harmful (e.g. endocrine disruptive, carcinogenic: Teuten et al. 2009; Ashton et al. 2010; Brennecke et al. 2016). Due to their large surface-to-volume ratios, MP particles are especially susceptible to contamination (Cole et al. 2011). Several studies have detected significant higher concentrations (up to 10^6) of these substances on MP surfaces than in the ambient seawater (Mato et al. 2001).

2. MP is not biochemically inert and leaches chemical additives ("plasticizers") to the aquatic environment, which have been incorporated during the manufacturing process in order to impart various properties to the product (e.g. heat stabilizers,

Table 1 Synopsis of plastic pollution studies in rivers

References	Country	River	Sampling site	Sampling method	Mesh size net (µm)	Detected sizes	Dominant size	Dominant genesis	Dominant type	Mean particle number/scale unit
Baldwin et al. (2016)	USA	29 Great Lakes tributaries	Surface water	Neuston net	333	MIP, MAP	MIP	SMP	Fibres	4.2/m³
Ballent et al. (2016)	Canada	4 tributaries of Lake Ontario	Sediment	Grab sampler	×	MIP, MAP	MIP	SMP	Fragments	610/kg
Battulga et al. (2019)	Mongolia	Selenga	Sediment	Hand sampling	×	MIP, MAP	MIP	SMP	Foam	MIP: 120.14 ± 121.49/ 100 m²
									Film	MAP: 10.88 ± 37.03/ 100 m²
Blair et al. (2017)	Scotland	Kelvin	Sediment	Hand sampling	×	MIP	×	SMP	Fibres	161–432/kg (count range)
Castañeda et al. (2014)	Canada	St. Lawrence	Sediment	Grab sampler	×	MIP	×	PMP	Spherules	13,759 ± 13,685/ m²
Dris et al. (2015b)	France	Seine	Surface water	Neuston net, Manta net	80, 330	MIP, MAP	MIP	×	Fibres	Plankton net: 30/m³
										Manta trawl: 0.35/m³
Faure et al. (2015)	Switzerland	Rhone	Surface water	Manta net	300	MIP, MAP	MIP	SMP	Fragments, foam	0.13–2.3/m³
Faure et al. (2015)	Switzerland	Aubonne	Surface water	Manta net	300	MIP, MAP	MIP	SMP	Fragments, foam	0.10 ± 0.04/m³

Acronyms used: MIP (microplastics), MAP (macroplastics, particles >5 mm), PMP (primary microplastics), SMP (secondary microplastics). Particle densities are given as mean values (± standard deviation, if available) or counts, indicated in brackets (count, count range). All values refer to MIP, unless otherwise specified (MAP). Empty fields indicate the lack of relevant information

Table 2 Synopsis of plastic pollution studies in rivers

References	Country	River	Sampling site	Sampling method	Mesh size net (µm)	Detected sizes	Dominant size	Dominant genesis	Dominant type	Mean particle number/scale unit
Faure et al. (2015)	Switzerland	Venoge	Surface water	Manta net	300	MIP, MAP	MIP	SMP	Fragments, foam	6.5–64/m³
Faure et al. (2015)	Switzerland	Vuachere	Surface water	Manta net	300	MIP, MAP	MIP	SMP	Fragments, foam	4.4 ± 1.3/m³
Hoellein et al. (2017)	USA	North Shore Channel	Surface water, Sediment	Neuston net, Grab sampler	333	MIP	×	×	Fibres	Surface water: 1.67–10.36/m³ (count range); Sediment: 36–1613/L (count range)
Hohenblum et al. (2015)	Austria	Danube	Water column	Various nets	41, 250, 500	MIP, MAP	×	SMP	Fragments	MIP + MAP: 0.029–0.516 g/1000 m³
Horton et al. (2017)	UK	Leach	Sediment	Hand sampling	×	MIP	×	SMP	Fibres	18.5 ± 4.2/100 g
Horton et al. (2017)	UK	Lambourn	Sediment	Hand sampling	×	MIP	×	SMP	Fibres	22.1 ± 9.5/100 g
Horton et al. (2017)	UK	The cut	Sediment	Hand sampling	×	MIP	×	SMP	Fragments	33.2–66/100 g
Hurley et al. (2017)	UK	Irwell	Sediment	Core sampler	×	MIP	×	SMP	Fragments	1793 ± 1275/m²
Hurley et al. (2018)	UK	10 Rivers	Sediment	Cylinder resuspension technique	×	MIP	×	×	Fragments, Spherules	Pre-flooding: 6350/kg Post-flooding: 2812/kg

Acronyms used: MIP (microplastics), MAP (macroplastics, particles >5 mm), PMP (primary microplastics), SMP (secondary microplastics). Particle densities are given as mean values (± standard deviation, if available) or counts, indicated in brackets (count, count range). All values refer to MIP, unless otherwise specified (MAP). Empty fields indicate the lack of relevant information

Table 3 Synopsis of plastic pollution studies in rivers

References	Country	River	Sampling site	Sampling method	Mesh size net (μm)	Detected sizes	Dominant size	Dominant genesis	Dominant type	Mean particle number/scale unit
Jiang et al. (2019)	Tibet	5 Rivers	Surface water, Sediment	Flow sampler, Hand sampling	45	MIP	×	×	Fibres	Surface water: 483–967/m³ Sediment: 50–195/kg
Kapp and Yeatman (2018)	USA	Snake	Surface water	Neuston net, Glass jar	100	MIP	×	SMP	Fibres	2.54/m³
Kataoka et al. (2019)	Japan	29 Rivers	Surface water	Neuston net	335	MIP	×	SMP	Fragments	1.6 ± 2.3/m³
Klein et al. (2015)	Germany	Main	Sediment	Hand sampling	×	MIP, MAP	MIP	SMP	Fragments	786–1368/kg (count range)
Klein et al. (2015)	Germany	Rhine	Sediment	Hand sampling	×	MIP, MAP	MIP	SMP	Fragments	228–3763/kg (count range)
Lahens et al. (2018)	Vietnam	Saigon	Surface water	Neuston net, Manta net, Water sample	300	MIP, MAP	MIP	SMP	Fibres, Fragments	Fibres: 172,000–519,000/m³ (count range) Fragments: 10–223/m³ (count range)
Lechner et al. (2014)	Austria	Danube	Surface water	Neuston net	500	MIP, MAP	MIP	PMP	Spherules	316.8 ± 4664.6/1000 m³
Leslie et al. (2017)	Netherlands	Amsterdam canals	Surface water, Sediment	Hand sampling, Grab sampler	× ×	MIP	×	SMP	Fibres	Surface water: 100 ± 49/L Sediment: 2071 ± 4146/kg

Acronyms used: MIP (microplastics), MAP (macroplastics, particles >5 mm), PMP (primary microplastics), SMP (secondary microplastics). Particle densities are given as mean values (± standard deviation, if available) or counts, indicated in brackets (count, count range). All values refer to MIP, unless otherwise specified (MAP). Empty fields indicate the lack of relevant information

acid scavengers, slip compounds, flame retardants). Frequent chemical compounds in these additives such as bisphenol A, phthalate and organotins are toxic. Their adverse effects on biota and humans are broadly described in the literature (see review by Teuten et al. 2009).
3. As the bioavailability of plastic increases with decreasing particle size, MP is available to a broad size-range of freshwater species, from lower trophic organisms in the food web (phyto- and zooplankton: Yokota et al. 2017; Imhof et al. 2013) to large apex predators (e.g. water birds, predatory fish, mammals: Holland et al. 2016; Smiroldo et al. 2019). Direct physical implications of ingestion, as internal abrasions and blockages (of the digestive system), can lead to diminished appetite, nutrient dilution, reduced growth rates and starvation (see review by Wright et al. 2013). Very small particles can even pass cell membranes and become incorporated into body tissue, where they trigger inflammation responses (see review by Eerkes-Medrano and Thompson 2018). Other harmful effects on biota arise from the simultaneous uptake of the above-mentioned hazardous chemicals.
4. MP has a high dispersal potential in rivers and streams. The combination of external transport vectors (e.g. current, discharge, wind, turbulence) and inert particle properties (e.g. density, shape, size) causes a broad-scale distribution of MP across habitats (benthic, pelagic, riparian and floodplain).

Rivers and streams have huge societal importance, as they provide many essential services to humans, including water supply for municipal-, industrial- and agricultural users, food production, recreation, and hydropower generation (Loomis et al. 2000). In spite of this, or because of it, the world's rivers are among the most threatened ecosystems, experiencing dramatic declines in biodiversity (Dudgeon et al. 2006). The principal anthropogenic stressors have been described in a recent review article by Best (2019). Beside *damming, climate change, water withdrawal, fragmentation, non-native species, sediment dredging, mining* and *bank erosion*, the author names *water pollution* as a severe problem, emphasizing the recently discovered significance of (micro-) plastic waste.

Based on the current state of knowledge, MP impacts fluvial systems at different levels of biological organization (e.g. cell, tissue, organ, individual, population) and spatial scales (from micro- to macrohabitats, from source to mouth). Targeting water quality and river restoration issues, plastic pollution will be one of the pressing problems in the years to come. As it concerns one of the world's most essential natural resources (water), it definitely deserves greater scientific and public attention.

This chapter deals with plastic pollution of rivers with an in-depth look at particles smaller than 5 mm (MP). The sparse literature on freshwater MP is characterized by an exceptionally high number of excellent review articles (Wagner et al. 2014, 2018; Eerkes-Medrano et al. 2015; Dris et al. 2018; Li et al. 2018a, b; Windsor et al. 2019), which (unsurprisingly) have much overlap in content. Another extensive review of the literature was therefore unnecessary. Instead, I present a compact introduction to the field, and include four interviews with renowned experts

(Dafne Eerkes-Medrano, Alice Horton, Hannes Imhof, Hubert Keckeis, Bill Turrell), who give insights into actual and prospective challenges of MP pollution research.

The chapter comprises four sections. The first one (*Sources*) covers potential pathways of MP to freshwater environments and discusses mitigation strategies. The second section (*En route*) highlights the various fates of MP during transport in rivers, namely the uptake by aquatic biota, the settlement of organisms on the particle surface, the deposition in different habitats and the removal of the material (by humans). The third section (*Input to oceans*) summarizes all available models that estimate plastic inputs from rivers into oceans. In the last section (*Danube*), various aspects of plastic pollution in Europe's second largest river are reviewed. The Austrian Danube is a rare case, with existing plastic abundance data over the whole river width and known point sources of MP within a national park area.

2 Sources

Obviously, all plastic litter items in rivers derive from human activities or omissions, involving the intentional (e.g. illegal dumping, careless discarding) and unintentional (e.g. accidental losses during transport and production, insufficient filtering systems at sewage drains, wear of plastic products) release of the material (Lechner and Ramler 2015; Rech et al. 2015). In order to stop present and future littering, pinpointing input locations of plastic waste is essential. Many studies emphasize the need for targeted research on the origin and sources of freshwater MP, and a clear distinction between these terms (as used in literature) is necessary.

Origin primarily defines a specific place of production (e.g. primary MP production plants) and infrequently the whole industry or product division (e.g. packaging sector, textile industry, plastics production industry). *Sources* are concrete locations (*point sources*) or general transport routes (*diffuse sources,* e.g. atmospheric fallout, surface runoff), over which MP enters the aquatic environment. Both origin and source identification in rivers proved to be complicated, owing to the high dispersal and dilution rates of the small particles (Klein et al. 2015).

A tracking of particles to their origin (production site) has rarely been successful: for example, when the place of production simultaneously acted as a point source (Lechner and Ramler 2015). Otherwise, sophisticated material analysis (e.g. FTIR, Raman spectroscopy, Pyrolysis-GC/MS), in combination with strategic sampling along the river course, can narrow down the possible place of origin, at least for primary MP (Mani et al. 2019). Regarding secondary MP, which dominates in rivers (see Tables 1–6), such investigations are ineffective due to polymer heterogeneity and the loss of origin identification traits during particle degradation in the environment (Ter Halle et al. 2016).

Until recently, substantial lack of knowledge also prevailed concerning the sources of MP in running freshwaters, but the scientific community is seeking to close this gap. Frequently, MP densities in rivers increase with flow length (Mani et al. 2015; Kapp and Yeatman 2018), and peak in urbanized and densely populated

watersheds (Yonkos et al. 2014; Zhang et al. 2015; Baldwin et al. 2016; Nel et al. 2018; Battulga et al. 2019), where they positively correlate with other indicators of water pollution (e.g. total phosphorous, total nitrogen, biochemical oxygen demand; Kataoka et al. 2019). Within these areas of intense human activity, the following sources of riverine MP are empirically proven.

2.1 *WWTPs-Wastewater Treatment Plants* (Point Source)

WWTPs potentially receive MP via municipal or industrial effluents and surface runoffs (storm water). Hence, they are collecting points for a variety of MP types.

Fibres and microbeads, the dominant particles in municipal wastewaters, are often directly rinsed down household drains. Browne et al. (2011) showed that different garments lose considerable amounts of fibres during machine washing, with fleeces and micro-fleece products shedding the most (more than 1900 fibres per wash). Additionally, the daily per capita discharge of microbeads from cosmetic and care products into domestic effluents approximately ranges between 2 and 200 mg (Gouin et al. 2011; Napper et al. 2015). Industrial effluents inter alia transport MP swarf from plastics processing (e.g. milling, shredding, sawing) and primary MP products (e.g. pellets, granule, spherules) (Mahon et al. 2014). Surface runoffs mobilize a potpourri of MP particles, most effectively from impervious grounds (e.g. factory yards, roads, urban places; see *surface runnoff*), and flush them to the sewerage system (Horton and Dixon 2018).

Commonly, WWTPs apply between one and three (cascading) treatment stages (primary, secondary, tertiary), producing effluents with ascending water quality and decreasing MP densities (Carr et al. 2016; Mintenig et al. 2017). However, single plants often feature individual cleaning processes and techniques within these purification stages (as screening, skimming, sedimentation, aeration, filtration and flocculation), implying different removal efficiencies for MP and for specific size- and density classes (Nizzetto et al. 2016a, b; Fahrenfeld et al. 2018). The retention potential is usually greater for denser particles (e.g. fibres), which are effectively retained in the sewage sludge (Bayo et al. 2016). Even at high removal rates, considerable amounts of MP can exit the plants when large volumes (i.e. population equivalents) are treated (Murphy et al. 2016; Kay et al. 2018). Furthermore, some WWTPs receive rainwater and sewage from one single sewer and release unfiltered amounts of this combined wastewater directly into rivers, when discharge levels in the sewer exceed a certain threshold.

Consequently, the measured MP densities in final WWTPs effluents and their concentrations in receiving surface waters are highly variable, as shown by the examples below:

- Based upon lab experiments, the removal efficiency for cosmetic microbeads in the Central Municipal Wastewater Treatment Plant of Ljubljana, Slovenia, was estimated at 52%. Assuming a daily per capita emission of 15.5 mg microbeads,

the authors extrapolated a daily input of 1 kg to the receiving River Ljubljanica, equating to a MP concentration of 21 particles/m^3 at average flow (Kalčíková et al. 2017a).

- According to Leslie et al. (2017), the average removal rate (in the sludge) of seven different WWTPs in Holland was 72%, with pronounced time-of-day variations in particle emission.
- Dris et al. (2015b) reported removal rates between 83% and 95% for fibrous MP (probably sourcing from domestic laundry) at the Seine-Centre wastewater treatment plant, with a corresponding mean count of 35,000 particles/m^3 in the final effluent.
- The River Clyde (Glasgow) received an estimated daily amount of 65,238,500 particles from a secondary municipal WWTP, even though 98% of the initial plastic load are being filtered (primary treatment: 78%, secondary treatment: 20%) (Murphy et al. 2016).
- A comparison between particle numbers in raw sewage inflow (97,000 particles/m^3) and tertiary outflow (1000 particles/m^3) revealed high MP removal efficiencies (98%) at the Ireland West waste water treatment plant (Mahon et al. 2014).
- Although high MP abundances were detected during primary treatment stages, tertiary effluents of ten WWTPs in Los Angeles were essentially MP free, suggesting that these plants contribute only minimal to the MP loads in adjacent rivers (Carr et al. 2016).
- Several studies detected elevated MP densities in the receiving waters downstream of WWTP effluents (McCormick et al. 2014, 2016; Mani et al. 2015; Hoellein et al. 2017; Vermaire et al. 2017; Kay et al. 2018), whereas others did not detect such correlations (Klein et al. 2015; Baldwin et al. 2016; McCormick et al. 2016; Campbell et al. 2017; Nel et al. 2018).

Due to the high fluctuation of measured removal efficiencies across different WWTPs, generalizing statements on their role as point sources of freshwater MP are not possible. Especially as another exit route of MP from WWTPs to the environment, the land application of contaminated sewage sludge, and its impact on rivers, has until now barely been investigated (see *surface runoff*).

2.2 DID-Direct Industrial Discharge (Point Source)

The sewers of plastic production and processing plants can directly release MP into receiving waters. As reported by Lechner and Ramler (2015), a polyethylene manufacturing site in Austria emitted approx. 200 g/day of *primary* MP (preproduction pellets) under normal operating conditions into the nearby River Schwechat. A maximum load of 50–200 kg was lost during a heavy rainfall event, caused by a malfunctioning waste water filtering system. Karlsson et al. (2018) investigated the effluent from another major production site of the same company in Sweden and detected concentrations of 3870 pellets/1000 m^3 in the surface water of

the receiving creek (Stenunge Å). The annual release of the facility was calculated to range between 3 and 36 million pellets (worst case scenario).

In spite of the fact that industrial precursors (i.e. pellets, spherules, granules) are a common category of freshwater MP (Lechner et al. 2014; Klein et al. 2015), further relevant studies on their direct discharge from production and application sites are absent in the literature.

2.3 Surface Runoff (Diffuse Source)

Storm-water runoff, commonly not treated, sluices terrestrial plastic litter into nearby waterbodies (Boucher et al. 2018). Due to their minimal weight, especially small particles get mobilized and MP densities in rivers have shown to disproportionally increase after rain events (compared to macroplastic densities) (Moore et al. 2011). The composition and abundance of MP litter is determined by the surface area drained.

Street runoff, for example, specifically contains small abrasion particles from vehicle tyres (Ballent et al. 2016) and dense composites of road-marking paints (Horton et al. 2017, see Interview 1). The transfer of these materials into adjacent rivers elicits pronounced MP concentration peaks, clearly exceeding dry period baselines up to 150-fold (Faure et al. 2015). Farmland runoff is a possible carrier of sludge-derived MP. The sewage sludge of WWTPs, known for its severe MP contamination (Kalčíková et al. 2017a; Li et al. 2018a, b), is used as fertilizer for agricultural applications (Mahon et al. 2016). Nizzetto et al. (2016a) estimated that "between 125 and 850 tons MP per million inhabitants are added annually to European agricultural soils". Yet, there are no studies on the runoff-mediated transport of MP from farmlands to running surface waters.

Recently, scientists detected high MP concentrations (mean \pm SD: 74.4 \pm 28.3 items per kg of sediment) in a terrestrial glacier environment (Forni Glacier, Italian Alps; Ambrosini et al. 2019). The prevailing synthetic fibres are thought to partly derive from high-tech outdoor gear, worn by hikers. The total amount of MP across the investigated glacier was estimated to range between 131 and 162 million particles. Hence, glacier runoff must be regarded as a significant vector of MP into glacier-fed rivers, gaining additional relevance in view of global warming (glacier melting).

2.4 Atmospheric Fallout (Diffuse Source)

In a pioneering study, Dris et al. (2015b) provided the first evidence of atmospheric MP fallout, by exposing stainless steel funnels on rooftops near Paris (on average 180 particles/m^2/day; 90% fibres). Subsequent work on the topic in sub-urban to urban environments around the French capital detected fallout rates of 110 \pm 69

(urban sampling site) and 53 ± 38 (sub-urban site) fibres/m^2/day (Dris et al. 2016). Material analysis (using FT-IR) revealed that 29% of these fibres contained plastic polymers and most probably derived from clothing. Based upon the average length-, section- and density values, the authors estimated the annual atmospheric fallout of synthetic fibres in the Parisian agglomeration (around 2500 km^2) to be up to 3–10 tons. Substantiated by high fibre numbers (of similar material qualities) found in the River Seine, part of these air-borne fibres likely end up in surface waters (Dris et al. 2015b). A realistic assessment of the atmospheric MP fluxes into rivers, however, requires more detailed investigations into the underlying transport mechanisms, including the governing environmental factors (e.g. rain, wind).

2.5 Disposal and Littering (Diffuse Source)

Plastic waste, inadequately disposed on land (in dumps and open landfills), can reach surface waters by air (wind) and water (runoff) driven dispersal (Jambeck et al. 2015). The presence of MP particles and associated pollutants in landfill leachates is indicated in the literature (Teuten et al. 2009; Kilponen 2016), but actual data on MP fluxes into freshwaters are missing to date. Nevertheless, it may be assumed that input quantities depend on the distance between waterbody and disposal site.

If discarded close to riverbanks, plastic litter will be entrained during rising water levels. Two studies, both using citizen-science-approaches, highlight the extent of riverside littering. Kiessling et al. (2019) investigated the riparian zones of major waterways and small rivers across Germany, being assisted by more than 5000 school children (referred to as "Plastic Pirates"). They observed mean litter densities of 0.54 ± 1.20 pieces per m^2 (with plastic items accounting for 30.5% of the total quantity) and identified recreational visitors as the main polluters. Similarly, Rech et al. (2015) had help from volunteers (teachers and students) when studying anthropogenic litter along four Chilean rivers. They found small and large illegal dumps along all river courses and reported on median litter densities from 0.14 to 3.42 items/m^2 in the riparian zones (with plastic waste being dominant). Both studies were restricted to meso- and macroplatics but the co-occurrence of MP at the sampling sites is very likely: large plastic items, disposed at riverbanks, are subject to intense weathering processes (e.g. UV-degradation, wave abrasion), accelerating the on-site degradation into MP (Battulga et al. 2019).

Cigarette butts are disposal products of special concern. Every year an estimated 4.5 trillion cigarette butts are thrown away globally, which makes them the most common debris item in many ecosystem (Barnes 2011). A single butt consists of up to 12,000 thermoplastic MP fibres (cellulose acetate), loaded with a mix of chemicals (e.g. arsenic, nicotine, heavy metals, polycyclic aromatic hydrocarbons) that are evidentially toxic for aquatic organisms (Register 2000; Slaughter et al. 2011; Parker and Rayburn 2017). Interestingly, cigarette butts are not referred to in freshwater MP studies and deserve special attention in the future.

2.6 Source Control

The identification and subsequent control of sources is widely recognized as the most promising approach for MP reduction in fluvial systems (Eerkes-Medrano et al. 2015).

The emission of harmful substances from diffuse and point sources into freshwater environments is usually regulated by legal limits (with developing countries having lower levels of pollution control; see Battulga et al. 2019). However, being a comparatively "new" contaminant, in terms of scientific and political awareness, MP has rarely been incorporated into national and international legislation to date. Also, scientific data proving the hazardous effects of MP are rarely considered in law-making procedures (Karbalaei et al. 2018). This is exemplified by means of certain EU directives below.

The EU Water Framework Directive (20/60/EEC) aims to achieve or preserve the good ecological status of its member state's surface waters (Article 4. a. II). Among the specific measures, deemed necessary to reach this goal, the reduction of discharges, emissions and losses of "priority substances" and "priority hazardous substances" is highlighted (Article 1. c). These substances are prioritized because of their aquatic toxicity (and human toxicity via aquatic exposure routes), persistency, ability to bio-accumulate and their widespread appearance in nature (Article 2, Article 16. 2. b). Though MP demonstrably fits this profile (see previous and subsequent sections of this chapter), it is not yet quoted in the relevant list (Annex X).

The EU Urban Waste Water Directive (91/271/EEC) aims to protect the environment from adverse effects of urban waste water and industrial discharges. The discharge requirements for WWTPs are listed in Annex 1. B. Accordingly, MP is categorized a suspended solid (like apple seeds, grass clippings, etc.) with optional (!) upper limits of emission ranging between 35 and 60 mg/L (depending on the population equivalents). Given the minimal mass of MP, this could result in high numbers of legally released MP particles into the receiving rivers and streams (Mahon et al. 2014).

The EU Sewage Sludge Directive (86/278/EEC) aims to regulate the use of sewage sludge in agriculture in order to prevent damage to soil, biota and man. The limit values for sludge application on farm land (Annex 1. B) solely relate to heavy metals and not MP.

Source control of freshwater MP, for the most part, is a legal affair and needs a legal framework based on the current state of scientific knowledge. Recently, several countries (e.g. Canada, United Kingdom, New Zealand and USA) implemented regulations on the use or production of microbeads in cosmetics and single-use MP (see Karbalaei et al. 2018). The international classification of plastic waste as hazardous, as recommended by Rochman et al. (2013a), would present another crucial step in the right direction.

Interview 1

Info: Alice Horton (AH) is an ecotoxicologist working at the Centre for Ecology and Hydrology (CEH), UK. Her research focusses on identifying the sources and transport pathways of microplastics from land to freshwaters, and the ecological effects of microplastics independently and in association with chemicals.

AL: Recently you stimulated a paradigm shift in MP pollution research (Horton and Dixon 2018**). What is the "Plastic Cycle"?**

AH: The Plastic Cycle concept highlights that the transport of plastic waste within the environment is not linear, i.e. from land to rivers to the sea. Instead, plastic can move along a variety of pathways and in a number of ways, including by wind, water and human activities. For example, microplastics may flow "upstream" on incoming tides, be returned from aquatic systems to land during flooding events, or be transported in any direction via air currents. Contrary to popular assumption, not all microplastics will ultimately flow to the oceans. In fact, many will be retained where they are first used within soils and on land, while microplastics that enter rivers and lakes may be retained within sediments. Therefore we need to consider all environmental compartments as one large interconnected system with flow of particles in various directions influenced by space, time and interactions.

AL: Particle flows between compartments of the "Plastic Cycle" further complicate the localization of plastic litter sources. What are the implications of your concept on MP source research?

AH: The research we are carrying out at CEH is investigating the sources and abundance of microplastics within the environment, in addition to the pathways by which microplastic particles can be transported. By examining particle shapes, sizes and polymer types, we are able to make inferences as to their origins, while knowledge of surrounding land use and local inputs such as drainage and wastewater outfalls enables us to make links between these pathways and the particles found in the environment. However, given microplastics' ability to be dispersed widely from their sources across land, water and air, it can be very difficult to determine exactly where a particle has derived from. The scientific community is still identifying and understanding sources of microplastics to the environment, for example it has only recently been recognized that the degradation of car tyres may contribute significant numbers of particles to terrestrial and freshwater systems. These complexities highlight the importance of carrying out research to further investigate the factors influencing particle fate and behaviour throughout the environment, taking into account seasonal and temporal variability, and alteration of particles as they age, to better trace their origins. An improved knowledge of environmental contamination is essential to better inform our understanding of possible long-term ecological implications of microplastics.

(continued)

Interview 1 (continued)

AL: The hazardous impact s of MP have been demonstrated for a variety of aquatic species (with possible knock-on effects for humans). Still, the legal control of MP is weak. In your opinion, which additional information on MP pollution must be delivered to get policy stronger involved?

AH: Despite a number of studies to date, the biggest gap in our knowledge currently is the understanding of how and why microplastics might cause harm to organisms, including humans. This is in part due to the novelty of the research and therefore a lack of data. However the main limitation in our ability to determine hazard is due to the complex nature of "microplastics" as a pollutant, incorporating a wide range of different polymer types, chemical additives, particle shapes, sizes and densities. All these characteristics can lead particles to behave in a different way, varying in their availability to organisms and their physical and chemical toxicity (if any). Considering shape, for example, a nylon fibre may have different effects on organisms than a nylon fragment, and even fragments of different sizes may induce different responses. Additionally, different species are varying in their susceptibility to exposure and harm, therefore the response of one species does not necessarily indicate the response of an ecosystem.

With further investigations on ecological effects across a range of environmentally relevant polymer and particle types there will be greater evidence on which to base policy decisions. Given that it will never be possible (or advisable) to eliminate all plastics, this evidence will also help inform which polymers/items are likely to cause the most harm and therefore which should be prioritized.

3 En Route

Once released, plastic items are exposed to heterogeneous and dynamic river environments, hosting a diversity of aquatic life. The dispersal and fate of plastic particles are mainly determined by external factors, such as physical forces and the influence of stream biota (Kooi et al. 2018). And in turn, the presence of plastics in rivers impinges on environmental parameters and organisms´ health (Eerkes-Medrano et al. 2015). In the following, a selection of processes, in which MP in rivers might be involved, is reviewed. Note that some of these processes affect transport and retention patterns of MP, relevant for assessing in situ contamination and emission to the seas (Besseling et al. 2017).

3.1 Deposition of MP

Fluvial systems do not merely transport plastic waste into the oceans; they simultaneously act as sinks and temporary traps of environmental MP (Jiang et al. 2019; Shruti et al. 2019). The retention probability of MP results from a combination of inert particle properties (e.g. density, shape, size) and external dispersal drivers (e.g. velocity, discharge, turbulence) (Horton et al. 2017). Riverine MP, as does other suspended or floating matter, inherently accumulates at depositional sites, such as riverbeds, low-flow stretches (e.g. upstream of dams, weirs and estuaries) and shorelines.

Receiving both naturally sinking particles (densities >1) and formerly buoyant particles (densities <1) that experienced a density increase (by biofouling, mineral adsorption or aggregate formation; Baldwin et al. 2016; Vermaire et al. 2017), riverbeds are especially contaminated. Here, the observed MP concentrations are frequently higher than in surface waters or marine benthic habitats (Castañeda et al. 2014; Hoellein et al. 2017; Leslie et al. 2017; Rodrigues et al. 2018; Tables 1–6). According to model simulations by Besseling et al. (2017), sedimentation and transport rates highly depend on plastic size (diameter): whereas size fractions between 1 and 50 μm are preferentially transported downstream, smaller and larger particles are prone to sedimentation. Once deposited, MP is available to a variety of ground-dwelling fishes and invertebrates (see *Interactions with organisms*). The impact of these animals (ingestion-defecation) can lead to a resuspension of the settled particles; on the other hand, MP is resuspended via bed erosion processes. Using a hydro-biogeochemical sediment transport model in the River Thames, Nizzetto et al. (2016b) predicted that high flows would remobilize the settled MP pool from the riverbed. This was confirmed by pre- and post-flooding sediment analysis in Australian and English streams, demonstrating that elevated discharges are capable of evacuating remarkable amounts of benthic MP from fluvial systems (Hurley et al. 2018; Nel et al. 2018).

Buoyant MP items, which cannot pass flow impediments as dams or weirs, gather in reservoirs (weir pools). In the Yangtze River, MP abundance increased with decreasing distance to the Three Gorges Dam (Zhang et al. 2015), reaching values up to 3.4 million items per km^2. According to Watkins et al. (2019), reduced flow conditions in reservoirs support the sedimentation of the retained MP flotsam. Furthermore, residence in reservoirs might increase particle fragmentation (through weathering) and encounter rates with other than typical stream biota (e.g. fish species that prefer stagnant waters, water birds and phytoplankton).

Besides being an aesthetic issue, the stranding of MP at riverbanks (e.g. due to wind, wave wash and entanglement in littoral vegetation) and floodplains (when the water recedes) is a crucial pathway in the "Plastic Cycle" (see *interview 1*), linking aquatic and terrestrial ecosystems and exposing the freshwater plastic load to taxa of the riparian zones (Horton and Dixon 2018).

Table 4 Synopsis of plastic pollution studies in rivers

References	Country	River	Sampling site	Sampling method	Mesh size net (µm)	Detected sizes	Dominant size	Dominant genesis	Dominant type	Mean particle number/scale unit
Mani et al. (2015)	Germany	Rhine	Surface water	Manta net	300	MIP	×	PMP	Spherules	892,777/km^2
Mani et al. (2019)	Germany	Rhine	Surface water	Manta net	300	MIP	×	PMP	Spherules	0.05–9.2/m^3 (count range)
McCormick et al. (2014)	USA	North Shore Channel	Surface Water	Neuston net	333	MIP	×	SMP	Fibres	Upstream WWTP: 1.94 ± 0.81/m^3 Downstream WWTP: 17.93 ± 11.05/m^3
McCormick et al. (2016)	USA	9 Rivers	Surface water	Neuston net	333	MIP	×	SMP	Fibres	Upstream WWTP: 2.35 ± 0.37/m^3 Downstream WWTP: 5.73 ± 0.85/m^3
Moore et al. (2011)	USA	Coyote Creek	Water column	Variuos net types	333, 500, 800	MIP, MAP	MIP	SMP	Fragments	40.86/m^3 (count)
Moore et al. (2011)	USA	Los Angeles	Water column	Variuos net types	333, 500, 800	MIP, MAP	MIP	×	Foam	3473.42/m^3 (count)
Moore et al. (2011)	USA	San Gabriel	Water column	Variuos net types	333, 500, 800	MIP, MAP	MIP	×	Foam	169.54/m^3 (count)
Morritt et al. (2014)	UK	Thames	Bottom water	Fyke net	×	MAP	×	×	Food wrappers	Plastic share on total litter: 20–25%

Acronyms used: MIP (microplastics), MAP (macroplastics, particles >5 mm), PMP (primary microplastics), SMP (secondary microplastics). Particle densities are given as mean values (± standard deviation, if available) or counts, indicated in brackets (count, count range). All values refer to MIP, unless otherwise specified (MAP). Empty fields indicate the lack of relevant information

Table 5 Synopsis of plastic pollution studies in rivers

References	Country	River	Sampling site	Sampling method	Mesh size net (μm)	Detected sizes	Dominant size	Dominant genesis	Dominant type	Mean particle number/scale unit
Nel et al. (2018)	South Africa	Bloukrans System	Sediment	Hand sampling	×	MIP	×	×	×	Summer: 6.3 ± 4.3/kg Winter: 160.1 ± 139.5/kg
Rech et al. (2015)	Chile	Elqui, Maipo, Maule, BioBio	Riverbank	Hand sampling	×	MAP	×	×	×	5.2–5.5/m²
Rodrigues et al. (2018)	Portugal	Antuã	Surface water, Sediment	Water pump, Grab sampler	55	MIP	×	SMP	Foam Fragments	Surface water: 5–1265/m² Sediment: 18–629/kg
Sadri and Thompson (2014)	UK	Tamar	Surface water	Manta net	300	MIP, MAP	MIP	SMP	Fragments	0.028/m³
Sarijan et al. (2018)	Malaysia	Skudai	Sediment	Box corer	×	MIP	×	SMP	Film	200 ± 80/kg
Sarijan et al. (2018)	Malaysia	Tebrau	Sediment	Box corer	×	MIP	×	SMP	Film	680 ± 140/kg
Shruti et al. (2019)	Mexico	Zahuapan	Sediment	Hand sampling	×	MIP	×	×	Fragments, Fibres	1633.34 ± 202.56/kg (summed means ± SEs)
Shruti et al. (2019)	Mexico	Atoyac	Sediment	Hand samplimg	×	MIP	×	×	Fragments, Fibres	1133.33 ± 72.76/kg (summed means ± SEs)

Acronyms used: MIP (microplastics), MAP (macroplastics, particles >5 mm), PMP (primary microplastics), SMP (secondary microplastics). Particle densities are given as mean values (± standard deviation, if available) or counts, indicated in brackets (count, count range). All values refer to MIP, unless otherwise

Table 6 Synopsis of plastic pollution studies in rivers

References	Country	River	Sampling site	Sampling method	Mesh size net (μm)	Detected sizes	Dominant size	Dominant genesis	Dominant type	Mean particle number/scale unit
Vermaire et al. (2017)	Canada	Ottawa	Surface water, Sediment	Hand sampling, Manta net, Grab sampler	100	MIP	×	SMP	Fibres	Surface water: 1.35/m³ Sediment: 220/kg
Wagner et al. (2014)	Germany	Elbe, Mosel, Neckar, Rhine	Sediment		500	MIP	×	×	Fragments	34–64/kg (count range)
Wang et al. (2017a)	China	Hanjiang	Surface water	Sieved water sample	50	MIP	×	SMP	Fibres	2933 ± 305.5/m³
Wang et al. (2017a)	China	Yangtze	Surface water	Sieved water sample	50	MIP	×	SMP	Fibres	2516.7 ± 911.7/m³
Wang et al. (2017b)	China	Beijiang	Sediment	Hand sampling	×	MIP	×	SMP	n.s.	544 ± 107/kg
Yonkos et al. (2014)	USA	Corsica	Surface water	Manta net	330	MIP	×	SMP	Fragments	5534–92,617/km²
Yonkos et al. (2014)	USA	Magothy	Surface water	Manta net	330	MIP	×	SMP	Fragments	36,013–99,129/km²
Yonkos et al. (2014)	USA	Patapsco	Surface water	Manta net	330	MIP	×	SMP	Fragments	59,785–297,927/km²
Yonkos et al. (2014)	USA	Rhode	Surface water	Manta net	330	MIP	×	SMP	Fragments	18,574–131,978/km²
Zhang et al. (2015)	China	Yangtze	Surface water	Manta net	112	MIP	×	SMP	Sheets	3407.7 × 10³ - 13617.5 × 10³/ km² (count range)

Acronyms used: MIP (microplastics), MAP (macroplastics, particles >5 mm), PMP (primary microplastics), SMP (secondary microplastics). Particle densities are given as mean values (± standard deviation, if available) or counts, indicated in brackets (count, count range). All values refer to MIP, unless otherwise specified (MAP). Empty fields indicate the lack of relevant information

3.2 Colonization of MP

In the year 2013, scientists initially came up with the term "plastisphere", describing the diverse eukaryotic and bacterial assemblages attached to marine plastic debris, which significantly differ (in taxonomic composition and community structure) from microbial communities in the surrounding sea water (Zettler et al. 2013).

As freshwater MP research gained momentum, similar findings were reported for rivers and streams. Accordingly, MP surfaces host unique biofilms, including "plastic eaters" and ("escaped") pathogens that usually do not proliferate in natural riverine environments (but see examples below).

- Eckert et al. (2018) mimicked waste water inflow into a receiving freshwater by mixing samples of pure lake water and municipal WWTP effluent in the lab. They added different amounts of MP to the mixtures and investigated changes in the bacterial community. After 15 days, the biofilms on MP surfaces were dominated by WWTP-derived bacteria, containing antibiotic-resistant genes (*int1*). High MP densities in waste water effluents accordingly favour the spread of these bacteria to natural freshwaters.
- Studies in urban rivers (USA) upstream and downstream of WWTP effluents demonstrated that biofilms on MP surfaces harbour bacterial assemblages which differ in taxonomic composition from those in adjacent habitats (water column, sediment). For example, MP surfaces contained certain taxa that were linked to plastic decomposing processes (*Pseudomonadaceae, Flavobacteriaceae, Comamonadaceae*) but also typical waste-water genera associated with human diseases and gastrointestinal infections (*Campylobacteraceae, Aeromonadaceae*) (McCormick et al. 2014, 2016; Hoellein et al. 2017).
- Miao et al. (2019) discovered that biofilms on natural (wood, stones) and MP surfaces differed not only in taxonomic composition and community structure but also regarding functional diversity (e.g. metabolic and degradation processes). According to the authors, this could impact nutrient and material cycles in areas of high MP concentration.

Beside the above-mentioned aspects, biofouling impacts the fate and effects of MP in limnic systems by changing particle behaviour in biological, chemical and physical interactions (reviewed by Rummel et al. 2017). Accordingly, biofilm formation might influence the vertical position of MP in the water column by increasing (upward transport) or decreasing (downward transport) particle buoyancy (Lagarde et al. 2016). Furthermore, nutritious microbial "toppings" on MP particles could lead to a preferred uptake by consumers (Carson 2013).

Biofilm coating also affects the exchange of pollutants between MP surface and surrounding water or biota, respectively: On the one hand, the high sorption capacities of biofilms (due to the sticky matrix of extracellular polymeric substances, EPS) can reinforce the accumulation of water-borne hydrophobic organic contaminants (HOCs) (Wang et al. 2016). On the other hand, many bacteria, algae and fungi can

decompose MP-derived (leached) HCOs, thereby reducing their bioavailability in the environment (Ghosal et al. 2016).

3.3 Interactions with Organisms

Plenty of in situ and lab-based studies have reported on the various implications of biota-plastic interactions in marine environments, covering several hundred species from different trophic levels (see reviews by Laist 1997; Gregory 2009). While a comparable database for freshwaters is missing, the main findings in oceans should be (more or less) transferable to rivers and streams, as current works suggest (Andrade et al. 2019; Smiroldo et al. 2019; Windsor et al. 2019).

First and foremost, the frequently observed ingestion of MP poses a complex threat to a plethora of aquatic organisms (Scherer et al. 2018). The small particles may be ingested *directly* (from the abiotic surrounding, i.e. water column, stream-bed) or *indirectly* (via MP contaminated prey), as well as *intentionally* (when mistaken for food) or *incidentally* (when swallowed along with natural food items as detritus, sediment or prey). Uptake probability and knock-on effect characteristics depend upon species-specific peculiarities (e.g. size, age, sex, morphological traits, feeding mode, appetite and trophic position; Scherer et al. 2017; Horton et al. 2018; Weber et al. 2018) and particle properties (e.g. abundance, size, age, shape, colour, taste, surface charge, polymer type; DeMott 1986; Redondo-Hasselerharm et al. 2018; Su et al. 2018).

The risk to the consuming individual arises from a triad of possible impacts: (1) Swallowed MP might elicit internal injuries and blockages (of the digestive system), leading to inflammatory responses, a false sense of satiation, impaired feeding capacity, reduced nutrient absorption, starvation and death (reviewed by Wright et al. 2013), (2) Harmful chemical additives (e.g. bisphenol A, phthalate and organotin compounds), incorporated in the plastic blend and (3) environmental pollutants adsorbed to the MP surface (e.g. polychlorinated biphenyls, polycyclic aromatic hydrocarbons) can leach/desorb from ingested particles and pass into animal tissue (Teuten et al. 2009). Hence, these contaminants are incorporated into aquatic food webs and could ultimately reach humans via trophic level transfer (Rochman et al. 2015; Silva-Cavalcanti et al. 2017).

In the following, a simplified aquatic food web (*decomposers, primary producers, primary-, secondary- and tertiary consumers*) is used to shed light on the reported interactions between river organisms and MP, focusing on particle ingestion. It must be stressed that dose-response bioassays on MP ingestion tend to use much higher particle concentrations than observed in the environment (Lenz et al. 2016), putting their ecological relevance into question (see *Interview 2*). For reasons of transparency, such experimental studies, explicitly exposing organisms to unrealistically high particle concentrations (compared to natural concentrations; see Tables 1–6), are marked by an asterisk (∗) below. Moreover, varying exposure durations (from hours to months) and the frequent use of test particles (spherical

microbeads) other than primarily found in rivers (irregular shaped fragments and fibres; see Tables 1–6) complicate environmental hazard assessment based on laboratory findings (Scherer et al. 2018; Weber et al. 2018).

3.3.1 Decomposers

Certain bacteria are capable of decomposing plastic material, possibly leading to a complete mineralization of the polymer (into CO_2, H_2O, N_2, H_2, CH_4, salts, minerals and biomass; Klein et al. 2018). For instance, Balasubramanian et al. (2010) identified two bacterial strains in the Indian Ocean that metabolize HDPE (high density polyethylene), Kathiresan (2003) observed the microbial breakdown of polyethylene in mangrove soils, and Yoshida et al. (2016) isolated the previously unknown species *Ideonella sakaiensis*, which uses PET (polyethylene terephthalate) as a major energy and carbon source, from sediments.

Although direct observations of plastic biodegradation in freshwaters are pending, the colonization of MP surfaces with bacterial strains, putatively involved in the polymer breakdown, is indicated for limnic systems as well (McCormick et al. 2016; Hoellein et al. 2017).

3.3.2 Primary Producers

The impact of plastic litter on photosynthetic organisms (cyanobacteria, micro- and macro algae and macrophytes) is of special concern, as they represent the bottom of freshwater food webs. So far, all related studies are laboratory-based and focus on very small particle sizes, including nanoplastics.

Nanoparticles demonstrably adsorb onto algal cells, which has been attributed to chemical (hydrogen bonding) and electrostatic (attraction) cellulose-plastic interactions (Bhattacharya et al. 2010∗). However, the reported consequences for the individuals are conflicting. While the freshwater algae *Chlorella* sp. and *Scenedesmus* sp. displayed reduced photosynthesis, potentially evoked by shading from attached particles (Bhattacharya et al. 2010∗), negligible or contradictory effects are documented for *Chlorella vulgaris* (Sjollema et al. 2016∗) and *Scenedesmus obliquus* (Besseling et al. 2014∗). In addition, the exposure to high nanoplastic concentrations caused growth inhibition and reduced chlorophyll *a* content in algal cells as well as temporal cell size fluctuations in freshwater cyanobacteria (*Microcystis aeruginosa*, *Dolichospermum flos-aquae*), but the underlying mechanisms remained unclear (Besseling et al. 2014∗; Yokota et al. 2017∗).

As far as the author knows, only two studies hitherto looked at the impact of plastic litter on higher freshwater plants. Van Weert et al. (2019∗) investigated the effects of micro- and nano-sized polystyrene beads (50 nm–500 µm) on the development of sediment-rooted macrophytes (*Myriophyllum spicatum* and *Elodea* sp.). Accordingly, the endpoints of several growth parameters (e.g. shoot length, root and shoot biomass, relative growth rate) showed correlations with nanoplastic

concentration in sediments. Most notably, shoot-to-root ratios (S:R) in both species decreased with increasing particle densities, possibly due to compensatory root growth in response to plastic-induced changes in nutrient availability (particles might bind nutrients in the sediment) or hampered nutrient uptake (particles might block roots). Kalčíková et al. (2017b∗) studied the impact of polyethylene cosmetic microbeads (30–600 μm) on the floating duckweed (*Lemna minor*). The presence of MP triggered a significant decrease in root growth, which the authors ascribed to the physical damaging of root cells (by sharp-edged particles) and mechanical growth disturbance (by adsorbed particles).

3.3.3 Primary Consumers

At this trophic level, MP ingestion is mainly documented for invertebrate taxa of the zooplanktonic and zoobenthic community (e.g. crustaceans, molluscs, annelids, ostracods, gastropods). Some of them are standard test species in aquatic ecotoxicology (e.g. *Daphnia magna, Tubifex tubifex* and *Gammarus pulex;* see also *Interview 2*) and play key roles in freshwater food webs (being major links between lower and higher trophic levels; Imhof et al. 2017). Summarized, many aspects of plastic ingestion (e.g. ingestion and excretion rates, effects at different biological levels) are highly species-specific and depend on the plastic supply (e.g. abundance, polymer type, particle sizes) in the environment or in the laboratory (Imhof et al. 2013∗; Scherer et al. 2017∗). Some general patterns, however, can be derived from the literature:

(a) The uptake probability likely correlates with the feeding type, putting nonselective and generalist feeders (e.g. filter feeders, suspension feeders) at higher ingestion risk than specialized feeders (e.g. raptorial feeders) (reviewed by Scherer et al. 2018).

(b) The amounts of ingested particles often reflect plastic concentrations in the surrounding medium (water and sediment; Scherer et al. 2017∗; Nel et al. 2018; Redondo-Hasselerharm et al. 2018∗; Weber et al. 2018∗). Therefore, some species are considered appropriate bio-indicators for riverine plastic pollution (Su et al. 2018).

(c) Ingestion rates of MP and knock-on effects depend on the simultaneous uptake of natural food items: a co-exposure to natural diets (algae, leafs, sand) often reduces plastic ingestion and gut retention times of particles (Jemec et al. 2016∗; Scherer et al. 2017∗).

Below, other specific effects and non-effects of MP ingestion on freshwater primary consumers are recapitulated. Regarding laboratory experiments, exposure durations of test organisms to plastic particles are given in brackets (d = days, h = hours).

Effects on Growth, Morphology, Reproduction and Gene Expression

- The (21 d) exposure of the small planktonic crustacean *Daphnia magna* to high nano-polystyrene (70 nm) concentrations not only reduced clutch and neonate body size but also increased the occurrence of neonate malformations (e.g. internal vacuoles, shortened antenna; Besseling et al. 2014∗). Once ingested, nano-particles can cross the gut's epithelial barrier in *D. magna* and translocate into oil storage droplets (Rosenkranz et al. 2009∗).
- The (28 d) exposure of the freshwater crustacean *Gammarus pulex* to high concentrations of polystyrene MP fragments (20–500 µm) induced growth inhibition, which has been attributed to ingested particles blocking the gut and lowering food assimilation (Redondo-Hasselerharm et al. 2018∗).
- The (28 d) exposure of Asian clams (*Corbicula fluminea*) to MP fragments (12–704 µm) increased histological abnormalities (tubular dilation), which was further aggravated when particles were spiked with priority pollutants (polychlorinated biphenyls; Rochman et al. 2017).
- When (48 h) exposed to microplastics (40 µm), *D. magna* displayed subtle and inconsistent changes in the expression of specific genes (HSP-genes), indicating increased stress levels (Imhof et al. 2017).
- Although 48% of the observed tubifex worms (*T. tubifex*) in the River Irwell basin (UK) were contaminated with MP (on average 0.8 ± 1.01 particles per worm), plastic concentrations in the sediments were not correlated to individual and population growth rates (Hurley et al. 2017).

Effects on Mortality

- The (21 d) exposure of *D. magna* to aged suspensions of nano-polystyrene (70 nm) and algae increased mortality rates up to the sixfold (Besseling et al. 2014∗). In this experimental setting, the indirect consumption of plastic particles adsorbed to algal cells might have resulted in very high ingestion rates. Otherwise, the consumption of not-contaminated algae, prior to MP exposure, can dampen and delay toxicity effects (Jemec et al. 2016∗).
- The (48 d) exposure of *G. pulex* to polyethylene terephthalate (PET) fragments (10–150 µm) did not affect mortality rates, though single individuals ingested up to 6500 particles within a 24 h period. Moreover, no effects of MP on feeding activity, energy reserves and molt periods were observed (Weber et al. 2018∗).
- The (28 d) exposure of six benthic invertebrates (*G. pulex, Hyalella azteca, Asellus aquaticus, Sphaerium corneum, Tubifex spp., Lumbriculus variegatusto*) to polystyrene MP (20–500 µm) did not affect their survival, even at extremely high concentrations (Redondo-Hasselerharm et al. 2018∗).

3.3.4 Secondary Consumers

Non-predatory riverine fish species are regular consumers of MP. The percentage of contaminated individuals, however, significantly varies between field studies: 7.5%

(Faure et al. 2015), 12% (Sanchez et al. 2014), 26.7% (Andrade et al. 2019), 32.8% (Horton et al. 2018), 45% (Peters and Bratton 2016), 73.5% (Campbell et al. 2017), 83% (Santos Silva-Cavalcanti et al. 2017), 85% (McNeish et al. 2018), 95.7% (Jabeen et al. 2017) and 100% (Pazos et al. 2017).

Contrary to invertebrates, feeding guild related differences in plastic ingestion rates have rarely been observed for fish (McNeish et al. 2018), with most of the relevant studies being inconclusive (Campbell et al. 2017; Pazos et al. 2017; Andrade et al. 2019).

But similar to invertebrates, it is suggested that MP abundances in the digestive systems (gut, stomach) of fish reflect environmental plastic concentrations (Peters and Bratton 2016, Santos Silva-Cavalcanti et al. 2017; Pazos et al. 2017; Horton et al. 2018).

Some fish might intentionally consume MP particles when mistaking them for prey, likely putting individuals with high-energy demands (e.g. larger individuals, females during spawning season) at greater ingestion risk (Peters and Bratton 2016; Horton et al. 2018). Due to its variety of colours and shapes, MP litter can resemble many different (natural) food items. Synthetic fibres, for example, have a similar appearance to filamentous algae (Horton et al. 2018), whereas fish eggs, a high-quality source of protein, look like (white) primary MP spherules at first glance (Fig. 2). In support of this, the ingestion of MP was found positively correlated to the consumption of fish eggs in two sunfish species in the Brazos River basin (US; Peters and Bratton 2016).

The uptake of plastic material has far-reaching consequences for the individuals. The exposure of juvenile common gobies (*Pomatoschistus microps*) to polyethylene particles (1–5 μm), virgin and spiked with a pollutant (pyrene), triggered significant reductions in the activity of acetylcholinesterase (AChE), an enzyme involved in neurological functions (Oliveira et al. 2013∗). Furthermore, pyrene-spiked particles inhibited isocitrate dehydrogenase (IDH), an enzyme relevant for cellular energy production. The down-regulation of both enzymes can give rise to severe fitness declines and mortality increases (Oliveira et al. 2013∗). Also, MP ingestion can

Fig. 2 Where is the egg? This picture shows two spherical MP particles, captured with plankton nets in the River Danube, and a non-fertilized egg of the nase carp (*Chondrostoma nasus*). Fish eggs are natural food items for many fish species and prey-resemblance might lead to intentional uptake of MP. By the way, the egg is in the middle

transfer toxic chemicals, sorbed to the particles, into fish tissue: the (2 month) exposure of Japanese medaka (*Oryzias latipes*) to polyethylene fragments (<5 mm), loaded with PBTs (persistent bioaccumulative and toxic substances), enhanced toxin body burdens in test organisms and produced hepatic stress (Rochman et al. 2013b).

3.3.5 Tertiary Consumers

Plastic is incorporated into freshwater food webs at low trophic levels. As discussed above, particles and associated chemicals have been shown to accumulate in primary and secondary consumers. Hence, apex predators (predatory fish, water birds, vertebrates, humans) face the risk of "biomagnification", i.e. the uptake of high particle and pollutant concentrations via contaminated diet. The transfer of plastic up the food chain is regularly indicated in the literature. Smiroldo et al. (2019), for instance, observed spherical MP particles in otter (*Lutra lutra*) faeces and suggested indirect uptake through predation on plastic charged cyprinids. Similarly, Campbell et al. (2017) detected higher MP abundances in the guts of piscivorous pike (*Esox lucius*) compared to non-predatory fish species. In predatory fish, the consumption of MP-loaded prey can elicit subtle effects on the molecular level (e.g. changes in gene expression; Rochman et al. 2017).

Given the fact that edible fish tissue might contain toxic plastic leachates (Rochman et al. 2013b), humans are likely end consumers of these substances (Rochman et al. 2015; Santos Silva-Cavalcanti et al. 2017). Although the harmful effects of common "plasticizers" on humans are known (see review by Karbalaei et al. 2018), extensive further research is needed to assess the real danger of diets containing freshwater fish. Specifically, knowledge is needed on the average concentrations of different (plastic derived) chemicals in the tissue of usually consumed species.

Independent of food web transfer, MP can penetrate human bodies more directly via drinking water. Recently, small plastic particles (down to 1 μm) were detected in drinking water treatment plants, tap water and bottled mineral water (Kosuth et al. 2018; Oßmann et al. 2018; Pivokonsky et al. 2018). Based upon the highest average particle concentrations in these studies, Eerkes-Medrano et al. (2018) estimated the worst case daily particle ingestion rates to range between 28 and 15,000 (assuming 3 L of water consumption). Drinking water is inter alia derived from freshwater sources (groundwater, rivers, lakes and reservoirs), all of which are prone to MP contamination.

3.4 Removal of MP

Regarding marine environments, the economic relevance of plastic pollution (threatening commercial fisheries, food security and tourism) has been recognized

(Newman et al. 2015; Rochman et al. 2015). This, in combination with a general rise in public awareness, initiated plenty of (governmental and non-governmental) beach and ocean clean-up activities as well as the development of plastic-collecting devices (for example, see www.theoceancleanup.com, www.plasticoceans.org, www. oceanconservancy.org, www.microplasticsurvey.org).

Inland fisheries (in rivers, lakes and reservoirs) are crucial sources of income, employment and food, especially in rural economies and developing countries (Welcomme et al. 2010). The global capture production of freshwater fishes in inland waters (aquacultures excluded) amounted to 10,323,188 t in 2016 (compared to 65,079,460 of marine fishes in the world's oceans; FAO 2018). Further, clean rivers and vital fish stocks promote local tourism (via recreational fishing, snorkelling, diving, boating, bank-side leisure activities; Lynch et al. 2016). Nevertheless, plastic clean-up initiatives in running freshwaters are comparably scarce (www.plasticsoupfoundation.org), indicating (a) the insufficient perception of the possible impacts on food and economic security but also (b) the difficult conditions for plastic removal from rivers and shorelines (Rech et al. 2015). Anyhow, all efforts to purge fluvial systems are toothless, as long as there is a steady supply of plastic litter (see *Source control*).

Interview 2

Info: *Hannes K. Imhof (HI) is working as aquatic ecologist at the Aquatic Systems Biology Unit, School of Life Sciences Weihenstephan, Technical University of Munich. His main interests are animal ecology, aquatic ecology and ecotoxicology and in this context he is currently investigating the impact of microparticles on aquatic ecosystems.*

AL: Aquatic ecotoxicology uses established standard test species (e.g. zebrafish, Daphnia, Gammarus). What do you consider model organisms for MP ingestion studies and which requirements must they meet?

HI: In my eyes an organism which can be used as a microplastic or microparticle standard test species should be (A) naturally exposed to particulate material and (B) should be among already established test species or the necessary knowledge about the test species should exist. The feeding strategy of the used species and with that the way the organism takes up the particles should result in a realistic exposure scenario which has an important influence on the validity of the test. Therefore, the proper design of the exposure has the same importance and should be adopted to the test species and the used particles. In addition, the exposure should be in a controlled and suitable way.

AL: According to Paracelsus, it is the dose that makes the poison. What is the ecological relevance of ingestion studies that use much higher MP densities than observed in the environment?

(continued)

Interview 2 (continued)

HI: The proof of principle, here the fact that a certain organism can ingest a certain particle, is often the first step in order to assess effects evoked by microplastic. However, to draw a complete image the use of high concentration alone is questionable.

Nevertheless, if ecotoxicological studies are performed which expose organisms to a range of concentrations from low dose to environmental relevant and up to unrealistically high amounts this information can indeed be useful to answer the question how toxic a certain particle is. Even if the answer is, that in the used scenario this certain particle is only toxic in a concentration which is highly unlikely to occur in the field.

On the other hand, the currently available data concerning the abundance of microplastic in the field, is incomplete due to the limited monitoring methods which in the current state-of-the art do not allow any routine measurements. Especially for particles in the lower micron or sub-micron range monitoring approaches which realistically allow detailed and large-scale assessment are lacking. Therefore, any conclusions about the number of particles which are "environmentally relevant" are uncertain. Especially for particles in the lower micron-range or sub-micron range currently only an increase with decreasing size can be anticipated.

For these reasons the use of "environmentally relevant" particle concentrations alone are in the same way questionable as the use of high-doses are. Comprehensive risk assessment studies should include different concentration ranges, polymers, sizes, additives, environmental contamination, appropriate particle control and last but not least should be comparable with other studies.

AL: Usually, freshwater MP ingestion studies demonstrate the uptake potential of a certain species xy (sometimes including knock-on effects for the individual). Can we extrapolate from these findings on population or ecosystem effects of MP? Which theoretical study design would allow such conclusions?

HI: The extrapolation of effects on population or ecosystem level based on data from sterile laboratory experiments is a complex topic with entire books devoted to its solutions which will never be solved satisfactory. However, in my eyes here two different points are important:

1. *In the case of the aquatic microparticle risk assessment, and I do not mean the uptake potential alone, we face comparable problems like the analytical counterparts. We need to establish test systems which enable us to assess the effects evoked by a suspended particle which has an influence on its environment but is also influenced by its environment. In a second step these need to be harmonized and standardized. Without comparable data we will not be able to conclude from a variety of laboratory studies,*

(continued)

Interview 2 (continued)
> although they are performed in good quality, to higher organization levels (microcosm, population, ecosystem).
> 2. Ecotoxicology is not only a tool to conclude from the laboratory level to the population or ecosystem level. It is also a tool which allows to perform standardized tests with chemicals (and particles in the future) before they are placed on the market to prevent toxic chemicals/particles to enter the environment. Currently, the particles are already in the environment because no regulations or standardized tests were available, and we scientists are currently only able to try to answer the question how bad it really is.

4 Input into the Oceans

Those plastic particles in rivers that are not ingested, permanently removed or retained, will sooner or later end up in the oceans. The annual global plastic input from rivers into the oceans likely amounts to some million tons (Lebreton et al. 2017; Schmidt et al. 2017). Such estimates frequently rest on plastic input- and transport models, which use different (mathematical) approaches and combine different data bases in order to predict the quantitative flow of riverine plastics at various spatial and temporal scales. The model outputs provide important information on operative management strategies and where to effectively apply them (simulated hot spots of pollution).

Some of these models try to parameterize complex processes, such as the behaviour of particles in rivers (i.e. retention, degradation, biofouling, hetero-aggregation; Unice et al. 2019) and WWTPs (removal efficiency; Siegfried et al. 2017). In many cases, the estimation of parameter values is based on limited observation data, questioning the reliability of model predictions (van Wijnen et al. 2019). Nevertheless, plastic transport models *"provide mechanism-based hypothesis on system behaviour that can be experimentally validated later on"* (Besseling et al. 2014), and the ongoing efforts in riverine plastic pollution research (Fig. 1) will undoubtedly improve model qualities in the future.

Below, a selection of studies, using different model approaches to estimate riverine plastic input into the oceans, is provided:

- The annual plastic inputs from the **global riverine system** to the oceans were estimated **between 1.15 and 2.41 million tons** by Lebreton et al. (2017). Their model processed geospatial data on population density and per capita amounts of mismanaged (i.e. littered or inadequately disposed) plastic waste on land, further integrating catchment runoff and artificial river barriers (e.g. dams and weirs) as decisive model parameters. The model was calibrated against studies on plastic concentrations in 13 rivers around the world. A major share of the simulated

plastic load (67%), entering the world's oceans, was transported by Asian rivers (top 1–3: Yangtze, Ganges, Xi).

- Using a similar model as Lebreton et al. (2017), yet calibrated against more empirical data (deriving from 57 rivers) and differentiated for micro- and macroplastics, Schmidt et al. (2017) estimated the *global plastic inputs from rivers* into the sea *between 0.47 and 2.75 million tons* per year (microplastics: 0.16–2.31 million tons; macroplastic: 0.15 million tons).
- Siegfried et al. (2017) estimated the annual input of specific WWTP-derived MP (tyre and road wear particles (TRWP), synthetic fibres, household dust, microbeads in care products) from large European rivers to the oceans. Calculations were made for the past (year 2000) and the future (2050), assuming two different scenarios of prospective environmental management (proactive, reactive). Their model integrated watershed parameters such as population density, population share connected to sewage treatment and per capita emission of MP, but also specific retention coefficients for MP in rivers and WWTPs. Accordingly, *large European rivers* exported *14.4 kilotons* of the investigated MP (mainly TRWP) in the year 2000 and the value was predicted to decline (reactive scenario: 1%, proactive: 18%) until 2050, due to future improvements in sewage treatment efficiencies.
- The GREMIS (Global Riverine Export of Microplastics into Seas) model, developed by Van Wijnen et al. (2019), extends the approach of Siegfried et al. (2017) to a global scale but also accounts for diffuse MP sources (i.e. the riverine degradation of macroplastics). For the year 2000, the *global riverine MP input* to the oceans was calculated to *47 kilotons* whereby most MP sourced from the fragmentation of mismanaged macroplastic litter, especially in countries with low sewage connection. Running three different scenarios for the year 2050, only the most proactive in terms of waste management (i.e. municipal solid waste collection rate of 90% and a WWTP removal rate of 95%) predicted a decline in the MP load (to 17 kilotons), whereas the others forecasted significant increases (57 and 71 kilotons).
- Unice et al. (2019) applied a mass balance model, considering physical particle properties and different freshwater transport processes (settling rate, heteroaggregation and particle degradation), to assess the emission of terrestrially generated TRWP into the English Channel via the *River Seine* (approx. *455 tons per year*).
- The model approach by van Emmerik et al. (2018) combined direct observations (visual counting of plastic litter over the river width, followed by subsampling to determine average particle weight and size) and hydrological (i.e. discharge) effects on particle fluxes to simulate the annual macroplastic emission of the *River Saigon* into the South China Sea (approx. *between 7.5 and 13.7 kilotons*).
- Based upon the mean recorded plastic densities in (manta trawl) surface samples of the *River Rhine*, close to the river mouth, Mani et al. (2015) estimated that over *191.6 million MP particles* enter the North Sea on a daily base. Similarly, Faure et al. (2015) extrapolated from manta trawl samples in the *River Rhone* that a daily freight of *540 kg MP* is transported into the Mediterranean Sea at least.

Interview 3

Info: Dafne Eerkes-Medrano (DEM) works as Marine Biodiversity Science Advisor with Marine Scotland Science. Her research focuses on marine biodiversity health, food webs and ecosystem health, biology and ecology of the deep sea, and microplastics in aquatic systems.

Bill Turrell (BT) is Programme Manager of the Environment Monitoring and Assessment (EMA) Programme in Marine Scotland Science. The EMA Programme covers a broad scope of advice in topics such as the Marine Strategy Framework Directive, the Water Framework Directive and climate change. Monitoring and assessment includes marine litter and microplastics and the Scottish Coastal Observatory. Current research areas include sources, sinks and pollutant hazards of microplastics in Scotland's seas.

AL: Plastic pollution research has a long history in marine systems compared to freshwaters. Which key findings, derived from ocean studies, are lacking in rivers so far?

DEM & BT: We focus this answer on the presence of microplastics in the environment, rather than on interactions of plastic with biota. In both aquatic habitats (marine and freshwater) early studies were predominantly about recording presence in the environment. Proportionally in relation to studies of presence and abundance, the studies on transport and degradation appear to be fewer in freshwaters. The latter are needed to understand the life histories of plastics in the environment and where we can expect to find hotspots of plastics as well as how long these hotspots can persist if present. To aid investigations of transport, accurate estimates of plastic concentrations and abundances in sources will be needed (see our answer to the third question below).

AL: Rivers transport large amounts of plastic litter into the oceans and marine pollution control is closely linked to the reduction of these supplies. Which reduction measures, in this respect, are considered most potent?

DEM & BT: The effectiveness of mitigation and management methods to reduce river transport of plastic litter into oceans will depend on the type of pollution (macro- or micro-plastics, and primary, secondary, or arising from everyday use). For example, regulation at the production level may help in preventing input of primary plastic from accidental spills. In the case of secondary plastic litter, recycling may help remove plastics from the waste stream; an investment to develop alternative materials can reduce plastics in the waste stream. Preventing entry of secondary microplastics and the entry of microplastics from wear into rivers is more of a challenge. The use of filters in washing machines, dryers, and sewage outflows may partially address this. Macro plastics are in some cases removed from rivers with nets, weirs, and other devices.

(continued)

Interview 3 (continued)

AL: Recent plastic transport models not only take into account particle properties (e.g. density, shape, size) and physical forces (e.g. current, wind, turbulence), but also en route-processes as biofouling, sedimentation and hetero-aggregation. Still, what are the big shortcomings of such models?

DEM & BT: An important shortcoming we still face is the need to quantify sources and sinks and to build these into transport models. If we focus on the issue of plastic litter in Scottish marine waters, there is a need to identify the sources (e.g. is it plastics transported from rivers, plastics discarded or degrading at sea, or is it plastics transported in ocean currents) and to quantify the size of the source (e.g. are they similar or are there order of magnitude differences between them). Estimates of sources will need to account for temporal and spatial variability and magnitude of variability.

5 Danube

The Danube is Europe's second largest river (2857 km), crossing ten countries from source (Germany) to mouth (Black Sea, Romania). It drains a total area of 817,000 km², including large agglomerations (Linz, Vienna, Bratislava, Budapest, Belgrade). The whole river has been subject to massive man-made regulations linked to navigation, power generation, land use and flood control (Tockner et al. 1998). Especially in the upper region, the Danube is a straightened channel with stabilized riverbanks that is interrupted by a cascade of impoundments (hydropower dams) (Keckeis and Schiemer 2002). The associated changes in natural flow regime have led to increased bed erosion (in free flowing stretches), enhanced sedimentation rates (in reservoirs) and a disconnection between main channel and floodplains (Schiemer et al. 1999). Stream organisms are directly affected by habitat loss and often detrimental shifts in abiotic parameters (e.g. current velocity, water temperature, discharge, turbulence, shear stress) (Keckeis et al. 1997; Reckendorfer et al. 1999; Schiemer et al. 2001; Lechner et al. 2013).

One of the rare free-flowing stretches of the upper Danube is situated between Vienna and Bratislava. Hosting the largest remnants of alluvial landscapes in Europe, the region was declared a national park ("Danube Alluvial Zone National Park") in 1996. Although ambitious restoration measures improved the ecological status of the river in this section (Tritthart et al. 2014), the main channel is still heavily regulated. The shorelines are formed by artificial, straightened embankments (rip-raps) and rock wing-dykes (groynes), supporting erosion control and navigability. This river part is characterized by high shipping intensities, with more than 1000 passages per month on average (Kucera-Hirzinger et al. 2009).

The national park is a well-studied area, in terms of ecology, with extensive basic research taking place. In the years 2010 and 2012, a study on the dispersal patterns of riverine fish larvae was carried out in the Danube main stem (see Lechner et al. 2013,

2017). Therefore, large numbers of chemically marked nase larvae (*Chondrostoma nasus*) were initially released at specific points and recaptured at varying distances downstream with fine-meshed (500 μm) stationary drift nets, exposed in shallow littoral zones (average water depth approx. 1 m).

In the course of sample processing, plastic litter turned out to be a substantial bycatch (Lechner et al. 2014). In sum, 951 drift samples contained a total of 24,049 young fish (comprising released and autochthonous individuals) and 17,349 plastic particles (micro- and macro-sized). The MP volume mainly consisted of industrial precursors (*primary* MP: *pellets, spherules, flakes*), whereas the larger fraction basically included fragments of consumer products.

Both plastic density and composition displayed distinct differences between sampling years (2010, 2012). The mean plastic density was clearly enhanced in 2010 (937.6 ± 8543.8 items per 1000 m^3 compared to 55.1 ± 75.4 in 2012), exhibiting pronounced peaks in single nets (up to 141,647 particles). Furthermore, *primary* MP dominated the catches in 2010 (86%) but fragments prevailed in 2012 (69%). Pooling all samples, however, the mean density of plastic litter (316.8 ± 4664.6 items per 1000 m^3), transported in the surface water of the Austrian Danube, was higher than those of larval fish (275.3 ± 745.0 individuals per 1000 m^3).

The plastic load in the observed river section was estimated at 3.91 g/s during average flow and extrapolated to 48.23 g/s at the mouth, considering the downstream increase in catchment population density. This equals a daily input of 4.2 t plastic litter into the Black Sea via the River Danube (at mean flow). The publication of these results triggered a major response from the media and started a national debate on freshwater plastic contamination. A leaky manufacturing plant, whose industrial discharge enters a Danube tributary within the national park, was identified as a relevant point source (Lechner and Ramler 2015). A malfunction of the company's water treatment system during heavy rainfalls triggered the detected peaks of *primary* MP in 2010.

A subsequent study on plastics in the Danube, commissioned by the Austrian government, investigated spatial transport patterns and correlations between river discharge and particle densities (Hohenblum et al. 2015). Furthermore, the effluent of the above-mentioned manufacturing plant was sampled in order to assess the daily MP release into the Danube system. The main channel surveys were conducted at opposite ends of the Austrian flow length, proximate to the German and Slovakian border. At both sites, plastic densities were measured at different water depths (i.e. surface, middle of water column, near bed) over the river cross section. Therefore, a specifically designed sampling device, consisting of six nets (mesh sizes 41–500 μm) vertically arranged at a steel rope, was exposed from road bridges with a mobile crane (see Liedermann et al. 2018). The calculated plastic loads (micro + macro) for the observed river sections ranged between 0.07–1.13 g/s (near Germany) and 0.12–7.5 g/s (near Slovakia), respectively, and were positively correlated with discharge (up to 60-fold increases during flood events!). At mean flows, however, plastic loads at both sampling sites were clearly below the 3.91 g/s estimated by Lechner et al. (2014). This gap is likely due to methodological

constraints in both studies. Whereas Lechner et al. (2014) exclusively sampled shallow bankside areas of the main channel, prone to accumulate plastic flotsam (Vermaire et al. 2017), the sampling device used by Hohenblum et al. (2015) was limited to water depths ≥ 3 m (personal information M. Liedermann). A more realistic estimation calls for data integration. Thus, upcoming plastic transport studies in rivers are advised to sample the *entire* cross section, and model approaches should consider lateral gradients in particle densities.

The sewer of the plastic production plant carried between 562 and 9507 pellets per day (equals 0.01–0.22 kg) (Hohenblum et al. 2015). Additionally, high loads of small fibres (<250 µm) were detected but could not be quantified with the methods applied. There was no obvious relationship between precipitation and plastic concentration but heavy rainfalls, known to strain the sewage system (Lechner and Ramler 2015), did not occur during sampling. The unfavourable positioning of the sampling gear, *between* installed MP filtering systems of the sewer, did not allow for any realistic estimation on the actual plastic import into the Danube system.

Noteworthy, even the maximum measured loads (0.22 kg/day) would be legally released into the environment. The Austrian Ordinance on Waste-Water Emission classifies plastic as a filterable substance, limiting the emission concentrations to 30 mg/L. Considering the authorized discharge at the sewer (550 m^3/day), this yields a daily plastic release of 16.5 kg into the receiving water within the law (Hohenblum et al. 2015).

The Austrian Danube is a good example to touch upon interactions and differences between MP pollution and other anthropogenic impacts to river systems (see also *Interview 4*):

- The intense vessel traffic on the Danube apparently promotes plastic retention in the riparian zones. The ship-induced waves lead to substantial stranding rates of floating MP particles along the shorelines, especially at low and mean water levels (personal observation). Moreover, some ships directly dispose the on-board generated waste into the river (personal observation), which makes them *diffuse* mobile *sources*.
- In addition to large reservoirs (upside of dams), smaller groyne fields along the river margins (see Fig. 3) serve as catch basins for plastic litter. Below mean flow, groyne fields are characterized by circular currents (small gyres; Tritthart et al. 2009) and trap large amounts of floating particles (personal observation). This plastic load is exposed to high densities of aquatic organisms, which use the fields as nursery and refuge habitats (Bischoff and Wolter 2001; Engelhardt et al. 2004).
- The channelization of the Danube severely affected the sensitive river-wetland ecosystem. The corresponding increase in streambed erosion, however, could foster a steady wash out of sedimented plastic particles (Hurley et al. 2018) and ultimately reduce pollution rates.
- Artificial changes in river morphology and flow regime (based upon damming) primarily endanger rheophilic (i.e. flow-preferring) fish species of the Austrian Danube (Schiemer and Spindler 1989). As MP concentrates in sedimentation areas of the river (reservoirs, groyne fields), it might affect limnophilic species, which prefer stagnant waters, in the first place.

Fig. 3 The River Danube approximately transports 1500 tons of plastic litter into the Black Sea every year (Lechner et al. 2014; Siegfried et al. 2017). Artificial river engineering structures as groynes, creating low-flow sedimentation areas (groyne fields) along the shorelines, foster plastic retention and in situ contamination of river systems. Photo: Copyright Hubert Keckeis

- So far, no large-scale initiatives have been launched to remove plastic litter from the Danube (or other rivers respectively!). Such measures will be most effective at sites of high plastic concentrations. Consequently, reservoirs should be considered important strategic points in upcoming plastic reduction plans.

Most rivers worldwide are regulated and evidence suggests that the majority of these rivers are contaminated with MP waste. Therefore a detailed study on the impacts of common regulation measures on MP fate and effects is overdue. A better understanding will help in refining plastic transport models and assessing in situ contamination of lotic systems.

Interview 4
Info: Hubert Keckeis (HK) is working at the Department of Limnology and Bio-Oceanography at the University of Vienna. He is studying and teaching fish ecology in rivers. The main topics are spatial and temporal distribution patterns, (early) life-history, reproduction, dispersal and migration, biodiversity and habitat use of fish assemblages and single species.

(continued)

Interview 4 (continued)

AL: For almost 35 years, you've been studying the Danube system in the field of tension between human impact and nature conservation. What are the main anthropogenic stressors of the river?

HK: The requirements of different resources which are delivered by this system has led to massive exploitation and alterations of the river which were significantly intensified and accelerated during the last approx. 150 years. The main issues are organic and industrial pollution, measures and changes related to water consumption, power generation, navigation and flood control. This has led to a large-scale destruction of floodplains, geomorphological degradation of the river channels, habitat-loss, reduction of connectivity and fragmentation of habitats and landscapes. As a result, we see disturbances in ecological processes (i.e. production, food webs) and a loss of biodiversity.

AL: In terms of individual- and population related implications on stream biota, how does plastic pollution differ from other man-made interferences in rivers and streams?

HK: Man made measures for bank stabilization, flood protection (i.e. dykes) and power generation (i.e. dams) significantly affect important biological processes and energy flows in the ecosystem. They also influence and change the occurrence and abundance of many aquatic organisms, which again alters their development and population dynamics.

In contrast to other organic and industrial pollution substances, plastic has been considered/classified to be a "non-effective" (i.e. nontoxic) substance in the environment. However, many studies reveal that plastic particles are consumed by different organisms (i.e. birds, fish, zooplankton, insect larvae, mussels, etc.) which may have direct (blockages, inflammation) or indirect effects (toxic properties and or hormonal effects of added chemical substances). The consequences of this uptake and accumulation in freshwater systems for individuals and populations are largely unknown.

As for many other substances, the sources of plastic contamination of rivers are point and diffuse sources. Irrespective of the source, once these materials are in the environment, an elimination, especially of micro- and nano particles is extremely difficult, if not impossible. The stability of plastic makes it a long-term factor with which the present and also the next generations will have to deal with.

AL: Can you outline possible feedback effects or interactions between river regulation measures (e.g. shoreline embankments, dams, reservoirs) and plastic pollution?

HK: River alterations like channelization and bank protection measures may lead to a fast downstream transport, on the other hand, dams may lead to accumulation of the transported substances in their reservoirs. The retention

(continued)

Interview 4 (continued)
of plastic in specific sections may lead to higher uptake rates by organisms, which may foster accumulation in the food webs. As a consequence, the riverine biota facing limitations by river regulation measures are additionally affected by higher concentrations of these harmful contaminants.

6 Conclusion

Freshwater plastic pollution research is on the rise. The referenced literature and the expert statements (*Interviews 1–4*) in this chapter demonstrate the scientific efforts, currently undertaken to better understand the problem of plastic waste in rivers. Moreover, recent legal restrictions (e.g. the *EU-Single Use Plastics Directive*, the ban of microbeads from personal care products in several countries) indicate the growing recognition of relevant scientific findings by political decision-makers.

However, large knowledge gaps still exist, which urgently need to be closed in order to expedite legal regulations. First and foremost, researchers must increasingly direct their attention to nanoparticles, which are commonly below the radar of riverine plastic studies. The quantification of this size-fraction is essential for realistic pollution assessments and will allow wider conclusions on plastic-biota interactions. Furthermore, in situ and laboratory studies should aim at compiling a ranking system of the most common and most harmful polymers in running waters, which will serve as a basis for legal provisions. Also, a deeper knowledge of in-river retention processes is needed, to identify plastic pollution hot-spots and effectively target plastic-removal actions. Finally, as many sources of plastic litter have yet been identified, more attention should be paid on how to minimize their discharge into rivers (e.g. new filtering procedures in WWTPs, efficient treatment of surface runoff).

Regarding the initial objective of this chapter to provide a compact overview on riverine plastic pollution instead of an extensive literature research, I failed. But as I combed the existing literature, almost each paper seemed relevant and worth mentioning. All the readers are advised to pursue the development of freshwater plastic pollution research, as new findings might directly be associated with their everyday life (e.g. MP in drinking water and edible freshwater fish).

Acknowledgments I would like to thank Dafne Eerkes-Medrano, Alice Horton, Hannes Imhof, Hubert Keckeis and Bill Turrell for their great contribution to this chapter! As many times before, Paul Humphries significantly improved my work.

I almost didn't finish this text, because there are three girls who continuously capture all my attention, passion and dedication.

References

Ambrosini R, Azzoni RS, Pittino F et al (2019) First evidence of microplastic contamination in the supraglacial debris of an alpine glacier. Environ Pollut 253:297–301. https://doi.org/10.1016/j.envpol.2019.07.005

Andrade MC, Winemiller KO, Barbosa PS et al (2019) First account of plastic pollution impacting freshwater fishes in the Amazon: ingestion of plastic debris by piranhas and other serrasalmids with diverse feeding habits. Environ Pollut 244:766–773

Andrady AL (2011) Microplastics in the marine environment. Mar Pollut Bull 62:1596–1605

Ashton K, Holmes L, Turner A (2010) Association of metals with plastic production pellets in the marine environment. Mar Pollut Bull 60:2050–2055

Balasubramanian V, Natarajan K, Hemambika B et al (2010) High-density polyethylene (HDPE)-degrading potential bacteria from marine ecosystem of Gulf of Mannar, India. Lett Appl Microbiol 51:205–211

Baldwin AK, Corsi SR, Mason SA (2016) Plastic debris in 29 Great Lakes tributaries: relations to watershed attributes and hydrology. Environ Sci Technol 50:10377–10385

Ballent A, Corcoran PL, Madden O et al (2016) Sources and sinks of microplastics in Canadian Lake Ontario nearshore, tributary and beach sediments. Mar Pollut Bull 110:383–395

Barnes RL (2011) Regulating the disposal of cigarette butts as toxic hazardous waste. Tob Control 20:45–48

Battulga B, Kawahigashi M, Oyuntsetseg B (2019) Distribution and composition of plastic debris along the river shore in the Selenga River basin in Mongolia. Environ Sci Pollut Res 26(14):14059–14072

Bayo J, Olmos S, López-Castellanos J et al (2016) Microplastics and microfibers in the sludge of a municipal wastewater treatment plant. Int J Sustain Dev Plan 11:812–821

Besseling E, Wang B, Lürling M et al (2014) Nanoplastic affects growth of S. obliquus and reproduction of D. magna. Environ Sci Technol 48:12336–12343

Besseling E, Quik JT, Sun M et al (2017) Fate of nano-and microplastic in freshwater systems: a modeling study. Environ Pollut 220:540–548

Best J (2019) Anthropogenic stresses on the world's big rivers. Nat Geosci 12:7–12

Bhattacharya P, Lin S, Turner JP, Ke PC (2010) Physical adsorption of charged plastic nanoparticles affects algal photosynthesis. J Phys Chem C 114(39):16556–16561

Bischoff A, Wolter C (2001) Groyne-heads as potential summer habitats for juvenile rheophilic fishes in the Lower Oder, Germany. Limnologica 31(1):17–26

Blair RM, Waldron S, Phoenix V et al (2017) Micro-and nanoplastic pollution of freshwater and wastewater treatment systems. Springer Sci Rev 5:19–30

Blettler MC, Abrial E, Khan FR, Sivri N, Espinola LA (2018) Freshwater plastic pollution: recognizing research biases and identifying knowledge gaps. Water Res 143:416–424

Boucher J, Faure F, Pompini O et al (2018) (Micro) plastic fluxes in Lake Geneva basin. TrAC Trends Anal Chem

Brennecke D, Duarte B, Paiva F et al (2016) Microplastics as vector for heavy metal contamination from the marine environment. Estuar Coast Shelf Sci 178:189–195

Browne MA, Crump P, Niven SJ et al (2011) Accumulation of microplastic on shorelines woldwide: sources and sinks. Environ Sci Technol 45:9175–9179

Campbell SH, Williamson PR, Hall BD (2017) Microplastics in the gastrointestinal tracts of fish and the water from an urban prairie creek. Facets 2:395–409

Carr SA, Liu J, Tesoro AG (2016) Transport and fate of microplastic particles in wastewater treatment plants. Water Res 91:174–182

Carson HS (2013) The incidence of plastic ingestion by fishes: from the prey's perspective. Mar Pollut Bull 74:170–174

Castañeda RA, Avlijas S, Simard MA et al (2014) Microplastic pollution in St. Lawrence River sediments. Can J Fish Aquat Sci 71:1767–1771

Cole M, Lindeque P, Halsband C et al (2011) Microplastics as contaminants in the marine environment: a review. Mar Pollut Bull 62:2588–2597

de Stephanis R, Giménez J, Carpinelli E et al (2013) As main meal for sperm whales: plastics debris. Mar Pollut Bull 69:206–214

DeMott WR (1986) The role of taste in food selection by freshwater zooplankton. Oecologia 69:334–340

Dris R, Imhof H, Sanchez W et al (2015a) Beyond the ocean: contamination of freshwater ecosystems with (micro-) plastic particles. Environ Chem 12:539–550

Dris R, Gasperi J, Rocher V et al (2015b) Microplastic contamination in an urban area: a case study in Greater Paris. Environ Chem 12:592–599

Dris R, Gasperi J, Saad M et al (2016) Synthetic fibers in atmospheric fallout: a source of microplastics in the environment? Mar Pollut Bull 104:290–293

Dris R, Imhof HK, Löder MG et al (2018) Microplastic contamination in freshwater systems: methodological challenges, occurrence and sources. In: Microplastic Contamination in Aquatic Environments. Elsevier, Amsterdam, pp 51–93

Dudgeon D, Arthington AH, Gessner MO et al (2006) Freshwater biodiversity: importance, threats, status and conservation challenges. Biol Rev 81:163–182

Eckert EM, Di Cesare A, Kettner MT, Arias-Andres M, Fontaneto D, Grossart HP, Corno G (2018) Microplastics increase impact of treated wastewater on freshwater microbial community. Environ Pollut 234:495–502

Eerkes-Medrano D, Thompson R (2018) Occurrence, fate, and effect of microplastics in freshwater systems. In: Microplastic Contamination in Aquatic Environments. Elsevier, Amsterdam, pp 95–132

Eerkes-Medrano D, Thompson RC, Aldridge DC (2015) Microplastics in freshwater systems: a review of the emerging threats, identification of knowledge gaps and prioritisation of research needs. Water Res 75:63–82

Eerkes-Medrano D, Leslie HA, Quinn B (2018) Microplastics in drinking water: a review and assessment of an emerging concern. Current Opinion in Environmental Science & Health

Engelhardt C, Krüger A, Sukhodolov A, Nicklisch A (2004) A study of phytoplankton spatial distributions, flow structure and characteristics of mixing in a river reach with groynes. J Plankton Res 26(11):1351–1366

Fahrenfeld NL, Arbuckle-Keil G, Beni NN et al (2018) Source tracking microplastics in the freshwater environment. TrAC Trends Anal Chem 112:248–254

FAO (2018) FAO yearbook. Fishery and Aquaculture Statistic 2016/FAO annuaire

Faure F, Demars C, Wieser O et al (2015) Plastic pollution in Swiss surface waters: nature and concentrations, interaction with pollutants. Environ Chem 12:582–591

Galgani F, Hanke G, Maes T (2015) Global distribution, composition and abundance of marine litter. In: Marine anthropogenic litter. Springer, Cham, pp 29–56

Ghosal D, Ghosh S, Dutta T et al (2016) Current state of knowledge in microbial degradation of polycyclic aromatic hydrocarbons (PAHs): a review. Front Microbiol 7:1369

Gigault J, Ter Halle A, Baudrimont M et al (2018) Current opinion: what is a nanoplastic? Environ Pollut 235:1030–1034

Gouin T, Roche N, Lohmann R et al (2011) A thermodynamic approach for assessing the environmental exposure of chemicals absorbed to microplastic. Environ Sci Technol 45:1466–1472

Gregory MR (2009) Environmental implications of plastic debris in marine settings—entanglement, ingestion, smothering, hangers-on, hitch-hiking and alien invasions. Philos Trans R Soc B 364:2013–2025

Hidalgo-Ruz V, Gutow L, Thompson RC et al (2012) Microplastics in the marine environment: a review of the methods used for identification and quantification. Environ Sci Technol 46:3060–3075

Hoellein TJ, McCormick AR, Hittie J et al (2017) Longitudinal patterns of microplastic concentration and bacterial assemblages in surface and benthic habitats of an urban river. Freshwater Sci 36:491–507

Hohenblum P, Frischenschlager H, Reisinger H, Konecny R, Uhl M, Mühlegger S et al (2015) Plastik in der Donau-Untersuchung zum Vorkommen von Kunststoffen in der Donau in Österreich. Umweltbundesamt-BOKU Report REP 547:1–120

Holland ER, Mallory ML, Shutler D (2016) Plastics and other anthropogenic debris in freshwater birds from Canada. Sci Total Environ 571:251–258

Horton AA, Dixon SJ (2018) Microplastics: an introduction to environmental transport processes. Wiley Interdiscip Rev Water 5:e1268

Horton AA, Svendsen C, Williams RJ et al (2017) Large microplastic particles in sediments of tributaries of the River Thames, UK–Abundance, sources and methods for effective quantification. Mar Pollut Bull 114:218–226

Horton AA, Jürgens MD, Lahive E et al (2018) The influence of exposure and physiology on microplastic ingestion by the freshwater fish Rutilus rutilus (roach) in the River Thames, UK. Environ Pollut 236:188–194

Hurley RR, Woodward JC, Rothwell JJ (2017) Ingestion of microplastics by freshwater tubifex worms. Environ Sci Technol 51:12844–12851

Hurley R, Woodward J, Rothwell JJ (2018) Microplastic contamination of river beds significantly reduced by catchment-wide flooding. Nat Geosci 11:251

Imhof HK, Ivleva NP, Schmid J et al (2013) Contamination of beach sediments of a subalpine lake with microplastic particles. Curr Biol 23:R867–R868

Imhof HK, Rusek J, Thiel M (2017) Do microplastic particles affect Daphnia magna at the morphological, life history and molecular level? PLoS One 12:e0187590

Jabeen K, Su L, Li J et al (2017) Microplastics and mesoplastics in fish from coastal and fresh waters of China. Environ Pollut 221:141–149

Jambeck JR, Geyer R, Wilcox C, Siegler TR, Perryman M, Andrady A et al (2015) Plastic waste inputs from land into the ocean. Science 347(6223):768–771

Jemec A, Horvat P, Kunej U et al (2016) Uptake and effects of microplastic textile fibers on freshwater crustacean Daphnia magna. Environ Pollut 219:201–209

Jiang C, Yin L, Li Z et al (2019) Microplastic pollution in the rivers of the Tibet Plateau. Environ Pollut 249:91–98

Kalčíková G, Alič B, Skalar T et al (2017a) Wastewater treatment plant effluents as source of cosmetic polyethylene microbeads to freshwater. Chemosphere 188:25–31

Kalčíková G, Gotvajn AŽ, Kladnik A et al (2017b) Impact of polyethylene microbeads on the floating freshwater plant duckweed Lemna minor. Environ Pollut 230:1108–1115

Kapp KJ, Yeatman E (2018) Microplastic hotspots in the Snake and lower Columbia rivers: a journey from the greater Yellowstone ecosystem to the Pacific Ocean. Environ Pollut 241:1082–1090

Karbalaei S, Hanachi P, Walker TR et al (2018) Occurrence, sources, human health impacts and mitigation of microplastic pollution. Environ Sci Pollut Res 25:36046–36063

Karlsson TM, Arneborg L, Broström G et al (2018) The unaccountability case of plastic pellet pollution. Mar Pollut Bull 129:52–60

Kataoka T, Nihei Y, Kudou K et al (2019) Assessment of the sources and inflow processes of microplastics in the river environments of Japan. Environ Pollut 244:958–965

Kathiresan K (2003) Polythene and plastics-degrading microbes from the mangrove soil. Rev Biol Trop 51:629–633

Kay P, Hiscoe R, Moberley I (2018) Wastewater treatment plants as a source of microplastics in river catchments. Environ Sci Pollut Res 25:20264–20267

Keckeis H, Schiemer F (2002) Understanding conservation issues of the Danube River. Fishery science: the unique contribution of early life stages. Blackwell Publishing, Oxford, p 272–288

Keckeis H, Winkler G, Flore L et al (1997) Spatial and seasonal characteristics of 0+ fish nursery habitats of nase, Chondrostoma nasus in the River Danube, Austria. Folia Zoologica-Praha 46:133–150

Kiessling T, Knickmeier K, Kruse K, Brennecke D, Nauendorf A, Thiel M (2019) Plastic Pirates sample litter at rivers in Germany–Riverside litter and litter sources estimated by schoolchildren. Environ Pollut 245:545–557

Kilponen J (2016) Microplastics and harmful substances in urban runoffs and landfill leachates: possible emission sources to marine environment

Klein S, Worch E, Knepper TP (2015) Occurrence and spatial distribution of microplastics in river shore sediments of the Rhine-Main area in Germany. Environ Sci Technol 49:6070–6076

Klein S, Dimzon IK, Eubeler J et al (2018) Analysis, occurrence, and degradation of microplastics in the aqueous environment. In: Freshwater Microplastics. Springer, Cham, pp 51–67

Kooi M, Besseling E, Kroeze C et al (2018) Modeling the fate and transport of plastic debris in freshwaters: review and guidance. In: Freshwater microplastics. Springer, Cham, pp 125–152

Kosuth M, Mason SA, Wattenberg EV (2018) Anthropogenic contamination of tap water, beer, and sea salt. PLoS One 13:e0194970

Kucera-Hirzinger V, Schludermann E, Zornig H et al (2009) Potential effects of navigation-induced wave wash on the early life history stages of riverine fish. Aquat Sci 71:94–102

Lagarde F, Olivier O, Zanella M et al (2016) Microplastic interactions with freshwater microalgae: hetero-aggregation and changes in plastic density appear strongly dependent on polymer type. Environ Pollut 215:331–339

Lahens L, Strady E, Kieu-Le TC, Dris R, Boukerma K, Rinnert E et al (2018) Macroplastic and microplastic contamination assessment of a tropical river (Saigon River, Vietnam) transversed by a developing megacity. Environ Pollut 236:661–671

Laist DW (1997) Impacts of marine debris: entanglement of marine life in marine debris including a comprehensive list of species with entanglement and ingestion records. In: Marine Debris. Springer, New York, NY, pp 99–139

Law KL, Morét-Ferguson S, Maximenko NA et al (2010) Plastic accumulation in the North Atlantic subtropical gyre. Science 329:1185–1188

Lebreton LC, Van der Zwet J, Damsteeg JW et al (2017) River plastic emissions to the world's oceans. Nat Commun 8:15611

Lechner A, Ramler D (2015) The discharge of certain amounts of industrial microplastic from a production plant into the river Danube is permitted by the Austrian legislation. Environ Pollut 200:159–160

Lechner A, Keckeis H, Schludermann E et al (2013) Shoreline configurations affect dispersal patterns of fish larvae in a large river. ICES J Mar Sci 71:930–942

Lechner A, Keckeis H, Lumesberger-Loisl F (2014) The Danube so colourful: a potpourri of plastic litter outnumbers fish larvae in Europe's second largest river. Environ Pollut 188:177–181

Lechner A, Keckeis H, Glas M et al (2017) The influence of discharge, current speed, and development on the downstream dispersal of larval nase (Chondrostoma nasus) in the River Danube. Can J Fish Aquat Sci 75:247–259

Lenz R, Enders K, Nielsen TG (2016) Microplastic exposure studies should be environmentally realistic. Proc Natl Acad Sci 113:E4121–E4122

Leslie HA, Brandsma SH, Van Velzen MJM et al (2017) Microplastics en route: field measurements in the Dutch river delta and Amsterdam canals, wastewater treatment plants, North Sea sediments and biota. Environ Int 101:133–142

Li X, Chen L, Mei Q et al (2018a) Microplastics in sewage sludge from the wastewater treatment plants in China. Water Res 142:75–85

Li J, Liu H, Chen JP (2018b) Microplastics in freshwater systems: a review on occurrence, environmental effects, and methods for microplastics detection. Water Res 137:362–374

Liedermann M, Gmeiner P, Pessenlehner S, Haimann M, Hohenblum P, Habersack H (2018) A methodology for measuring microplastic transport in large or medium rivers. Water 10(4):414

Loomis J, Kent P, Strange L et al (2000) Measuring the total economic value of restoring ecosystem services in an impaired river basin: results from a contingent valuation survey. Ecol Econ 33:103–117

Lynch AJ, Cooke SJ, Deines AM, Bower SD, Bunnell DB, Cowx IG et al (2016) The social, economic, and environmental importance of inland fish and fisheries. Environ Rev 24 (2):115–121

Mahon AM, Officer R, Nash R et al (2014) Scope, fate, risks and impacts of microplastic pollution in Irish freshwater systems. EPA Research Programme, 2020. ISBN: 978-1-84095-705-1

Mahon AM, O'Connell B, Healy MG et al (2016) Microplastics in sewage sludge: effects of treatment. Environ Sci Technol 51:810–818

Mani T, Hauk A, Walter U et al (2015) Microplastics profile along the Rhine River. Sci Rep 5:17988

Mani T, Blarer P, Storck FR et al (2019) Repeated detection of polystyrene microbeads in the lower Rhine River. Environ Pollut 245:634–641

Mato Y, Isobe T, Takada H et al (2001) Plastic resin pellets as a transport medium for toxic chemicals in the marine environment. Environ Sci Technol 35:318–324

McCormick A, Hoellein TJ, Mason SA et al (2014) Microplastic is an abundant and distinct microbial habitat in an urban river. Environ Sci Technol 48:11863–11871

McCormick AR, Hoellein TJ, London MG et al (2016) Microplastic in surface waters of urban rivers: concentration, sources, and associated bacterial assemblages. Ecosphere 7:e01556

McDermid KJ, McMullen TL (2004) Quantitative analysis of small-plastic debris on beaches in the Hawaiian archipelago. Mar Pollut Bull 48:790–794

McNeish RE, Kim LH, Barrett HA et al (2018) Microplastic in riverine fish is connected to species traits. Sci Rep 8:11639

Miao L, Wang P, Hou J et al (2019) Distinct community structure and microbial functions of biofilms colonizing microplastics. Sci Total Environ 650:2395–2402

Mintenig SM, Int-Veen I, Löder MG et al (2017) Identification of microplastic in effluents of waste water treatment plants using focal plane array-based micro-Fourier-transform infrared imaging. Water Res 108:365–372

Moore CJ, Lattin GL, Zellers AF (2011) Quantity and type of plastic debris flowing from two urban rivers to coastal waters and beaches of Southern California. Rev Gestão Costeira Integrada: J Integr Coast Zone Manag 11(1):65–73

Morritt D, Stefanoudis PV, Pearce D, Crimmen OA, Clark PF (2014) Plastic in the Thames: a river runs through it. Mar Pollut Bull 78(1–2):196–200

Murphy F, Ewins C, Carbonnier F et al (2016) Wastewater treatment works (WwTW) as a source of microplastics in the aquatic environment. Environ Sci Technol 50:5800–5808

Napper IE, Bakir A, Rowland SJ et al (2015) Characterisation, quantity and sorptive properties of microplastics extracted from cosmetics. Mar Pollut Bull 99:178–185

Nel HA, Dalu T, Wasserman RJ (2018) Sinks and sources: assessing microplastic abundance in river sediment and deposit feeders in an austral temperate urban river system. Sci Total Environ 612:950–956

Newman S, Watkins E, Farmer A (2015) The economics of marine litter. In: Marine anthropogenic litter. Springer, Cham, pp 367–394

Nizzetto L, Futter M, Langaas S (2016a) Are agricultural soils dumps for microplastics of urban origin? Environ Sci Technol 20:10777–10779

Nizzetto L, Bussi G, Futter MN et al (2016b) A theoretical assessment of microplastic transport in river catchments and their retention by soils and river sediments. Environ Sci: Processes Impacts 18:1050–1059

Obbard RW, Sadri S, Wong YQ et al (2014) Global warming releases microplastic legacy frozen in Arctic Sea ice. Earth's Future 2:315–320

Oliveira M, Ribeiro A, Hylland K et al (2013) Single and combined effects of microplastics and pyrene on juveniles (0+ group) of the common goby Pomatoschistus microps (Teleostei, Gobiidae). Ecol Indic 34:641–647

Oßmann BE, Sarau G, Holtmannspötter H et al (2018) Small-sized microplastics and pigmented particles in bottled mineral water. Water Res 141:307–316

Panno SV, Kelly WR, Scott J et al (2019) Microplastic contamination in karst groundwater systems. Groundwater 57:189–196

Parker TT, Rayburn J (2017) A comparison of electronic and traditional cigarette butt leachate on the development of Xenopus laevis embryos. Toxicol Rep 4:77–82

Pazos RS, Maiztegui T, Colautti DC et al (2017) Microplastics in gut contents of coastal freshwater fish from Río de la Plata estuary. Mar Pollut Bull 122:85–90

Peters CA, Bratton SP (2016) Urbanization is a major influence on microplastic ingestion by sunfish in the Brazos River basin, Central Texas, USA. Environ Pollut 210:380–387

Pivokonsky M, Cermakova L, Novotna K (2018) Occurrence of microplastics in raw and treated drinking water. Sci Total Environ 643:1644–1651

Rech S, Macaya-Caquilpán V, Pantoja JF et al (2015) Sampling of riverine litter with citizen scientists—findings and recommendations. Environ Monit Assess 187:335

Reckendorfer W, Keckeis H, Winkler G et al (1999) Zooplankton abundance in the River Danube, Austria: the significance of inshore retention. Freshw Biol 41:583–591

Redondo-Hasselerharm PE, Falahudin D, Peeters ET et al (2018) Microplastic effect thresholds for freshwater benthic macroinvertebrates. Environ Sci Technol 52:2278–2286

Register K (2000) Cigarette butts as litter-toxic as well as ugly. Underw Nat 25:23–29

Rochman CM, Browne MA, Halpern BS et al (2013a) Policy: classify plastic waste as hazardous. Nature 494:169

Rochman CM, Hoh E, Kurobe T et al (2013b) Ingested plastic transfers hazardous chemicals to fish and induces hepatic stress. Sci Rep 3:3263

Rochman CM, Tahir A, Williams SL et al (2015) Anthropogenic debris in seafood: plastic debris and fibers from textiles in fish and bivalves sold for human consumption. Sci Rep 5:14340

Rochman CM, Parnis JM, Browne MA et al (2017) Direct and indirect effects of different types of microplastics on freshwater prey (Corbicula fluminea) and their predator (Acipenser transmontanus). PLoS One 12:e0187664

Rodrigues MO, Abrantes N, Gonçalves FJM et al (2018) Spatial and temporal distribution of microplastics in water and sediments of a freshwater system (Antuã River, Portugal). Sci Total Environ 633:1549–1559

Rosenkranz P, Chaudhry Q, Stone V et al (2009) A comparison of nanoparticle and fine particle uptake by Daphnia magna. Environ Toxicol Chem 28:2142–2149

Rummel CD, Jahnke A, Gorokhova E et al (2017) Impacts of biofilm formation on the fate and potential effects of microplastic in the aquatic environment. Environ Sci Technol Lett 4:258–267

Sadri SS, Thompson RC (2014) On the quantity and composition of floating plastic debris entering and leaving the Tamar Estuary, Southwest England. Mar Pollut Bull 81(1):55–60

Sanchez W, Bender C, Porcher JM (2014) Wild gudgeons (Gobio gobio) from French rivers are contaminated by microplastics: preliminary study and first evidence. Environ Res 128:98–100

Sarijan S, Azman S, Said M I M (2018) Microplastics pollution In Skudai and Tebrau river, Malaysia. Sharing visions and solutions for better future, 16-18 Conference Proceedings, IGCESH2018. ISBN:978-967-2171-27-0

Scherer C, Brennholt N, Reifferscheid G et al (2017) Feeding type and development drive the ingestion of microplastics by freshwater invertebrates. Sci Rep 7:17006

Scherer C, Weber A, Lambert S et al (2018) Interactions of microplastics with freshwater biota. In: Freshwater microplastics. Springer, Cham, pp 153–180

Schiemer F, Spindler T (1989) Endangered fish species of the Danube River in Austria. Regul Rivers Res Manag 4(4):397–407

Schiemer F, Baumgartner C, Tockner K (1999) Restoration of floodplain rivers: the 'Danube restoration project'. River Res Appl 15:231–244

Schiemer F, Keckeis H, Reckendorfer W et al (2001) The "inshore retention concept" and its significance for large rivers. Arch Hydrobiol (Suppl)(Large Rivers) 135:509–516

Schmidt C, Krauth T, Wagner S (2017) Export of plastic debris by rivers into the sea. Environ Sci Technol 51:12246–12253

Shruti VC, Jonathan MP, Rodriguez-Espinosa PF et al (2019) Microplastics in freshwater sediments of Atoyac River basin, Puebla City, Mexico. Sci Total Environ 654:154–163

Siegfried M, Koelmans AA, Besseling E (2017) Export of microplastics from land to sea. A modelling approach. Water Res 127:249–257

Silva-Cavalcanti JS, Silva JDB, de França EJ et al (2017) Microplastics ingestion by a common tropical freshwater fishing resource. Environ Pollut 221:218–226

Sjollema SB, Redondo-Hasselerharm P, Leslie HA et al (2016) Do plastic particles affect microalgal photosynthesis and growth? Aquat Toxicol 170:259–261

Slaughter E, Gersberg RM, Watanabe K et al (2011) Toxicity of cigarette butts, and their chemical components, to marine and freshwater fish. Tob Control 20:i25–i29

Smiroldo G, Balestrieri A, Pini E et al (2019) Anthropogenically altered trophic webs: alien catfish and microplastics in the diet of Eurasian otters. Mammal Res 64:165–174

Su L, Cai H, Kolandhasamy P et al (2018) Using the Asian clam as an indicator of microplastic pollution in freshwater ecosystems. Environ Pollut 234:347–355

Ter Halle A, Ladirat L, Gendre X et al (2016) Understanding the fragmentation pattern of marine plastic debris. Environ Sci Technol 50:5668–5675

Teuten EL, Saquing JM, Knappe DR et al (2009) Transport and release of chemicals from plastics to the environment and to wildlife. Philos Trans R Soc B 364:2027–2045

Tockner K, Schiemer F, Ward JV (1998) Conservation by restoration: the management concept for a river-floodplain system on the Danube River in Austria. Aquat Conserv Mar Freshwat Ecosyst 8:71–86

Tritthart M, Liedermann M, Habersack H (2009) Modelling spatio-temporal flow characteristics in groyne fields. River Res Appl 25(1):62–81

Tritthart M, Glas M, Liedermann M et al (2014) Numerical study of morphodynamics and ecological parameters following alternative groyne layouts at the Danube River. In: Lehfeldt R and Kopmann R (eds) ICHE 2014. Proceedings of the 11th International Conference on Hydroscience & Engineering. Hamburg, Germany, pp 685–692

Unice KM, Weeber MP, Abramson MM et al (2019) Characterizing export of land-based microplastics to the estuary-part I: application of integrated geospatial microplastic transport models to assess tire and road wear particles in the seine watershed. Sci Total Environ 646:1639–1649

van Emmerik T, Kieu-Le TC, Loozen M et al (2018) A methodology to characterize riverine macroplastic emission into the ocean. Front Mar Sci 5:372

van Weert S, Redondo-Hasselerharm PE, Diepens NJ et al (2019) Effects of nanoplastics and microplastics on the growth of sediment-rooted macrophytes. Sci Total Environ 654:1040–1047

van Wijnen J, Ragas AM, Kroeze C (2019) Modelling global river export of microplastics to the marine environment: sources and future trends. Sci Total Environ 673:392–401

Vermaire JC, Pomeroy C, Herczegh SM et al (2017) Microplastic abundance and distribution in the open water and sediment of the Ottawa River, Canada, and its tributaries. Facets 2:301–314

Villarrubia-Gómez P, Cornell SE, Fabres J (2018) Marine plastic pollution as a planetary boundary threat–the drifting piece in the sustainability puzzle. Mar Policy 96:213–220

Wagner M, Lambert S (eds) (2018) Freshwater Microplastics - Emerging Environmental Contaminants? Springer International Publishing, Cham, Switzerland. ISBN 978-3-319-61614-8

Wagner M, Scherer C, Alvarez-Muñoz D et al (2014) Microplastics in freshwater ecosystems: what we know and what we need to know. Environ Sci Eur 26:12

Wang J, Tan Z, Peng J et al (2016) The behaviors of microplastics in the marine environment. Mar Environ Res 113:7–17

Wang W, Ndungu AW, Li Z, Wang J (2017a) Microplastics pollution in inland freshwaters of China: a case study in urban surface waters of Wuhan, China. Sci Total Environ 575:1369–1374

Wang J, Peng J, Tan Z, Gao Y, Zhan Z, Chen Q, Cai L (2017b) Microplastics in the surface sediments from the Beijiang River littoral zone: composition, abundance, surface textures and interaction with heavy metals. Chemosphere 171:248–258

Watkins L, McGrattan S, Sullivan PJ, Walter MT (2019) The effect of dams on river transport of microplastic pollution. Sci Total Environ 664:834–840

Weber A, Scherer C, Brennholt N et al (2018) PET microplastics do not negatively affect the survival, development, metabolism and feeding activity of the freshwater invertebrate Gammarus pulex. Environ Pollut 234:181–189

Welcomme RL, Cowx IG, Coates D, Béné C, Funge-Smith S, Halls A, Lorenzen K (2010) Inland capture fisheries. Philos Trans R Soc B 365(1554):2881–2896

Windsor FM, Durance I, Horton AA et al (2019) A catchment-scale perspective of plastic pollution. Glob Chang Biol 25:1207–1221

Woodall LC, Sanchez-Vidal A, Canals M et al (2014) The deep sea is a major sink for microplastic debris. R Soc Open Sci 1:140317

Wright SL, Thompson RC, Galloway TS (2013) The physical impacts of microplastics on marine organisms: a review. Environ Pollut 178:483–492

Yokota K, Waterfield H, Hastings C et al (2017) Finding the missing piece of the aquatic plastic pollution puzzle: interaction between primary producers and microplastics. Limnol Oceanogr Lett 2:91–104

Yonkos LT, Friedel EA, Perez-Reyes AC et al (2014) Microplastics in four estuarine rivers in the Chesapeake Bay, USA. Environ Sci Technol 48:14195–14202

Yoshida S, Hiraga K, Takehana T et al (2016) A bacterium that degrades and assimilates poly (ethylene terephthalate). Science 351:1196–1199

Zettler ER, Mincer TJ, Amaral-Zettler LA (2013) Life in the "plastisphere": microbial communities on plastic marine debris. Environ Sci Technol 47:7137–7146

Zhang K, Gong W, Lv J et al (2015) Accumulation of floating microplastics behind the three gorges dam. Environ Pollut 204:117–123

Zylstra ER (2013) Accumulation of wind-dispersed trash in desert environments. J Arid Environ 89:13–15

Small Plastic Wastes in Soils: What Is Our Real Perception of the Problem?

Andrés Rodríguez-Seijo and Ruth Pereira

Abstract Soils and terrestrial ecosystems have been widely ignored as part of the problem of environmental contamination with plastic wastes, even though this resource is likely the main source of microplastics to aquatic systems. In the last few years, several studies have been carried out on terrestrial ecosystems and some of them highlighted the potential negative impacts of small plastic wastes (microplastics and nanoplastics) on soil properties and soil biota. This chapter makes an overview of existing information and aims to demonstrate how scarce and limited it still is in order to give a clear idea of whether the soil ecosystem is really at risk. Realizable exposure assessments are constrained by extraction and analytical methodologies and effects assessment is restricted to a reduced number of species, a great variety of polymers, concentrations and exposure conditions, which globally provide few data for a quantitative risk assessment. However, and being aware of the difficulties to clean soils of all the plastic wastes (especially smaller particles) accumulated for decades, efforts should be concentrated on the risk assessment of biodegradable polymers and on specific regulations to control the use of these new polymers.

Keywords Ecotoxicology · Soil invertebrates · Terrestrial plants · Soil microbial community · Soil properties

A. Rodríguez-Seijo (✉)
CIIMAR—Interdisciplinary Centre of Marine and Environmental Research, Department of Biology, University of Porto, Matosinhos, Portugal
e-mail: andres.seijo@fc.up.pt

R. Pereira
GreenUPorto—Sustainable Agrifood Production Research Center, Department of Biology, Faculty of Sciences, University of Porto, Porto, Portugal
e-mail: ruth.pereira@fc.up.pt

© Springer Nature Switzerland AG 2020
M. Streit-Bianchi et al. (eds.), *Mare Plasticum – The Plastic Sea*,
https://doi.org/10.1007/978-3-030-38945-1_9

1 Plastics as an Environmental Issue

The synthesis of plastic polymers, widely used today, took place between 1930 and 1950 (Geyer et al. 2017; Hahladakis et al. 2018). Their massive introduction into the market, at the end of the 1980s, was an industrial and commercial revolution. These new versatile materials, with their higher durability, electrical resistance, plasticity, malleability, and especially their low-cost production, have become crucial and sometimes almost irreplaceable in our daily lives. They can be used for several purposes as packages, components and artefacts, in several types of manufacturing industry, including food transformation and food safety, telecommunications, automotive, medical devices and sterilization consumables, moulds and textiles among others. In the primary sector as for example in the agriculture, they provide a competitive advantage by allowing several annual harvests, the conservation of soil moisture, improved irrigation and weed suppression (Geyer et al. 2017; Hahladakis et al. 2018; Rodríguez-Seijo and Pereira 2019). The extreme versatility of plastic polymers has led to a plastic production which has not stopped growing since the 1950s. In 2017, the worldwide production of polymers exceeded 380 Mt. per year, with seven polymers being the most used, especially polypropylene and polyethylene (together comprising 54% of total usage) (Geyer et al. 2017; PlasticsEurope 2018).

Around 40% of the plastic produced is made for packaging and single-use plastics with a short lifespan (approx. 50% of plastics have a service life between 10 min and 30 days). This represents an environmental issue, as waste management has not increased at the same rate as plastic production and use (Geyer et al. 2017; Hahladakis et al. 2018; PlasticsEurope 2018; Haider et al. 2019). Furthermore, conventional plastic materials do not degrade quickly in the environment. Sometimes they contain chemical additives that can make recycling difficult or even impossible, given the environmental costs of recycling processes or even the lack of recycling solutions. Unlike glass or steel, plastic materials may also lose their characteristics after repeated recycling, which reduces their reuse (Geyer et al. 2017; Hahladakis et al. 2018; Haider et al. 2019). According to Geyer et al. (2017), more than 8300 Mt. of plastic polymers were produced between 1950 and 2015. Around 30% of this plastic is still in use, while the remaining 70% became waste. Of this figure, approximately 9% was recycled, 12% was incinerated for energy production, and the remaining 79% was finally disposed of in landfills. Both recycling and incineration for energy recovery are "recent solutions", which were negligible until the 1980s (Geyer et al. 2017; Lambert and Wagner 2017; Haider et al. 2019; Paço et al. 2018).

The recognition that landfills are no more the preferable option for plastic wastes disposal, the incapacity of recycling companies to deal with huge amounts of diverse plastic wastes, the lack of a real public perception of the problem in all of its aspects and the subsequent irresponsible use and improper disposal in the environment has contributed for making plastic one of the greatest perceived environmental challenges of the century. Different governments are now building up legal instruments and working to reduce single-use plastics or to ban their use for several applications

(Brennholt et al. 2018; Lam et al. 2018; European Commission 2019). However, the uncontrolled accumulation of plastic wastes in the environment has more than amenity impacts, and we are far from having a global picture of the problem and of solutions to deal with it.

Environmental issues associated with plastic wastes and its impacts on soil properties and organisms will be analysed in this chapter. In the following sections, we will seek to provide a state of the art about the impact of plastic residues (mainly microplastics) in soils. A literature survey was performed using the Scopus® database, and it was performed using the keywords "microplastics" and "plastic wastes" in combination with "soil enzymatic activity", "soil microbial", "soil properties", "terrestrial plants" and "soil organisms". Literature survey covers papers published up to May 2019.

2 Microplastics and Their Impacts on Soil Systems

The fragmentation of plastic wastes enhances and amplifies their hazard, as they can be easily spread, enter the trophic chains and gain the potential to affect several ecosystem functions. On the top of food chains, small fragments, as microplastics (MP) (size <5 mm according to Horton et al. 2017) and nanoplastics, are also being perceived as a potential food safety problem as they can be ingested by several animal species that are part of human food chains (Galloway 2015; Huerta Lwanga et al. 2017a, b; Prata 2018; Smith et al. 2018; Ribeiro et al. 2019) or be released from food packages. Other potential exposure pathways have to be analysed (e.g. inhalation of microfibers—Ribeiro et al. 2019) since a recent study from Schwabl et al. (2019) indicated the presence of MP in human faeces; however, these studies only contribute for starting to characterize exposures, while direct cause-effect relationships with specific human health disturbances are far from being identified.

Although terrestrial ecosystems are the source of more than 85% of plastics arriving in aquatic ecosystems, and one of the main sinks of plastics released onto land, less than 6% of peer-reviewed publications have been focused on soils in terms of its contribution for exposures, its role as a pathway, as well as target of negative impacts (Rodríguez-Seijo and Pereira 2019).

There are several sources of plastic debris to the terrestrial environment, some of which are "invisible" or inconspicuous, such as wastewaters used for irrigation purposes, biosolids and organic fertilizers from different sources including water treatment plants; the mismanagement and environmental degradation of agricultural, construction and industrial plastics; car tyre abrasions, etc. (Zubris and Richards 2005; Barnes et al. 2009; Horton et al. 2017; Jan Kole et al. 2017; Bläsing and Amelung 2018; Sommer et al. 2018; Redondo-Hasselerharm et al. 2018; de Souza Machado et al. 2018; Weithmann et al. 2018; Wijesekara et al. 2018; Zhu et al. 2019). Besides this, some researchers also suggested that wind masses can act as carriers of MP, mainly microfibers from industrial sources and urban areas (Dris

et al. 2016; Liu et al. 2019), which can thus attain more remote areas, even at high altitudes (Scheurer and Bigalke 2018; Allen et al. 2019). Allen et al. (2019), for example, recorded the presence of fibres, films and fragments (up to 750 μm size) of polystyrene and polyethylene in atmospheric depositions captured in collectors at the French Pyrenees (France). Rezaei et al. (2019) also highlighted the role of wind erosion in the transport of low-density MP in Iran agricultural areas.

Until now, the vast majority of existing information on the impacts of plastic wastes on the soil is mainly linked with macroplastics (e.g. mulch and greenhouse plastic film). Adverse impacts on soil moisture, nitrate concentration, microbial activities and organic carbon cycling in soil systems have been reported (Ramos et al. 2015; Steinmetz et al. 2016; Wang et al. 2016; Ma et al. 2018). Agricultural plastics can also contain organic and inorganic contaminants added during the manufacturing process or throughout their residence time in the environment, as for example through the adsorption of agrochemicals (Ramos et al. 2015; Steinmetz et al. 2016; Hahladakis et al. 2018; Rodríguez-Seijo et al. 2019) which may account for their hazard to soil biota and soil functions. However, the lack of interest in the impact of MP on soils as opposed to oceans, resulting from a lower perception of the problem on soils, coupled with the absence of validated and standardized methodologies to extract and quantify plastic wastes in soils, is responsible for the little advances on the characterization of this problem in this environmental compartment. The first analytical techniques to identify and extract MP from soils were recently proposed (He et al. 2018; da Costa et al. 2018; Zhang et al. 2018; Rillig et al. 2019), including different wet extraction methods with several solutions in sequential time steps to float the plastic particles (Hurley et al. 2018; Zhang et al. 2018; Corradini et al. 2019). In some cases, a previous removal of organic material from environmental matrices such as soils or sludges could be needed before these wet extraction methods. According to Hurley et al. (2018), the most suitable methods for removing organic material from soils and sludge are the use of H_2O_2 Fenton's reagent or alkaline digestion with NaOH and KOH.

Following either new proposed methodologies or existing ones, previously described for sediments (e.g. Rodríguez-Seijo and Pereira 2017), some characterization studies started to provide data for soils. Piehl et al. (2018), after a wet-sieving extraction, reported an average of 206 macroplastics ha^{-1} and 0.34 ± 0.36 MP items per kg of soil for German agricultural soils, mainly resulting from the weathering of plastics used for mulching and silage (two-thirds of all macroplastics were ranged between 5 and 50 mm, and only three pieces >300 mm). Also, for agricultural soils undergoing the addition of biowaste compost as fertilizer, Weithmann et al. (2018) reported up to 140 particles per kg of soil with a diameter less than <1 mm. In Chinese agricultural fields, Liu et al. (2019) found an average of 78 particles per kg of soil; 59% of the plastic items were less than 1 mm, mostly fibres, fragments and films. Zhang and Liu (2018) assessed the presence of MP in different soil fractions from agricultural areas and found abundances of up to 18,760 particles kg^{-1} of soil. Also, when comparing different soil fractions (10–1 mm, 1–0.25 mm and 0.25–0.05 mm), they found that more than 80% of the particles were in the smaller fraction. Zhou et al. (2019) reported the abundance of MP in suburban soils in China,

with abundances ranging between 22,000 and 690,000 particles kg^{-1} (81% of particles ranged from 10–100 µm). These authors also found that such MP particles contained different levels of potentially toxic elements, particularly Cd, Hg, Mn and Pb. However, studies with urban or suburban soils are still scarce. From all of these studies remains the doubt if the reasons beyond such variability are related only with both the intensity of soil use and the size of particles analysed or also with the methodologies applied. Quality control and quality assurance of these methodologies are never provided.

Microplastics are not inert particles, and they can affect physicochemical and biochemical properties of soils, apparently with slight differences between polymer types and sizes (de Souza Machado et al. 2018; Yang et al. 2018; Rillig et al. 2019). Furthermore, MP can reduce soil density, apparently with positive consequences. On the one hand, this can favour the penetration of roots, and on the other hand, increase soil's porosity and water movement as well as aeration, with potential impacts on soil microbial activity and root growth (Liu et al. 2017; de Souza Machado et al. 2018, 2019; Rillig et al. 2019).

Wan et al. (2019) concluded that the smaller the size of the plastic particles (2, 5 and 10 mm) was, the greater was the impact on water evaporation through the analyses of desiccation cracking of soils. The smallest plastic particles (2 mm) favoured water evaporation by creating rills for water movement. Based on these results, the authors suggested that plastic contamination is affecting the water cycle in soils, although they considered that the laboratory observations must be confirmed at the field scale. Microplastics can also affect the stability of soil aggregates when they entangle with soil particles (Rillig et al. 2019). In the presence of soil microbiota, a reduction in soil aggregate stability after microfibres addition was observed by de Souza Machado et al. (2018) and Lehmann et al. (2019). The application of polyester (polyester fibres, 5 mm length at 0.001% of soil dry weight MP particles) (Lehmann et al. 2019) and polyacrylic fibres (100% acrylic *"Rozetti Puzzle"* yarn, 3756 µm × 18 µm at 0.05%, 0.10%, 0.20% and 0.40% of soil dry weight) (de Souza Machado et al. 2018) neutralized the increase in the aggregate stability observed for samples without microfibres under the influence of soil biota.

Soil temperature also has an important role in physical, chemical and microbiological processes that take place in soils (Yolcubal et al. 2004). However, the impact on the direct incorporation of plastic residues on soil temperature is still unknown, and this information is crucial as through changes in temperature MPs may indirectly affect soil properties and soil functions (Bandopadhyay et al. 2018). In what regards the impacts on biochemical processes, Liu et al. (2017) showed that after 7 and 30 days of presence in soil, propylene can increase and accelerate soil organic matter degradation. The same authors also indicated that a higher level of MP in soils can stimulate the enzymatic activity of hydrolysis of fluorescein diacetate and the enzyme phenol oxidase due to an increase in the soil porosity. This improvement of microbial hydrolytic activity resulted in an increment in dissolved organic matter (DOM), although soil organic carbon (SOC) has not changed. The authors concluded that MP addition can promote the cycling of nitrogen (N), phosphorus (P) and

dissolved organic carbon (C), and therefore increase the bioavailability of organic C, N and P for plants.

2.1 Soil Organisms

Despite some advances, knowledge about the distribution and ecotoxicological impacts of MP on soil biota is still limited (Horton et al. 2017; Chae and An 2018; Ng et al. 2018; Rodríguez-Seijo et al. 2018, 2019). Some papers on the effects of MP on soil organisms have been published since 2016, but with several differences regarding how tested doses were expressed (e.g. mg MP kg^{-1} soil dry weight ($soil_{dw}$), plastic items by hectare, number of plastic particles per kg^{-1} $soil_{dw}$, etc.), the experimental design in what regards the number of doses tested (i.e. *ANOVA* or *ECx* design), the test substrate, the exposure times, the chemical composition of polymers and the combined exposure to MP and adsorbed contaminants (Horton et al. 2017; Chae and An 2018; Ng et al. 2018; Rodríguez-Seijo et al. 2018; Ribeiro et al. 2019). To date, nematodes, springtails and earthworms have been the most used test species to assess the impact of MP on soil organisms, and polystyrene and polyethylene have been the polymers most studied (Chae and An 2018; Rodríguez-Seijo et al. 2018; Ribeiro et al. 2019). Tables 1, 2 and 3 compile the data provided by these studies in what regards the ecotoxicological effects of MP on soil biota.

Nematodes have diverse roles as bacterial and fungal feeders, omnivore predators or plant parasites (Neher 2001; Yeates 2003). Given the great diversity of species and functions nematodes have an important role in the turnover of the soil microbial biomass, and therefore on soil fertility (Neher 2001; Savin et al. 2001; Yeates 2003; Gebremikael et al. 2016; Treonis et al. 2018). Similar roles have also been suggested for collembolans (springtails), with an important activity in the degradation of organic matter through the control of soil microbial activity or the mobilization of available nutrients, and also improving the soil microstructure through micro-tunnels or by the formation of soil agglomerates (Rusek 1998; Culliney 2013; Siddiky et al. 2012). Besides this, earthworms are called as "soil engineers", due to their essential paper on soil structure, bulk density, availability of soil nutrients and the acceleration of nitrogen mineralization or soil organic matter decomposition (Blouin et al. 2013). Nematodes, springtails and earthworms are excellent bioindicators of soil health status (Rusek 1998; Yeates 2003; Culliney 2013; Blouin et al. 2013), and it is expected that the presence of MP in soils can also modify the activity of these soil organisms (as indicated in Tables 1, 2 and 3), with adverse effects on their functions (Rodríguez-Seijo et al. 2017).

Besides the studies described in the tables, some researchers also showed the impact of MP on terrestrial snails (*Achatina fulica* and *Helix* species). Song et al. (2019) reported adverse effects on *A. fulica* after an exposure to polyethylene terephthalate fibres for 28 days (concentrations ranged from 0.01 to 0.71 g kg^{-1}). The fibres caused a reduction in snails' food intake, provoked damages in the

Table 1 An overview of the effects of nanoplastics/microplastics on nematodes

Species testing	Type of plastic polymer	Particle size	Doses	Exposure conditions (test media and time of exposure)	Observed endpoints	References
Nematodes						
Caenorhabditis elegans (Maupas, 1900)	Fluorescently labelled PS	100–1000 nm	100 μL suspension of 1.0×10^9 mL^{-1} of 0.5 μm and 1.0×10^8 mL^{-1} of 1.0 μm microspheres in S-basal buffer	Agar plates 30 min	Uptake and accumulation in the intestine and pharynx	Kiyama et al. (2012)
	PA, PE, PP, PVC	~70 μm	MP suspension in K-medium (32 mM L^{-1} KCl, 51 mM L^{-1} NaCl) added to nematode growth medium at different concentrations (0.5, 1.0, 5.0 and 10.0 mg m^{-2})	Agar-padded slide 2 days	Inhibition of growth, survival and reproduction; decreased intestinal calcium levels, microplastic accumulation in the intestine, and oxidative stress (increased expression of Glutathione S-transferase 4)	Lei et al. (2018)
	Fluorescently labelled PS	0.1, 1.0 and 5.0 μm				
C. elegans	Nano-PS	50 and 200 nm	17.3 mg L^{-1} and 86.8 mg L^{-1}	Agar-padded slide 1 day	Inhibition of locomotion and reproduction Induction of oxidative stress (ROS production) Changes in energy metabolism (reduction on TCA cycle intermediates, lactic acid and glucose). Uptake and accumulation of nanoplastics in the intestine	Kim et al. (2019)
	TiO$_2$-Nano-PS	108.2 ± 4.5 nm	0.01, 0.1, or 1 μg L^{-1} by 1% solid suspension in water	Agar-padded slide 1 day	Inhibition of locomotion and induction of intestinal ROS production	Dong et al. (2018)

PA polyamides, *PE* polyethylene, *PP* polypropylene, *PVC* polyvinyl chloride, *PS* polystyrene. *NanoPS* nanopolystyrene, *TCA cycle* tricarboxylic acid cycle

Table 2 An overview of the effect of nanoplastics/microplastics on springtails species

Species testing	Type of plastic polymer	Particle size	Doses	Exposure conditions (soil type and time of exposure)	Observed endpoints	References
Springtails						
Folsomia candida (Willem, 1902)	Urea-formaldehyde and PET	<100 mm and 100–200 mm	2.5 mg of the <100 mm 5 mg of the 100–200 mm fraction	Direct exposure on petri dishes. without substrate 7 days	Ability to transport and distribute MP	Maaß et al. (2017)
	PVC	80–250 μm	0 and 1 g MP kg^{-1} $soil_{dw}$	*OECD artificial soil* 56 days	Inhibition of growth and repro- duction Changes in gut microbiota and in the carbon and nitrogen elemental absorption	Zhu et al. (2018a)
	PVC	80–250 μm	5000 particles	Direct exposure on petri dishes. Without substrate 7 days	Transport and distribution of MP up to 9 cm	Zhu et al. (2018b)
Lobella sokamensis (Deharveng and Weiner, 1984)	PE and PS	0.47–0.53 μm, 27–32 μm, and 250–300 μm	Several concentra- tions (4–1000 mg kg^{-1})	*LUFA soil type no. 2.2* <1 day	Inhibition of movement	Kim and An (2019)
Proisotoma minuta (Tullberg, 1871)	Urea-formaldehyde and PET	<100 mm and 100–200 mm	2.5 mg of the <100 mm 5 mg of the 100–200 mm fraction	Direct exposure on petri dishes. Without substrate 7 days	Ability to transport and distribute MP	Maaß et al. (2017)

MP microplastics, *PET* polyethylene terephthalate, *PE* polyethylene, *PVC* polyvinyl chloride, *PS* polystyrene

Table 3 An overview of the effect of nanoplastics/microplastics on oligochaeta species

Species testing	Type of plastic polymer	Particle size	Dose	Exposure conditions	Observed endpoints	References
Oligochaeta						
Enchytraeus crypticus (Westheide and Graefe, 1992)	NanoPS	0.05–0.1 μm	0, 0.025, 0.5, and 10% dry weight within oatmeal	Petri dishes with *E. crypticus* medium (2 mmol $CaCl_2$, 1 mmol $MgSO_4$, 1 mmol $NaHCO_3$, 0.1 mmol KCl, and 17 g agarose l^{-1}, pH 7.8) 7 days	Changes on gut microbiome composition, weight decrease and stimulation of cocoons production	Zhu et al. (2018c)
Lumbricus terrestris (Linnaeus, 1758)	HDPE single-use plastic carrier bags	0.92 ± 1.09 mm	0.35% of the soil mass	Agricultural soil 28 days	Zn accumulation from single-use plastic carrier bags	Hodson et al. (2017)
	PE	<150 μm	0, 7, 28, 45, and 60% $soil_{dw}$	Sandy soil (50% sand, 50% loamy silt, with 0.2% organic matter) 60 days	Increase of mortality, inhibition of growth rate Uptake and release of MP in casts	Huerta Lwanga et al. (2016)
	LDPE	<400 mm		Sandy soil (50% sand, 50% loamy silt, with 0.2% organic matter) 14 days	Growth inhibition, enhanced formation of burrows and incorporation of MP in burrow walls	Huerta Lwanga et al. (2017a)
	PE beads	710–850, 1180–1400, 1700–2000 and 2360–2800 μm	750 mg in 2.5 kg of soil	*Albic Luvisol* (73.6% sand, 18.8% silt and 7.6% clay) 21 days	Uptake and accumulation of MP in casts	Rillig et al. (2017)

(continued)

Table 3 (continued)

Species testing	Type of plastic polymer	Particle size	Dose	Exposure conditions	Observed endpoints	References
Oligochaeta						
L. terrestris	LDPE	<150 µm, 150–250 µm, 250 µm—1 mm	7% soil$_{dw}$	Sandy soil 14 days	Enhanced formation of burrows and incorporation of MP in burrow walls	Yu et al. (2019)
	LDPE and starch-based biodegradable plastic	50, 250, 500 and 1000 µm	1% soil$_{dw}$	Sandy soil. 4 months	Inhibition of growth under exposure to biodegradable MP	Qi et al. (2018)
	Polyester microfibers	361.6 ± 387.0 µm length × 40.7 ± 3.8 µm diameter	0, 0.1 and 1.0% w/w	Natural soil (arable *cambisol*) 35 days	Uptake of microfibers Enhanced expression of metallothionein-2; decreased expression of heat shock protein (hsp70)	Prendergast-Miller et al. (2019)
Eisenia andrei (Bouché, 1972)	PE	250 µm to 1 mm	0, 62.5, 125, 250, 500 and 1000 mg kg^{-1} soil$_{dw}$	*OECD artificial soil* 56 days	Histopathological damages on gut and changes in whole body molecular composition	Rodríguez-Seijo et al. (2017)
	Bioplastics (*Mater-Bi DF04A* and *Mater-Bi EF04P*)	Not indicated	10 g in 800 g *OECD soil*	*OECD artificial soil* 56 days	No changes on mortality, growth and reproduction of adults	Sforzini et al. (2016)
E. fetida (Savigny, 1826)	PS	58 µm	0, 0.25, 0.5, 1 and 2% (w/w)	Agricultural soil 30 days	Growth inhibition. Enhanced mortality	Cao et al. (2017)

PE	250 μm to 1 mm	0, 62.5, 125, 250, 500 and 1000 mg MP kg^{-1} soil$_{dw}$	OECD artificial soil 28 days	Inhibition of catalase activity; increased activity of GST and LDH activities; lipid peroxidation	Rodríguez-Seijo et al. (2018)
PE and PS	PE ≤ 300 μm and PS ≤ 250 μm	0, 1, 5, 10, and 20% soil$_{dw}$	Agricultural soil (sandy loam, pH 7.14, organic matter content 1.21%) 28 days	Uptake of MP. Inhibition of SOD and GST activities; increase in CAT activity; lipid peroxidation. Bioaccumulation of PCB and PAHs released from contaminated MP	Wang et al. (2019)

MP microplastics, *HDPE* high-density polyethylene, *LDPE* low-density polyethylene, *PE* polyethylene, *PS* polystyrene, *NanoPS* Nanopolystyrene, *GST* glutathione S-transferase, *LPO* lipid peroxidation, *SOD* superoxide dismutase

gastrointestinal tract and an increase of reactive oxygen species (ROS; increase of glutathione peroxidase) in parallel with the inhibition of antioxidant enzymes (total antioxidant capacity and malondialdehyde) in the liver of animals. In addition, Panebianco et al. (2019) also reported the presence of MP in the terrestrial snails directly collected from agricultural fields. Seventy-eight fibres (size range between 200 and 2500 μm) were isolated after tissue digestion from 44 out of the 85 samples analysed from the collected species (*Helix aperta*, *H. aspersa* and *H. pomatia*). Jemec et al. (2018) did not observe significant effects in survival rates, body mass and energy reserves in terrestrial isopods (*Porcellio scaber*) exposed to MP from plastic bag films (polyethylene, mean size 183 ± 93 μm) and from a facial cleanser (polyethylene, mean size 137 ± 51 μm).

Some of the published papers have shown the ability of soil biota to ingest nano/microplastic, both through the direct identification of the particles tested on the gut or by their accumulation in the casts (e.g. Huerta Lwanga et al. 2016; Rillig et al. 2017). The induction of oxidative stress responses is the main effect reported for the uptake of nano and MP. However, and despite some studies have reported effects at the individual level (e.g. mortality, growth inhibition, impaired reproduction), existing data do not allow to infer which could be the consequences in natural populations. This knowledge gap is further reinforced by the ecological relevance of some exposure conditions. In situ *tests*, which could provide a more realistic evaluation of the impact of MP on soil biota, will always be limited by the existence of soils totally free of MPs and other contaminants that could be used as controls. Some evidences also start to appear about some possible indirect effects of nano and MPs on soil biota, as for example the induction of changes in the gut microbiome of springtails (e.g. Zhu et al. 2018a) and oligochaetes (e.g. Zhu et al. 2018c) (Tables 2 and 3), but once again more studies are necessary to understand the impact of these indirect effects in the functions carried out by these organisms. Some authors also highlighted the role of springtails and earthworms in acting as carriers of MP in soils, contributing for their distribution (e.g. Huerta Lwanga et al. 2017a; Maaβ et al. 2017; Zhu et al. 2018a) (Tables 2 and 3). However, such observations were not consensual, as other authors did not confirm this occurrence (Rodríguez-Seijo et al. 2019). Also, few studies have dedicated their attention to the effect of other kinds of plastic polymers, such as the biodegradable or recycled forms, which should be the focus of future studies, given all the regulatory advances that are being made to ban previous polymers by these more sustainable solutions.

2.2 Can Microplastics Be a Hazard to Plants?

Research into the potential impact of plastic wastes in plants is still recent. Since plants cannot absorb MP (Ng et al. 2018; Rillig et al. 2019), most studies have focused on nanoplastics.

Bosker et al. (2019) recently reported the effects of different fluorescent polystyrene nanoplastics and MP (50, 500 and 4800 nm of diameter) on the growth of

Lepidium sativum (cress), in Petri dishes for 8, 24 and 72 h periods of exposure (seeds were placed on filter paper and 5 mL of each tested concentration (10^3, 10^4, 10^5, 10^6, 10^7 particles mL^{-1}) were added to the Petri dishes). These authors observed that exposure to nanoplastics had significant and size-dependent adverse effects on germination. Root length was also affected but only for smaller size (50 and 500 nm) nanoplastics. The presence of nanoplastics in the epidermis and root hairs as well as the accumulation of larger particles (4800 nm) on the pores of the seed coat and close to the embryo endosperm was recorded by confocal laser microscopy, and it was probably the cause of the delays in seed germination (germination rates were reduced under short-term exposure (8 h), but no differences were recorded after 24 h of exposure, regardless of the size of the plastic used). Thus, the possibility of this effect having occurred by chance cannot be neglected.

Similar observations were recently described by Jiang et al. (2019) for *Vicia faba* (broad bean) exposed to nanoplastics (100 nm) and MP (5 μm) of fluorescent polystyrene at different concentrations (10, 50 and 100 mg L^{-1}) after 48 h of exposure (seeds were placed on the skimmed cotton soaked with a solution with MP, and incubated at 24.5 °C). Through the determination of biomass, enzymatic activities (catalase, superoxide dismutase and peroxidase) and lipid peroxidation, nanoplastics showed more toxicological effects than MP. By using laser confocal scanning microscopy images, these authors confirmed the uptake of nanoplastics through the root system of *V. faba*. Similarly, Bandmann et al. (2012) have previously demonstrated that polystyrene nanoplastics (<100 nm) may enter tobacco cells through endocytosis.

In addition to plastic waste sizes, the chemical composition of plastics, including biodegradable plastic polymers, is gaining the interest of researchers. The impact of biodegradable MP (*Mater-Bi*, a biopolymer based on starch and vinyl alcohol; size <1 mm) was assessed through the exposure in artificial *OECD soil* at 1% (w/w), after 6 months of degradation, in the germination of *Sorghum saccharatum* (sorghum, great millet) and *L. sativum* (Sforzini et al. 2016). In a Petri dish test (72 h of exposure), these authors also did not observe significant effects in the germination of plants. Serrano-Ruíz et al. (2018) analysed the obtained extracts (32 g of ground films with 400 mL of the sterile mineral fraction of *Murashige and Skoog* (*MS*) culture medium at 5× concentration) from seven biodegradable plastics, paper (*Mimgreen®paper*) and non-biodegradable polyethylene films, which were used in mulching crops of tomato (*Lycopersicon esculentum*) and lettuce (*Lactuca sativa*). Using in vitro tests, reduction in seeds germination, root development and growth of aerial parts of plants was recorded, with tomato plants being more sensitive. However, the same authors showed that the phytotoxic effects on plants were bioplastic dependent.

The potential phytotoxicity of the starch-based biodegradable plastics was also previously reported by Qi et al. (2018), who assessed the impact of conventional mulch polyethylene on wheat growth (*Triticum aestivum*) (agricultural sandy soil as test substrate). By testing mesoplastics (6–7 mm) and MP (1 mm, 500 μm, 250 μm and 50 μm) 2 and 4 months, they observed that plant height, biomass, size and

number of leaves were affected by the presence of plastic remains in soil, especially biodegradable plastics.

Additionally to the focus on direct phytotoxicity Rillig et al. (2019) and de Souza Machado et al. (2018, 2019) recently highlighted the importance of studying the hazard of nanoplastics and MP to plants following holistic approaches, as the presence of MP in soils affects different soil properties with a direct impact on plant development. De Souza Machado et al. (2019) evaluated the effects of different types of polymers, both in size and composition (polyamide (15–20 μm), polyester (5000 μm), polyethylene high density (2–3 mm), polystyrene and polyethylene terephthalate (2–3 mm)) and different soil concentrations (0.2–2% w/w) on the growth of spring onions (*Allium fistulosum*) after 2 months of exposure in a greenhouse pot experiment (controlled conditions, 21 ± 1 °C) with an agricultural loamy sandy soil as test substrate. The authors observed that plants biomass, elemental tissue composition and root traits were affected. The presence of MP also affected soil structure and water dynamics, nutrient immobilization and soil microbial activity (assessed using hydrolysis of fluorescein diacetate) and very likely these disturbances affected plants development.

In any case, there is still much to be investigated in this field due to the extensive use of plastic polymers in agriculture for a wide range of applications. Plastic degradation in agricultural soils can be accelerated as it is easily fragmented by machinery and more exposed to degradation by weathering and UV light. Further, we still have a long way to go in what regards the understanding of the combined effects of plastics and other contaminants, as organic and inorganic pesticides, intentionally applied to soils, as well as on how MP affect soil functions, as the production of biomass and fibres, carbon sequestration and organic matter degradation.

2.3 Can Microplastics Affect Soil Microbial Communities?

In general, long-term contamination by plastic film residues has been correlated with the inhibition of soil microbial activity and fertility due to changes in the activity of enzymes involved in C, N and P biogeochemical cycles (e.g. soil dehydrogenase, soil phosphatase, soil urease, solid-β-glucosidase and/or soil chitinase) (e.g. Qian et al. 2018). However, up to now, the study of the interaction of nanoplastics and MP with the soil microbial community has received few attention. In the last 2 years, only some studies were made and all were using soil enzymes activity as markers of disturbance (Table 4). As some authors suggested (Liu et al. 2017; de Souza Machado et al. 2018; Rillig et al. 2019), MPs and other plastic wastes, once in the soil, may affect soil structure, changing aggregates stability, increasing porosity, and thus favouring soil aeration (e.g. de Souza Machado et al. 2018, 2019). Aerobic microorganisms would benefit, and increased enzymatic activity could promote the recycling of C, N and P compounds in the soil increasing the availability of these elements (Liu et al. 2017). However, according to de Souza Machado et al. (2018),

Table 4 An overview of the effect of nanoplastics/microplastics on soil microbial communities

Type of plastic	Particle size	Dose	Exposure conditions (soil type and time of exposure)	Observed endpoints	References
PAN fibres	3756 × 18 μm	0.05, 0.10, 0.20, 0.40% of soil$_{dw}$	Loamy sand soil 5 weeks	Inhibition of soil microbial activity through the assessment of FDA hydrolysis	de Souza Machado et al. (2018)
PA beads	15–20 μm diameter	0.25, 0.50, 1 and 2% of soil$_{dw}$			
PES fibres	5000 × 8 μm	0.05, 0.10, 0.20, 0.40% of soil$_{dw}$		Inhibition of soil microbial activity through the assessment of FDA hydrolysis	
HDPE fragments	±643 μm	0.25, 0.50, 1 and 2% of soil$_{dw}$		No clear effect on soil microbial activity	
PP	<180 μm	0, 7 and 28% of soil$_{dw}$	Calcaric cambisol 7 and 30 days	Increased activity of phenol oxidase and FDA hydrolysis	Liu et al. (2017)
Plastic film mulch (PVC) + contaminated with phthalate acid esters	20 mm × 20 mm	0, 67.5 and 337.5 kg ha^{-1}	Luvisol 60 days	Reduction of soil microbial C and N (measured by fumigation extraction method) Reduction of enzymatic activities (FDA and dehydrogenase activities) and functional diversity (community-level physiological profile)	Wang et al. (2016)
NanoPS	32.6 nm ± 11.9 nm	10, 100, and 1000 ng PS-NPs g^{-1} dry soil	Stagnic-Luvisol 28 days	Reduced microbial biomass carbon (measured by chloroform fumigation extraction) Inhibition of enzymatic activities (dehydrogenases, leucine-aminopeptidase, β-cellobiohydrolase, β-glucosidase, alkaline-phosphatase enzyme activities)	Awet et al. (2018)

FDA hydrolysis of fluorescein diacetate, *PAN* polyacrylic, *PA* polyamide, *PES* polyester, *HDPE* high-density polyethylene, *PP* polypropylene, *NanoPS* nanopolystyrene

despite the changes in the soil properties, the activity of soil enzymes is not following the expected pattern of response. In line with this, Awet et al. (2018) call the attention for the potential antimicrobial activity of polystyrene nanoplastics. After 28 days of exposure, these authors showed inhibition in soil microbial biomass, measured by the chloroform fumigation extraction method, dehydrogenases and other soil enzymes activity involved in C, N and P cycles (e.g. leucine-aminopeptidase, cellobiohydrolase, ß-glucosidase and alkaline-phosphatase).

3 Biodegradable Plastics on the Environment: A New Potential Hazard to Soils

Biodegradable plastic polymers are being proposed as an environmentally safe alternative to conventional plastics, although few is known about their real residence time in soils at different environmental conditions, as well as their degradation by-products. These plastics are usually produced from composites of polyvinyl alcohol, starch, natural fillers (e.g. sugarcane bagasse) and nutrients to stimulate the biodegrading microbiota (Thomas et al. 2012; Ashter 2016; Moreira et al. 2018). For example, biodegradable plastic polymers can be composed of different compounds (e.g. 37.1% of a polysaccharide polymer called *Pullulan*, 44.6% polyethylene terephthalate (PET) and 18.3% polybutylene terephthalate (PBT) (Qi et al. 2018)) whose toxicity is unknown. Besides, oxo-biodegradable plastics (plastics made from polyethylene but with chemical additives to improve degradation) have been proposed as an environmentally friendly alternative for single-use carrier plastic bags, the packaging uses or mulching films (Thomas et al. 2012). According to manufactures, these plastics are highly degraded under ultraviolet sunlight, oxygen or heat exposure, and the final products or fragments can be easily oxidated by microorganisms (Thomas et al. 2012; Ashter 2016; Martín-Closas et al. 2016; Moreira et al. 2018; Haider et al. 2019). However, these oxo-biodegradable plastics have special additives to catalyse the breakdown of long molecular chains from plastic materials into small fragments when they reach the soil or water systems. These additives are metal salts of carboxylic acids or dithiocarbamates, usually based on cerium, cobalt, iron, manganese or nickel, and therefore these plastics can also be a source of metals and other organic contaminants to the environment (Thomas et al. 2012; Ashter 2016). Oxo-biodegradable plastics are also the source of new nanoplastics and MP as shown by González-Pleiter et al. (2019) for secondary nanoplastics released from polyhydroxybutyrate, a biodegradable plastic, that also exhibited adverse effects on cyanobacteria (*Anabaena* sp. *PCC7120*), green microalgae (*Chlamydomonas reinhardtii*) and the aquatic crustacean *Daphnia magna*.

Despite that, regarding the impact on soil properties, some studies conducted with biodegradable plastics showed their potential as a source of carbon to soil organisms, with low impacts on soil health (Bandopadhyay et al. 2018; Moreira et al. 2018).

Several authors (Bandopadhyay et al. 2018; Moreira et al. 2018; Sintim et al. 2019) argued that the incorporation into soil of biodegradable plastics, such as biodegradable mulch films, could improve some soil properties as it was shown for other plastic wastes.

Studies of long-term exposures with biodegradable plastics are still scarce. Recently, Napper and Thompson (2019) showed that biodegradable, oxo-biodegradable and compostable single-use carrier bags are not yet a real alternative to conventional plastic bags, usually composed of low- or high-density polyethylene. These authors exposed several plastic bags to three different environments (open-air, submerged in seawater and buried in soil) for 3 years. While the compostable bag dissipated in 3 months submerged in seawater, the same type of bag persisted after 27 months buried in the soil. All bags were converted into fragments after 9 months exposed to open air. However, the by-products of these decomposition processes were not evaluated, and therefore much more information is urgently needed about the environmental impacts of these plastics, as they can represent a risk even greater, since their biodegradable label may continue to lead to an unregulated use.

4 Final Statement

Plastic wastes of different sizes have become a new environmental issue that begins to encompass all ecosystems, both aquatic and terrestrial. The special attention given to the oceans withdrew the attention from soils, which are the main sink, source and pathway of plastic wastes to inland aquatic resources and oceans. However, it seems more evident that once left in the land, MP are not inert and can pose a risk to terrestrial organisms, namely animals, plants and soil microbial communities. Standard methodologies of extraction and analysis for characterizing exposures and studies with new organisms at relevant environmental concentrations and conditions are still required. Nevertheless, once lessons have been learned, and considering that it will be almost impossible to remove these contaminant from soils, the focus should be on assessing the safety of new biodegradable polymers that are being proposed as alternatives and on the development of appropriate regulation to ban non-biodegradable polymers. Furthermore, it is also important to prevent soils from being saturated with biodegradable polymers, which will soon become persistent, if soil functions are compromised.

Acknowledgments This work has been supported by the LABEX DRIIHM, French program "Investissements d'Avenir" (*ANR-11-LABX-0010*), which is managed by the Agence Nationale de la Recherche (ANR) within the Observatoire Hommes-Milieux Estarreja (*OHM-E/2018/Proj.4*). This research was supported by national funds through FCT—Foundation for Science and Technology within the scope of *UIDB/04423/2020, UIDP/04423/2020* (CIIMAR) and *UIDB/05748/2020, UIDP/05748/2020* (GreenUPorto). A.R.S. would like to thank the FCT and the CIIMAR for their individual research contract (*CEECIND/03794/2017*).

References

Allen S, Allen D, Phoenix VR, Le Roux G, Durántez Jimenez P, Simonneau A, Binet S, Galop D (2019) Atmospheric transport and deposition of microplastics in a remote mountain catchment. Nat Geosci 12:339–344. https://doi.org/10.1038/s41561-019-0335-5

Ashter SA (2016) Introduction to bioplastics engineering. William Andrew, Cambridge. https://doi.org/10.1016/C2014-0-04010-5

Awet TT, Kohl Y, Meier S, Straskraba S, Grün AL, Ruf T, Jost C, Drexel R, Tunc E, Emmerling C (2018) Effects of polystyrene nanoparticles on the microbiota and functional diversity of enzymes in soil. Environ Sci Eur 30:11. https://doi.org/10.1186/s12302-018-0140-6

Bandmann V, Müller JD, Köhler T, Homann U (2012) Uptake of fluorescent nano beads into BY2-cells involves clathrin-dependent and clathrin-independent endocytosis. FEBS Lett 586:3626–3632. https://doi.org/10.1016/j.febslet.2012.08.008

Bandopadhyay S, Martin-Closas L, Pelacho AM, DeBruyn JM (2018) Biodegradable plastic mulch films: impacts on soil microbial communities and ecosystem functions. Front Microbiol 9:819. https://doi.org/10.3389/fmicb.2018.00819

Barnes DKA, Galgani F, Thompson RC, Barlaz M (2009) Accumulation and fragmentation of plastic debris in global environments. Philos Trans R Soc Lond Ser B Biol Sci 364(1526):1985–1998. https://doi.org/10.1098/rstb.2008.0205

Bläsing M, Amelung W (2018) Plastics in soil: analytical methods and possible sources. Sci Total Environ 612:422–435. https://doi.org/10.1016/j.scitotenv.2017.08.086

Blouin M, Hodson ME, Delgado EA, Baker G, Brussaard L, Butt KR et al (2013) A review of earthworm impact on soil function and ecosystem services. Eur J Soil Sci 64:161–182. https://doi.org/10.1111/ejss.12025

Bosker T, Bouwman LJ, Brun NR, Behrens P, Vijver MG (2019) Microplastics accumulate on pores in seed capsule and delay germination and root growth of the terrestrial vascular plant *Lepidium sativum*. Chemosphere 226:774–781. https://doi.org/10.1016/j.chemosphere.2019.03.163

Brennholt N, Heß M, Reifferscheid G (2018) Freshwater microplastics: challenges for regulation and management. In: Wagner M, Lambert S (eds) Freshwater microplastics, The handbook of environmental chemistry, vol 58. Springer, Cham, pp 239–272

Cao D, Wang X, Luo X, Liu G, Zheng H (2017) Effects of polystyrene microplastics on the fitness of earthworms in an agricultural soil. IOP Conf Series Earth Environ Sci 61:012148. https://doi.org/10.1088/1755-1315/61/1/012148

Chae Y, An YJ (2018) Current research trends on plastic pollution and ecological impacts on the soil ecosystem: a review. Environ Pollut 240:387–395. https://doi.org/10.1016/j.envpol.2018.05.008

Corradini F, Meza P, Eguiluz R, Casado F, Huerta-Lwanga E, Geissen V (2019) Evidence of microplastic accumulation in agricultural soils from sewage sludge disposal. Sci Total Environ 671:411–420. https://doi.org/10.1016/j.scitotenv.2019.03.368

Culliney TW (2013) Role of arthropods in maintaining soil fertility. Agriculture 3(4):629–659. https://doi.org/10.3390/agriculture3040629

da Costa JP, Paço A, Santos PSM, Duarte AC, Rocha-Santos T (2018) Microplastics in soils: assessment, analytics and risks. Environ Chem 16:18–30. https://doi.org/10.1071/EN18150

de Souza Machado AA, Lau CW, Till J, Kloas W, Lehmann A, Becker R, Rillig M (2018) Impacts of microplastics on soil biophysical environment. Environ Sci Technol 52:9656–9665

de Souza Machado AA, Lau CW, Kloas W, Bergmann J, Bachelier JB, Faltin E, Becker R, Görlich AS, Rillig MC (2019) Microplastics can change soil properties and affect plant performance. Environ Sci Technol 53(10):6044–6052. https://doi.org/10.1021/acs.est.9b01339

Dong S, Qu M, Rui Q, Wang D (2018) Combinational effect of titanium dioxide nanoparticles and nanopolystyrene particles at environmentally relevant concentrations on nematode *Caenorhabditis elegans*. Ecotox Envorn Saf 161:444–450. https://doi.org/10.1016/j.ecoenv.2018.06.021

Dris R, Gasperi J, Saad M, Mirande C, Tassin B (2016) Synthetic fibers in atmospheric fallout: a source of microplastics in the environment? Mar Pollut Bull 104:290–293. https://doi.org/10. 1016/j.marpolbul.2016.01.006

European Commission (2019) European Commission—Statement. Circular Economy: Commission welcomes European Parliament adoption of new rules on single–use plastics to reduce marine litter STATEMENT/19/1873. http://europaeu/rapid/press-release_STATEMENT-19-1873_enhtm. Accessed 12 Apr 2019

Galloway TS (2015) Micro- and Nano-plastics and Human health. In: Bergmann M, Gutow L, Klages M (eds) Marine anthropogenic litter. Springer, Cham, pp 343–366. https://doi.org/10. 1007/978-3-319-16510-3_13

Gebremikael MT, Steel H, Buchan D, Bert W, De Neve S (2016) Nematodes enhance plant growth and nutrient uptake under C and N-rich conditions. Sci Rep 6:32862. https://doi.org/10.1038/ srep32862

Geyer R, Jambeck JR, Law KL (2017) Production, use, and fate of all plastics ever made. Sci Adv 3 (7):e1700782. https://doi.org/10.1126/sciadv.1700782

González-Pleiter M, Tamayo-Belda M, Pulido-Reyes G, Amariei G, Leganés F, Rosa R, Fernández-Piñas F (2019) Secondary nanoplastics released from a biodegradable microplastic severely impact freshwater environments. Environ Sci Nano 6:1382–1392. https://doi.org/10.1039/ C8EN01427B

Hahladakis JN, Velis CA, Weber R, Iacovidou E, Purnell P (2018) An overview of chemical additives present in plastics: migration, release, fate and environmental impact during their use, disposal and recycling. J Hazard Mater 344:179–199. https://doi.org/10.1016/j.jhazmat.2017. 10.014

Haider TP, Völker C, Kramm J, Landfester K, Wurm FR (2019) Plastics of the future? The impact of biodegradable polymers on the environment and on society. Angew Chem Int Ed 58:50–62. https://doi.org/10.1002/anie.201805766

He D, Luo Y, Lu S, Liu M, Song Y, Lei L (2018) Microplastics in soils: Analytical methods, pollution characteristics and ecological risks. Trends Anal Chem 109:163–172. https://doi.org/ 10.1016/j.trac.2018.10.006

Hodson ME, Duffus-Hodson CA, Clark A, Prendergast-Miller MT, Thorpe KL (2017) Plastic bag derived-microplastics as a vector for metal exposure in terrestrial invertebrates. Environ Sci Technol 51(8):4714–4721. https://doi.org/10.1021/acs.est.7b00635

Horton AA, Walton A, Spurgeon DJ, Lahive E, Svendsen C (2017) Microplastics in freshwater and terrestrial environments: evaluating the current understanding to identify the knowledge gaps and future research priorities. Sci Total Environ 586:127–141. https://doi.org/10.1016/j. scitotenv.2017.01.190

Huerta Lwanga E, Gertsen H, Gooren H, Peters P, Salánki T, Van Der Ploeg M et al (2016) Microplastics in the terrestrial ecosystem: implications for *Lumbricus terrestris* (Oligochaeta, Lumbricidae). Environ Sci Technol 50(5):2685–2691. https://doi.org/10.1021/acs.est.5b05478

Huerta Lwanga E, Gertsen H, Gooren H, Peters P, Salánki T, van der Ploeg M, Besseling E, Koelmans AA, Geissen V (2017a) Incorporation of microplastics from litter into burrows of *Lumbricus terrestris*. Environ Pollut 220:523–531. https://doi.org/10.1016/j.envpol.2016.09. 096

Huerta Lwanga E, Vega JM, Quej VK, de los Angeles Chi J, Sanchez del Cid L, Chi C, Escalona Segura G, Gersten H, Salánki T, van der Ploeg M, Koelmans AA, Geissen V (2017b) Field evidence for transfer of plastic debris along a terrestrial food chain. Sci Rep 7:14071. https://doi. org/10.1038/s41598-017-14588-2

Hurley RR, Lusher AL, Olsen M, Nizzetto L (2018) Validation of a method for extracting microplastics from complex, organic-rich, environmental matrices. Environ Sci Technol 52 (13):7409–7417. https://doi.org/10.1021/acs.est.8b01517

Jan Kole P, Löhr AJ, Van Belleghem FGAJ, Ragas Ad MJ (2017) Wear and tear of tyres: a stealthy source of microplastics in the environment. Int J Environ Res Public Health 14(10):1265. https:// doi.org/10.3390/ijerph14101265

Jemec A, Horvat P, Skalar T, Krzan A (2018) Plastic bag and facial cleanser derived microplastic do not affect feeding behaviour and energy reserves of terrestrial isopods. Sci Total Environ 615:761–766. https://doi.org/10.1016/j.scitotenv.2017.10.020

Jiang X, Chen H, Liao Y, Ye Z, Li M, Klobučar G (2019) Ecotoxicity and genotoxicity of polystyrene microplastics on higher plant *Vicia faba*. Environ Pollut 250:831–838. https://doi.org/10.1016/j.envpol.2019.04.055

Kim SW, An YJ (2019) Soil microplastics inhibit the movement of springtail species. Environ Int 126:699–706. https://doi.org/10.1016/j.envint.2019.02.067

Kim HM, Lee DK, Long NP, Kwon SW, Park JL (2019) Uptake of nanopolystyrene particles induces distinct metabolic profiles and toxic effects in *Caenorhabditis elegans*. Environ Pollut 246:578–586. https://doi.org/10.1016/j.envpol.2018.12.043

Kiyama Y, Miyahara K, Ohshima Y (2012) Active uptake of artificial particles in the nematode *Caenorhabditis elegans*. J Exp Biol 215:1178–1183. https://doi.org/10.1242/jeb.067199

Lam CS, Ramanathan S, Carbery M, Gray K, Swaroop Vanka K, Maurin C, Bush R, Palanisami T (2018) A comprehensive analysis of plastics and microplastic legislation worldwide. Water Air Soil Pollut 229:345. https://doi.org/10.1007/s11270-018-4002-z

Lambert S, Wagner M (2017) Environmental performance of bio-based and biodegradable plastics: the road ahead. Chem Soc Rev 46(22):6855–6871. https://doi.org/10.1039/c7cs00149e

Lehmann A, Fitschen K, Rillig MC (2019) Abiotic and biotic factors influencing the effect of microplastic on soil aggregation. Soil Syst 3(1):21. https://doi.org/10.3390/soilsystems3010021

Lei L, Wu S, Lu S, Liu M, Song Y, Fu Z, Shi H, Raley-Susman KM, He D (2018) Microplastic particles cause intestinal damage and other adverse effects in zebrafish *Danio rerio* and nematode *Caenorhabditis elegans*. Sci Total Environ 619–620:1–8. https://doi.org/10.1016/j.scitotenv.2017.11.103

Liu H, Yang X, Liu G, Liang C, Xue S, Chen H, Ritsema CJ, Geissen V (2017) Response of soil dissolved organic matter to microplastic addition in Chinese loess soil. Chemosphere 185:907–917. https://doi.org/10.1016/j.chemosphere.2017.07.064

Liu K, Wang X, Fang T, Xu P, Zhu L, Li D (2019) Source and potential risk assessment of suspended atmospheric microplastics in Shanghai. Sci Total Environ 675:462–471. https://doi.org/10.1016/j.scitotenv.2019.04.110

Ma D, Chen L, Qu H, Wang Y, Misselbrook T, Jiang R (2018) Impacts of plastic film mulching on crop yields, soil water, nitrate, and organic carbon in Northwestern China: a meta-analysis. Agric Water Manag 202:166–173. https://doi.org/10.1016/j.agwat.2018.02.001

Maaβ S, Daphi D, Lehmann A, Rillig MC (2017) Transport of microplastics by two collembolan species. Environ Pollut 225:456–459. https://doi.org/10.1016/j.envpol.2017.03.009

Martín-Closas L, Costa J, Cirujeda A, Aibar J, Zaragoza C, Pardo A, Suso ML, Moreno MM, Moreno C, Lahoz I, Mácua JI, Pelacho AM (2016) Above-soil and in-soil degradation of oxo- and bio-degradable mulches: a qualitative approach. Soil Res 54:225–236. https://doi.org/10.1071/SR15133

Moreira AA, Mali S, Yamashita F, Bilck AP, de Paula MT, Merci A, Martinez de Oliveira AL (2018) Biodegradable plastic designed to improve the soil quality and microbiological activity. Polym Degrad Stab 158:52–63. https://doi.org/10.1016/j.polymdegradstab.2018.10.023

Napper IE, Thompson RC (2019) Environmental deterioration of biodegradable, oxo-biodegradable, compostable, and conventional plastic carrier bags in the sea, soil, and open-air over a 3-year period. Environ Sci Technol 53(9):4775–4783. https://doi.org/10.1021/acs.est.8b06984

Neher DA (2001) Role of nematodes in soil health and their use as indicators. J Nematol 33(4):161–168

Ng EL, Huerta Lwanga E, Eldridge SM, Johnston P, Hu HH, Geissen V, Chen D (2018) An overview of microplastic and nanoplastic pollution in agroecosystems. Sci Total Environ 627:1377–1388. https://doi.org/10.1016/j.scitotenv.2018.01.341

Paço A, Jacinto J, da Costa JP, Santos PSM, Vitorino R, Duarte AC, Rocha-Santos T (2018) Biotechnological tools for the effective management of plastics in the environment. Crit Rev Environ Sci Technol 49:410–441. https://doi.org/10.1080/10643389.2018.1548862

Panebianco A, Nalbone L, Giarratana F, Ziino G (2019) First discoveries of microplastics in terrestrial snails. Food Control 106:106722. https://doi.org/10.1016/j.foodcont.2019.106722

Piehl S, Leibner A, Löder MGJ, Dris R, Bogner C, Laforsch C (2018) Identification and quantification of macro- and microplastics on an agricultural farmland. Sci Rep 8:17950. https://doi.org/10.1038/s41598-018-36172-y

PlasticsEurope (2018) Annual review 2017–2018. Association of Plastics Manufacture Brussels, Belgium. https://wwwplasticseuropeorg/en/resources/publications. Accessed 14 Feb 2019

Prata JC (2018) Airborne microplastics: consequences to human health? Environ Pollut 234:115–126. https://doi.org/10.1016/j.envpol.2017.11.043

Prendergast-Miller MT, Katsiamides A, Abbass M, Sturzenbaum SR, Thorpe KL, Hodson ME (2019) Polyester-derived microfibre impacts on the soil-dwelling earthworm *Lumbricus terrestris*. Environ Pollut 251:453–459. https://doi.org/10.1016/j.envpol.2019.05.037

Qi Y, Yang X, Mejia Pelaez A, Huerta Lwanga E, Beriot N, Gertsen H, Gabeva P, Geissen V (2018) Macro- and micro- plastics in soil-plant system: effects of plastic mulch film residues on wheat (*Triticum aestivum*) growth. Sci Total Environ 645:1048–1056. https://doi.org/10.1016/j.scitotenv.2018.07.229

Qian H, Zhang M, Liu G, Lu T, Qu Q, Du B, Pan X (2018) Effects of soil residual plastic film on soil microbial community structure and fertility. Water Air Soil Pollut 229:261. https://doi.org/10.1007/s11270-018-3916-9

Ramos L, Berenstein G, Hughes EA, Zalts A, Montserrat JM (2015) Polyethylene film incorporation into the horticultural soil of small periurban production units in Argentina. Sci Total Environ 523:74–81. https://doi.org/10.1016/j.scitotenv.2015.03.142

Redondo-Hasselerharm PE, de Ruijter VN, Mintenig SM, Verschoor A, Koelmans AA (2018) Ingestion and chronic effects of Car Tire tread particles on freshwater benthic macroinvertebrates. Environ Sci Technol 52(23):13986–13994. https://doi.org/10.1021/acs.est.8b05035

Rezaei M, Riksen MJPM, Sirjani E, Sameni A, Geissen V (2019) Wind erosion as a driver for transport of light density microplastics. Sci Total Environ 669:273–281. https://doi.org/10.1016/j.scitotenv.2019.02.382

Ribeiro F, O'Brien JW, Galloway T, Thomas KV (2019) Accumulation and fate of nano- and micro-plastics and associated contaminants in organisms. Trends Anal Chem 111:139–147. https://doi.org/10.1016/j.trac.2018.12.010

Rillig MC, Ziersch L, Hempel S (2017) Microplastic transport in soil by earthworms. Sci Rep 7:1362. https://doi.org/10.1038/s41598-017-01594-7

Rillig M, Lehmann A, de Souza Machado AA, Yang G (2019) Microplastic effects on plants. New Phytol 223(3):1066–1070. https://doi.org/10.1111/nph.15794

Rodríguez-Seijo A, Pereira R (2017) Morphological and physical characterization of microplastics. In: Rocha-Santos TAP, Duarte AC (eds) Characterization and analysis of microplastics, Comprehensive Analytical Chemistry Series. Elsevier B.V., Amsterdam, pp 49–66. https://doi.org/10.1016/bs.coac.2016.10.007

Rodríguez-Seijo A, Pereira R (2019) Chapter 3: Microplastics in agricultural soils. Are they a real environmental Hazard? In: Sánchez-Hernández JC (ed) Bioremediation of agricultural soils. CRC Press, New York, pp 45–60. https://doi.org/10.1201/9781315205137

Rodríguez-Seijo A, Lourenço J, Rocha-Santos TAP, da Costa J, Duarte AC, Vala H, Pereira R (2017) Histopathological and molecular effects of microplastics in *Eisenia andrei* Bouché. Environ Pollut 220:495–503. https://doi.org/10.1016/j.envpol.2016.09.092

Rodríguez-Seijo A, da Costa JP, Rocha-Santos T, Duarte AC, Pereira R (2018) Oxidative stress, energy metabolism and molecular responses of earthworms (*Eisenia fetida*) exposed to low-density polyethylene microplastics. Environ Sci Pollut Res 25:33599. https://doi.org/10.1007/s11356-018-3317-z

Rodríguez-Seijo A, Santos B, Ferreira E, Cachada A, Pereira R (2019) Low-density polyethylene microplastics as a source and carriers of agrochemicals to soil and earthworms. Environ Chem 16:8–17. https://doi.org/10.1071/EN18162

Rusek J (1998) Biodiversity of Collembola and their functional role in the ecosystem. Biodivers Conserv 7(9):1207–1219. https://doi.org/10.1023/A:1008887817883

Savin MC, Görres JH, Neher DA, Amador JA (2001) Uncoupling of carbon and nitrogen mineralization: role of microbivorous nematodes. Soil Biol Biochem 33(11):1463–1472

Scheurer M, Bigalke M (2018) Microplastics in Swiss floodplain soils. Environ Sci Technol 52:3591–3598. https://doi.org/10.1021/acs.est.7b06003

Schwabl P, Köppel S, Königshofer P, Bucsics T, Trauner M, Reiberger T, Liebmann B (2019) Detection of various microplastics in human stool: a prospective case series. Ann Intern Med 171(7):453–457. https://doi.org/10.7326/M19-0618

Serrano-Ruíz H, Martín-Closas L, Pelacho AM (2018) Application of an in vitro plant ecotoxicity test to unused biodegradable mulches. Polym Degrad Stab 158:102–110. https://doi.org/10.1016/j.polymdegradstab.2018.10.016

Sforzini S, Oliveri L, Chinaglia S, Viarengo A (2016) Application of biotests for the determination of soil ecotoxicity after exposure to biodegradable plastics. Front Environ Sci 4:68. https://doi.org/10.3389/fenvs.2016.00068

Siddiky MRK, Schaller J, Caruso T, Rillig MC (2012) Arbuscular mycorrhizal fungi and Collembola non-additively increase soil aggregation. Soil Biol Biochem 47:93–99. https://doi.org/10.1016/j.soilbio.2011.12.022

Sintim HY, Bandopadhyay S, English ME, Bary AI, DeBruyn JM, Schaeffer SM, Miles CA, Reganold JP, Flury M (2019) Impacts of biodegradable plastic mulches on soil health. Agric Ecosyst Environ 273:36–49. https://doi.org/10.1016/j.agee.2018.12.002

Smith M, Love DC, Rochman CM, Neff RA (2018) Microplastics in seafood and the implications for human health. Curr Environ Health Rep 5(3):375–386. https://doi.org/10.1007/s40572-018-0206-z

Sommer F, Dietze V, Baum A, Sauer J, Gilge S, Maschowski C, Gieré R (2018) Tire abrasion as a major source of microplastics in the environment. Aerosol Air Qual Res 18(8):2014–2028. https://doi.org/10.4209/aaqr.2018.03.0099

Song Y, Chao C, Qiu R, Hu J, Liu M, Lu S, Shi H, Raley-Susman KM, He D (2019) Uptake and adverse effects of polyethylene terephthalate microplastics fibers on terrestrial snails (*Achatina fulica*) after soil exposure. Environ Pollut 250:447–455. https://doi.org/10.1016/j.envpol.2019.04.066

Steinmetz Z, Wollmann C, Schaefer M, Buchmann C, David J, Tröger J, Muñoz K, Frör O, Schaumann GE (2016) Plastic mulching in agriculture. Trading short-term agronomic benefits for long-term soil degradation? Sci Total Environ 550:690–705. https://doi.org/10.1016/j.scitotenv.2016.01.153

Thomas NL, Clarke J, McLauchlin AR, Patrick SG (2012) Oxo-degradable plastics: degradation, environmental impact and recycling. Water Resour Manag 165:133–140. https://doi.org/10.1680/warm.11.00014

Treonis AM, Unangst SK, Kepler RM, Buyer JS, Cavigelli MA, Mirsky SB, Maul JE (2018) Characterization of soil nematode communities in three cropping systems through morphological and DNA metabarcoding approaches. Sci Rep 8:2004. https://doi.org/10.1038/s41598-018-20366-5

Wan Y, Wu C, Xue Q, Hui X (2019) Effects of plastic contamination on water evaporation and desiccation cracking in soil. Sci Total Environ 654:576–582. https://doi.org/10.1016/j.scitotenv.2018.11.123

Wang J, Lv S, Zhang M, Chen G, Zhu T, Zhang S, Teng Y, Christie P, Luo Y (2016) Effects of plastic film residues on occurrence of phthalates and microbial activity in soils. Chemosphere 151:171–177. https://doi.org/10.1016/j.chemosphere.2016.02.076

Wang J, Coffin S, Sun C, Schlenk D, Gan J (2019) Negligible effects of microplastics on animal fitness and HOC bioaccumulation in earthworm *Eisenia fetida* in soil. Environ Pollut 249:776–784. https://doi.org/10.1016/j.envpol.2019.03.102

Weithmann N, Möller JN, Löder MG, Piehl S, Laforsch C, Freitag R (2018) Organic fertilizer as a vehicle for the entry of microplastic into the environment. Sci Adv 4:eaap8060. https://doi.org/10.1126/sciadv.aap8060

Wijesekara H, Bolan NS, Bradney L, Obadamudalige N, Seshadri B, Kunhikrishnan A, Dharmarajan R, Ok YS, Rinklebe J, Kirkham MB, Vithanage M (2018) Trace element dynamics of biosolids-derived microbeads. Chemosphere 199:331–339. https://doi.org/10.1016/j.chemosphere.2018.01.166

Yang X, Bento CPM, Chen H, Zhang H, Xue S, Huerta Lwanga E, Zomer P, Ritsema CJ, Geissen V (2018) Influence of microplastic addition on glyphosate decay and soil microbial activities in Chinese loess soil. Environ Pollut 242:338–347. https://doi.org/10.1016/j.envpol.2018.07.006

Yeates GW (2003) Nematodes as soil indicators: functional and biodiversity aspects. Biol Fertil Soils 37:199–210. https://doi.org/10.1007/s00374-003-0586-5

Yolcubal I, Brusseau ML, Artiola JF, Wierenga PJ, Wilson LG (2004) Environmental physical properties and processes. In: Artiola JF, Pepper IL, Brusseau ML (eds) Environmental monitoring and characterization. Elsevier Inc., Amsterdam, pp 207–239. https://doi.org/10.1016/B978-012064477-3/50014-X

Yu M, van der Ploeg M, Huerta Lwanga E, Yang X, Zhang S, Ma X, Ritsema CJ, Geissen V (2019) Leaching of microplastics by preferential flow in earthworm (*Lumbricus terrestris*) burrows. Environ Chem 16:31–40. https://doi.org/10.1071/EN18161

Zhang GS, Liu YF (2018) The distribution of microplastics in soil aggregate fractions in southwestern China. Sci Total Environ 642:12–20. https://doi.org/10.1016/j.scitotenv.2018.06.004

Zhang S, Yang X, Gertsen H, Peters P, Salánki T, Geissen V (2018) A simple method for the extraction and identification of light density microplastics from soil. Sci. Total Environ 676–617:1056–1065. https://doi.org/10.1016/j.scitotenv.2017.10.213

Zhou Y, Liu X, Wang J (2019) Characterization of microplastics and the association of heavy metals with microplastics in suburban soil of central China. Sci Total Environ 694:133798. https://doi.org/10.1016/j.scitotenv.2019.133798

Zhu D, Chen QL, An XL, Yang XR, Christie P, Ke X, Wu LH, Zhu YG (2018a) Exposure of soil collembolans to microplastics perturbs their gut microbiota and alters their isotopic composition. Soil Biol Biochem 116:302–310. https://doi.org/10.1016/j.soilbio.2017.10.027

Zhu D, Bi QF, Xiang Q, Cheng QL, Christie P, Ke X, Wu LH, Zhu YG (2018b) Trophic predator-prey relationships promote transport of microplastics compared with the single *Hypoaspis aculeifer* and *Folsomia candida*. Environ Pollut 235:150–154. https://doi.org/10.1016/j.envpol.2017.12.058

Zhu BK, Yang YM, Zhu D, Christie P, Ke X, Zhu YG (2018c) Exposure to nanoplastics disturbs the gut microbiome in the soil oligochaete *Enchytraeus crypticus*. Environ Pollut 239:408–415. https://doi.org/10.1016/j.envpol.2018.04.017

Zhu F, Zhu C, Wang C, Gu C (2019) Occurrence and ecological impacts of microplastics in soil systems: a review. Bull Environ Contam Toxicol 102(6):741–749. https://doi.org/10.1007/s00128-019-02623-z

Zubris KAV, Richards BK (2005) Synthetic fibers as an indicator of land application of sludge. Environ Pollut 138:201–211. https://doi.org/10.1016/j.envpol.2005.04.013

Europe's Move Towards Plastic-Free Ocean

Māris Stuļģis

Abstract Ocean plastic is an ever-increasing challenge to the marine and coastal biodiversity. Plastic makes up to 85% of marine litter on European beaches. Marine litter costs the European Union economy some 900 Mio EUR per year. Most of the 165 Mio tons of marine litter currently in oceans accumulate in five oceanic gyres, gradually degrade into micro- and nanoplastics and may enter our food chain, e.g. through mussels or fish. Plastic in oceans may affect marine organisms due to entangling, ingestion or ghost fishing.

European institutions contribute with solutions from different perspectives. European Commission initiates new legislative initiatives (e.g. banning certain single-use plastic items), allocates funds to develop innovative solutions or to adjust ports infrastructure to receive waste from ships all across Europe. Fishermen are compensated for bringing ashore waste caught into their nets during normal fishing operations rather than dumping back into the sea. EU encourages industry to move from linear to circular plastic production, by significantly increasing use of recycled plastic. Awareness of kids and adults on oceans facing huge consequences from human actions is crucial to change our behaviour to more sustainable with avoiding plastic packaging and single-use items, using reusable water bottles and coffee cups, etc.

But Europe also supports, where relevant, the creative, inspiring, impactful solutions by collaborating with representatives from science, education, NGOs, governments and industry. A lot of scientific breakthroughs, innovative market solutions and good governmental practices exist and it is crucial the world knows about them.

Keywords Europe · Oceans · Marine plastic litter · Science · Innovation · Maritime policy

M. Stuļģis (✉)
Maritime Innovation, Marine Knowledge and Investments, Maritime Affairs and Fisheries, European Commission Brussels, Brussels, Belgium
e-mail: Maris.STULGIS@ec.europa.eu

© Springer Nature Switzerland AG 2020
M. Streit-Bianchi et al. (eds.), *Mare Plasticum – The Plastic Sea*,
https://doi.org/10.1007/978-3-030-38945-1_10

1 Marine Plastic Litter as a Global Challenge

Plastic is the most visible type of marine litter in sea and on beaches (Fig. 1). But visible plastic is only the tip of the iceberg, as 94% of plastic in oceans lays on the sea floor (Eunomia Research and Consulting Ltd: Plastics in the Marine Environment 2016). Around 8 million tons of plastic enter the oceans annually. When in oceans, plastic continuously degrades into smaller parts and may enter our food chain, for example, through mussels or fish. EU chief scientists conclude that microplastic is found in water, soil, food and even drinking water (Group of Chief Scientific Advisors, European Commission: Environmental and Health Risks of Microplastic Pollution 2019), but risks to the environment and human health are not widespread yet.

Most of the plastic in oceans originates from land-based sources, while shipping, fishing and aquaculture are important sources of sea-based plastic pollution.

Marine litter causes economic damage. For instance, the cost of litter to the fishing industry has been estimated up to €300 million per year or around 5% of total revenues of the EU fishing fleet (Marine Strategy Framework Directive: Marine Litter, DG Environment 2019) in terms of damaged nets, entangled propellers, blocked cooling systems, contaminated catch, etc. Beach clean-ups in Europe cost €630 million annually.

Plastic marine litter is one of the clearest symbols of a resource inefficient economy. Valuable materials are polluting our beaches and damaging our environment instead of being pumped back into the economy. 95% of the plastic packaging material (value: $80–120 Bio) (Ellen MacArthurs Foundation: The New Plastics Economy 2016) is lost to the economy after short first use.

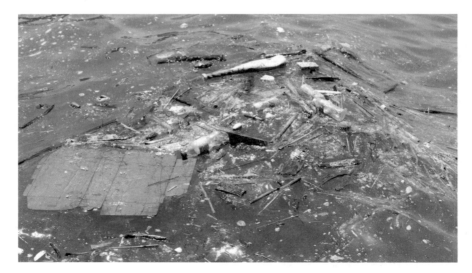

Fig. 1 Plastic marine litter (Picture: Kristiana Stuļģe)

"The problem is the magnitude of synthetic materials that are used briefly, then thrown away for eternity, thereby permanently changing the nature of the world". Sylvia A. Earle

2 Marine Litter: A Unique Opportunity

The huge amount of unused marine plastic waste opens a window of opportunity to drive the move from linear to circular plastic economy. There is a potential to develop innovative, sustainable and profitable businesses that reduce, reuse and recycle ("*3Rs principle*") the waste that ends up in or originates from oceans. The private sector can reorient its production processes to new and better designed materials or sustainable plastic alternatives (e.g. 100% bio-based and biodegradable plastic). European Commission is boosting innovation by driving investments and research where most needed and by encouraging new impactful initiatives (e.g. Plastic alliance aiming to reach recycled content in plastic products 10 Mio tons in Europe by 2025). To ensure that all voices are heard and wise decisions are made, the Commission looks for and spreads good practices by organising stakeholder events and engaging in a more participatory way with all relevant stakeholders and EU citizens.

According to *Ellen MacArthur's foundation*, currently in Europe 53% of plastic packaging could be recycled economically and environmentally effectively. Provided that only around 10% of plastic is recycled in Europe, the immediate recycling potential is quite obvious. . .

Awareness on the marine litter challenge has mobilised enormous engagement of citizen, public sector, scientific and education institutes, non-governmental organisations and businesses.

3 How European Union Curbs Marine Litter

European Green Deal (EGD) for the European Union (EU) and its citizens (11/12/ 2019) sets the EU ambition to tackle the climate and environmental-related challenges as this generation's defining task. Its zero-pollution action plan (foreseen for 2021) will look how to better monitor, report, prevent and remedy pollution from water. To achieve this, the EU and Member States will look more systematically at all policies and regulations by greening national budgets (broad-based tax reforms, removing subsidies for fossil fuels, shifting the tax burden from labour to pollution, and taking into account social considerations), by digitalising distance monitoring of water pollution, by ensuring that all packaging in the EU market is reusable or recyclable in an economically viable manner by 2030, by supporting the circular design of all products based on a common methodology and principles, etc.

When plastic litter enters the ocean, it is very difficult and expensive to retrieve it, bring ashore and recycle. Effective technologies do not exist yet. Therefore, the overarching vision of the EU is to **prevent** plastic entering oceans on the first hand.

To address the magnitude of the challenge the *EU Plastic Strategy in the Circular economy* (European Strategy of Plastics in the Circular Economy 2019) is transforming the way plastic products are designed, used, produced and recycled in the EU. Better design of plastic products, higher plastic waste recycling rates, and more and better quality recyclates will help boosting the market for recycled plastics. The strategy includes new regulations to gradually ban certain plastic products (oxodegradable plastic, single-use plastic items), where alternatives exist. After short first use, these products create long-term environmental damage. The strategy will help to protect our environment, reduce marine litter, greenhouse gas emissions and our dependence on imported fossil fuels. It will support more sustainable and safer consumption and production patterns for plastics.

Single Use Plastics Directive entered into force on 2 July 2019 and has been an act of courage. It addresses the 10 single-use plastic products most often found on beaches in Europe, as well as lost and abandoned fishing gear. Interestingly, *Collins Dictionary* named "single-use" their word of the year in 2018, citing a fourfold increase in usage since 2013.

The new *Port reception facilities directive* (published on 7 June 2019) will ensure that all waste from ships, including fishing vessels and recreational boats, is delivered to adequate port reception facilities by implementing indirect fee to all vessels. The *European Maritime and Fisheries Fund EMFF* will help to adjust the port reception facilities.

The revised *Fisheries Control Regulation* will improve the rules on reporting lost fishing gear, e.g. through the introduction of e-reporting, on retrieval equipment on board for the lost fishing gear and extending gear marking for smaller vessels.

Leading by example, the Commission has phased out all single-use plastic cups in water fountains and vending machines in all its buildings and at all meetings. It achieved this by improving its green public procurement since 2017.

Science and innovation are important EU cornerstones for finding new and innovative solutions to tackle marine litter. Under *Horizon 2020* research funding there are developed innovative solutions to remove litter, to prevent its leakage into the seas and oceans and to mitigate the effects of plastic on the environment.

For example, *Sailclean* (H2020 EU Research Project Sailclean 2019) project is developing a customised boat capable of capturing marine litter and algal blooming that causes eutrophication.

WasteShark (H2020 EU Research Project WasteShark 2019) is an aquadrone to autonomously deliver to shore and empty waste, debris or biomass, from ports and inland waters.

The *ResponSEAble* (H2020 EU Research Project ResponSEAble 2019) project has worked to create interactive educational tools to inform the public on how their actions could contribute to the ocean's environmental degradation.

The *Ecolactifilm* (H2020 EU Research Project Ecolactifilm 2019) project, led by a pioneering French SME, has created a soluble solution for packaging based on milk proteins to replace the environment damaging fossil polymers.

Under the *EMFF Blue economy call*, 5 projects started 1/1/2019 to look at innovative solutions like electronic tagging of fishing gear, underwater monitoring by drones or on reduction of marine litter from aquaculture. The projects above are

EMODnet seafloor litter data
MSFD region aggregated distribution of litter categories
(2011-2017)*

*Different sampling devices were used in the two regions (North East Atlantic Ocean and Baltic Sea).
GOV trawl gear type is the most used in the North East Atlantic Ocean

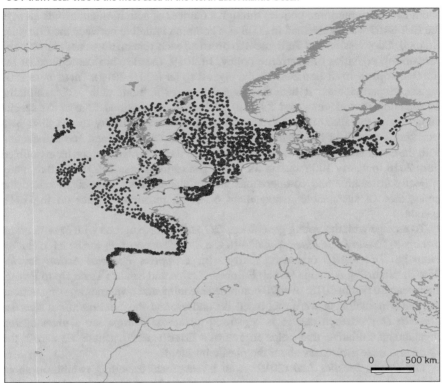

Fig. 2 Seafloor marine litter data (Source: *EMODnet—European Maritime Observation and Data Network*) (Aggregated data products are generated by EMODnet Chemistry under the support of DG MARE Call for Tenders MARE/2008/03-lot3, MARE/2012/10-lot4 and EASME/EMFF/2016/006-lot4) (EMODnet 2019)

just few examples and many more could be found in relevant databases (EU Research Projects 2019; EMFF Projects 2019; EU LIFE Projects 2019; INTERREG Projects 2019; EU Eco-Innovation Projects 2019).

Through the future *Mission for a Healthy Oceans, Seas and Inland Waters* under the new *Horizon Europe*, EU will further bundle and intensify the research and innovation efforts to address, among others, the ocean plastics challenge.

Reliable **marine litter data** and **maps** are crucial to develop effective prevention measures and responses. Marine litter distribution maps are now available through the *European Maritime Observation and Data Network* (*EMODnet*) (2019). The map on seabed marine litter (Fig. 2) clearly shows that fishermen will continue to get litter in their nets and plastic will be further washed ashore, especially after storms.

Awareness rising and citizen and youth engagement is crucial to move towards a plastic-free ocean.

The *European Maritime Day (EMD)* is the flagship event of the *Directorate for Maritime Policy and the Blue Economy (DG MARE)*. It is both the event where "Ocean Leaders Meet" and also the opportunity for many EU citizens to find out about European maritime policies through a number of activities and events all over the EU. *EMD* was established in 2008 as a common initiative between the European Council, Commission and Parliament to organise each year an awareness raising and networking activities on maritime policy. In 2019, the flagship conference of the *EMD* took place in Lisbon and was the biggest so far (EMD 2019). There were 1500 registered participants; it had the biggest ever exhibition, with 105 exhibitors, 28 stakeholder workshops and 7 *DG MARE* break-out sessions. One of the special things about the *EMD* is that stakeholders have the opportunity to run their own workshops as part of the event. As a result, stakeholders' interest and satisfaction with the event is on the rise, as applications for stakeholder workshops have doubled from 2018 to nearly 100 requests for 2019. The result is that *EMD* has led to many project partnerships and co-operations among stakeholders, as well as raised the importance of sustainable management of ocean resources higher on the EU's agenda.

To engage with the young generation, *DG MARE* have agreed with *Smurfs* brand owners to **"Smurf our blue planet"**—to use *Smurfs* supporting the beach clean-up campaign *DG MARE* organises yearly with *European External Action Service* (Fig. 3) (Smurfing our Blue Planet: European Union and Smurfs Team Up to Protect the Ocean 2019). In 2018, over 70 combined cleaning and awareness-raising actions and 3000 participants were mobilised on and around the *"International Coastal Cleanup Day"*. Beach clean-ups organised all across Europe are a great citizen engagement initiative that helps to **remove litter** washed ashore all across the world and raise awareness about the plastic problem.

The *Ocean Plastics Lab* (2019) is an international travelling exhibition about science: it showcases the contribution of science to understand and tackle the problem of plastics in the ocean. It helps to reach out to young people and citizens,

Fig. 3 News item on Europa website 17/04/2019 on Commission teaming up with *Smurfs* brand to promote annual beach-clean-up campaign (Source: European Union) (Smurfing our Blue Planet: European Union and Smurfs Team Up to Protect the Ocean 2019)

to raise awareness about the problem and possible solutions and to enable its visitors to understand what is happening once plastics enter the sea.

European Environment Agency has developed an app for mobile phones, called **Marine Litter Watch** (2019), that enables people to report litter found on European beaches. Since 2015 this app has been providing data thus supporting EU policy-making, and at the same time helping to change human behaviour to prevent and reduce litter.

When fishing at sea, fishermen get plastic litter into their nets during their normal fishing operations. Instead of throwing it back, many fishermen join the **Fishing for litter** activities. On a European scale, fishermen from 14 EU Member States benefit from EU money (*EMFF*) to deliver to ports marine litter caught into their fishing nets. Also, more than 700 fishing vessels are part of the *Fishing for litter* initiative coordinated by *KIMO international (Municipalities for Sustainable Seas)*. Also *OSPAR Commission* (protection of the marine environment of the North-East Atlantic) actively promotes fishing for litter among its members.

As consumers, we have so much power to change the world by just being careful in what we buy. Emma Watson

Dear readers, allow me to finish with some **inspirational examples of businesses catching the opportunities** stemming from plastic pollution.

More and more drinks producers (like *Evian, Tropicana, Nestlé,* etc.) make the bottles with recycled content (*rPET* plastic), which reduces the need for petrol-based plastic (Fig. 4).

Some other producers use recycled plastic bottles and/or recycled plastic waste from oceans to produce clothes or shoes (like *Fourth Element, Adidas/Parley, Seaqual, Maura,* etc.) (Figs. 5 and 6).

End-of-life fishing gear and "ghost" gear are considered as serious threat to the marine environment, as left unintended at sea, they may continue to fish and may cause accidents to ships. But there are companies that bring new life to those old nets. *Plastix Global* transform old fishing nets into plastic granules, from which the plastics converting companies produce new plastic items (furniture, picnic benches, bottles, etc.), replacing virgin plastic as a source (Fig. 7). Some other companies involved are: *Healthy Seas* (produces socks), *Axiom* (cycling gear), *Fishy filaments* (3D printing from nylon nets), *Bureo* (frisbee gears), *Verdura* (shoes), *Econyl* (swimwear) and many more.

Fig. 4 Label on the plastic bottle stating the 50% of recycled plastic content (Picture: Māris Stuļģis)

Fig. 5 *Parley for Oceans* cooperates with *Adidas* to make sport shoes and *Manchester United* T-shirts from recycled ocean plastic (Picture: Māris Stuļģis)

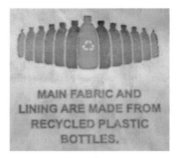

Fig. 6 *Maura* makes women's clothes from recycled plastic bottles (Picture: Māris Stuļģis)

Fig. 7 Plastic items made from fishing gear recycled by *Plastix Global*: design "pig table" and picnic set (Photos: Bernard Merkx, *Waste Free Oceans*)

Sometimes small things can make a big difference. De Panne municipality in Belgium makes citizen aware that marine litter from streets can directly reach the seas (Fig. 8).

Fig. 8 *"Here starts the sea"*. Indication on the street in De Panne, Belgium (Picture: Māris Stuļģis)

Fig. 9 Covers of the kids' books *"The Ocean is my home"* and *"Plastian, the little fish"* (Pictures from *EuroGOOS* and *Waste Free Oceans*) (Eparkhina and Lehtonen 2017; Intemann and Patschorke 2017)

One must notice excellent awareness raising initiatives on plastic pollution, targeting kids, like the book *"The Ocean is my home"* (Eparkhina and Lehtonen 2017) from *EuroGOOS* and *"Plastian, the little fish"* from *Waste Free Oceans* (Intemann and Patschorke 2017) (Fig. 9).

Sylvia Earle, a world-famous oceanographer, *National Geographic* explorer, author, who was called a *"Hero for the Planet"* by *Time magazine* said once: *"I have lots of heroes: anyone and everyone who does whatever they can to leave the natural world better than they found it"*.

I really hope this book will inspire you to become a new hero of the ocean!

Disclaimer: This article represents solely the views of its author and cannot in any circumstances be regarded as the official position of the Commission.

References

Ellen MacArthurs Foundation: The New Plastics Economy (2016). https://www.ellenmacarthurfoundation.org/publications/the-new-plastics-economy-rethinking-the-future-of-plastics. Accessed 28 June 2019

EMD (2019) Lisbon. https://ec.europa.eu/maritimeaffairs/maritimeday/en/conference#content-heading-6. Accessed 28 June 2019

EMFF Projects (2019). https://ec.europa.eu/easme/en/emff-projects. Accessed 28 June 2019

EMODnet (2019) EMODnet Chemistry litter data maps—First release! http://www.emodnet.eu/emodnet-chemistry-litter-data-maps-first-release. Accessed 8 July 2019

Eparkhina D, Lehtonen K (2017) The ocean is my home. EuroGOOS, Brussels, Belgium. http://eurogoos.eu/download/publications/TheOceanIsMyHome.pdf. Accessed 28 June 2019

EU Eco-Innovation Projects (2019). https://ec.europa.eu/environment/eco-innovation/projects/. Accessed 28 June 2019

EU LIFE Projects (2019). http://ec.europa.eu/environment/life/project/Projects/index.cfm. Accessed 28 June 2019

EU Research Projects (2019). https://cordis.europa.eu/projects/en. Accessed 28 June 2019

Eunomia Research & Consulting Ltd: Plastics in the Marine Environment (2016). https://www.eunomia.co.uk/reports-tools/plastics-in-the-marine-environment/. Accessed 28 June 2019

European Strategy of Plastics in the Circular Economy (2019). http://ec.europa.eu/environment/waste/plastic_waste.htm. Accessed 28 June 2019

Group of Chief Scientific Advisors, European Commission: Environmental and Health Risks of Microplastic Pollution (2019). https://ec.europa.eu/info/sites/info/files/research_and_innovation/groups/sam/ec_rtd_sam-mnp-opinion_042019.pdf. Accessed 28 June 2019

H2020 EU Research Project Ecolactifilm (2019). https://cordis.europa.eu/project/rcn/211108/brief/en. Accessed 28 June 2019

H2020 EU Research Project ResponSEAble (2019). https://www.responseable.eu/. Accessed 28 June 2019

H2020 EU Research Project Sailclean (2019). https://cordis.europa.eu/project/rcn/217880/brief/en. Accessed 28 June 2019

H2020 EU Research Project WasteShark (2019). https://cordis.europa.eu/project/rcn/213717/brief/en. Accessed 28 June 2019; https://www.ranmarine.io/. Accessed 28 June 2019

Intemann N, Patschorke J (2017) Plastian the little fish. Waste Free Oceans, Brussels, Belgium. https://www.wastefreeoceans.org/plastianthelittlefish. Accessed 8 July 2019

INTERREG Projects (2019). https://www.keep.eu/. Accessed 28 June 2019

Marine Strategy Framework Directive: Marine Litter, DG Environment (2019). http://ec.europa.eu/environment/marine/good-environmental-status/descriptor-10/index_en.htm. Accessed 28 June 2019

MarineLitterWatch (2019). https://www.eea.europa.eu/themes/water/europes-seas-and-coasts/assessments/marine-litterwatch. Accessed 28 June 2019

Ocean Plastics Lab (2019). https://oceanplasticslab.net/. Accessed 28 June 2019

Smurfing our Blue Planet: European Union and Smurfs Team Up to Protect the Ocean (2019). https://ec.europa.eu/maritimeaffairs/press/smurfing-our-blue-planet-european-union-and-smurfs-team-protect-ocean_en. Accessed 28 June 2019

Plastic Pollution in the Oceans: A Systemic Analysis—Status Quo and Possible Sustainable Solutions

Gianlauro Casoli and Shyaam Ramkumar

Abstract In a constant interconnected, integrated, dynamic, multilayered and open social, cultural, economic and political landscape, a renewed approach is necessary to properly face the uncertainties and the questions put forward by the actual level of plastic pollution of the oceans of our planet. Coming to recognize the causes and their impact on marine and human life and how it is possible to influence them lies at the core of the complexity when tackling this large worldwide phenomenon. Involving people from different sectors of society and background in an open discussion about the different nuances and practicalities which characterize the complexity of the problem is what several national and international bodies are trying to implement nowadays. However, the lack of interactions and coordination between the various political, industrial and financial players as well as society at large must be overcome. This chapter will highlight the status quo of the plastics problem and existing and emerging circular solutions that try to tackle this issue. It will show that a systemic perspective is needed to effectively address the problem. And that implementing paradigm changes, raising awareness, and putting in place integrated environmental legislation and financing is of paramount importance. The chapter underlines that the time to find a remedy as well as technological and sustainable solutions is short, while the problem in terms of economic impact and environmental consequences is huge.

Keywords Plastic pollution · Systemic analysis · Complex systems · Circular models · Global awareness · Social actions

G. Casoli (✉)
Research Laboratory on Corporate Social Responsibility, Department of Economics, University of Parma, Parma, Italy

ETHICALFIN Ltd., London, UK
e-mail: gc@ethicalfin.com

S. Ramkumar
Department of Social and Political Science, University of Milan, Milan, Italy
e-mail: shyaam.ramkumar@unimi.it

© Springer Nature Switzerland AG 2020
M. Streit-Bianchi et al. (eds.), *Mare Plasticum – The Plastic Sea*,
https://doi.org/10.1007/978-3-030-38945-1_11

1 Thinking in Systems

The compelling problem of plastic pollution in the oceans necessitates a new frame of thinking and analysis. The complexity and the multifaceted aspects of the issue highlight the need for a systemic approach that sheds light on the interconnections and the quality of relations among different actors.

The markedly dynamic, interconnected, highly turbulent and changeable panorama which characterizes current society and contemporary market economy is evidence that the linear paradigm is outdated and problematic. Our current way of thinking leads to a temporary and illusory static control over the natural and social environment, which is, in actual fact, in constant flux. Today, decisions are made on the basis of the presumptions of apparent exhaustive information and complete analysis that govern economic activities. This encourages structural rigidities and inequalities which blocks the essential adjustment to a qualitative sustainable development and impedes an effective and stable social, cultural and economic growth and it provokes economic and huge natural crises at different levels. Plastic pollution in the oceans is one of them.

Thinking in systems can uncover hidden causes and effects as well as a more holistic view. It can highlight the deficiencies of the current paradigm and the consequent shortcomings of proper connections among different actors that have generated the present conditions, and it pinpoints possible alternatives.

A systemic analysis considers a multidimensional perspective that takes into account different strategic facets—like the cultural, scientific, social, political, industrial, economic and financial. And it allows for the coordination and the development of integrated and structured collaborative circular sustainable solutions that combine these aspects, which can then be scaled up in the near future. This is connected with a more all-inclusive paradigm that takes into account how different kinds of relations are in play, their shape and dynamics. Such a paradigm aims to discover the systemic multiplicity which moves the plastic value chain and its different related aspects in a non-linear fashion as complex system with its adaptive and dynamic premises:

- **Organic and interrelated**—have common dynamics similar to ecosystems and the evolution of the organisms more than machines. Their behaviour is not generally foreseeable or planned.
- **Based on dynamic relations which build self-organized behavioural framework**—foster paths or relational structures which are able to be stable and at the same time they show some variations and fluctuations that can evolve in new behavioural framework.
- **Emergence**—behaviours are born from an emerging process or a change leading to characteristics qualitatively different from those in the past or those that are foreseeable.
- **Dependence on the future evolution of present events**—derive from the unfolding of details and choices in the present time, but it does not follow automatically, regularly and easily from what happened in the past although the

latter makes and gives a certain measure and rhythm to the present. No matter how much knowledge and brilliant methodologies are employed, future forecasts based on present and past data do not always provide an accurate prediction of future events—multiple future scenarios are always possible.

• **Characterized by several causes**—simply linear chains of cause and effects do not generally exist but the results produced are defined and influenced by different interacting factors which occur by chance or are dependent on present and past interactions in the global environment.

The approach towards complexity on the basis of its characteristics is aimed at creating a fluid and adaptive system fully integrated in the related setting, pointing out the quality of relations between subjects and placing the attention in their dynamic and in the emerging meaning created. This attitude allows a greater awareness of the consequences of the actions undertaken, of their impacts and connections with different realities.

2 Current Status of the Plastics Problem

The impact of the amount of plastics in the oceans is considerable in terms of the significant damages to marine species and the alteration in the food chain, and the planet as a whole. Recent studies have produced evidence that the presence of at least five trillion pieces of plastic debris, particularly in the form of micro- and nano-sized particles (Tyree and Morrison 2018), are affecting the biophysical and biochemical behaviour of the Earth as a whole. This is hurting the planet's vital processes at the core and severely threatening its capacity for resilience. There is only a barely emerging understanding of plastic pollution as a global systemic problem and its geophysical and biological effects (Villaruba-Gomez et al. 2018).

In order to analyse why the biosphere is so deeply affected by anthropic activities and the resulting marine plastic pollution—such that geologists have even termed this era of human activity as the Anthropocene—it is significant to underline when plastic came into use. Plastic was adopted by industries starting from the '50s uniquely for its cost convenience, flexibility and versatility, without considering a wider systemic perspective in terms of impacts on the social and natural environment. The acceleration in the production of plastic is due mainly to the global shift from reusable to cost-convenient single-use containers, which made packaging the largest market for plastics (Geyer et al. 2017). This has resulted in a huge and evident problem of plastic pollution in the environment, particularly in the last few years. There has been an exponentially increasing production in plastic that has passed from 15 million tonnes in 1964 to 348 million tonnes in 2017. The period between 2008 and 2017 saw the production of nearly 35% of all the virgin plastics ever manufactured since 1950, which is equal to 8.3 billion tonnes (Statista 2019).

Considering the period dating back from 1950 until 2015, the cumulative waste generation of primary and secondary (recycled) plastic waste amounted to 6.3 billion

tonnes. Of this, approximately 800 million tonnes (12%) has been incinerated and 600 million tonnes (9%) has been recycled, only 10% of which has been recycled more than once. The remaining 79% was discarded and is accumulated in landfills or in the natural environment (Geyer et al. 2017). In 2010, 275 million tonnes of plastic waste were generated in 192 coastal countries, within 50 km of the coast, with 4.8–12.7 million tonnes entering the ocean. It is calculated that each year an average of 8 million tonnes of this garbage goes from land into the marine environment. Of this, 70–80% comes from middle- and low-income countries located mainly in South and Southeast Asia, Africa, and Central and Latin America (Jambeck et al. 2015).

This situation highlights the gap in terms of proper governance and legislation and, above all, the lack of an efficient international convention on marine plastics. There is a global debate that is going on, but despite the urgency of the present condition, policy integration and coherence remain a missing point.

There are global instruments regulating land-based pollution, like the *Stockholm, Rotterdam* and *Basel Convention*; however, they do not specifically focus on plastic. The latter was recently amended with norms regarding the import/export of plastics (see Sect. 2.1). So far only the *UN Convention on the Law of the Sea* provides a broad overarching duty to prevent land-based sources of all marine pollution (Boyle 1985).

Among the various international bodies, the European Union is doing a considerable amount in the specific field of plastic pollution. The EU has the *Marine Strategic Framework Directive, Descriptor 10* (European Commission 2018a, b, c) and *Article 9* of the *Joint Communication on International Ocean Governance* (European Commission 2019a, b), which supports the *Sustainable Development Goal 14* under *UN agenda 2030*. The EU also has launched an *EU Plastic Strategy* by European Commission in January 2018 as part of the *EU Circular Economy Package* initiated in 2015 (European Commission 2019a, b).

Moreover, the role of private financial sector is primarily passive on this issue by not properly addressing the investment in innovative and more technological recycling infrastructure as well as circular economy processes and practices. A renewed approach in the structures and processes in the financial industry are necessary to align to a more holistic attitude towards businesses, particularly in the plastic value chain (*Working Group FinanCE* 2016). A more detailed analysis of the EU legislation and the private financial sector is discussed later (see Sect. 3).

The current situation is the result of the present and past economic and industrial model. Over the years, this has enabled a way of production that has been unaware of the consequences of a linear paradigm. Such a model has accumulated waste without proper capabilities to manage it effectively and has not satisfactorily considered the complexities of the context in which it operates.

The lack of suitable infrastructure in waste management and in the recycling process in both developed and developing countries, albeit for very different social and economic reasons and at a different scale, as well as the global import/export of plastic waste, are the most evident proof of this. A complete and large shift is required not only at the level of production processes and the value chain, but also in terms of interactions. A different paradigm is needed that is able to bring a diverse

view of how the economic actors behave, relate, and interact with each other in a circular and holistic way, while considering the social, environmental and economic arenas. In addition, the implementation of a large-scale innovation and shared operating platforms in every business sector is required (*Ellen MacArthur Foundation* 2017).

However, among the most problematic obstacles that need to be tackled are the global issue of import/export of plastic scrap and the increasingly growing of production of plastics. This brings more barriers and increased difficulties in the diffusion of efficient and effective reusable and recyclable systems for plastic waste. And it presents again a significant gap in proper governance and legislation that are fundamental to provide a coherent international convention on the import, export, and treatment of plastic garbage. Furthermore, the current economic and industrial model has enabled and continues to enable a way of production that does not sufficiently account for the complexities of the generation of waste.

These two key topics are discussed in more details in the next two sub-sections.

2.1 Import and Export of Plastics[1]

The exponential increase in the production of plastics is closely linked to the question of how to manage the amount of waste accumulated. Over the years, developed countries had to deal with this urgent problem, and considering their inability to properly develop appropriate waste management systems and recycling infrastructure, they elected to export their garbage to developing countries.

Due to this, the flow of import/export of plastic scrap, mainly from Europe and North America to Asian countries like China, Indonesia, Malaysia and Vietnam grew constantly, making the developing countries an easy solution for the problem of plastic trash of developed countries. At the same time, developing countries saw in this trade a business opportunity; however, the waste management systems and recycling infrastructure in these countries were limited, mostly ineffective and ungoverned or non-existent (Wong 2019a, b).

In addition to the import of plastic products, developing countries also saw an increase in the production and use of plastic domestically (Green and Whitebread 2019). As a result, this created over the years one of the main causes of plastic pollution in the oceans (Wong 2019a, b).

In the 1980s and 1990s, many of these Southeast Asian countries had a lot of small companies that used to import and deal with solid garbage, including plastic waste. These countries had very lax policies related to how this discarded material

[1]This section is based on a phone interview with Dr. Steve Wong, President and CEO of Fukutomi Recycling Ltd— http://www.fukutomi.com/ —and recognized as a worldwide expert on plastic scrap treatment.

was treated, owing to a lack of will and prioritization of the local governments, not to mention cases of political corruption (Wong 2019a, b).

As the amount of waste being imported increased into the 1990s and 2000s, more and more companies entered the waste management sector. While operating waste management companies required licences and adherence to policies regarding the handling of waste, these were not strictly enforced or governed by local authorities. This led to a lot of issues related to bribery and lax enforcement by local officials, as well as a large number of illegal and unlicenced waste management operations. Many of these Asian countries began increasingly to crack down on unlicenced waste treatment companies, but despite these efforts, illegal operations and smuggling of plastic waste imports continued (Wong 2019a, b).

As a result of these issues plastic accumulated in the streets, spilled from makeshift dumpsites, were blown into rivers and waterways, and eventually ended up in the ocean. In coastal areas, plastics waste is blown directly into the ocean or accumulated on beaches from costal dumpsites (Green and Whitebread 2019).

There was a growing attention in China on the worsening environmental conditions, which threatened human health and lives. Moreover, pressure mounted on the Chinese authorities to improve the situation considering that the country is one of the biggest global producers of plastics. Attention was focused to the small recycling operations without any environmental controls and the imported foreign waste coming into the nation (Wong 2019a, b).

In 2017, China announced a new policy, the *National Sword*, which came into effect on the 1st of January 2019. According to this policy, China no longer accepted shipments of mixed trash, the wrong or low-quality type of recyclables, and any scrap plastic. In addition to the bans, China not anymore issued any import licences from 1st of January 2019, meaning that fewer businesses will be able to import waste under these rules. It was a wake-up call that reshaped the solid-waste treatment, especially the import of plastic scrap. And it was a leading example of a huge government policy change in order to shift the waste industry towards national garbage and shake the consciousness of the general public on plastic pollution (Wong 2019a, b).

The effect of this ban was a movement of recyclers out of China if they could not deal with the new environmental regulations or source their materials domestically. These plastic waste processing operations moved to the other Southeast Asian countries, most popularly Malaysia and Thailand (Wong 2019a, b) (Table 1).

However, over time, major import problems regarding the smuggling of contaminated e-waste came to the surface and triggered tightened regulatory controls in these countries for all types of waste, including plastic. The massive flow of plastic scrap into Thailand, Malaysia and Vietnam far exceeded permitted volumes and thousands of containers were abandoned at ports or sent back to the senders (Reintjes 2018).

The consequence of this and China's new policy started a large-scale enforcement campaign in these Southeast countries like Malaysia and Thailand. These countries began to take stronger steps to reduce the amount of polluted waste that gets imported as well as to shut down illegal operations. Following the tightening of

Table 1 Changes in imports year-over-year (YoY) of plastic waste (Wong 2019a, b)

Top **importing** countries (YoY changes) - plastic scrap	(Unit : million tons)				
Country	2016	2017 (YoY changes)		2018 (YoY changes)	
China	7.35	5.83	-20.68%	0.36	-93.83%
China (Hong Kong)	2.88	1.89	-34.37%	0.43	-77.24%
Malaysia	0.29	0.55	89.66%	0.97	76.36%
China (Taiwan)	0.18	0.20	11.11%	0.42	110.00%
Indonesia	0.12	0.13	8.33%	0.33	153.85%
Vietnam	0.30	0.61	103.33%	0.46	-24.59%
Thailand	0.07	0.21	200.00%	0.51	142.86%
sub-total : above markets otherthan China & China (Hong Kong)	0.96	1.70	77.08%	2.69	58.24%
rest of World	4.29	3.94	15.48	2.75	-30.20%
Grand total	15.48	13.36	-13.70%	6.23	-53.37%

Table 2 Changes in exports year-over-year (YoY) of plastic waste (Wong 2019a, b)

Top **exporting** countries - plastic scrap	Unit : million tons			
Country	2016	2017	2018 (YoY changes)	
USA	1.62	1.67	1.07	-35.90%
Japan	1.53	1.43	0.95	-33.57%
Germany	1.45	1.22	0.97	-20.49%
United Kingdom	0.81	0.68	0.59	-13.25%
Netherlands	0.48	0.39	0.35	-10.26%
rest of World	5.85	5.85	2.30	-60.68%
Grand total	11.74	11.24	6.23	-46.93%

plastic scrap imports and pollution control standards, many recyclers began a second shift to less regulated countries like Cambodia, Laos, Myanmar, Eastern Europe and Turkey, as well as Africa and Central and Latin America (Wong 2019a, b).

The *National Sword* also gave a clear message to the developed countries that used quite lax standards regarding the export of waste, another key aspect of the problem. European Directives and trade laws within different countries regulate the import and export of waste. While some countries such as Italy, the Netherlands are quite strict when it comes to following these laws, others such as Portugal, Spain and Poland are more lax. Oftentimes waste streams are improperly recorded, falsified or shipped illegally. The most strict trade international regulation is the *Basel Convention*, which prevents the transfer of hazardous wastes from developed to developing countries (Secretariat of the *Basel Convention* 2011) (Table 2).

In order to ensure that developed countries take plastic waste exports more seriously, Norway introduced an amendment to the *Basel Convention* to classify

plastic waste as hazardous waste. The Norwegian proposal was ratified by 187 parties in May 2019 (Staub 2019). The introduction of this amendment is meaningful because it places restrictions on exporting actions more than importing. The aim is to deter developed countries from sending plastic garbage abroad and try to encourage greater local recycling and reuse of plastic waste streams. And it also affected the markets for recycling in the developing countries as well, particularly India (Wong 2019a, b).

It remains to be seen to what extent these developments in import/export legislation, the reshaping of the recycling industry, and augmented awareness will affect the flow of plastic into the ocean. Much of these activities are dictated by market conditions of the demand for recycled plastic, the quality of recycled plastic, and the price and supply of virgin plastic, which affects the cost and convenience of recycling procedures (Gray 2018).

2.2 Trends for Plastic Production[2]

As mentioned earlier in this section (see Sect. 2), the global production of virgin plastic from fossil fuels has grown exponentially. This is because the cost of petroleum and fracked natural gas is very low, leading to low costs for virgin plastic. Meanwhile, alternative solutions that substitute this plastic with more reusable or recyclable materials are more costly for companies, since there are high costs for collecting, sorting and recycling post-consumer plastics (Gray 2018; Hopewell et al. 2009). And due to its convenience and price, business and society have built a lot of behaviours that focus on single-use plastics, rather than turning towards more reusable or recyclable solutions that are more efficient from a systemic perspective.

Thus, the growth in the production of plastic could potentially continue in the future. It is estimated that the primary plastic is expected to increase by 4% a year to at least 2035 (Bruggers 2019). Annual consumption of plastic bottles alone is expected to exceed 500 billion by 2021, with over 1.2 million bottles expected to be produced per minute (Laville and Taylor 2017).

A large part of this increase comes from the oil and gas sector, which looks at plastic as one of the primary sources of growth. A key scenario, according to the BP 2019*Energy Outlook* (*BP* 2019), involves the industry focusing on non-combusted uses for oil, gas and coal, such as feedstock for petrochemicals like lubricants and bitumen, and a strong growth in plastics, particularly in single-use bags, sachets, single-use plastic food containers, etc. Currently, more than 78 million tonnes of

[2]This section is based on a phone interview with Neil Tangri, Ph.D. in Climate Science from Stanford University and Science and Policy Director at the Global Alliance for Incinerator Alternatives (GAIA).

plastic packaging is produced globally each year by a sector worth nearly $198 billion (Gray 2018). Most of this production is thrown away after its first use and only a small fraction is recycled. Despite all the possible efforts from the waste management side and the effort to reduce and regulate the import/export of plastics to prevent them from leaking into the oceans, their exponential production every year makes the plastic issue worse and worse (Tangri 2019).

The transformation to a circular economy that produces less plastics and more recyclable materials will significantly affect the oil and gas industry. Therefore, these firms have been closely following the changing opinion and growing pushback against single-use plastic among consumers and governments. They will likely resist initiatives that call for greater reduction in plastic use and in the shift from virgin to recycled plastics (Tangri 2019). While these companies have vocally supported the end-of-use treatment of plastic in the value chain, few have been involved in the actual implementation of the shift to recycled plastic and have even blocked measure to reduce the use of plastic (Root 2019).

In order to tackle the plastics problem in a systematic way, there needs to be not only a focus on the management of plastic waste but also a cap in the production of virgin plastic. Reducing the production of plastic in the future and moving towards alternatives will have a significant and fundamental impact in terms of reduction of the amount of plastic entering into the ocean.

The next section provides more details on some of the existing and emerging solutions that develop not only new materials but also different ways of thinking and interacting to reduce the use and the need for plastic.

3 Circular Thinking for Innovation: Existing and Emerging Solutions

One of the most important aspects of circular thinking is about patterns. Precisely, it stresses the dynamic patterns of relations within and between social and economic systems, which are characterized by variability, iteration, reflexivity and a multiplicity of synergistic processes. Circular thinking takes into account all levels, from the individuals to organizations to the system as a whole and the incessant interplay between these parts.

Understanding, identifying and naming these patterns in a wider complex landscape and coming to recognize their source and their impact in terms of innovation lies at the core of the complexity in the circular economy. Such patterns can appear over time and space as well as in particular times and places. They show up in social interactions, physical environments, emotional experiences and conceptual models. And they can be defined as similarities, differences and connections that could have specific meanings across space and time.

This mode of thinking gives a deep, subtle and at the same time simple way to capture and reflect on the complexity of innovation processes. Circular thinking

stresses more the qualitative aspects such as the nature of relations and operative procedures to implement innovations, rather than solely the quantitative aspects such as profits, growth targets and productivity measures that are typical of the current linear mindset.

All of this challenges the traditional, linear way of reasoning of innovation as a simple exchange of information and knowledge. As said by Shaw, "it is becoming increasingly clear that simple control over the outcome of complex interaction is indeed illusory" (Shaw 2002). Instead, innovation emerges from non-linear processes of interaction, to be built and "negotiated", in a way that enables the emergence of novelties, creativity, and genuine, constructive and dynamic learning.

These processes require a different level of awareness and consciousness that is not stored in a cerebral closed box. The lack of mindfulness about the interlinked consequences of socio-economic decisions and activities, not to mention the environmental impacts, needs to be addressed when developing innovative solutions. The resulting difficulties mentioned in the earlier sections were the outcome of closed-minded thinking and unawareness and underestimation of the problems to come.

Thus, the creative and innovative process is not a simple mind product. It is a systemic characteristic that emerges from particular needs and solutions to particular problems. And it is influenced by the right environment and the quality, typology and intensity of interactions mediated by a peculiar alchemy of situations.

In his opening remarks during the *EU Circular Economy Stakeholder Conference* (European Commission 2018a, b, c), the EU Commissioner Frans Timmermans underlined the existence of a strong global consensus on the need to change the economic model. This opened up a new era of collaboration among all actors that play different roles in the social and economic system and established a clear and official stand in the battle against plastic waste. In December 2015, the European Commission launched the *Circular Economy Package* (European Commission 2019a, b) with a group of 54 actions in different areas to be delivered in 3 years in order to promote the whole product lifecycle and progress in legislation for an advanced European waste management system. There are also EU engagements to create synergies between chemical production and waste policy, to financing and research, to raise awareness, and to better track and measure the progress towards the circular economy.

As the EU is producing an average of 25 million tonnes of plastic waste per year with a very low recycling rate, which means 95% of the economic value lost from plastic packaging in 1 year, the European Commission promoted in January 2018 the first complete *EU Plastic Strategy* (European Commission 2018a, b, c). This set out a new vision for a smart, innovative and sustainable plastics industry, with reuse and recycling activities integrated into production chains. The *Strategy* addresses the whole value-chain, creates synergies between economic and environmental goals, and aims to produce a close systemic collaboration with every stakeholder, including EU citizens. They will work together to achieve an effective circular economic model and systemic network of relations to convert to completely reusable or recyclable plastic packaging by 2030.

The consequence of this will be that certain types of plastics will disappear from the market as they are very difficult and costly to recycle. But one of the most important points of EU strategic actions is the support towards a growing recycling market with more products made of recycled material and the limitation of single-use plastics. Also, the leakage and the unintended release of micro-plastics that are present in textiles and other types of products like tyres (Tyree and Morrison 2018) are the subject of the *Plastic Strategy*.

To support and inform better the European policy makers and funding decisions towards the transition to an all-inclusive and more connected economy, a report titled "*A Circular Economy for Plastics*" (De Smet et al. 2019) was published in March 2019. It provides recommendations for sectorial policymaking and insight for strategic programming to the *EU Strategy for Plastics* that recognize innovation as a key enabler for transforming the system. This fundamental aspect affects the entire value chain from renewable energies and feedstock to product design, business models and reverse logistics, collection and sorting mechanisms, mechanical and chemical recycling technologies, compostability and biodegradability.

The legislative efforts have to be combined with the role of finance in underpinning innovation and coordination among the different stakeholders in building a circular economic system. This is of paramount importance for giving directions in order to overcome financial barriers. The financial sector should focus the attention on enhancing collaboration in the value chain and on creating financial instruments that invest in a chain or in a network of businesses rather than in one business at a time disconnected from its referred environment. In this way, risks and opportunities can be shared and the incentives to collaborate enhanced with the aim to create virtuous circular connections and innovations where all the actors involved take advantage and are made more aware of the social and environmental impact (*Working Group FinanCE* 2016).

There are many initiatives in place that are trying to tackle the problem of plastic pollution from different angles and to implement circular collaborations and innovations. However, these solutions are just the beginning of the more systemic process that is required to resolve the global problem of plastic waste in our oceans. Basically, it is possible to group them into two categories: the ones that are facing the problem of performing in reusing and recycling plastics material and others that are researching new design and new materials. A brief digest of these is discussed in the next two sub-sections.

3.1 Reuse and Recycle Existing Plastic

One of the main streams of innovations facing the plastics issue focuses on the collection, reuse and recycling of existing plastic waste. These solutions aim to tackle the problem of ocean plastic that was highlighted earlier (see Sect. 2.1), trying to reduce the amount of accumulated plastic waste that currently exists in the planet's waters.

There are many initiatives that focus on the collection of plastic waste from the ocean, beaches and waterways. One of the most well-known ocean initiatives is the *The Ocean Cleanup* (2019), a project founded by a young Dutch man named Boyan Slat. The project aims to create a passive collection system for plastic waste using ocean currents, and is mainly targeting the Great Pacific Garbage Patch. However, the project has had some issues during the initial trials and the team is taking steps to address the problems identified (Peters 2018).

Other solutions aim to clean beaches to get rid of plastic such as *Terracycle's Beach Plastic Cleanup Program* (*Terracycle* 2019), *4Ocean's* global clean-up operations in the ocean and on coastlines (*4Ocean* 2019), *Parley for the Ocean's Global Cleanup Network* (*Parley* 2019), and many more volunteer, citizen-based projects. These local and global initiatives try to collect plastic washed up onshore so that they do not pollute waters again, as well as attempting to clean up plastic near coastlines before it enters the ocean.

And yet another group of solutions tries to clean up plastic waste in waterways, like rivers and canals, to collect plastic before it reaches the ocean. Some of these innovations focus on emerging technologies like drones and autonomous cleaning units, such as the *Baltimore Waterfront's Mr. Trash Wheel* (*Baltimore Waterfront* 2019) and *RanMarine Technology's WasteShark* (*RanMarine* 2019). Other projects such as the *Plastic Whale* in Amsterdam arrange plastic fishing expeditions, where people compete against each other to collect the most plastic from the canals in boats made from plastic waste (*Plastic Whale* 2019).

Another aspect of the plastics problem, which was mentioned earlier (see Sect. 3), is the presence of micro- and nanoplastics (Tyree and Morrison 2018). There are innovations and technological advancements that are combatting this issue as well. One of the greatest solutions to this problem is the filtration of water to capture these particles before they end up in the ocean. For example, *GoJelly* (2019) is an EU-funded project that uses the characteristics of jellyfish to develop a filter which captures micro- and nanoparticles of plastic in the water before they reach the environment. Another example is *PlanetCare*, which develops filtration devices for both commercial and industrial laundry machines that capture 60–80% of plastic microfibers from washing clothes (*PlanetCare* 2019). And major companies such as *L'Oréal* are reformulating their products to remove plastic microbeads and to use alternatives (*L'Oréal* 2017).

In addition to these different solutions and innovations to collect plastic, there are many initiatives that exist to recycle and reuse this waste plastic to create new products. *Adidas* and *Parley,* for example, formed a partnership to take collected plastic from the ocean and turn them into shoes (*Adidas* 2019). *Aquafil*, an Italian company, produces textiles and fabrics from discarded plastic fishing nets recovered from the ocean (*Aquafil* 2019). Similarly, *Buero* partners with other companies to transform plastic fishing nets into products such as skateboards, sunglasses, bicycles, chairs and many other products (*Buero* 2019). And companies like *Loop Industries* use innovative chemical processes to recycle plastic waste into new material for various applications that is as good as virgin PET (polyethylene terephthalate) plastic, and even safe to use for food applications (*Loop Industries* 2019).

The number of types of plastic that are actually recyclable is quite small, and very little plastic is recyclable in an economic way. However, there are companies that have found solutions to reuse even non-recyclable plastic. Some companies like *GreenMantra* (2019) and *BioCellection* (2019) transform plastic waste, even hard to recycle materials such as plastic film and grocery bags, into valuable products such as synthetic waxes, polymer additives and other chemicals. While others like *Agilyx* (2019) and *Bin2Barrel* (2019) are engaged in reverse production, transforming plastic waste back into fossil fuels like diesel and synthetic crude oil.

These solutions are certainly steps in the right direction, but each of them addresses specific aspects of the plastic waste problem. They do not take a more systematic view of the problem and do not provide an all-inclusive solution that addresses bigger changes needed across the entire plastic value chain. For example, what happens to the products that are made from waste plastic after their end of use? Moreover, many of these solutions could be linked together but are not currently connected. For example, clothes produced from recycled plastic should be aligned with microplastics filters to prevent the leakage of microfibers into the water while washing.

3.2 Reduce and Substitute Plastic

Other innovations focus on the substitution of plastic with other materials, or the reduction of plastic through new designs and new business models. These solutions target directly the problem of growing primary production, which was mentioned earlier (see Sect. 2.2), and try to reduce the need for plastic.

One of the big mainstream solutions to the plastic problem are bio-based plastics, although in general still more expensive than traditional plastics. Rather than being produced from fossil fuels, these plastics use plants as their feedstock. It is estimated that 90% of current plastics could be derived from plant sources instead of fossil fuel sources (Drawdown 2019). These plastics also have the advantage of in some cases and circumstances being bio-degradable, so it is expected to also tackle the problem of plastic waste. There are some concerns about the impact of bioplastics production on agriculture and land use. However, the percentage of land currently used for production of this kind of plastics is extremely small. Advancements in experimentations have opened new possibilities to use plant residues and other sources like chitin from crustaceans and insects (Issbruecker 2018), or even cactus (Heyden 2019).

However, the benefits of bioplastics can only be realized with more advanced waste management systems, so that they can be appropriately processed at the end of their life. In many cases, bio-based plastics have been shown to not properly biodegrade when disposed of without proper treatment at industrial composting plants (Thomlinson 2019). But some newer bio-based plastic materials called PHA (polyhydroxyalkanoate), such as the ones produced by companies like *Bio-On* (2019), can potentially degrade in soil and in the ocean as well. In any case, further

research is required to understand better the level and the quality of biodegradability of this material and its impact in the environment, compared with conventional plastics.

Other solutions combine innovative designs and new materials to present alternatives to the current production process and use of plastics. *New Light Technologies* has taken a completely different approach to plastics production, taking methane-based carbon (from landfills, farms, etc.) and converting it into a plastic substitute they call *AirCarbon* (*New Light Technologies* 2019). And products like *Ooho* (*Notpla* 2019), a seaweed pouch filled with water, are reimaging what products like plastic water bottles could look like with a more sustainable design. The London marathon in 2019 decided to replace plastic water bottles with *Ooho*, the largest ever trial of the product (Frearson 2019).

There are also some solutions that have developed new consumption models to present different ways for consumers to use plastic, aimed at preventing the need for more plastic products. Companies like *Cupclub* (2019) provide reusable cups at cafes, and Dutch start-up *Ozarka* (2019), provides reusable takeaway containers at restaurants and for office lunch catering. New brands like *Splosh* furnish home-cleaning, laundry, and dish-washing products through a packaging system that uses refillable containers that cut plastic packaging by 95% (*The Scotsman* 2012). And companies like *Terracycle* have partnered with major brands to launch *Loop*, a new grocery delivery system for households that uses reusable metal containers (*Loop* 2019).

Lastly, some companies focus on raising awareness of the problem among consumers to change their behaviours. Organizations like *WaytoEco* (Magrin 2019) provide important information to consumers, organizing workshop in schools in order to educate students on how to use less plastics and informing them on which plastics are recyclable and advising companies and local councils how they can better manage plastic waste. The organization is part of the *International Solid Waste Association*, an international task force of individuals and organizations around the world that help communities in different countries better manage their waste (Magrin 2019).

These innovative solutions are trying to make great strides in reducing the plastics production problem. But, as we mentioned with the bioplastics example, they fail to properly account for the end-of-life treatment and all the different ways that their products are disposed of and potentially enter the environment. And, most importantly, similar to the solutions discussed earlier (see Sect. 3.1), they are developed in isolation without taking a systemic view to identify the dynamics of the bigger problem, the types of infrastructure changes that are needed, and how they can fit together to more effectively tackle the problem of plastic waste.

4 Taking a Complex Systems Perspective

Nature has survived and flourished through times of radical change and disruption by dynamically networking and collaborating among species bringing sustainable prosperous success. It is a web of energized interconnections, a dynamic non-equilibrium of chaos within order, order within chaos. Humans and human organizations are included in this, as part of Nature, while exhibiting their uniqueness (Hutchins 2012). This core concept is one of the most important implicit characteristics of complex systems that emerge logically from the premises presented (see Sect. 1). Only the capability to be part of and to participate in a network of interactions, as well as to respond and to align in a proper way to external stimuli, brings the possibility to maintain sustainable entities that work in partnership within their ecosystem.

Circular Economy is a participatory process that is integrated with the Earth's complex system. Its characteristics have to be lined up with resilience, flexibility, and adaptability in order to create renewed and strong industries with multidisciplinary leadership and capabilities. This will support and empower diversity, achieve robustness and richness of the networks of relations, and further enable more resilience, flexibility and adaptability. Learning from the processes of Nature in every aspect is essential to build and to start this virtuous circle. And it requires considering not only external operations but also an internal attitude shaped by an awareness of the chain of cause and effect of one's actions.

The principles of Biomimicry can aid in addressing this process. "*Biomimicry is an approach to innovation that seeks sustainable solutions to human challenges by emulating nature's time-tested patterns and strategies. The goal is to create products, processes and policies—new ways of living—that are well-adapted to life on Earth over the long haul*" (*Biomimicry Institute* 2019a, b). The basic postulates that lay the foundations connecting socio-economic systems with Nature's unifying patterns are offered by the *Biomimicry Institute*. They are shown briefly in the list below (*Biomimicry Institute* 2019a, b).

- Use only the energy needed and rely on the freely available one.
- Recycle all materials.
- Be resilient to disturbances.
- Tend to optimize rather than maximize.
- Provide mutual benefits.
- Run on information/be transparent.
- Use chemistry and materials that are safe for living beings.
- Build using abundant local resources and incorporate rare resources only sparingly.
- Be locally attuned to local conditions and opportunities.
- Use shape to determine functionality rather than added materials and energy.

In implementing these principles, the role of governance and a proper integrated policy and legislation is fundamental, in order to educate and engage stakeholders at

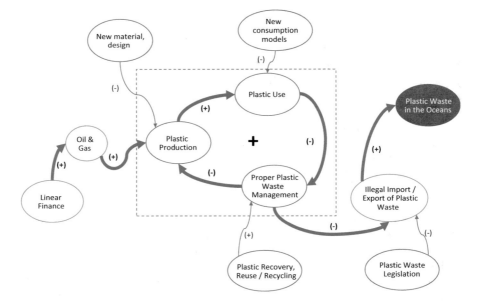

Fig. 1 Simplified global model of plastic waste problem

all levels across the entire value chain. Beyond the different rules and processes, governance for circular economy has to show responsibility and the capability to promote collaborative relations and innovation not only within the organizations themselves but in the entire related ecosystems (Steubling and Anton de Vries 2018). Thus, a cooperative resilient network of knowledge can be shaped in order to create a renewed business model in line with the natural and complex principles introduced in Sect. 1.

In doing this, being aware of the interdependence of actions and decisions, and consequently understanding the impact of these actions on other actors, is paramount. "Good governance is reflective of community empowerment and ecological wisdom, the absence of good governance is characterized by the lack of either or both" (Bosselmann et al. 2008). There needs to be greater interdependent collaboration at all levels, and at the same time an effort to understand the dynamic of the related environment, in order to adapt and to thrive in a vibrant and ever-changing setting with respect to other actors.

On the basis of what has been discussed until now, the present conditions of the plastic value chain are sketched in a simplified global model (see Fig. 1) in order to capture the very basic variables and the driving forces that have caused a huge amount of plastics to end up into the oceans over the years. In the diagram, the various forces are highlighted in the oval shapes. The blue ovals signify the plastics value chain, while the orange and the brown ones signify, respectively, the driving forces that contribute to plastic waste and those that help to solve it. The arrows connecting various forces represent the cause-and-effect links in the way of their

directions. The positive sign denotes a reinforcing feedback loop relationship, while the negative denotes a balancing one.

In current system, linear finance supports the oil and gas industry, which extract materials for plastic production. This trend is expected to increase in the future at a rate of 4% a year (see Sect. 2.2). Plastics are produced and used by society in a large and growing scale.

This process nourishes an increasing reinforcing loop, that is at the core of the model, which brings an exponential production of plastics and in turn a growing usage. And since there is a lack of proper plastic waste management, the more plastic is utilized, the less is treated appropriately.

As a result, the illegal import and export of plastic waste increases, which leads to more plastic waste in the oceans (see Sect. 2.1). In the graph, the variable "Proper Plastic Waste Management System" captures both systems in developed and in developing countries, which are both problematic although for different reasons as analysed in Sect. 2.1.

The graph also highlights some of the innovations described above (see Sects. 3.1 and 3.2). Existing and emerging solutions like new materials and designs, new consumption models, plastic collection and reuse, and plastic waste legislation, all tackle different aspects of the problem. However, as the model shows, these initiatives are not coordinated or connected to each other, and are instead developed in isolation. Solutions that create new materials and designs are unaware of innovations in new consumption models or plastic waste treatment.

In order to have a more effective impact on the plastic waste problem, there needs to be a greater integration of solutions. The different initiatives that are working on combatting plastic waste need to collaborate in order to develop truly closed loop solutions that address the more systemic issues. In the diagram, the weakness and the inadequacy of these solutions in dealing with the plastic issue is showed by the thinner arrows.

In addition, what is missing from the model is a greater global awareness of the plastic waste problem. **There is a very weak link between the problem of plastic waste in the oceans and the societal use of plastic**. Thus, the impact of increasing usage is not considered. There needs to be a more concerted effort to raise the level of global awareness, in order to change the mindset of society to move away from plastics and towards more innovative solutions.

To face the growing plastic problem in a systemic way, it is necessary to take a two-pronged approach. One key aspect is to increase the level of global awareness through coordinated actions, and another key aspect is to tackle the use of plastic in society by providing sustainable closed loop alternatives. And for both of these, the role of proper integrated legislation is crucial.

On the basis of the properties of complex systems (see Sect. 1), social actions are dynamically emerging from the damages caused to marine species and food chains by plastic waste in the oceans. These social actions arising from diverse types of initiatives, promoted by different stakeholders around the world, build an underlying process of increased level of global awareness of the plastic waste problem and their impact on the environment. Increased global awareness is crucial to encourage

people to shift towards new consumption models and change their behaviour when it comes to plastic use.

There also need to be new ways of consuming that provide new business models and viable alternatives to plastics, in order to reduce societal usage. Innovations in waste management should inspire new materials and new design so that they can be easily collected, reused and recycled. This truly closed loop product cycle is thus supported by environmental legislation and funded through circular economy financing at local and international levels.

The increased global awareness in new behaviour and new alternatives should in turn stimulate proper international and local governance and legislation. This will coordinate strategically integrated actions that promote the reduction of harmful plastics production, as well as enhance and stimulate the efficiency and the innovation in recycling industry and in waste management.

Therefore, the model below (see Fig. 2) introduces a balancing loop of "Global Awareness" through "Social Actions" in order to cap and to produce a consequential and exponential decrease in the 4% growth in expected plastic production. The green arrow in the figure shows how this balancing loop enhances the increasing reinforcing loop of new solutions—"Innovation in design and new materials", "New consumption models", "Environmental Legislation, Circular Finance", and "Proper Recovery, Reuse/Recycling". And in turn, this reinforcing loop reverses the direction, from increasing to decreasing as shown by the yellow arrow, of the reinforcing plastic loop system at the core of the graph causing, in this way, a decrease in the production and in the use of plastic.

In this scenario, the various solutions against plastic waste are coordinated and work together to change society's consciousness towards more responsible and effective behaviour. By doing so, there will be a reduced societal demand for plastics production from fossil fuel, reducing the present dependence on the oil and gas industry. Moreover, this greater awareness will encourage proper waste management of plastics and plastic alternatives, which will eliminate the illegal import and export of plastic waste and the main causes of plastic garbage in the ocean.

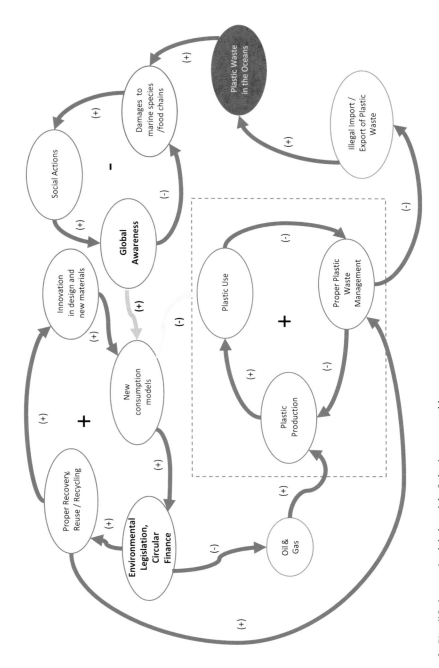

Fig. 2 Simplified systemic global model of plastic waste problem

5 Conclusion

The analysis made has focused on the main macro trends and causes that have resulted in the huge pollution of our rivers and oceans with plastic garbage. And it underlined the urgent necessity our society has to adopt a systemic approach, also from a financial point of view, to face and to deal with a complex reality. This investigation has avoided certain aspects that could be treated separately in a more detailed manner, in order to provide an understandable overview of the key variables behind the problem of plastic waste in the ocean and its management.

A key aspect to underline is the role of proper integrated governance at all levels. This is the engine for building a virtuous systemic flux of materials, as well as more intangible aspects such as networks of relations. It reflects a global growing awareness of the plastic waste problem, and also influences the implementation of circular values and precepts in the financial sector.

The recent EU legislation—the *Circular Economy Package* in 2015, the 2018 strategies and 2019 guidelines and recommendations to tackle the plastic waste problem, and the *Circular Economy Stakeholder Platform*—is a good and encouraging starting point and a unique global example until now. Nevertheless, there is a huge amount of work that needs to be done in order to activate a more conscious way of thinking and acting.

From our analysis, it has clearly surfaced that a cost-revenue mentality has and is largely dominating every aspect of decision-making in managing the plastic issue since the beginning. This attitude has failed to take into account the impacts and the consequences that these decisions would have on natural environment and society as a whole.

This standpoint is at the root of a linear economic paradigm. What is happening for plastics is only a consequence of a wide and general demeanour that has created huge problems in other areas like climate change and CO_2 emissions, the 2008 global financial crises, the global loss of biodiversity, etc.

Therefore, it is important to note that a system perspective is not only relevant for the specific problem of plastic pollution. Instead, it should, in our opinion, be applied to many other fields. This will lead towards a more pertinent and effective paradigm of human actions and events in every area.

Circular Economy is only a beginning and a stimulus towards a more integrated, genuine and effective social and economic reality in the direction of transforming the internal priorities and empowering the cultural and universal values.

"The movement to a lasting society cannot occur without transformation of individual value priorities... Materialism simply cannot survive the transition to a sustainable world"
Worldwatch Institute "State of the World Report", 1990

References

4Ocean (2019) Cleanup Operations. https://4ocean.com/cleanups/. Accessed 25 July 2019

Adidas (2019) Adidas X Parley Collection. https://www.adidas.com/us/parley. Accessed 25 July 2019

Agilyx (2019) Our History. https://www.agilyx.com/our-solutions/history. Accessed 25 July 2019

Aquafil (2019) The ECONYL YARN. https://www.aquafil.com/sustainability/econyl/. Accessed 25 July 2019

Baltimore Waterfront (2019) Trash Wheel Project. https://www.baltimorewaterfront.com/healthy-harbor/water-wheel/. Accessed 25 July 2019

Bin2Barrel (2019) Bin2Barrel. https://bin2barrelcom/ Accessed 25 July 2019

BioCellection (2019) Innovation. https://www.biocellection.com/innovation. Accessed 25 July 2019

Biomimicry Institute (2019a) What is Biomimicry? https://biomimicry.org/what-is-biomimicry/. Accessed 03 Aug 2019

Biomimicry Institute (2019b) Nature's Unifying Patterns. https://toolbox.biomimicry.org/core-concepts/natures-unifying-patterns/. Accessed 03 Aug 2019

Bio-on (2019) Mission. http://www.bio-on.it/mission.php. Accessed 25 July 2019

Bosselmann K, Engel R, Taylor P (2008) Governance for sustainability—issues, challenges, successes. IUCN, Gland, Switzerland

Boyle AE (1985) Marine pollution under the law of the sea convention. Am J Int Law 7 (2):347–372. https://doi.org/10.2307/2201706

BP (2019) BP Energy Outlook 2019 Edition. https://www.bp.com/content/dam/bp/business-sites/en/global/corporate/pdfs/energy-economics/energy-outlook/bp-energy-outlook-2019.pdf. Accessed 27 July 2019

Bruggers J (2019, June 7) What's Worrying the Plastics Industry? Your Reaction to All That Waste, for One. https://insideclimatenews.org/news/06072019/plastic-waste-ocean-global-summit-industry-solutions-recycling-climate-change. Accessed 15 July 2019

Buero (2019) Netplus Materials. https://bureo.co/pages/bureo-collection2. Accessed 25 July 2019

CupClub (2019) About Us. https://cupclub.com/page/about. Accessed 25 July 2019

De Smet M, Linder M, et al (2019) A circular economy for plastics. https://publications.europa.eu/en/publication-detail/-/publication/33251cf9-3b0b-11e9-8d04-01aa75ed71a1/language-en/format-PDF/source-87705298. Accessed 19 July 2019

Drawdown (2019) Materials Bioplastic. https://www.drawdown.org/solutions/materials/bioplastic. Accessed 25 July 2019

Ellen MacArthur Foundation (2017) The New Plastics Economy: Catalysing action. https://www.ellenmacarthurfoundation.org/publications/new-plastics-economy-catalysing-action. Accessed 22 July 2019

European Commission (2018a) Descriptor 10: Marine Litter. https://ec.europa.eu/environment/marine/good-environmental-status/descriptor-10/index_en.htm. Accessed 21 July 2019

European Commission (2018b) Opening Keynote Speech of Frans Timmermans at the Circular Economy Stakeholder Conference. http://europa.eu/rapid/press-release_SPEECH-18-943_en.htm. Accessed 24 July 2019

European Commission (2018c) Plastic Waste: a European strategy to protect the planet, defend our citizens and empower our industries. http://europa.eu/rapid/press-release_IP-18-5_en.htm. Accessed 25 July 2019

European Commission (2019a) International ocean governance: an agenda for the future of our oceans. https://ec.europa.eu/maritimeaffairs/policy/ocean-governance_en. Accessed 21 July 2019

European Commission (2019b) Implementation of the Circular Economy Action Plan. https://ec.europa.eu/environment/circular-economy/index_en.htm. Accessed 21 July 2019

Frearson A (2019, April 29) London Marathon offers edible seaweed drinks capsules as alternative to plastic bottles. https://www.dezeen.com/2019/04/29/london-marathon-ooho-edible-drinks-capsules-seaweed/. Accessed 25 July 2019

Geyer R, Jambeck J, Law KL (2017) Production, use, and fate of all plastics ever made. Sci Adv 3 (7):e1700782. https://doi.org/10.1126/sciadv.1700782

GoJelly (2019) About GoJelly. https://gojelly.eu/about/. Accessed 25 July 2019

Gray R (2018, July 6) What's the real price of getting rid of plastic packaging? https://www.bbc.com/worklife/article/20180705-whats-the-real-price-of-getting-rid-of-plastic-packaging. Accessed 23 July 2019

Green J, Whitebread E (2019) Tackling Plastic Waste and Pollution for Human Health and Marine Biodiversity—A Call for Global Action. https://learn.tearfund.org/~/media/files/tilz/circular_economy/2019-tearfund-consortium-tackling-plastic-waste-and-pollution-en.pdf?la=en. Accessed 23 July 2019

GreenMantra (2019) About Us. http://greenmantra.com/aboutus/. Accessed July 25 2019

Heyden T (2019, June 4) How to make biodegradable 'plastic' from cactus juice. https://www.bbc.com/news/av/stories-48497933/how-to-make-biodegradable-plastic-from-cactus-juice. Accessed 25 July 2019

Hopewell J, Dvorak R, Kosior E (2009) Plastics recycling: challenges and opportunities. Philos Trans Roy Soc B: Biol Sci 364(1526):2115–2126. https://doi.org/10.1098/rstb.2008.0311

Hutchins G (2012) The nature of business. Green Books, UK

Issbruecker C (2018, February 28) How much land do we really need to produce bio-based plastics? https://www.european-bioplastics.org/how-much-land-do-we-really-need-to-produce-bio-based-plastics/. Accessed 25 July 2019

Jambeck J, Geyer R et al (2015) Plastic waste inputs from land into the ocean. Science 347 (6223):768–770. https://doi.org/10.1126/science.1260352

L'Oréal (2017) L'Oréal completed the reformulation of its wash-off products using plastic microbeads as cleansing or exfoliating agents. https://www.loreal.com/media/news/2017/mar/reformulation-of-products-using-microbeads. Accessed 4 Aug 2019

Laville S, Taylor M (2017, June 28) A million bottles a minute: world's plastic binge 'as dangerous as climate change'. https://www.theguardian.com/environment/2017/jun/28/a-million-a-minute-worlds-plastic-bottle-binge-as-dangerous-as-climate-change. Accessed 25 July 2019

Loop (2019) Loop US. https://loopstore.com/. Accessed 25 July 2019

Loop Industries (2019) About Us. https://www.loopindustries.com/en/about. Accessed 25 July 2019

Magrin D (2019, July 1) Phone interview

New Light Technologies (2019) Aircarbon. https://www.newlight.com/aircarbon/. Accessed 25 July 2019

NotPla (2019) Made from Notpla: Ooho and our other packaging solutions. https://www.notpla.com/. Accessed 12 Sept 2019

Ozarka (2019) Ozarka. https://www.ozarka.club/. Accessed 25 July 2019

Parley (2019) Parley Global Cleanup Network. https://www.parley.tv/updates/parley-global-clean-up-network. Accessed 25 July 2019

Peters A (2018) The giant Ocean Cleanup device is having some trouble cleaning up the ocean. https://www.fastcompany.com/90278272/the-giant-ocean-cleanup-device-is-having-some-trouble-cleaning-up-the-ocean. Accessed 04 Aug 2019

PlanetCare (2019) Our Solutions. https://planetcare.org/en/products/. Accessed 25 July 2019

Plastic Whale (2019) Our Story. https://plasticwhale.com/our-story/. Accessed 25 July 2019

RanMarine (2019) WasteShark. https://www.ranmarine.io/wasteshark. Accessed 25 July 2019

Reintjes M (2018, July 4) Wong: plastic scrap imports to Thailand and Vietnam have come to a halt. https://recyclinginternational.com/business/wong-plastic-scrap-imports-to-thailand-and-vietnam-have-come-to-a-halt/16377/. Accessed 30 June 2019

Root T (2019) Inside the Long War to Protect Plastic. https://publicintegrity.org/environment/pollution/pushing-plastic/inside-the-long-war-to-protect-plastic. Accessed 29 July 2019

Secretariat of the Basel Convention (2011) Basel Convention Overview. http://www.basel.int/TheConvention/Overview/tabid/1271/Default.aspx. Accessed 2 July 2019

Shaw P (2002) Changing conversations in organizations: a complexity approach to change. Taylor & Francis Ltd, London. https://doi.org/10.4324/9780203402719

Statista (2019) Global plastic production from 1950 to 2017 (in million metric tons). https://www.statista.com/statistics/282732/global-production-of-plastics-since-1950/. Accessed 29 July 2019

Staub C (2019) Basel Convention countries consider plastic proposal. https://resource-recycling.com/plastics/2019/05/01/basel-convention-countries-consider-plastic-proposal/. Accessed 3 July 2019

Steubling S, Anton de Vries C (2018) Governance for the Circular Economy. https://cirql.eu/download-request/. Accessed 03 Aug 2019

Tangri N (2019, June 18). Phone interview

Terracycle (2019) Beach Plastic Cleanup Program. https://www.terracycle.com/en-US/brigades/beachcleanup. Accessed 25 July 2019

The Ocean Cleanup (2019) The Ocean Cleanup. https://theoceancleanup.com/. Accessed 25 July 2019

The Scotsman (2012, September 15) Entrepreneur Angus Grahame hoping to clean up with new product. https://www.scotsman.com/lifestyle/personal-finance/entrepreneur-angus-grahame-hoping-to-clean-up-with-new-product-1-2529261. Accessed 25 July 2019

Thomlinson I (2019, May 3) When biodegradable plastic is not biodegradable. https://theconversation.com/when-biodegradable-plastic-is-not-biodegradable-116368. Accessed 25 July 2019

Tyree C, Morrison D (2018) Invisibles: The Plastics Inside Us. https://orbmedia.org/stories/Invisibles_plastics/. Accessed 21 July 2019

Villaruba-Gomez P, Cornell S, Fabres J (2018) Marine plastic pollution as a planetary boundary threat—the drifting piece in the sustainability puzzle. Mar Policy 96:213–220. https://doi.org/10.1016/j.marpol.2017.11.035

Wong S (2019a, June 28). Phone interview

Wong S (2019b) East West trade impasse: trade impacts on circular economies and what business need to be considered. Presented at Plasticity Amsterdam, Amsterdam, 20 June 2019

Working Group FinanCE (2016) Money makes the world go round. https://usfl-newwphumuunl/wp-content/uploads/sites/232/2016/04/FinanCE-Digitalpdf Accessed 20 July 2019

Toys for the Winter

Eugenio Triana Mataix

Abstract The story *"Toys for the Winter"* aims to bring the worries and possibilities of a future made of modern composite materials to life. Complex man-made materials are seen with suspicion and worry, but there is a purpose behind their design, and understanding this purpose is key to establishing an emotional connection with our creations. Taking inspiration from the noted science fiction writer and promoter Brian Aldiss, *"Toys for the Winter"* tries to change the way in which plastic has a place in our imaginations as a sterile, polluting thing and to show how, with the right usage, it can generate as much wonder and possibilities as the creations of nature.

Keywords A plastic story · Plastic vision · Plastic fiction

1 Introduction

Brian Aldiss (1925–2017), a long-term Oxford resident, was one of the UK's most influential figures in the field of science-fiction. Writer of more than 80 books and 300 short stories, mainly in that genre, he was also the editor of numerous influential anthologies, vice-president of the *H.G. Wells Society* and a founding member of the *Birmingham Science Fiction Group*, which meets regularly to this day. He won two *Hugo Awards* and one *Nebula Award*.

One of his most famous short stories is *"Supertoys Last All Summer Long"*, which served as the basis for the Stanley Kubrick/Steven Spielberg film *"A.I. Artificial Intelligence"* (2001). A story of human parents and their artificial human son, which they find hard to bond with, it is a story about the difference between the organic and the artificial, and whether those differences can ever be breached.

E. Triana Mataix (✉)
Film Production, Film Marketing and Distribution, Birmingham City University, Birmingham, UK
e-mail: Eugenio.Triana@bcu.ac.uk

© Springer Nature Switzerland AG 2020
M. Streit-Bianchi et al. (eds.), *Mare Plasticum – The Plastic Sea*,
https://doi.org/10.1007/978-3-030-38945-1_12

Here we have reversed the set-up, as a way to draw the focus away from questions of identity and more towards our relationship with the materials that make us and the world around us. In this case our beings are, of course, made of plastic.

Plastic is notoriously durable, which made it a controversial if effective material for household objects. Increasingly, we have moved away from its use in our everyday lives and instead found new uses in more specialized situations.

One of these uses is as a material for artificial limbs. New research is also seeing plastic being used to make artificial skin that emulates human flesh with all its advantages and applications, further blurring the line between who we are and what we want to be.

Rather than looking at plastic as being simply good or bad, we hope this story examines the complex relationship along with its technological uses.

2 Toys for the Winter

Run down your fingertip between your wrist and your elbow. Notice how smoothly it traces a path. Your skin feels much the same as it did when you were created, 11 years ago. It will be almost as smooth a 100 years from now.

The secret to your longevity is your immunity to biological processes. Bacteria don't yet want you. There are, in fact, very few organisms in nature that derive their energy from the complex hydrocarbons from which you are made of. There is thus nothing the world created that is out there to eat you. Maybe a few harmless fish. This is a very unique advantage in the history of this Earth.

You need only fear sunlight. This is why we live inside. It's why I insist you never go outside during the daytime. The ultraviolet radiation in sunlight is the one thing that can get past your defences and break down the complicated network of polymers that bind together to make you who you are. Sunlight turns your skin into simpler stuff. That stuff ages faster.

Now press down. Create friction by drawing your finger without release down the same route again, from bottom of the wrist to the top of your elbow. Can you feel the ridges? These small indentations are all the tiny holes that were created on the surface of your polymer skin to allow you to cool your body. Place your hand near an area of your body after heavy exercise and you will feel soft steam rise from it, the mix of water and air that is the residue of the systems that help regulate your temperature.

Press down firmly. Notice the hard tension that presses back against your forefinger. Your skin is not easily breached. It is the result of hundreds of layers that are folded into each other to create a harder whole. They also protect the pressure sensors that allow you to make contact with the world around you.

Hold up your hand to the light. With the right light, if you focus, you can see the tiny electrical impulses that flow through your body, between thousands of tiny

electrodes. This is living information flowing throughout you. Your skin protects this too.

Scratches can build up on your arms, but they will quickly repair. The skin that shields them has been designed to stretch and be malleable, so it can rearrange itself and coat its own breaches.

But you must be careful: at lower temperatures your skin loses its pliability and its ability to heal. This is why I ask you to always check your thermometer. It is why we live in a climate-controlled environment. At very, very low temperatures, your body becomes an enemy to itself, turning heavy and brittle. Always be careful of this.

Now let's bring Sprinkles into the picture. Sprinkles is quite small, so let's place him on your lap. Softly, he is quite sensitive as well.

Let's compare: pass your fingertip down Sprinkles' arms and you can immediately tell the difference. He's covered in thick fur. Sprinkles' temperature regulating system is not as sophisticated as yours, and he needs a permanent coat to keep him shielded.

Press down as we did with you before, but, again, not too sharply. Feel that? His skin is softer, easier to harm but more flexible than yours. Sprinkles can move quite freely in temperatures that might cause you trouble.

Sprinkles has other advantages. He does not need to draw energy from a source. He does so from his environment. The sun doesn't hurt him, rather, it gives him energy. Leave him outside, and, while you sleep, he will be renewed. With that and one of the many apples you feed him he can keep playing for a long time without tiring. This is why toys are more active in the summer but cosier in the winter, when we can bring them in from outside to use their excess energy to warm us back up.

Scrape the surface of Sprinkles' skin. Can you feel that? That moisture is sweat, it is the way that Sprinkles keeps himself cool. It is similar to the way you do it, right? Isn't it curious that there are as many similarities as there are differences between you and Sprinkles?

Well, think about it. We built you, but who built us? Someone very much like us. And who built them? If you go far back enough, it was creatures quite similar to Sprinkles.

They were adapted creatures, and they changed over many years to come to wear many solutions against their environment. Like Sprinkles, they were flexible and independent beings who could survive in multiple surroundings.

So why make us? By the time they came to master nature, as we have, those who created us understood they were, at their core, made of quite simple materials. They also knew they could now design bodies to fit in a particular environment, as they lived inside like we do. They made us of a much more complex group of materials: plastic.

Because of plastic we can live many times longer than they ever could. There are disadvantages, but time is our one great strength. It is why we will spend many winters together.

Here is what I want you to understand. The point of this whole speech. Sprinkles is not like us. He is more like our creators. His skin decays quickly and is nowhere

near as durable as yours. There are a lot of tiny beings in nature that want to have their tiny bits of him, and one day they will win out.

This is true of all the objects we use. They degrade, as we live on. Sprinkles is for keeping boredom at bay in the winter, when it's too cold to go outside. Once you tire of him, or want a new toy, then he will be gone.

And that is as it should be.

"The Bottlenose Dolphin" (An Eco-comic)

Wolfgang Trettnak

Abstract Comics is a medium for transporting messages and information in a very direct and efficient way, since it is primarily based on visual information, which may be extremely reduced and focused. This makes it not only suitable especially for children, but also for adult people. Although comic magazines once have been considered as "junk", comics today has gained enormous reputation, which is evidenced by the large number of high-level graphic novels on the market. "*The bottlenose dolphin*" is a short comic attempting to send an ecological message to the (young) reader.

Keywords Comic · Eco-comic · Environment · Plastic pollution

1 Introduction

Comics is a medium for transporting messages and information in a very direct and efficient way, since it is primarily based on visual information, which may be extremely reduced and focused. This makes it not only suitable especially for children, but also for adult people. Although comic magazines once have been considered as "junk", comics today has gained enormous reputation, which is evidenced by the large number of high-level graphic novels on the market.

"*The bottlenose dolphin*" is a short comic attempting to send an ecological message to the (young) reader. Such "eco-comics" for sure are not a novelty, but have a long history, especially in Northern America (McLaughlin 2013). Already in the 1970s *Captain Enviro* said (Captain Enviro 1972):

> "*There is still time to save the maritime environment!*"

W. Trettnak (✉)
ARSCIENCIA, Werndorf, Austria
e-mail: wolfgang@trettnak.com

References

Captain Enviro (1972) Committee of Environment Ministers, Council of Maritime Premiers. Comic
 Book World, Halifax, Nova Scotia, Canada
McLaughlin MJ (2013) Rise of the eco-comics: the state, environmental education and Canadian
 comic books, 1971–1975. Mat Cult Rev 77/78:9–20

Printed in the United States
by Baker & Taylor Publisher Services